NEW YORK

city of islands

The Bronx

Manhattan

Queens

Brooklyn

Staten Island

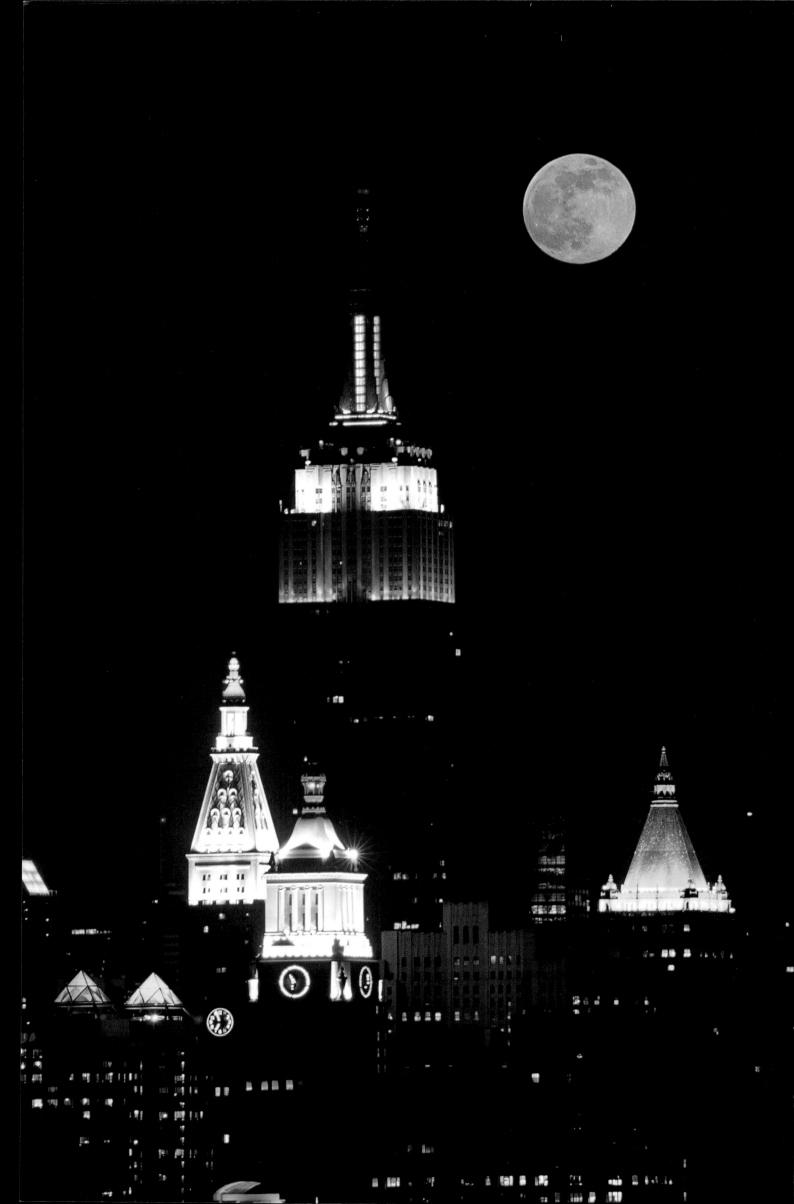

jake rajs

NEW YORK

city of islands

essay by **Pete Hamill**

THE MONACELLI PRESS

First published in the United States of America in 1998 by
The Monacelli Press, Inc.
10 East 92nd Street, New York, New York 10128.

Library of Congress Cataloging-in-Publication Data
Rajs, Jake.
New York : city of islands / Jake Rajs ; essay by Pete Hamill.
p. cm.
ISBN 1-58093-009-3
1. New York (N.Y.)—Pictorial works. I. Hamill, Pete, 1935– . II. Title.
F128.37.R26 1998
974.7'1'00222—dc21 98-30246

Printed and bound in Hong Kong

Designed by 2x4, New York City

Preceding Page Midtown Manhattan

Contents

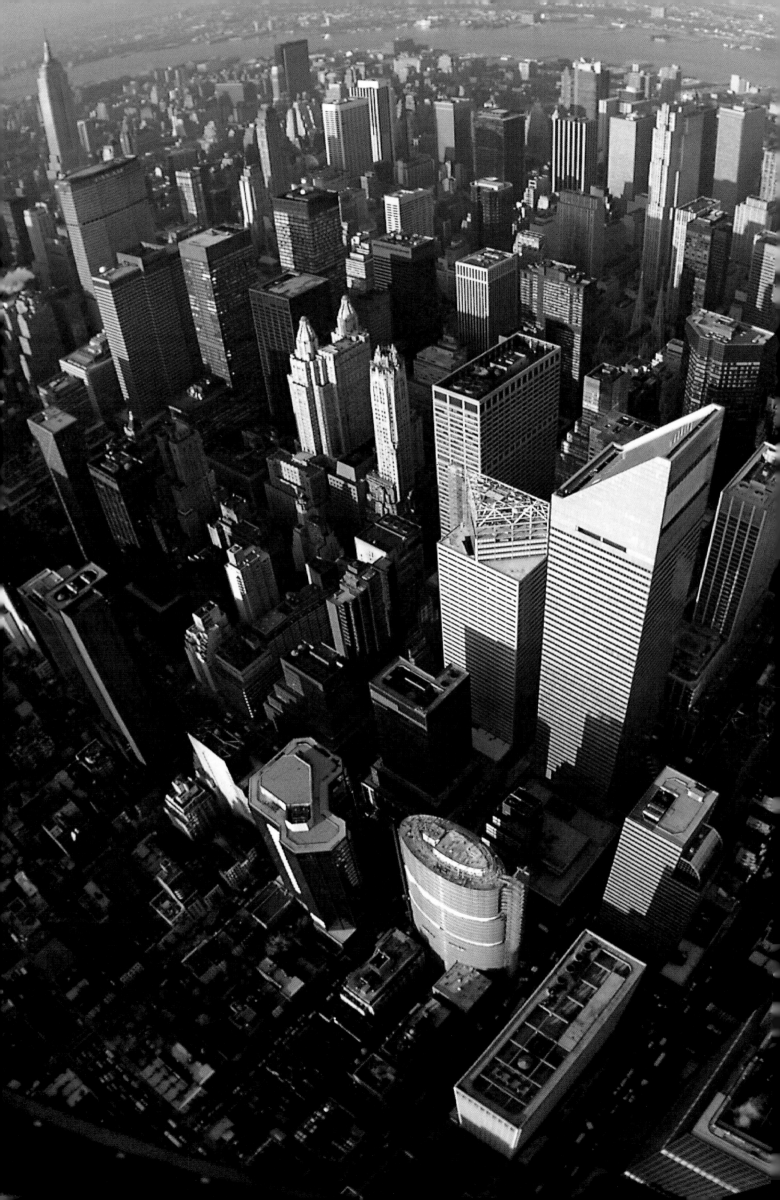

The archipelago of New York is seen most clearly from the air. You are arriving from some distant place on a day bright with the sparkle and clarity of October. You are in a window seat on the left side of the airplane. Below you is the great harbor, its entrance guarded by the steel geometry of the Verrazano-Narrows Bridge, which ties together Brooklyn and the green pastures of Staten Island. There in the harbor, as tiny as a toy, are the Statue of Liberty and, directly behind it, Ellis Island. And then, announced suddenly by eruptions of spires and the glitter of a million windows, Manhattan. It is long and irregular, narrowing as it moves north, with the mighty Hudson coursing down its western coast and the estuary called the East River separating it from the head of Long Island. There are dots of green visible from the sky as well as the long sward of Central Park, but from the air, as the airplane banks to the right, it appears that every last acre has been shaped by man.

Midtown Manhattan

Off to the left, as the airplane turns, up there above Manhattan, is the Bronx. It is the only one of New York's five boroughs that is on the mainland, and from the air it does look oddly separate, a dark painting with a scumbled texture but no borders, no frame; its northern edge simply eases into the rest of America. You can see Yankee Stadium. You can see the narrowing Hudson. You can see the waters of Long Island Sound. But from the air, the Bronx seems different. It is not until you move through its streets and sense its emotional and psychic separation from the mainland that you realize that the Bronx too is one of the New York islands.

You are over Long Island now. It is shaped like an immense scaly fish with sharp humps that has come aground in flight from Europe. Queens and Brooklyn are its head. Queens is at the top of the head curving around behind Brooklyn to form a jaw. Brooklyn is the immense snout, pushing at the harbor. Shea Stadium is the tiny green eye. The immense fish seems poised to gnaw at Manhattan.

From the air, Queens and Brooklyn are flatter than Manhattan, more collage than bas-relief. Queens is brighter. The houses are newer, hundreds of thousands of them built after World War II. They are painted white. They have shingled rooftops. They have backyards, and in some you can glimpse the azure shimmer of tiny swimming pools. Brooklyn is darker, older, a place of brownstone and brick, of aging tenements and ugly housing projects. The street grids of both boroughs are less rigid than that of Manhattan; some streets go off at odd angles, a few form circles, others end abruptly, as if the builders got lost. Boulevards, avenues, and highways cut through them, going west to Manhattan or east to the suburbs of Nassau and Suffolk. At the southern edge, you can sometimes see the tiny islands of Jamaica Bay and the bright white beaches of Coney Island and the Rockaways, all of them washed by the endless Atlantic.

City of islands. Shaped by geography and history, by the great harbor and the millions who entered it to build the city. Without the harbor and the rivers, the history would have been different. But it was that harbor and the emerging port that drew the millions. They lashed themselves together with 76 bridges, large and small, and 722 miles of subway track. Bridges and tunnels connect them to the rest of the United States, to the west and north and south. And upon the five main islands, they evolved other islands, shaped by commerce or manufacturing, by ethnicity, by class. Those islands can't be seen from the air.

The driving forces in the making of New York remain essential parts of its

character: greed, energy, tolerance, and optimism. Greed certainly brought the first Europeans into sight of the archipelago. A man named Giovanni da Verrazano arrived in 1524 in command of a huge warship. He was from Florence but had been commissioned by the king of France to find a passage to Asia, a short route to the lands of silk and spices. He sailed into the Narrows, near where the bridge now stands that bears his name, and could see the vast bay, which he thought was a huge lake, and the river beyond that was feeding the bay. There were indigenous people, called Indians since the time of Columbus, and Verrazano and his crew received a friendly reception. "The people," he would write later, "clothed with the feathers of various colors, came toward us joyfully, shouting with admiration, showing us where we could land the boat more safely."

One of Verrazano's sailors was smashed by the surf and rescued by the Indians, who helped him recover, embraced him, marveled at his white skin, and sent him back to his boat. But there was no sustained contact. A hard wind suddenly rose, and the cautious Verrazano turned, departed, and never returned. If he had planted the French flag in that harbor and claimed the river, much of American history would have been different. The following year, another explorer arrived. He was a black Portuguese named Estéban Gómez and he was commanding a ship for Spain. He took a look, saw no cities, and sailed away. For more than eighty years, no other Europeans made landfall in the great harbor.

Ticker-tape parade on Broadway, Lower Manhattan

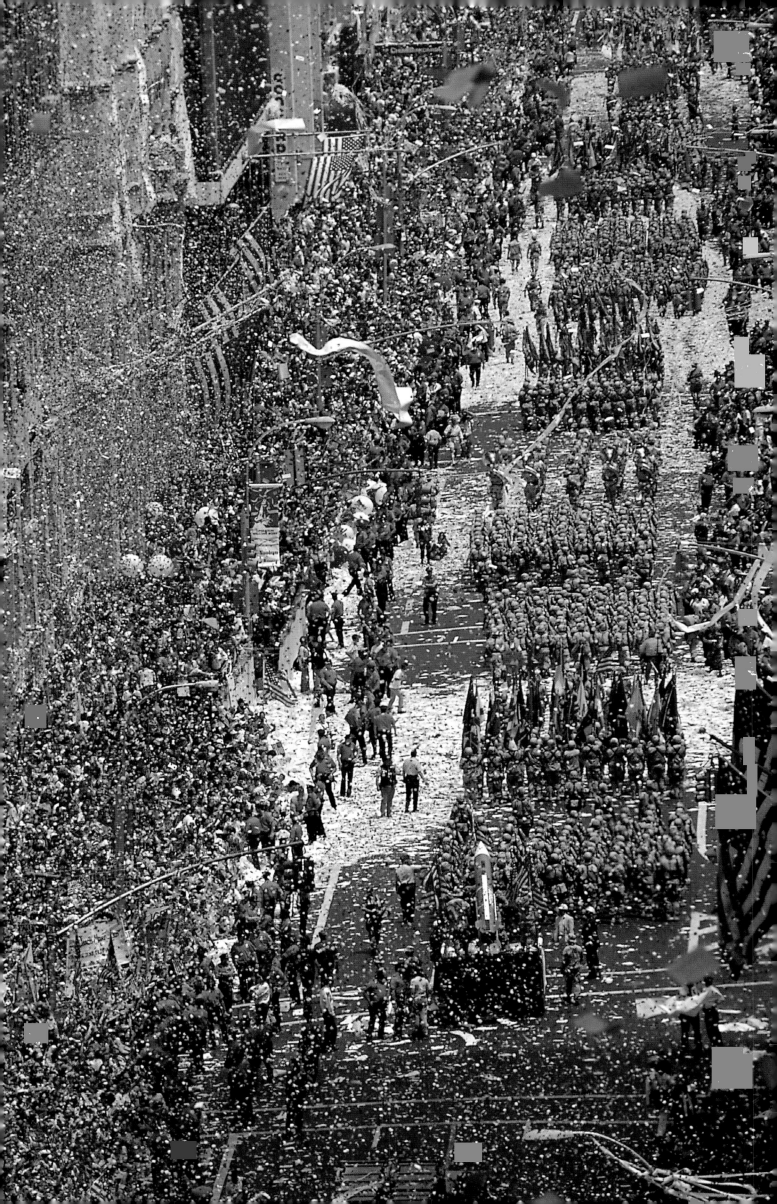

During those years, as in countless years before the abrupt appearances of these strange men, the rhythms of life continued in the wooded islands. They were roamed by Indians: the Algonquian clans called the Mahicans, who lived in the present Bronx and lower Westchester; the Canarsie, from Long Island; the Delaware, from New Jersey. They found fresh water, abundant game, and rivers thick with shellfish, but few settled permanently on the island they called Manahatta, "the place encircled by many swift tides and sparkling waters." As generations of later visitors would learn, it could be a place of fierce winters and brutal summers. But in good weather, and usually in summer, Indians of different clans came to Manahatta to consume clams and oysters and mussels, leaving behind mounds of shells, to fish in the clear waters, to hunt deer and rabbit, wild turkey and geese. The island's twenty-two square miles were thickly wooded; the vast stands of birch were often blindingly white in the sun. There were bear in those dense woods, and wolves, and even an occasional mountain lion. But there were few human beings; this Manahatta was a nice place to visit, they just didn't want to live there.

The white men of the sixteenth century had little interest in such small pleasures. Verrazano had arrived. Estéban Gómez had arrived. Both swiftly departed. Such men were not attracted by the beauties of nature, or anthropological curiosity, or plans for long-term settlement. They were driven by two goals: that fabled passage to Asia, or loot. The Europeans knew about the great hoard of gold and silver plundered from Mexico and Peru by Spain; that nation was still living on the proceeds, using its treasury to finance even greater imperial expansion and, ultimately, national calamity. There were legends of still undiscovered American empires, mountains of gold and silver, the Seven Cities of Cíbola. They lured bands of European adventurers and explorers into violence and madness. But the passage to Asia, the short route to fabled Cathay, promised even greater riches than naked conquest. It seemed less and less likely that any additional golden cities existed in America, but the gaudy vision of the Northwest Passage was never fully extinguished.

In 1609 an Englishman named Henry Hudson appeared in the harbor in command of a small Dutch ship called the *Half Moon*. He, too, was searching for the Northwest Passage. He, too, was greeted warmly by the Indians, who were dressed in deerskins and copper ornaments. But then Hudson made a very special contribution to New York history: he pulled off the first kidnapping. He grabbed two young Mahicans, intending to bring them back to the Netherlands either for scrutiny or as evidence of his own great exploits. (From the point of view of the Mahicans, of course, this was also the first, and probably last, alien abduction in New York history.) But instead of turning toward Europe, Hudson sailed north in the river that now bears his name. He hoped that this river led to another, which would branch west, toward Asia.

As he moved up river, the two kidnapped Indians made a break for freedom. One drowned in the river. But the other made it to shore and eventually found his way back to his tribe. He carried a tale of the perfidy and danger of the white man. Hudson sailed on, going as far as the present city of Albany, before deciding that this was not the route to Cathay. It was just a river. On his way back, the Indians were waiting. Hiding in ambush in the marshy weeds at the top of Manhattan that would later be called Spuyten Duyvil, they attacked in six long boats, racing at the small, seventy-four-foot-long *Half Moon*. Only primitive European technology—Hudson had a small cannon on board—prevented the Indians from massacring the kidnappers. The Indians dispersed into the forests. They have left behind no records, but these indigenous people must have sensed that an enormous change was about to happen in their world.

The Dutch were the agents of that change. In Amsterdam, a small group of merchants carefully read Hudson's reports. The explorer was generally optimistic about the possibilities of logging and agriculture, but it was the promise of a lucrative fur trade that widened their eyes. As he sailed upriver beyond Manhattan, the Englishman had seen many Indians wearing pelts of beaver and otter. That was an opportunity. In Europe, wild animals had been extinct for many years, and the furriers of the day imported pelts from Russia, paying for them in gold. In this new America, they could get similar pelts in exchange for beads and tools. Buy cheap, sell high: that was among the earliest New York mottoes. In 1610 the first of many Dutch expeditions returned to the New World.

They must have convinced the Indians that Hudson's behavior was atypical, because the fur trade began to flourish. Two Indians were persuaded to make a voyage to the Netherlands of their own free will; their exotic presence, a primitive form of advertising, further inflamed the European imagination. By 1621, the Dutch West India Company had been formed to bring some order to the expanding fur trade. In 1624 the first permanent settlement was established at the foot of Manhattan. As an augur of the city that was to come, the charter was held in the name of the trading company, not of the Netherlands, that is, the city was to be a business enterprise, not an outpost of a nation. The Dutch colony of New Netherlands stretched from Albany to the state of Delaware; New Amsterdam was its center.

In 1625 the Dutch began building Fort Amsterdam, which would be the heart of the new town. Located near the present site of the U.S. Custom House, the circumference of this pentagonal structure was to be 1,050 feet, and it was surrounded by a moat fifty-four feet wide and eight feet deep (the building of the fort would take years, thus establishing the New York tradition for endless municipal projects). A town plan was designed, including the present Broad Street, Pearl Street, and Beaver Street. That original plan—designed by an engineer

named Crijn Fredericks—included the present Broadway, Park Row, Fourth Avenue, and the Bowery. The same year, near what is now Whitehall Street, the Dutch erected the city's first office building. It preceded the fort and the first church.

The director of this tiny branch office was a remarkable man named Peter Minuit, a controversial character who deserves some credit for his part in founding the city. He arrived in 1626, when there were about two hundred Dutch people scattered widely throughout the area. He pulled them together, under the protection of Fort Amsterdam. While he was in New Amsterdam, canals were dug, swamps drained for farmland to feed the settlers, and the first stone houses built. Knowing about earlier skirmishes with local Indians, Minuit insisted on making a clearly defined deal to avoid further bloodshed. On May 6, 1626, in a formal ceremony at the present Bowling Green, he met with some leaders of the visiting Canarsies and bought Manhattan island for sixty guilders worth of tools, knives, cloth, ceramics, and beads. This has often been offered up as an example of the cunning and craftiness of the Dutch, one of the greatest real-estate bargains in history. In fact, it was a more typical example of the business practices of the coming city. The Canarsie Indians were just visitors from Long Island; they bargained away an island they did not own.

Under Minuit, other basic components of the future city were established, not all of them honorable. The first slaves—eleven African men—arrived in 1626. Two years later, three women arrived. They were essentially booty captured on the high seas; it would be almost another twenty years before the first slave ship arrived directly from Africa. The first slaves were all put to work on public-works projects, such as the building of the fort; later arrivals worked in agriculture in Manhattan and Long Island. By 1664, about 9 percent of the population was African, including some who had been freed by their masters. But race had been introduced into the city's basic structure. Slavery lasted until 1827; race continues to be an essential part of New York reality.

The great New York tradition of corruption also started in this period. Far from the scrutiny of Amsterdam, Minuit and others began helping themselves. Double bookkeeping, profiting from contraband, land deals, influence peddling: the era might have given birth to a later New York slogan, "A poor politician is a poor politician." Nothing was ever proven, and no formal charges were ever brought against Minuit, but the morale of the tiny colony suffered. There were whispers, accusations, angry words. After six years, Minuit was called home and fired. Municipal corruption did not end.

At the same time, other components of the New York character were being established. One was tolerance. Although the Dutch were nominally Calvinist, their long wars with Spain had been about religious freedom; they could hardly demand such freedoms for themselves and deny them to others. In 1654 the first Jews arrived, twenty-three Sephardic refugees from Brazil. They had been working in Recife for almost twenty years, when control of that city shifted from the tolerant Dutch to the much more severe Portuguese. The Inquisition had the Jews in its sights, and so they took to the sea. They made their way to the Dutch colony of Curaçao, then across the Caribbean and up the coast to New Amsterdam. But they were not yet truly safe.

The governor then was the tough, one-legged Peter Stuyvesant, a former soldier who had been put in power seven years earlier. The arrogant, high-handed Stuyvesant was the first of a long line of New York reformers. He had cracked down on the heavy drinking of the colonists (another New York tradition) and banned all religious observances except those of the Dutch Reformed Church. When the Jewish refugees arrived, he wanted to keep them out of New Amsterdam. It wasn't simply that he was anti-Semitic. He was also anti-Catholic and anti-Quaker, against anyone and anything that did not conform to his own narrow beliefs. But he failed in his attempt to ban Jews from New Amsterdam. He was overruled by the Dutch West India Company, which was involved in a variety of business dealings with Jews, and was horrified at Stuyvesant's bigotry. That first group of Jews settled into the village that would eventually become one of the greatest Jewish cities in the world.

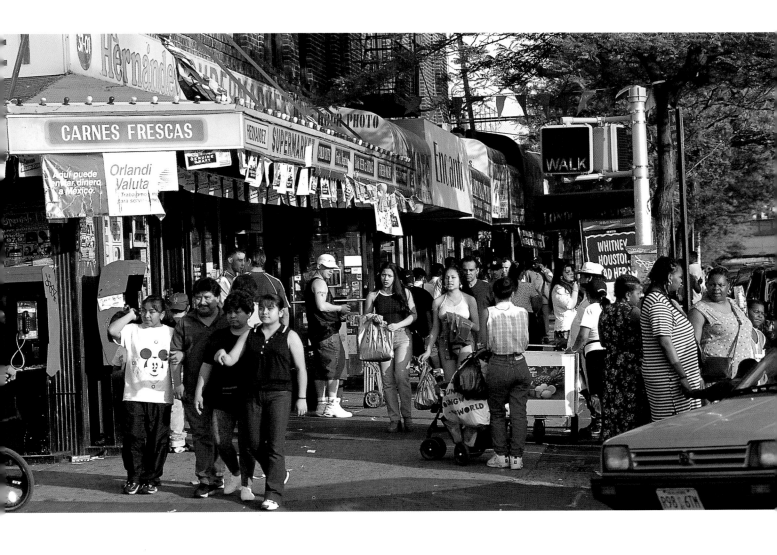

Junction Boulevard, Jackson Heights, Queens

Their cemetery, named Shearith Israel, was founded in 1683 just off what is now called Chatham Square; it is still there, engulfed by Chinatown, and is believed to be the oldest surviving man-made place left in Manhattan.

So by the 1640s, another characteristic of the future city was taking hold: its ethnic and linguistic pluralism. The majority of the inhabitants were Dutch, of course, but there were also Englishmen and Italians, Irish and Poles, Portuguese and Germans, Spaniards and Swedes, and at least two Danes. One of these immigrants was Jonas Bronck. He settled with his wife in New Amsterdam in 1639 and swiftly prospered. He was intelligent and educated; his stone house soon contained the finest library in the Dutch colony. He also began the process of settling the mainland, establishing a huge farm (Bronck's Farm) near the present 132nd Street and Lincoln Avenue, hosting in that farmhouse a peace conference with the Weckquasgeek Indians. The Bronx River was named for Jonas Bronck and therefore his name remains attached to the only borough that is part of the mainland.

In certain ways, the colony must have reminded the Dutch of the country they had left behind. Houses hugged the ground. Skies were immense. Then, as now, the sunsets were full of melodrama. Surviving maps suggest that from a distance the colony probably looked like views of the Netherlands by the painter Jacob van Ruisdael. And from all reports, the hard-drinking, cursing, wenching population could have been painted by Frans Hals. Even today, the light in Brooklyn, glancing off the mirror of the bay, resembles the light in paintings by Jan Vermeer, the great, mysterious master of Delft. All of these painters, and one other, were making their extraordinary art back home in Holland while Peter Stuyvesant was tap-tapping on his silver-wrapped wooden leg around the streets of New Amsterdam. That other painter was, of course, Rembrandt. I just wish he had somehow made that two-month voyage to New Amsterdam at least once. There are no paintings from New Amsterdam of ordinary people, those who had crossed a vast ocean, survived the horrors of the passage, and were trapped in this small colony, often surrounded by hostile natives. There are official portraits of some leaders of the colony, including the hawk-nosed, suspicious face of Stuyvesant. But only a Rembrandt could have done justice to the others, their fears, their hopes, their nostalgias.

As the years went by, the Dutch pushed into Brooklyn, Queens, and finally Staten Island. In most places they made straight cash deals with the Indian inhabitants, complete with deeds and official documents. The essential Dutch creed was simple: make money. Peace was essential to that process. But this was also a complicated proposition. Peter Stuyvesant would eventually lose his moral authority because of his own great gifts for personal enrichment. He built a grand stone house downtown, on what became known as Whitehall Street. He grabbed himself a huge farm that stretched from Fourth Avenue to the East River, Fifth Street to Seventeenth Street. He threw grand parties. He and his wife liked dressing in finery for small entertainments. As he got older, his penchant for self-righteous torture of religious or political opponents increased, and so did what we now call paranoia.

When the crisis came, and a British fleet sailed into the harbor one morning in August 1664, Stuyvesant had nobody who would help him fight. The British were doing what they did best: stealing. There had been no declaration of war. They just sailed in with their guns drawn and pulled off one of the most successful stickups in New York history. The Dutch surrendered without firing a shot.

It is unnecessary to trace the long, complex history of New York City after the Dutch to sense the dense layered quality of the city as it now exists. But as this sketch indicates, many of the basic themes have been here from the earliest days of the European settlements. The most important of all is the holy grail of wealth, what F. Scott Fitzgerald imagined as the diamond as big as the Ritz. Wealth is power: political power, social power. History is full of the tales of what men did to attain such power, and when you walk the city,

you can see the monuments they built to themselves, from Carnegie Hall to Trump Tower. New York has produced its share of patriots, but there has always been—and continues to be—a solid core of people who are basically citizens of the country of money.

The possibility of wealth still draws people here from all over the planet. The new immigrants arrive with the same goals that pulled the Irish, the Italians, and the Jews of a century ago: political freedom, material comfort, and, for a few, the gaudy vision of incredible wealth. All will change the city to fit their own visions, but the original templates, cut during the time of the Dutch, will remain the same. New York is one of those few places where the only constant is change. I was born here, grew up here, was educated on street corners and in classrooms here. But every time I think I finally understand New York, I look up and something has shifted. Suddenly one morning, there are fifty thousand Haitians walking across the Brooklyn Bridge in a protest against police brutality. Suddenly one morning, the police have arrested seventy-three deaf Mexicans, enslaved in some racket that makes money peddling pencils on subways. Suddenly one morning, I pick up the *Daily News* and read about some new mafia that has developed in the shadows. It's the Russians now. Or the Vietnamese. Or the Colombians. At such moments, you understand that the New York that you knew has gone and you didn't even see it going. Something new is here, some immense new presence, and it will take a while to understand and absorb it.

This continual change drives two other basic components of the city's character: memory and nostalgia. Among older New Yorkers there is a myth of what the Mexican poet Ramón López Velarde once called the "subverted Eden." Once upon a time, says the myth, there was a New York that was paradise. Everything and everyone worked. Crime was low. Rents were cheap. For my generation, that period was the wonderful parenthesis between the end of World War II and the assassination of John F. Kennedy. Everybody you knew had a job. There were seven daily newspapers and three baseball teams (until 1957, when the Dodgers and Giants left for the West), and the city was reaping the benefits of one of the greatest pieces of social legislation in the country's history: the G.I. Bill of Rights. In that period, the sons of bricklayers and mechanics and longshoremen were walking out of universities with degrees, the first people in all the history of their families to do so. It was a thrilling time.

But it also fed that permanent New York nostalgia that is based on a sense of loss. The young men who went to the universities broke the long histories of which their fathers were a part. As manufacturing plants closed, the blue collar gave way to the white collar. Men who had worked with their hands found it difficult to talk to their children, who worked with their minds. The fathers were often torn: proud of their sons, but longing for the certainties of a simpler time.

The overlapping nostalgias cross all backgrounds. The immigrants remember the countries they have left behind, the simple villages of Calabria or Sicily, County Mayo or the shtetls of Poland. Nobody longs for the carabinieri or the British army or the cossacks descending upon a village in the blood heat of a pogrom. They remember simpler things: songs in the evening, the countryside, food, the odors of morning. Some immigrants carried with them to America a handful of earth from the old country, or a teapot, or brown photographs of fathers and grandmothers. They are doing that today, except that the countries are different, and the jet airplane makes the journey seem less permanent. But the central myths always divide fathers from sons, mothers from daughters. When I was a boy, my father's myths involved the IRA and old music-hall songs and chants for vanished soccer teams. My myths were about Jackie Robinson and Captain Marvel and the gleaming towers of Manhattan. My father and mother had left behind the old country and lived with no ambition for themselves. They inhabited the tenements of Brooklyn and worked as hard as anyone I've ever known, but their sacrifices were made for us, for my brothers and my sisters. They infused us with extraordinary optimism, saying, in effect, This is America, this is New York, and here, everything is possible, if only you work.

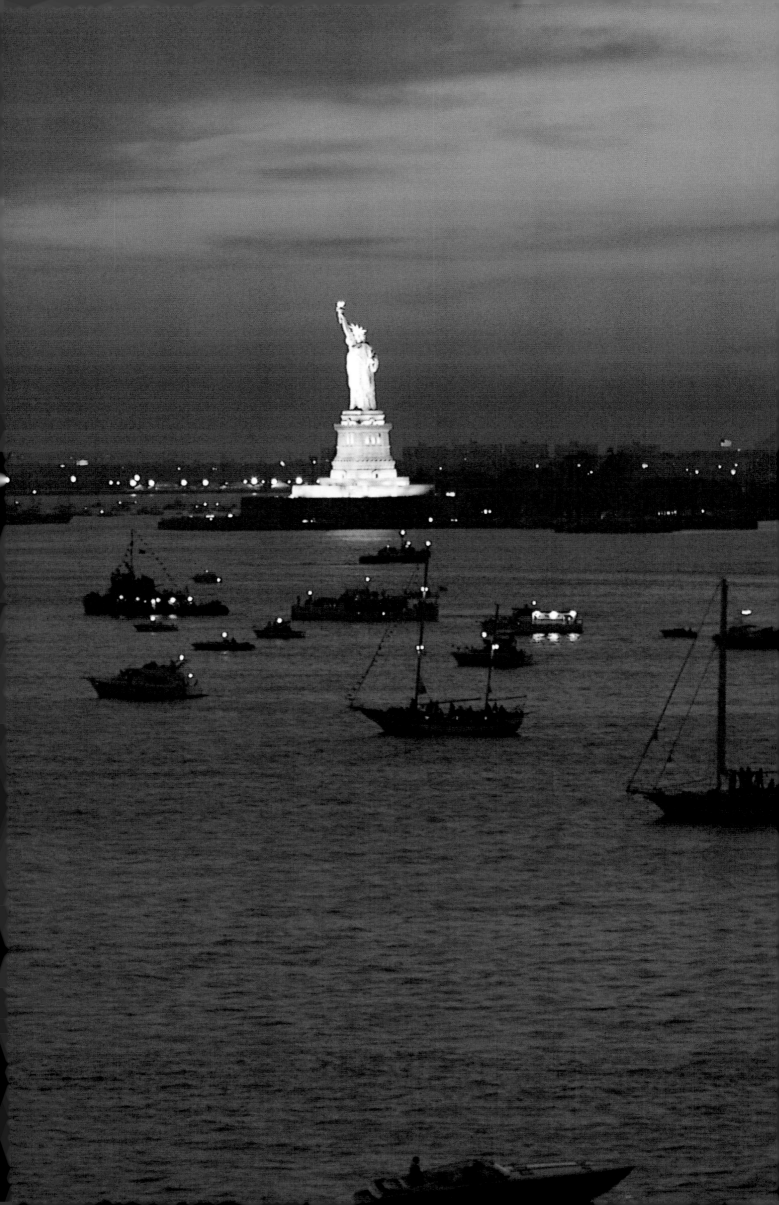

Work was the key. And if the visitor wanders the streets of this city, the primacy of work is obvious. Within each of the city's islands, there are other, smaller islands, and many of them are organized around work: the Garment District, the Theater District, Silicon Alley, the Diamond District, the Flower District, the Antiques District. Go down to Chinatown on a Saturday night and walk a few blocks west and look up and the lights are burning in the loft buildings; inside, Chinese women are bent over sewing machines. Gaze up at the World Trade Center and see the lights on certain floors; men are waiting for news from distant financial markets. A few years ago, as a reporter, I covered a riot and protest march in Washington Heights. A stream of angry Dominican men came marching down Broadway, past the old Audubon Ballroom, where Malcolm X was assassinated. There were almost no women in the march. They were upstairs in the sweatshop lofts, working.

The myth of redemptive work, so crucial to the idea of New York and its poor people, was, in fact, true. When I was a boy in Brooklyn, virtually every candy store was operated by poor Jews. They opened at six in the morning to sell newspapers to men and women heading for the subways; they closed at eight at night. They did this so that their children would not have to operate candy stores. Today, there isn't a Jewish candy store left anywhere, and the reason is simple: those men and women succeeded. They worked so that their children could go to schools and universities, and that is exactly what happened.

Today, the candy stores are run by men from Pakistan or India. The Italians have given up the fruit and vegetable stores to the Koreans. But the steady New York rhythm repeats itself. First you work for someone else. Then you work for yourself. Then others work for you.

In the earliest years of the city's history, a traveler referred to the "Dutch Babel" of New Amsterdam. That remains essential to the character of the city. Our language appropriates what it likes from the languages that pass through. I have heard Puerto Ricans using the Yiddish word *shmuck*. Koreans tell me they are operating bodegas. The mixture of languages and cultures is essential to our humor, too. The Irish and the Jews contributed a humor of catastrophe; no matter how good things might be, they will get worse. The Jews also contributed irony to that style, based on the often great gap between what is promised and what is delivered. All New Yorkers develop an assortment of sardonic ironies as a kind of armor. This is not cynicism. It is self-defense. New Yorkers don't want to be disappointed, or hurt, but if you listen carefully, you understand that they are willing to be surprised.

In that sense, New York is truly multicultural. Here we can sample the foods of every world culture; there are more than seventeen thousand restaurants in Manhattan alone. We can hear the music of all those cultures and even take them home from the record store. There are cultural collisions, of course, and misunderstandings and occasional cruelties and stupidities. But as it was in the time of the Dutch, the city somehow makes its diversity work. New York is not a melting pot, but it is certainly a salad bowl. The tomato remains a tomato, the lettuce remains lettuce, the cucumbers or chilis or olives remain themselves; but the salad is unique, a mixture, transformed by the imagination of the chef. There is no master chef in New York, but there is history. Its power to create visions of tolerance and opportunity has made the modern city possible and will drive the city of the future.

But this also must be said: every attempt to freeze the city in time is doomed to failure. Nobody can truly say "this is New York" and expect that it will always be that way. The old Dutch city is long gone, the victim of terrible fires, or of the remorseless advance of early real-estate speculators. Nor is there much to see of the British city before the Revolution; much of that was destroyed in the great fire of 1835. There are street names and an essential grid. We can trace some of those who came before us in museums and old books. We know that the city where Henry James was young had largely vanished by the time he returned in 1905. But there are the lovely houses on the north side of Washington Square, and others in the West Village, and the elegant spire of Trinity

Upper New York Bay and the Statue of Liberty

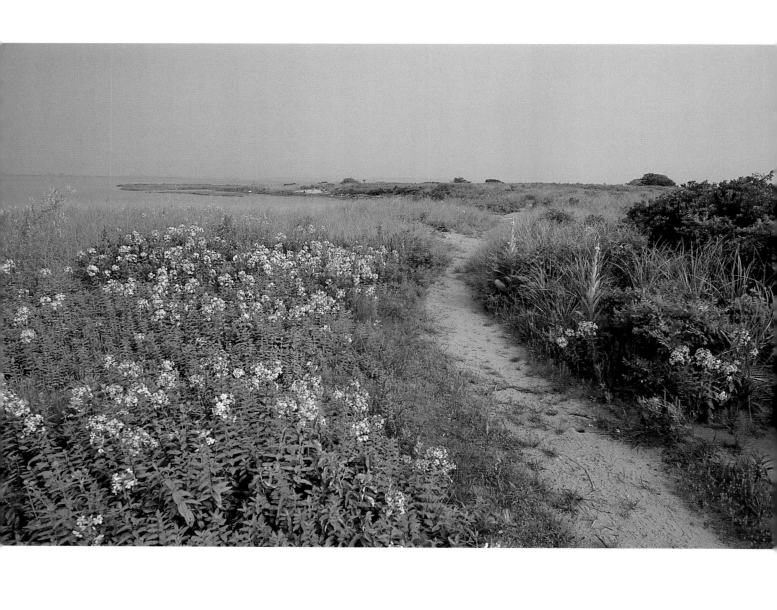

Jamaica Bay Wildlife Refuge, Gateway National Recreation Area, Brooklyn/Queens

Church. And in those streets, James would surely recognize the New York of his youth. The marvelous photographs in this book reveal aspects of the city as it is now; seen fifty years from now, they will provoke nostalgia.

In my own time, I've seen enormous changes. When I was a boy, there were still farms in Brooklyn and Queens. Those in Queens provided milk and vegetables for the tables of Manhattan. Those in Brooklyn were content to help feed Brooklyn. On summer mornings, we would take the Coney Island Avenue trolley car to the beach and rattle through some of those farms; and then one summer they were gone. That year, 1948, divided the present from the past; the farms of Brooklyn became part of the city of memory and loss.

There was more to come: Ebbets Field and the Polo Grounds, Penn Station and the New York Aquarium, Luna Park and Steeplechase, the Funny Place. The great evil stretch of Forty-second Street between Times Square and Eighth Avenue has become Disneyfied. Newspapers died: the *Mirror,* the *Journal-American,* the *World-Telegram,* the *Herald-Tribune.* Gimbel's department store died and S. Klein, where the poor shopped, and Alexander's and Korvette's. Teachers died. Friends died. Neighborhoods died.

And yet the city today seems more full of energy and possibility than at any time since I was young. Crime is way down. The drug plague seems to be fading. The new immigrants have given the city an infusion of energy and hope, driven by the engine of work, and in the process have added social cement. Neighborhoods that once seemed on the verge of collapse into rubble are being rebuilt by those immigrants. Public schools that once made the middle class flee to the suburbs are suddenly providing decent, even excellent educations to the young. You see people walking the streets on summer evenings without the burden of fear. You see construction crews altering the face of the familiar city. The subways are packed. The restaurants are crowded. We have survived another cycle of decline and are once more on the rise. Those who are young now will surely remember this time when they are old. Warmly. With nostalgia. I hope for all of them, in all the islands within the city of islands, that there are no unacceptable losses.

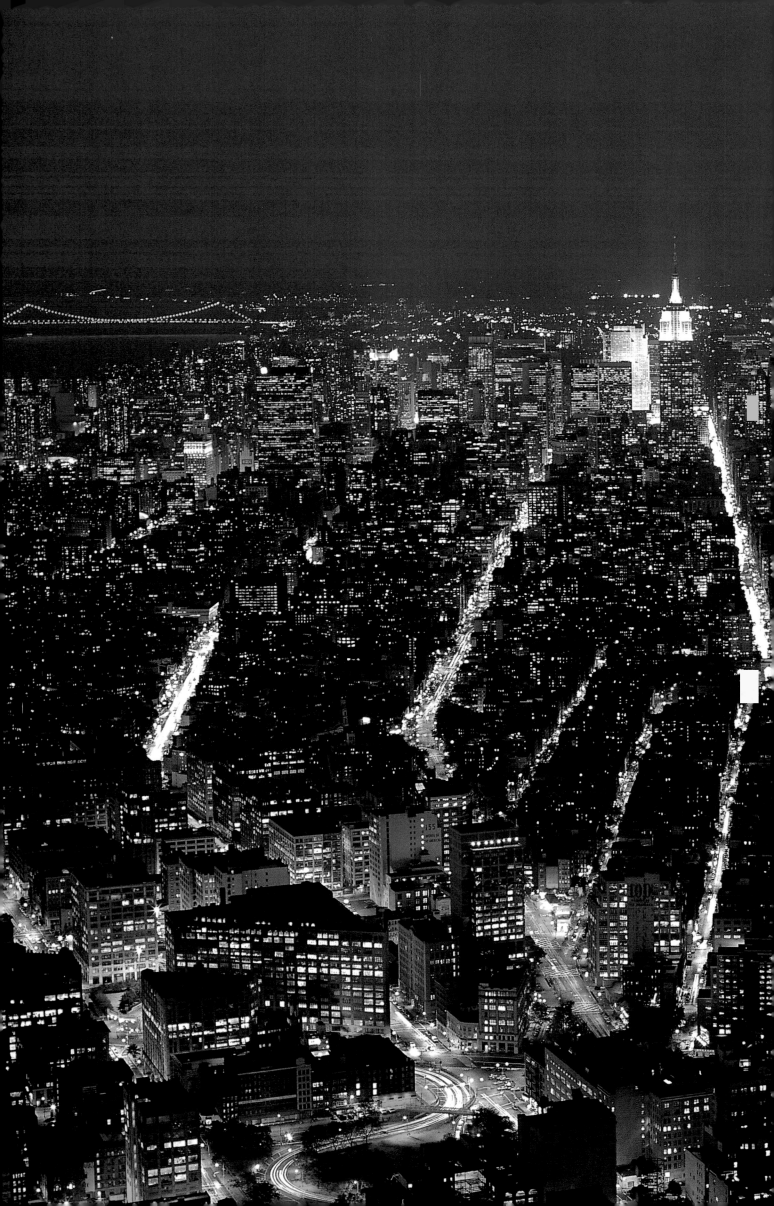

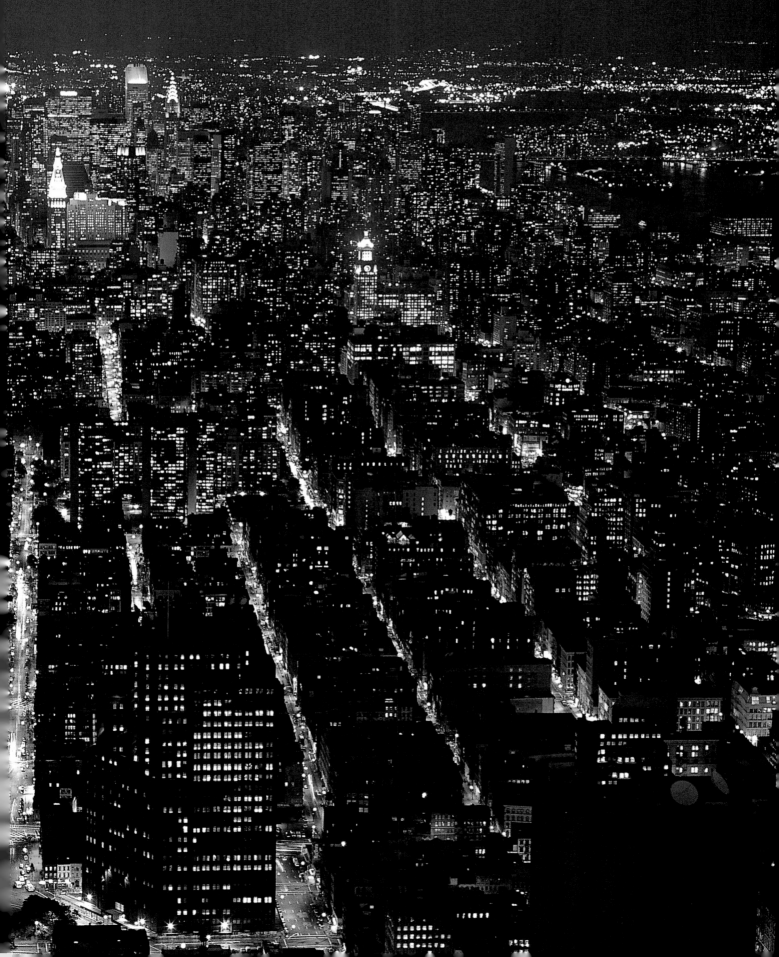

PASSAGE

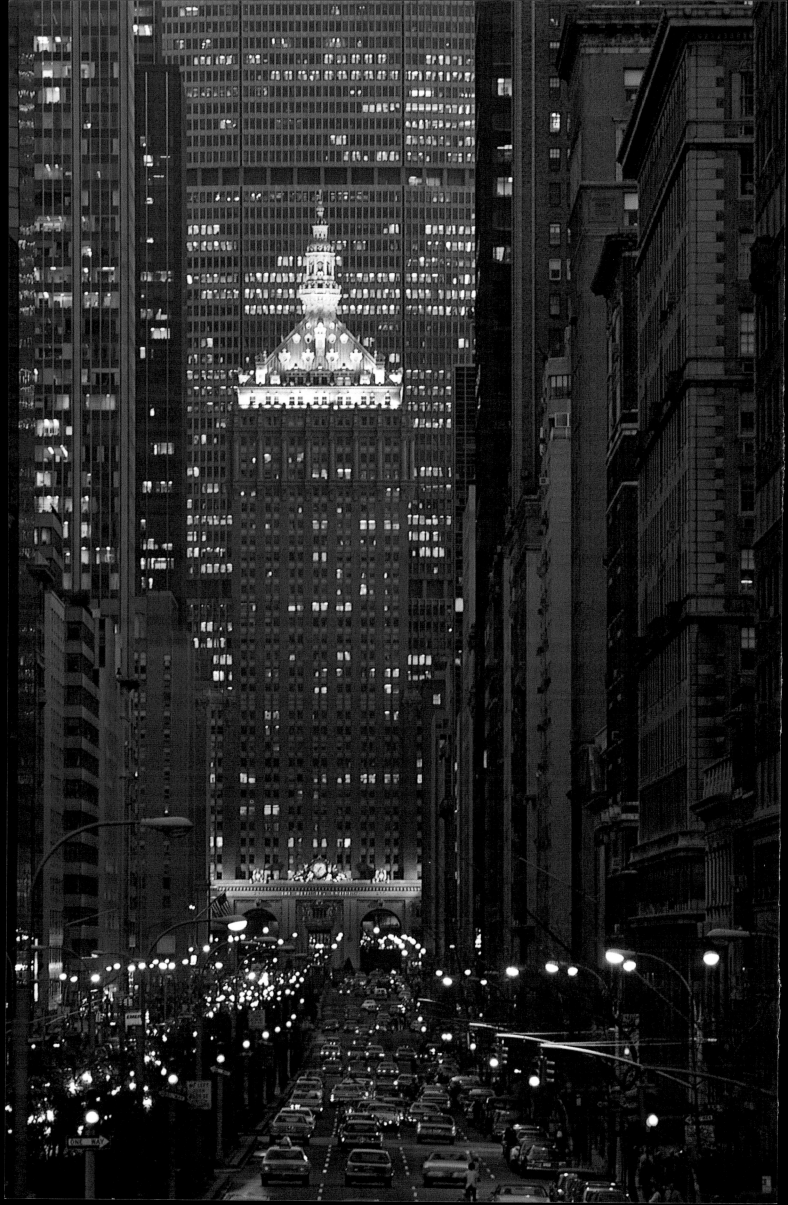

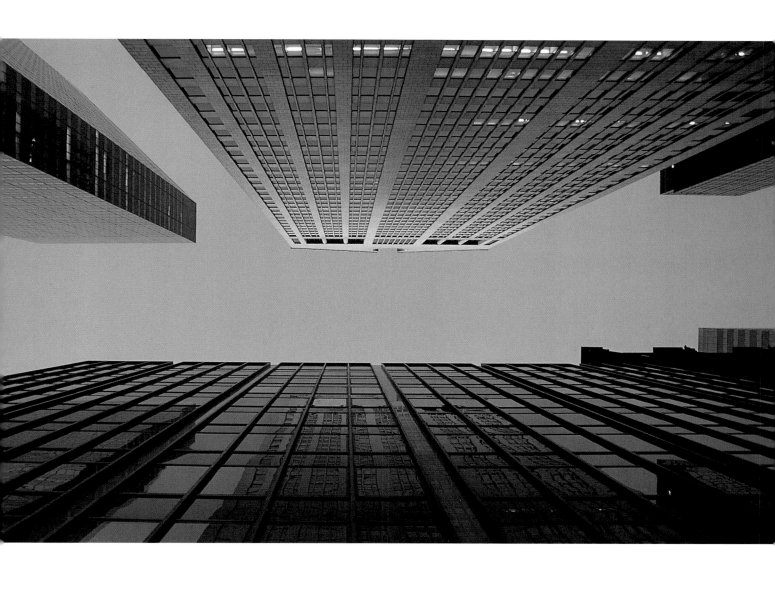

Above Madison Avenue, Manhattan
Opposite Park Avenue, Manhattan
Preceding pages Manhattan
Overleaf Skyline, Brooklyn

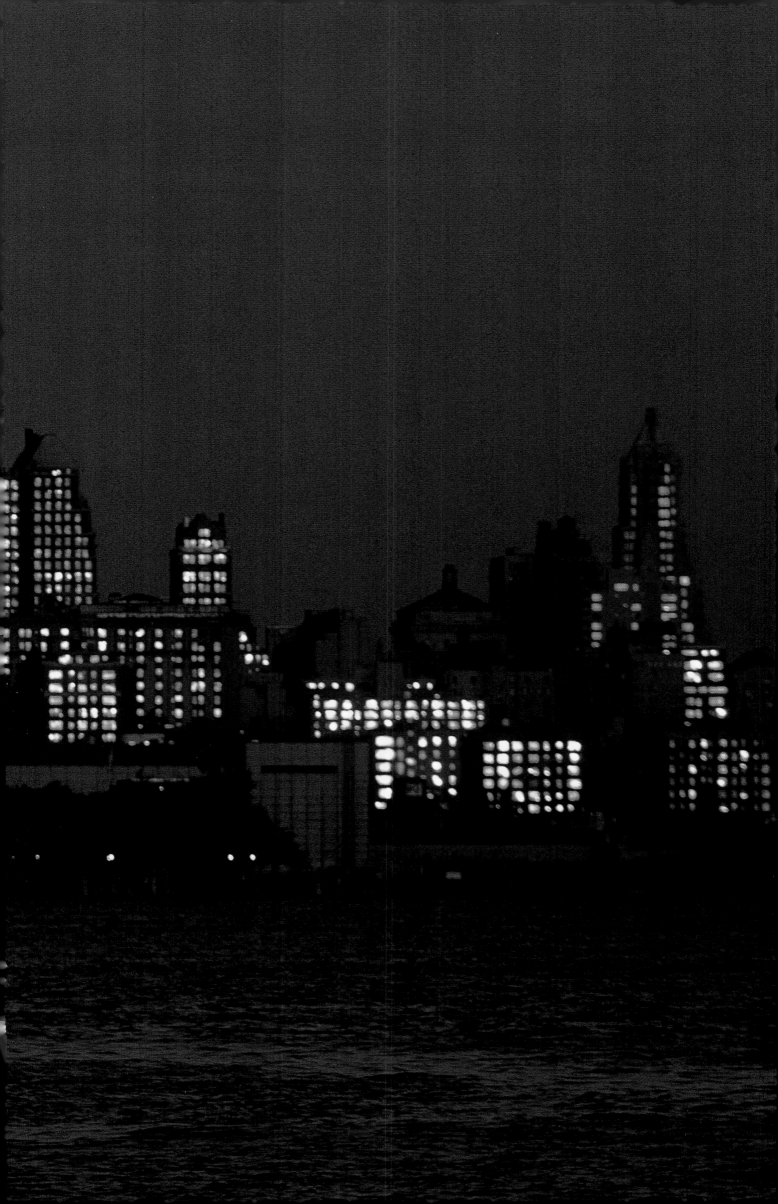

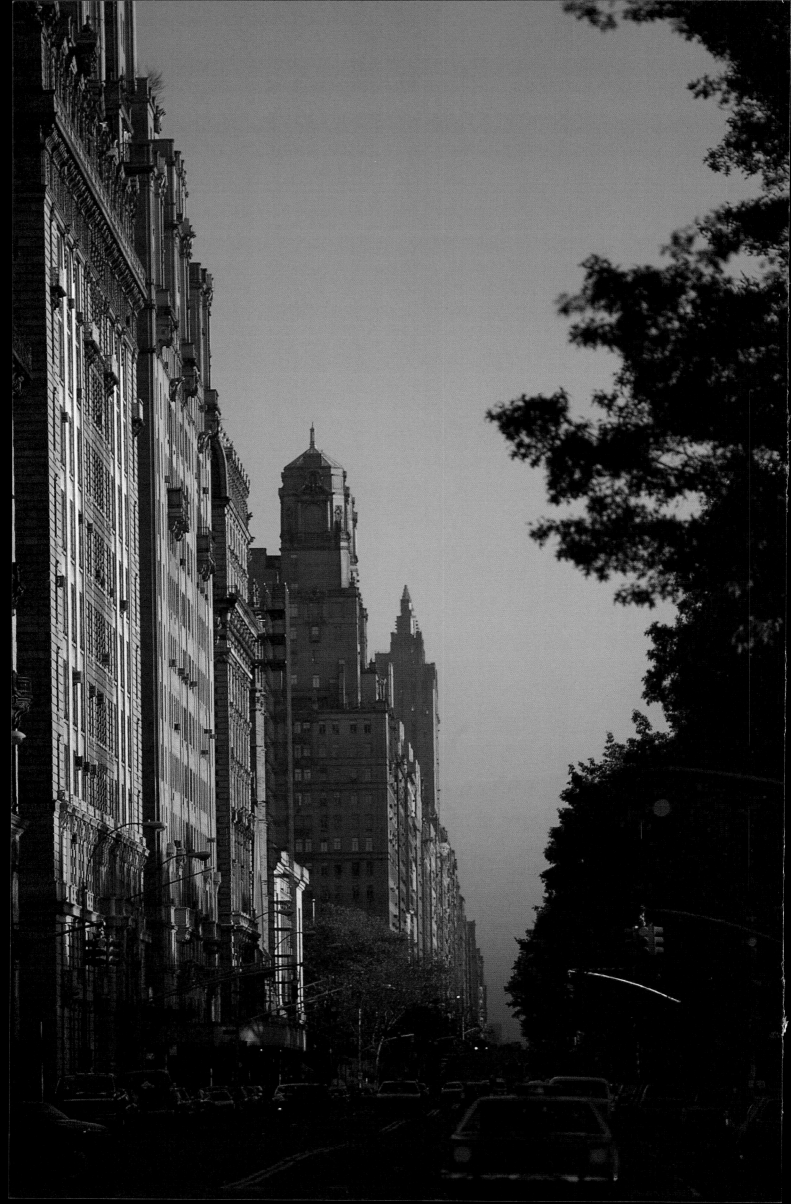

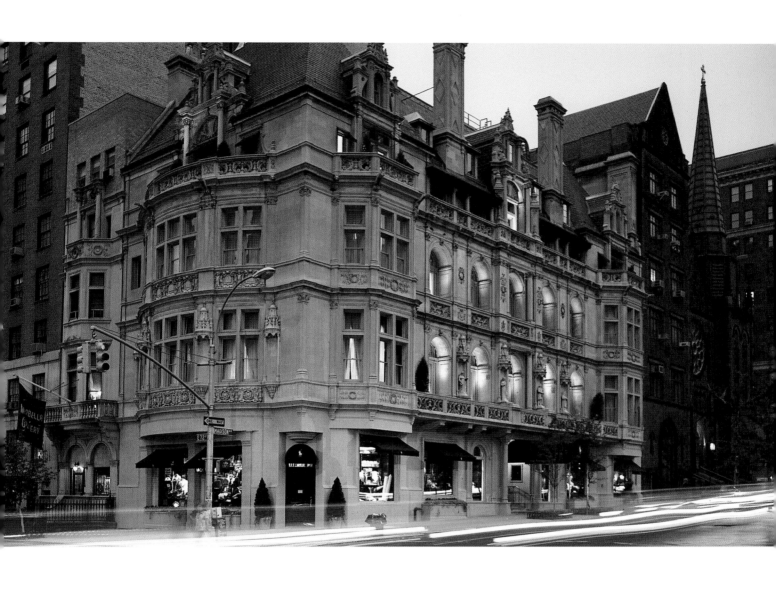

Above Ralph Lauren Store, Madison Avenue and Seventy-second Street, Manhattan
Opposite Central Park West, Manhattan
Overleaf Plaza Hotel, Manhattan

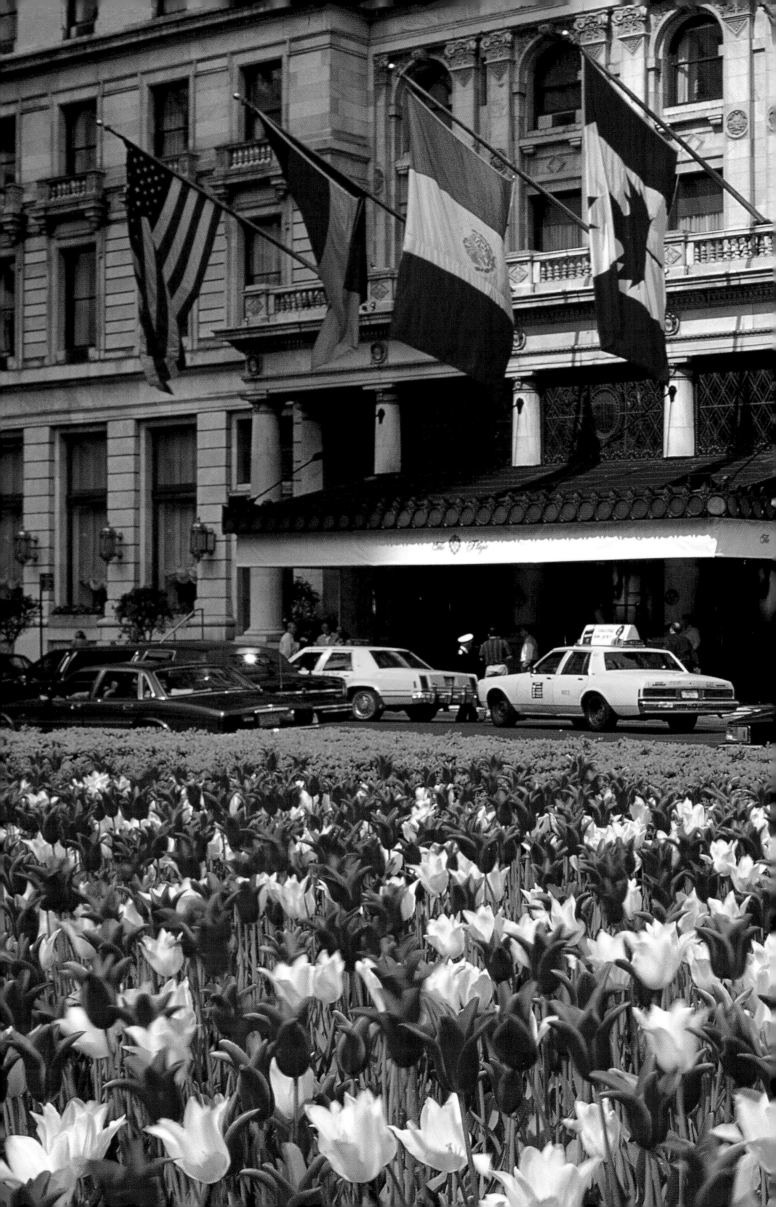

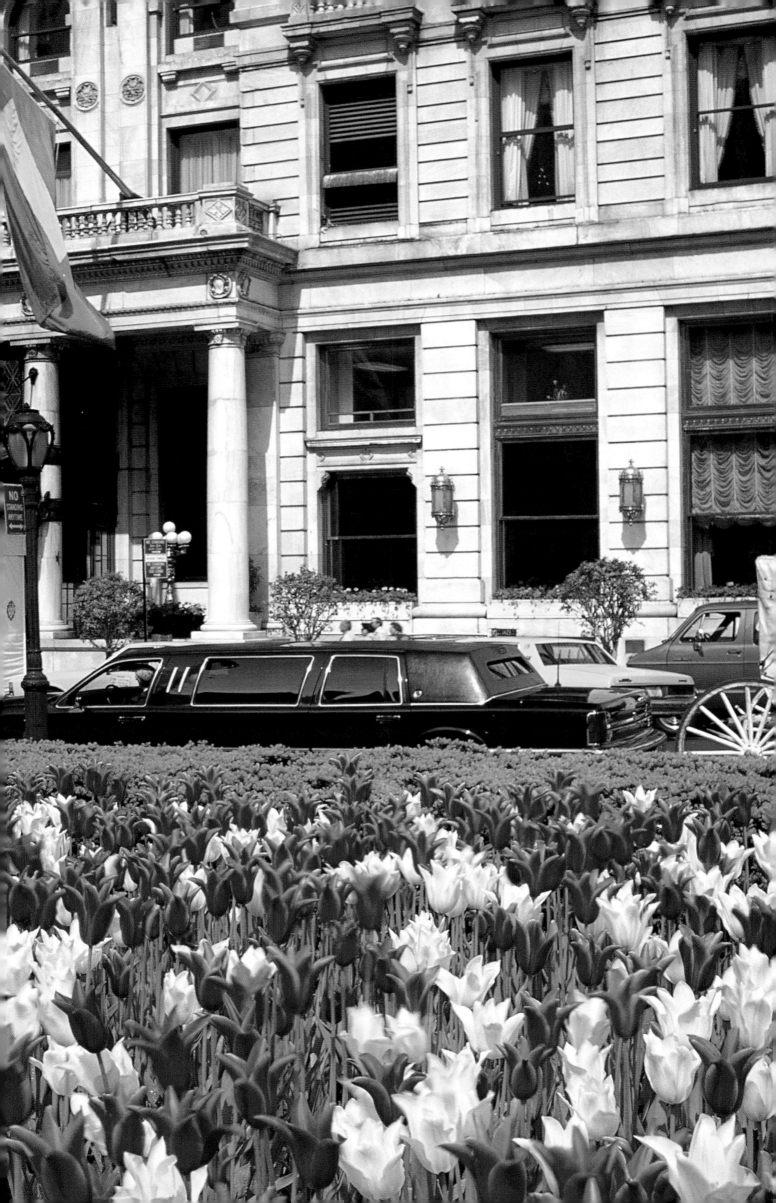

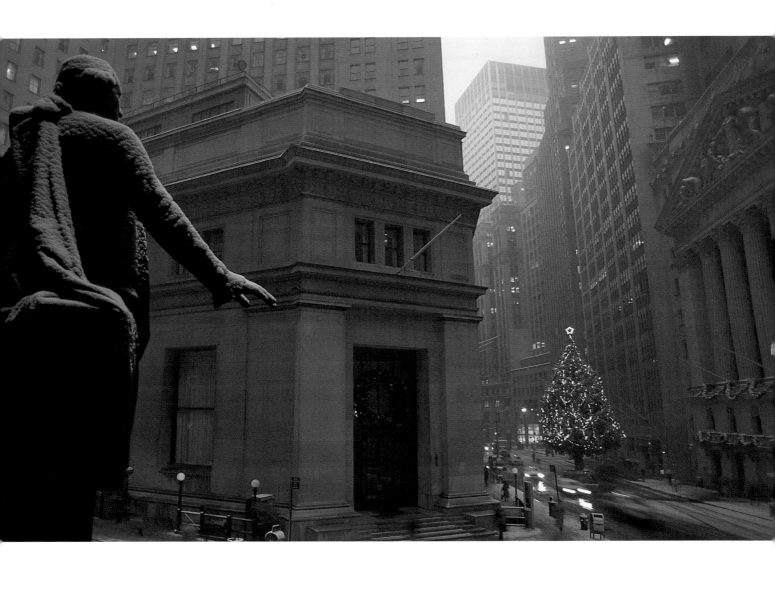

Above View from steps of Federal Hall National Memorial Museum, with New York Stock Exchange at right, Manhattan
Opposite Statue of composer George M. Cohan, Duffy Square, Times Square, Manhattan

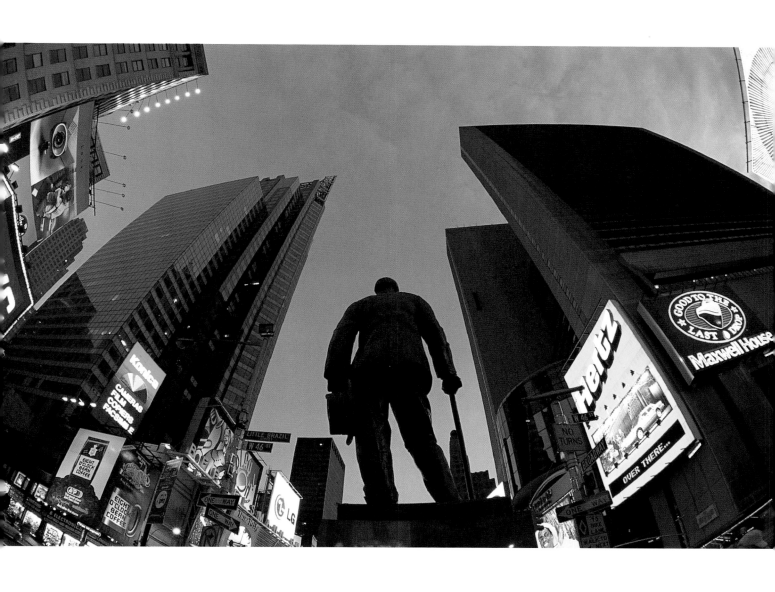

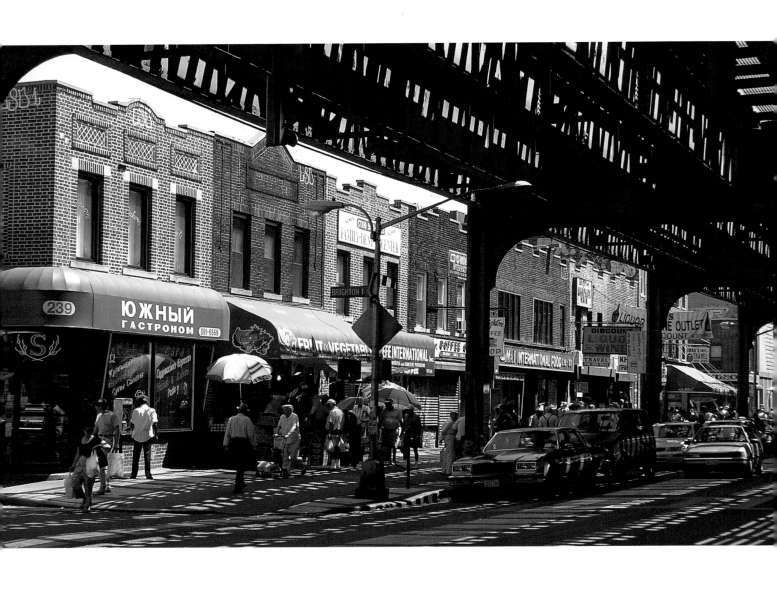

Above Little Odessa, Brighton Beach, Brooklyn
Opposite Fire escapes, Greenwich Village, Manhattan

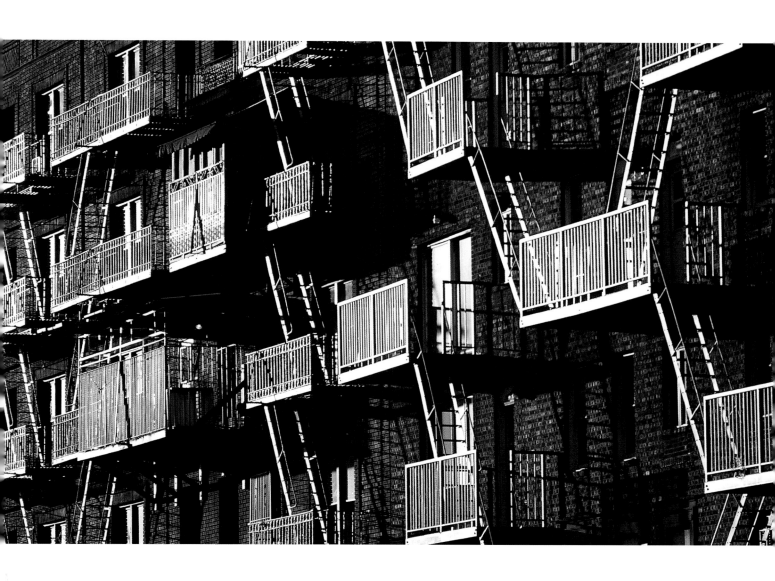

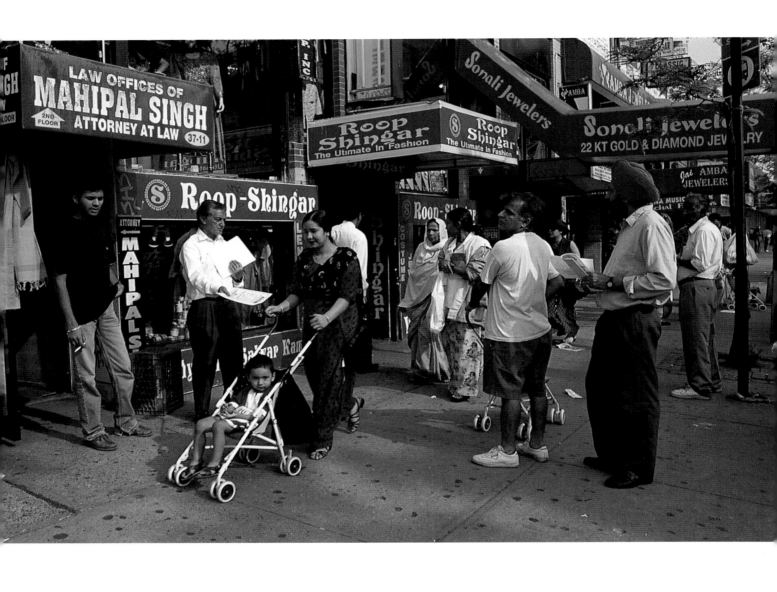

Above Seventy-fourth Street, Little India, Jackson Heights, Queens
Opposite Number 7 train, Queens

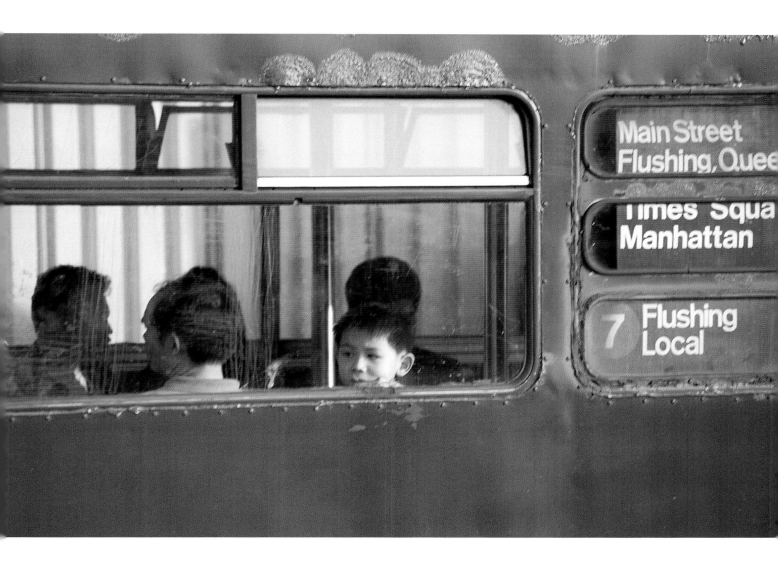

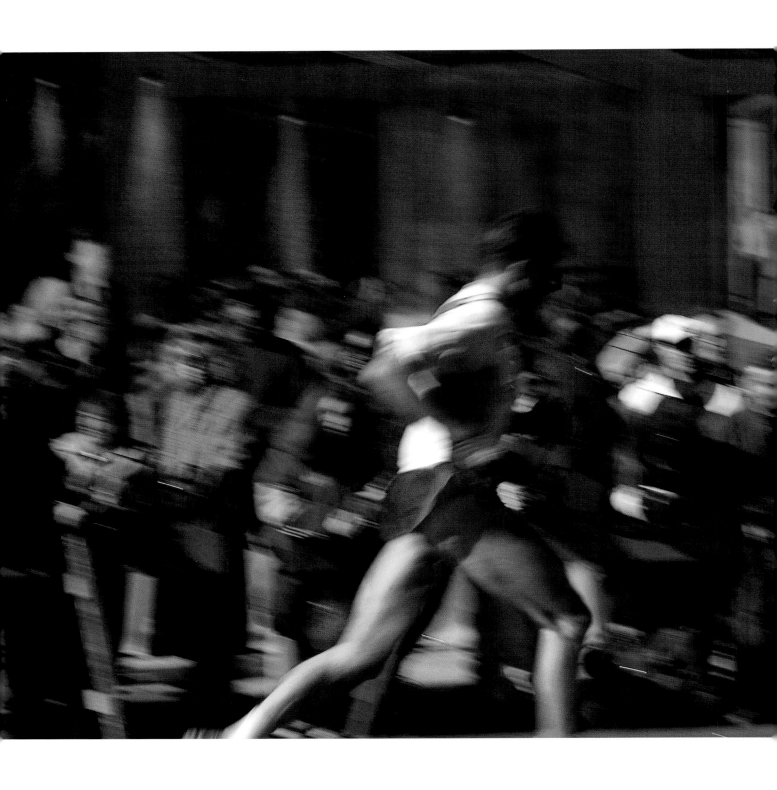

Above New York City Marathon, Manhattan
Opposite Sculpture at Columbia University, Morningside Heights, Manhattan
Overleaf, left West Thirtieth Street, Manhattan
Overleaf, right Trinity Church and Wall Street, Manhattan

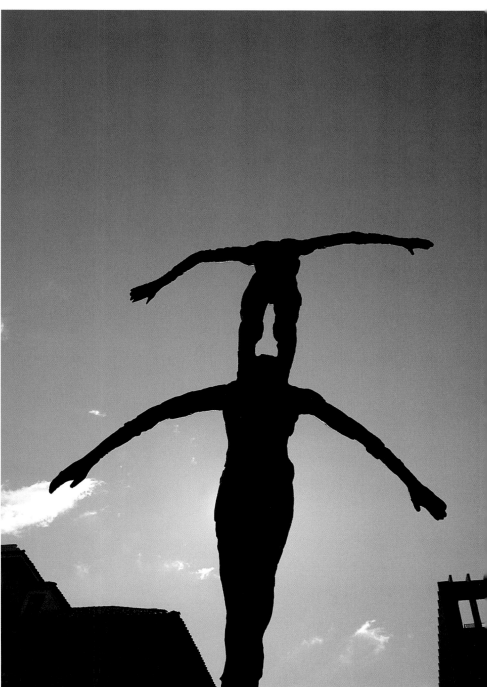

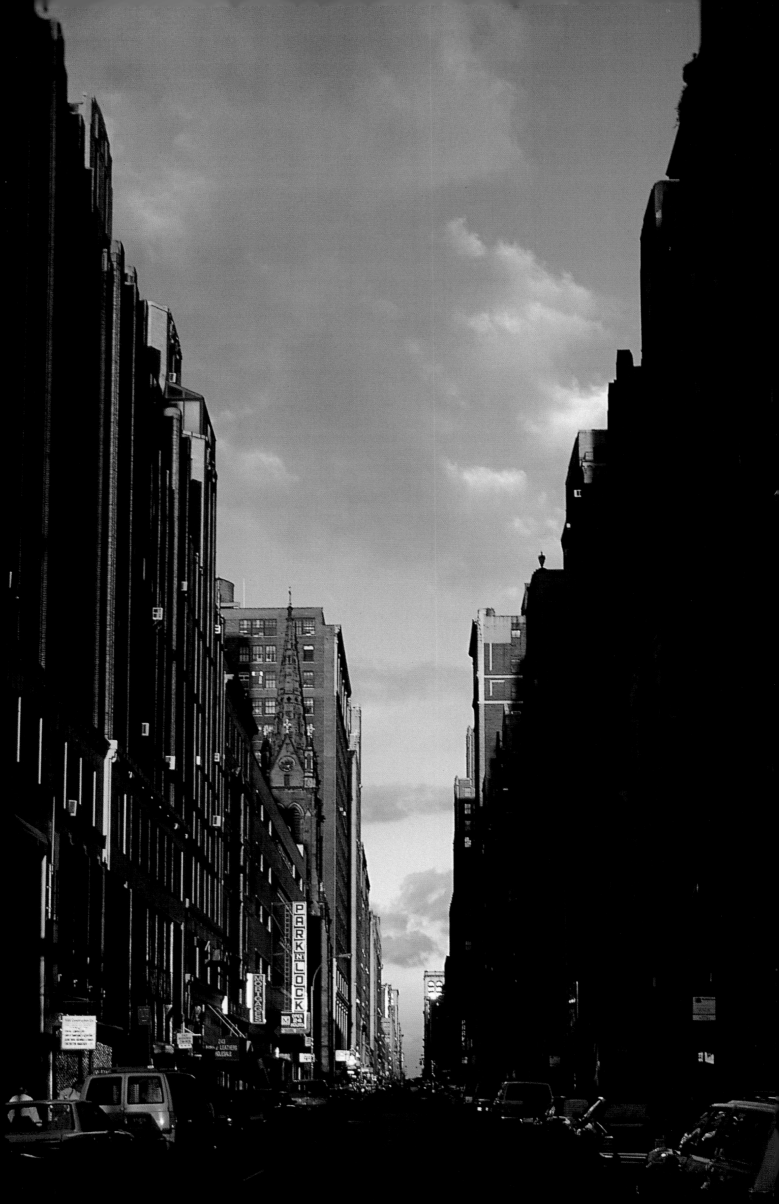

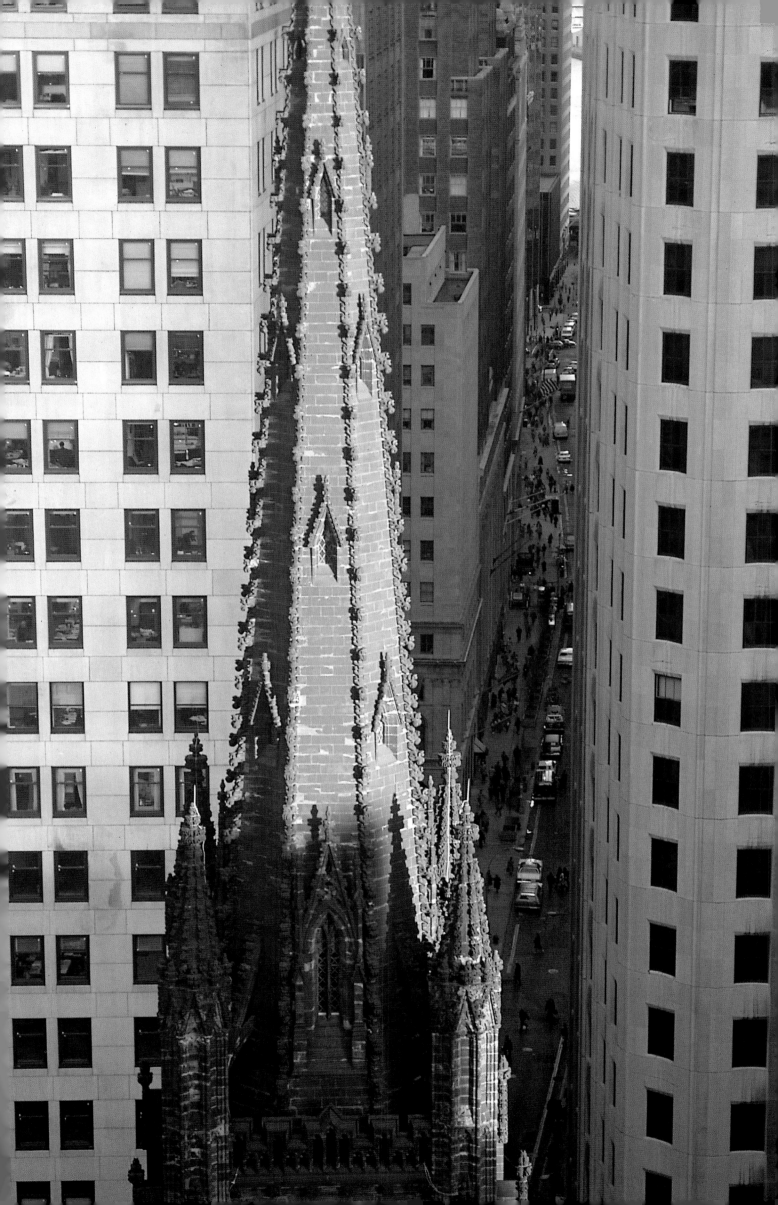

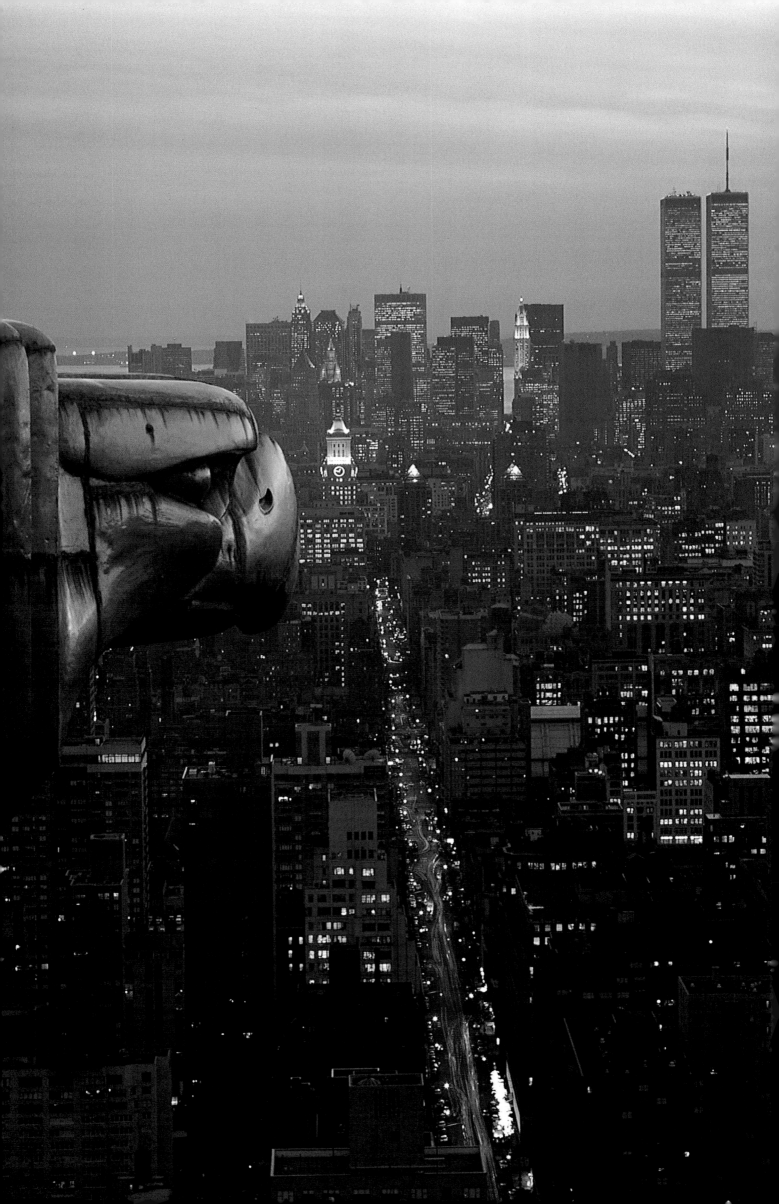

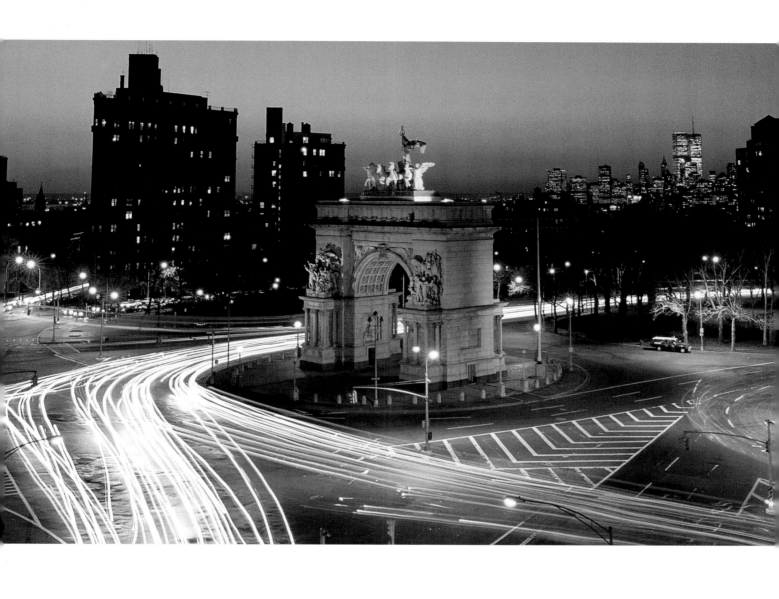

Above Grand Army Plaza, Brooklyn
Opposite View of Lexington Avenue and Lower Manhattan from Chrysler Building
Overleaf and second overleaf, left Times Square, Manhattan
Second overleaf, right Sony Theatres, Upper West Side, Manhattan
Third overleaf Trans World Airlines Terminal, John F. Kennedy Airport, Queens

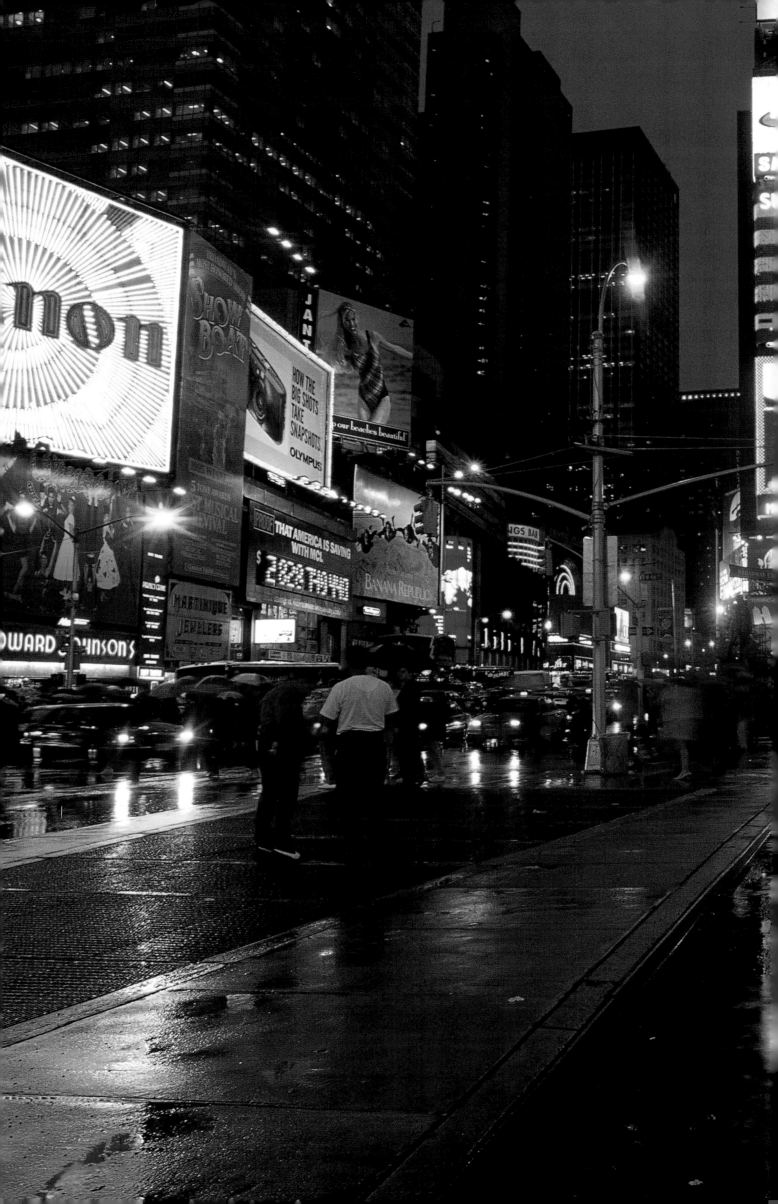

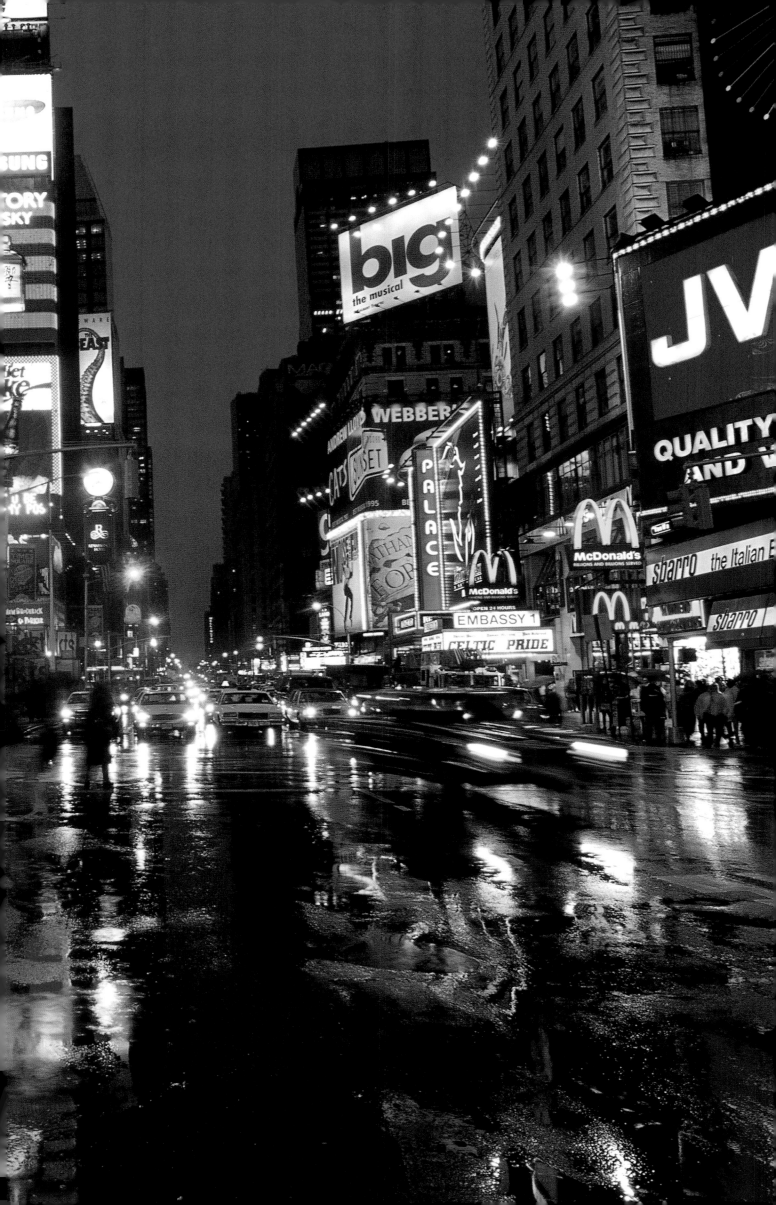

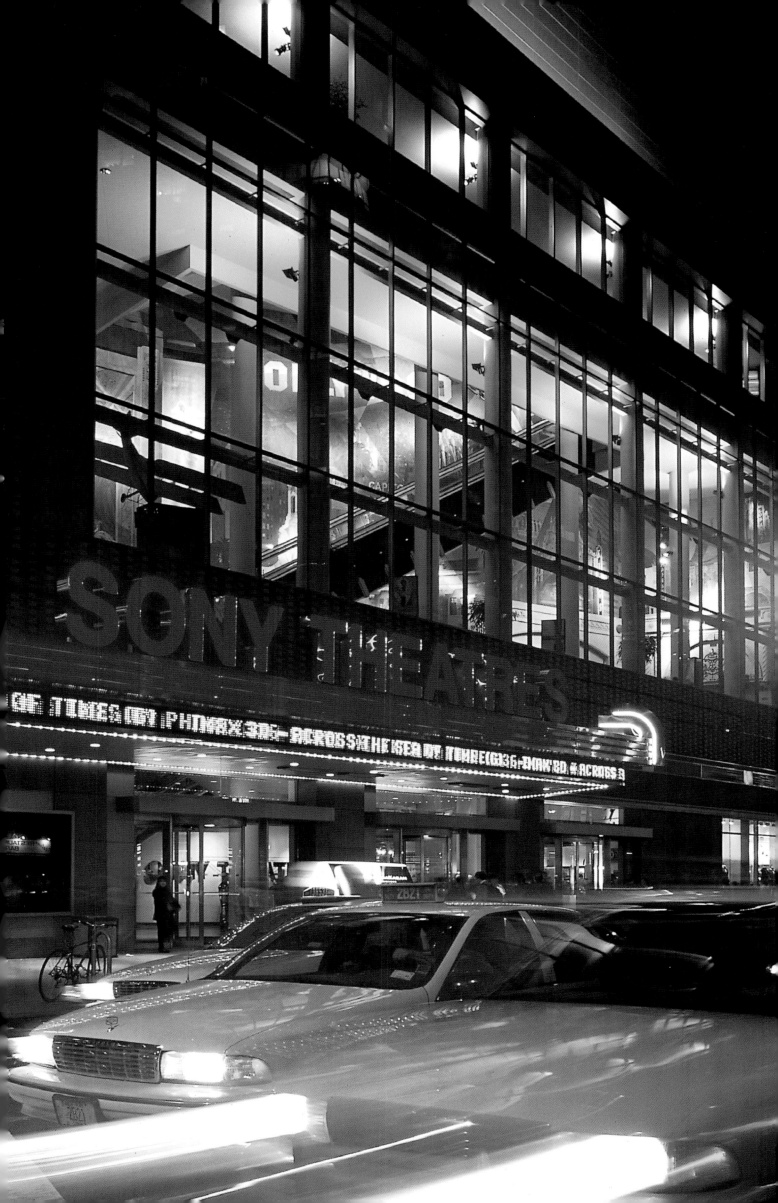

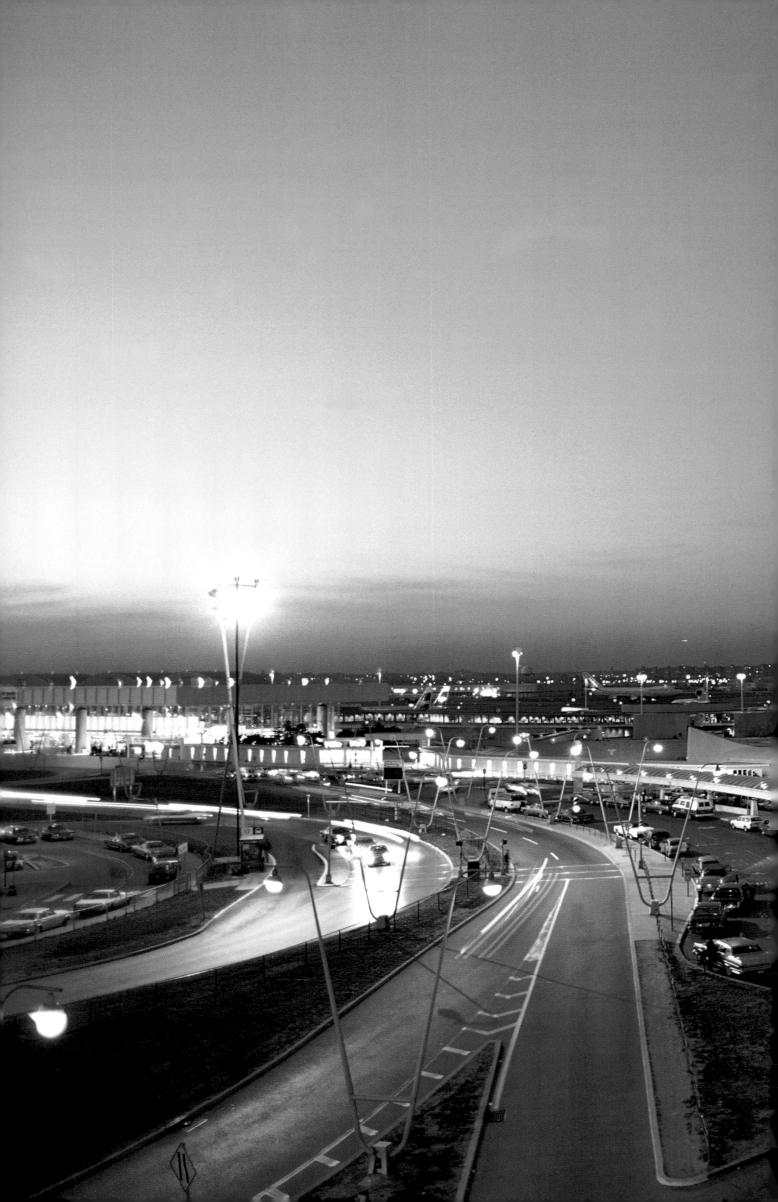

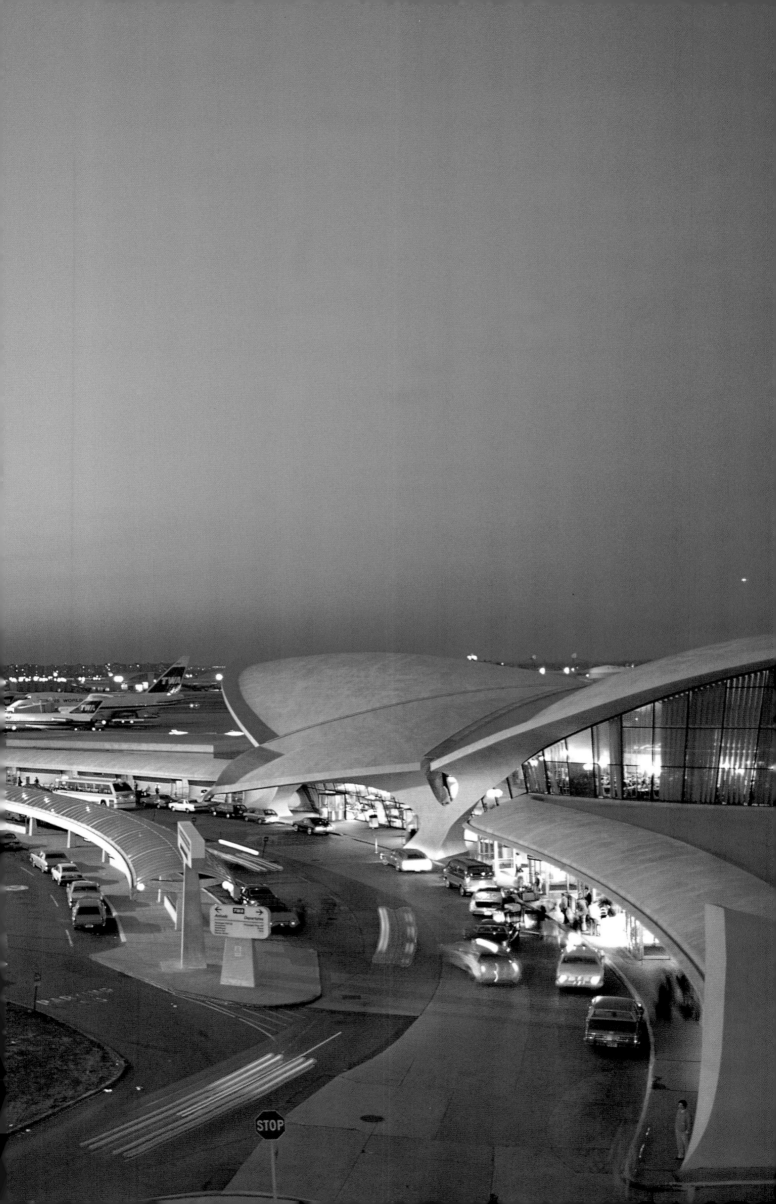

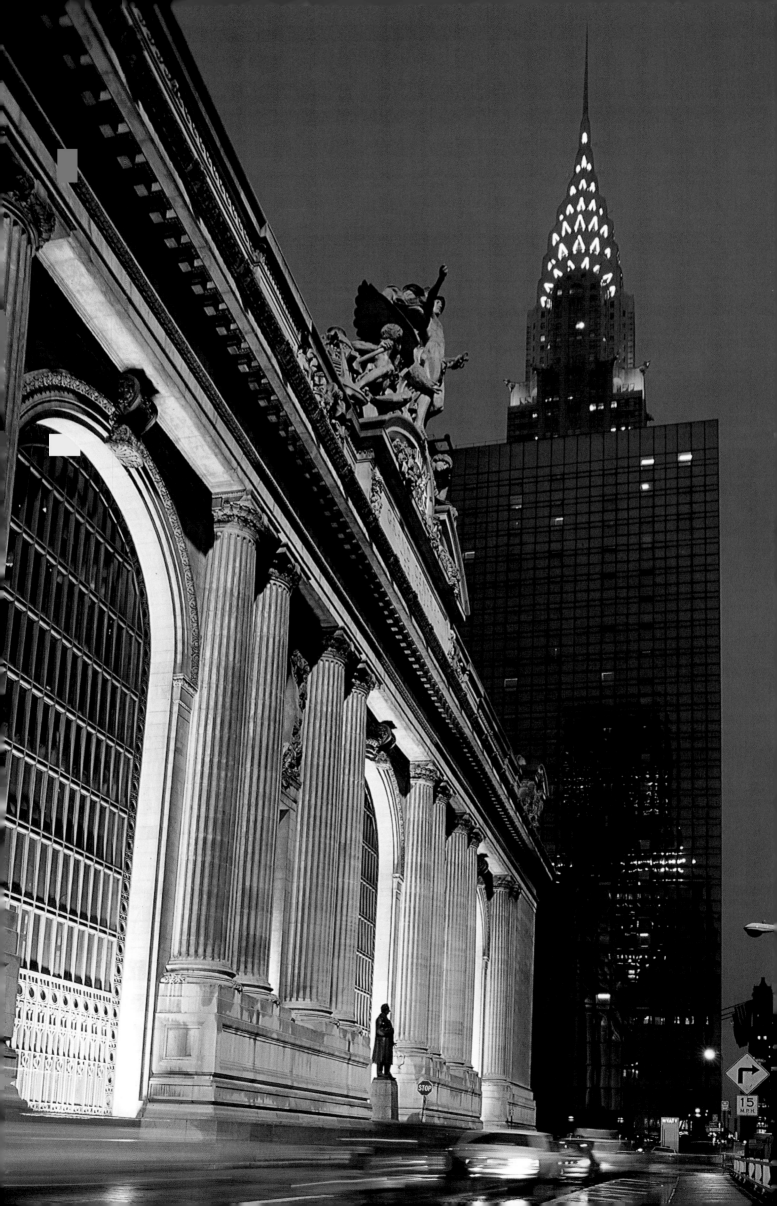

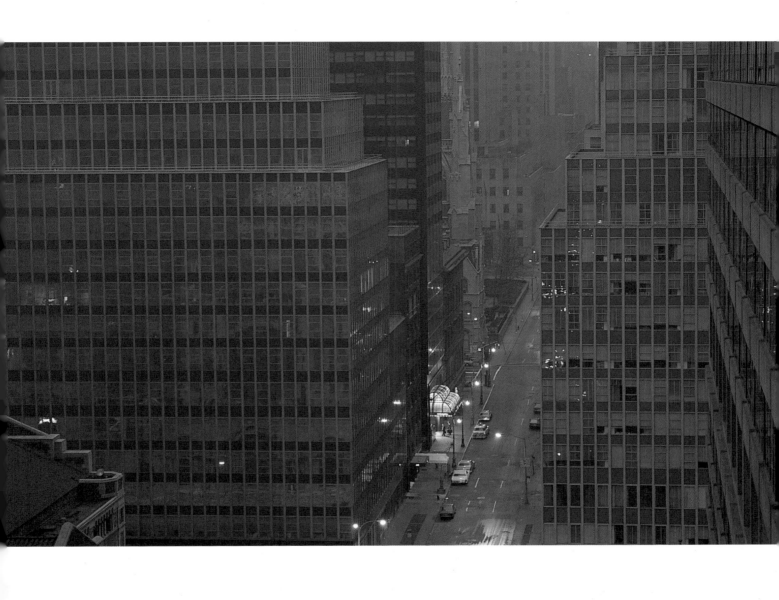

Above Fifty-first Street with New York Palace Hotel and St. Patrick's Cathedral, Manhattan
Opposite Grand Central Station and Chrysler Building, Manhattan

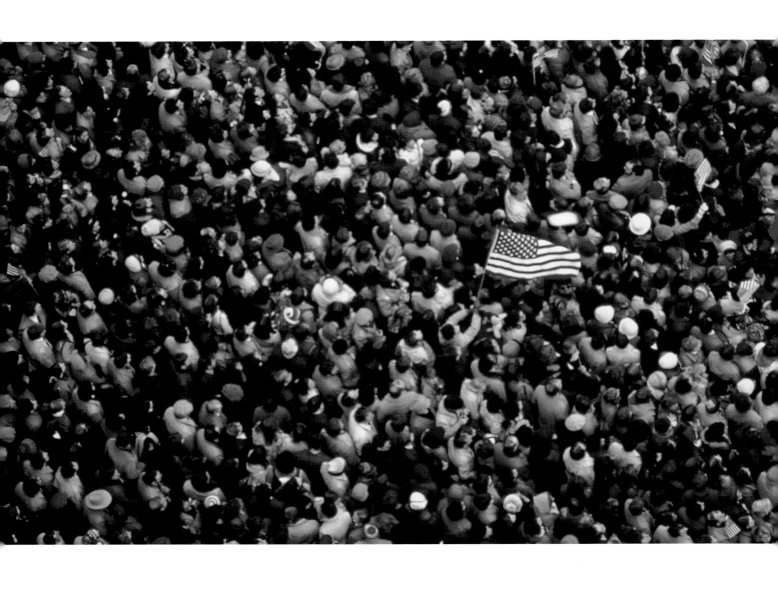

Above Broadway, Manhattan
Opposite Christopher Street, Manhattan
Overleaf, left Central Park and Fifth Avenue, with Metropolitan Museum of Art in foreground, Manhattan
Overleaf, right Thirty-fourth Street and Seventh Avenue, Manhattan

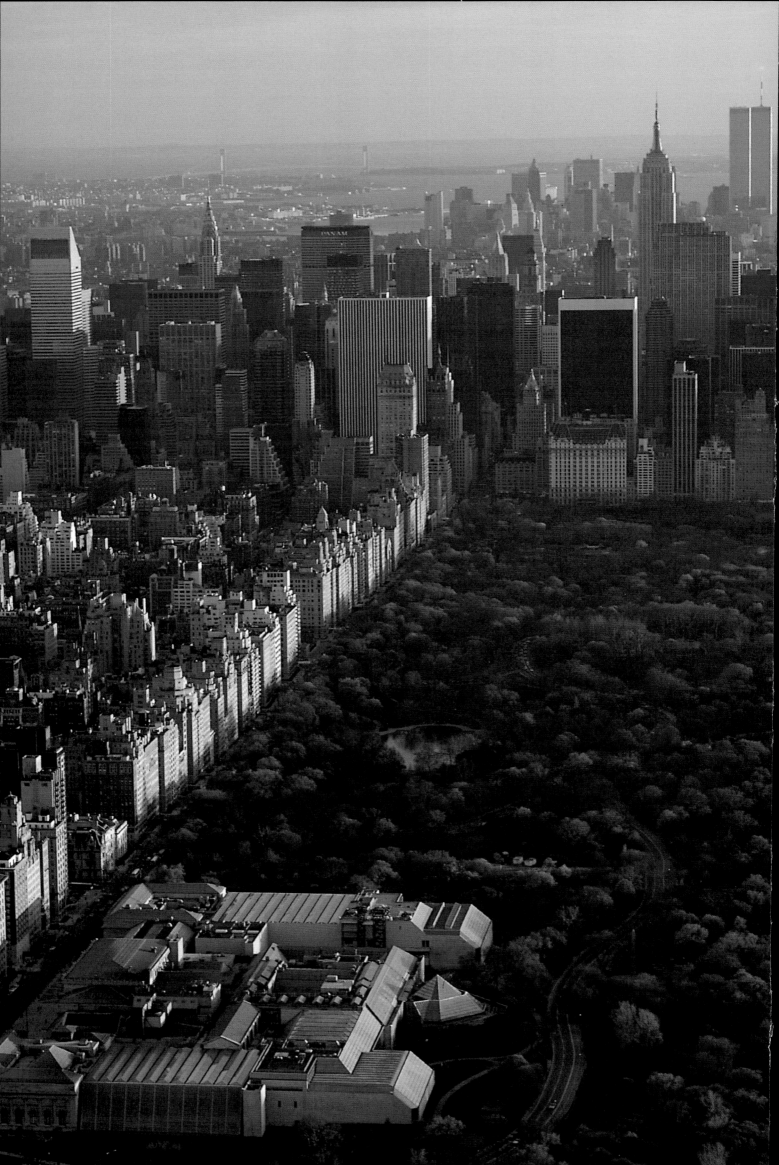

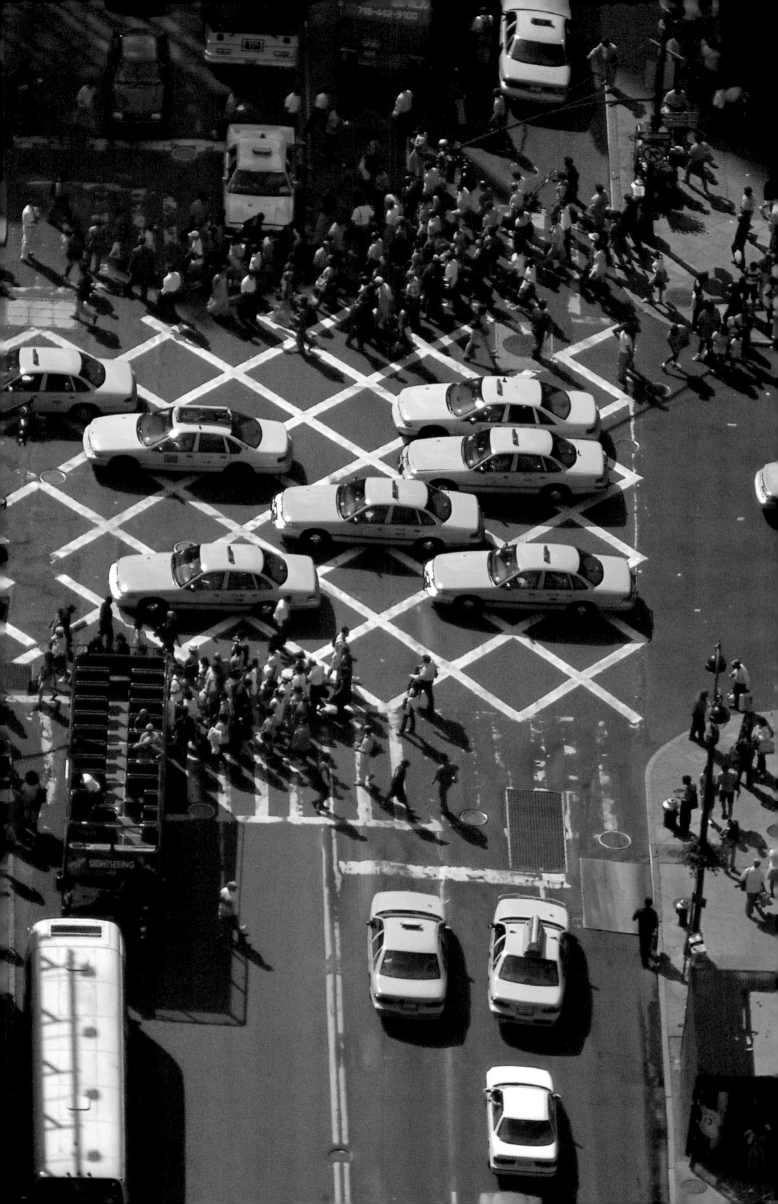

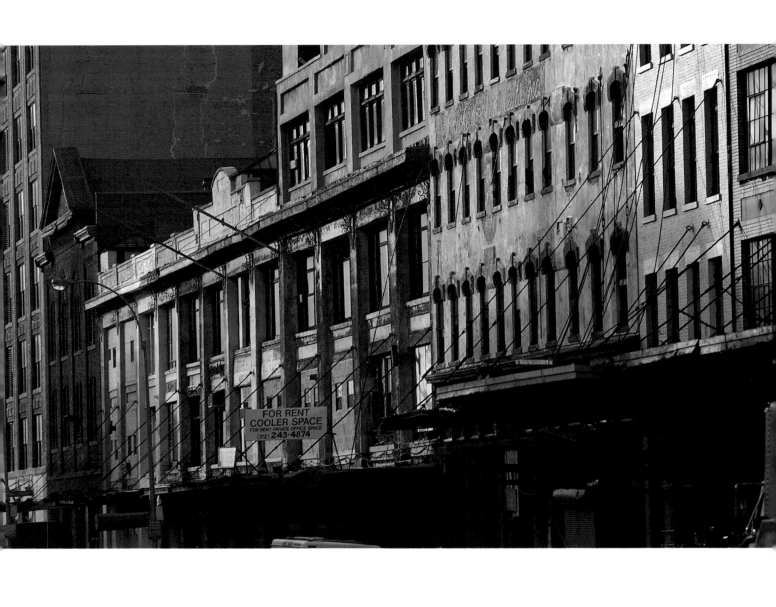

Above Fourteenth Street, Manhattan
Opposite King Model Houses (Strivers' Row), West 138th Street, Harlem, Manhattan

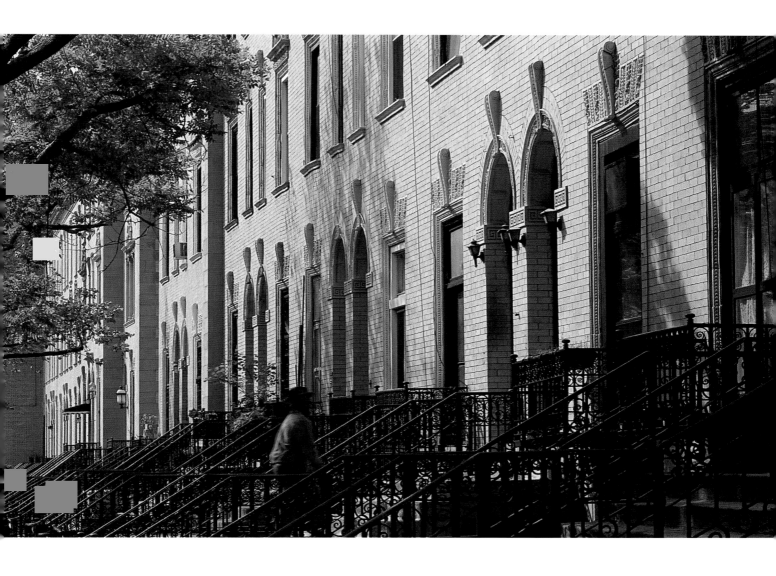

Above Park Avenue and 106th Street, Harlem, Manhattan
Opposite Greenwich Village, Manhattan
Overleaf Fruit vendor, Richmond Terrace, Staten Island

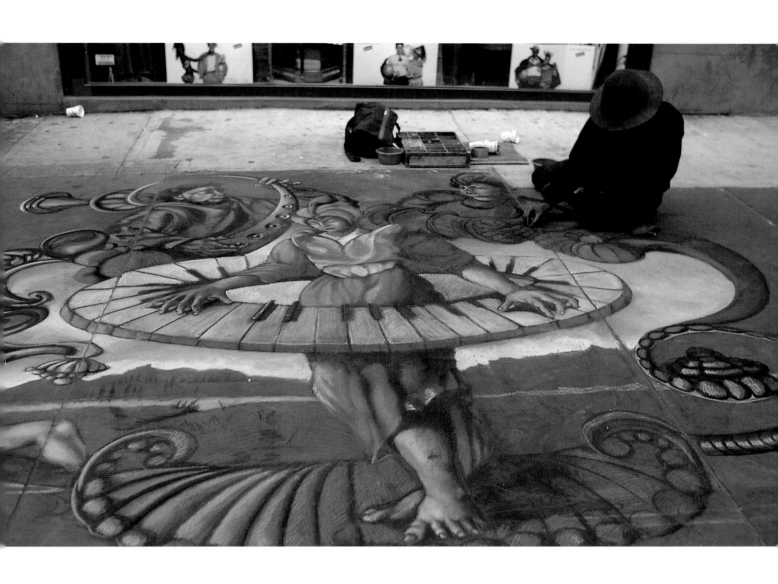

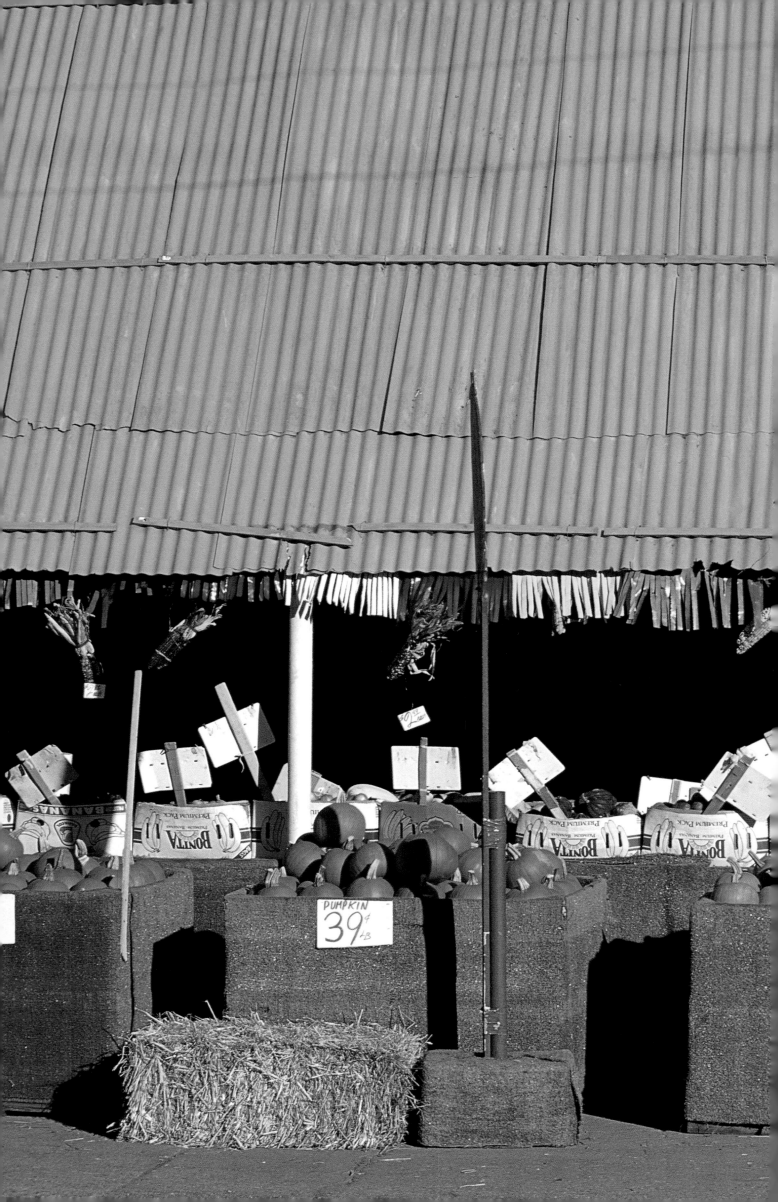

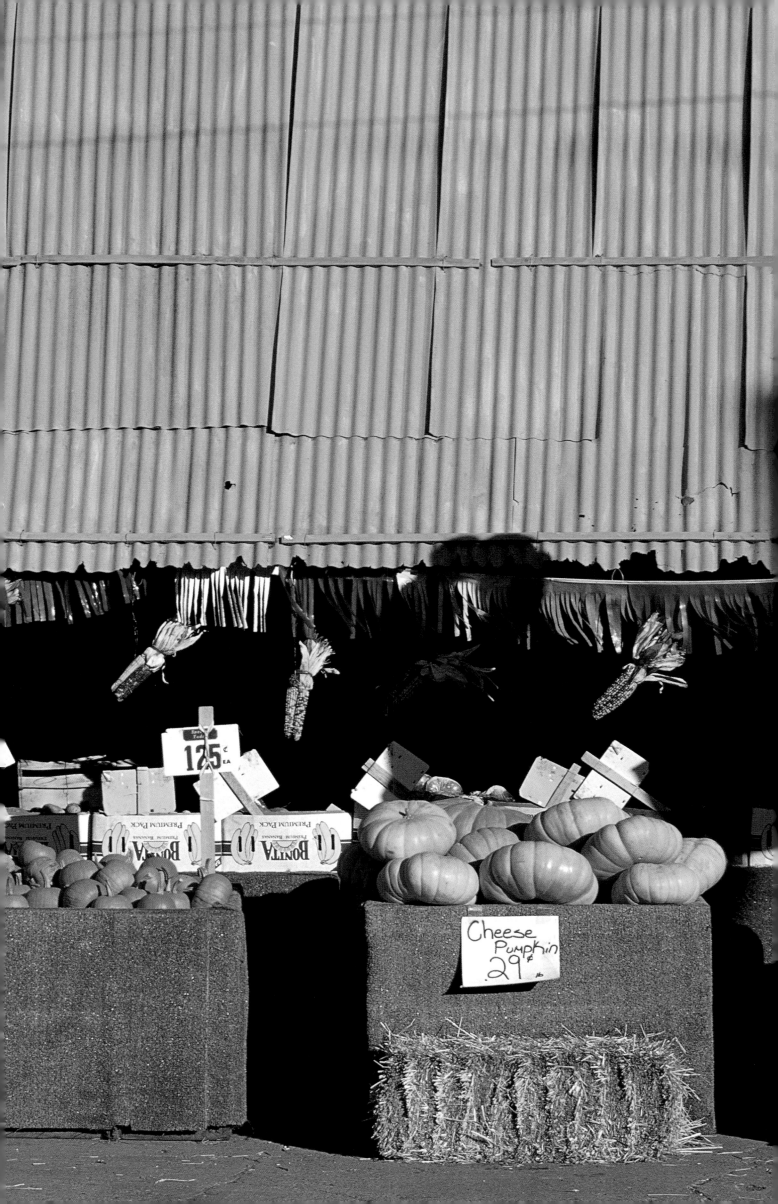

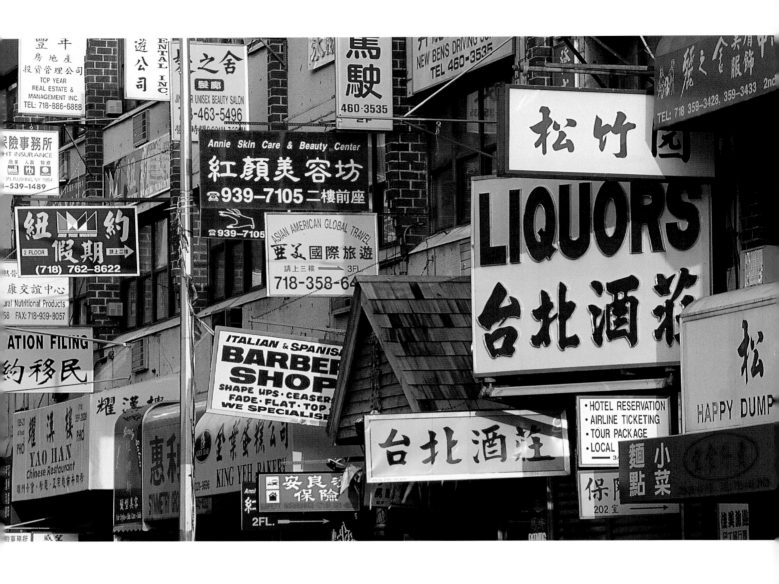

Above Chinese neighborhood, downtown Flushing, Queens
Opposite Chinatown, Manhattan

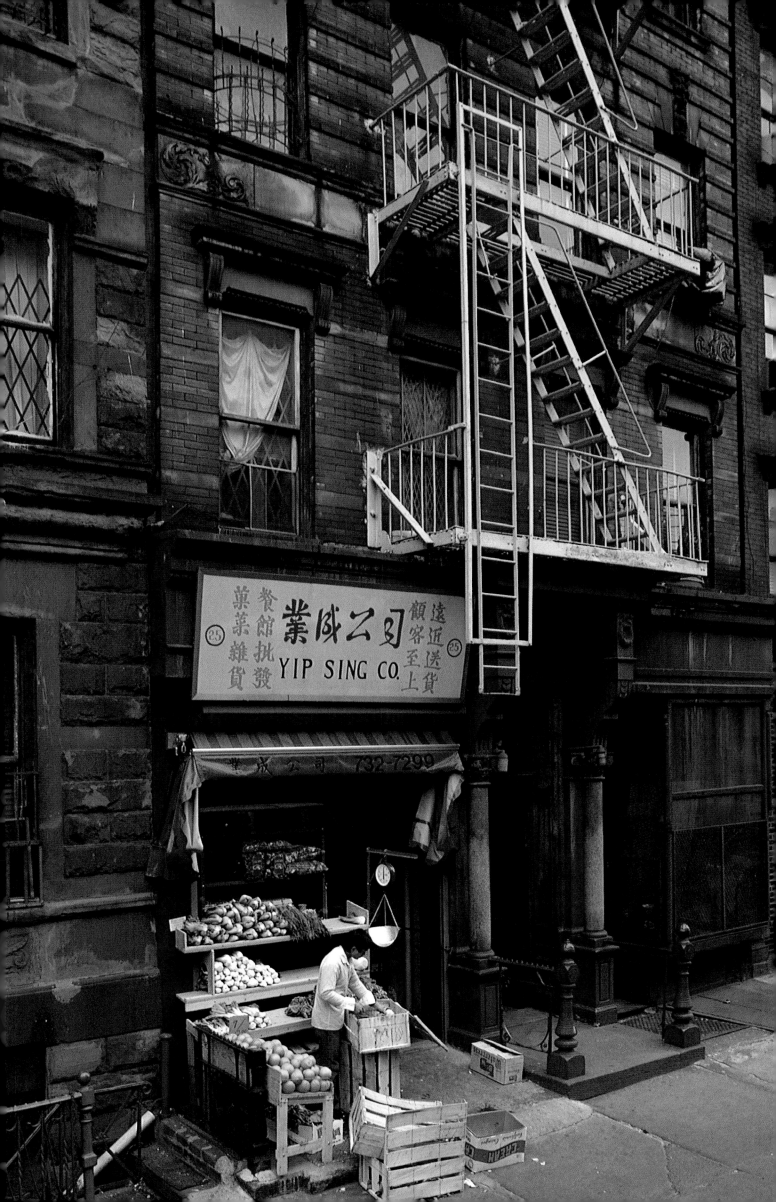

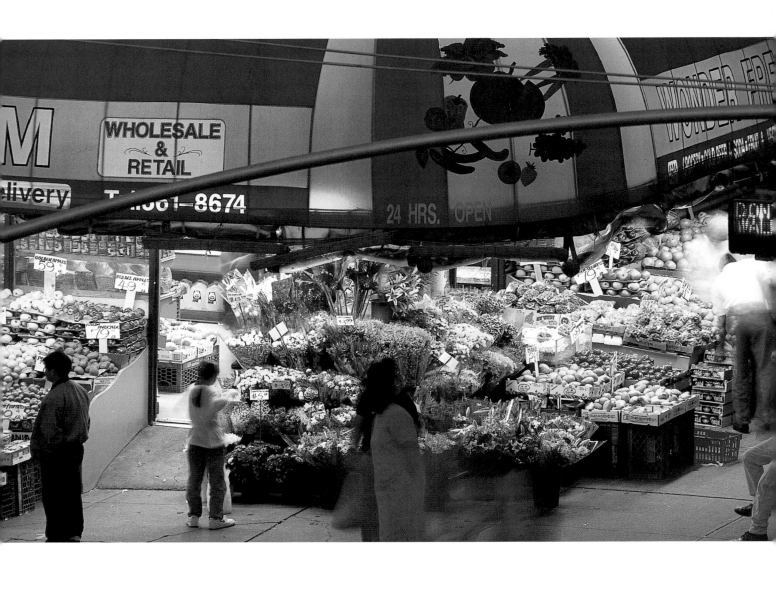

Above Korean fruit vendor, Queens Boulevard, Woodside, Queens
Opposite Bodega, East 103rd Street, Spanish Harlem, Manhattan

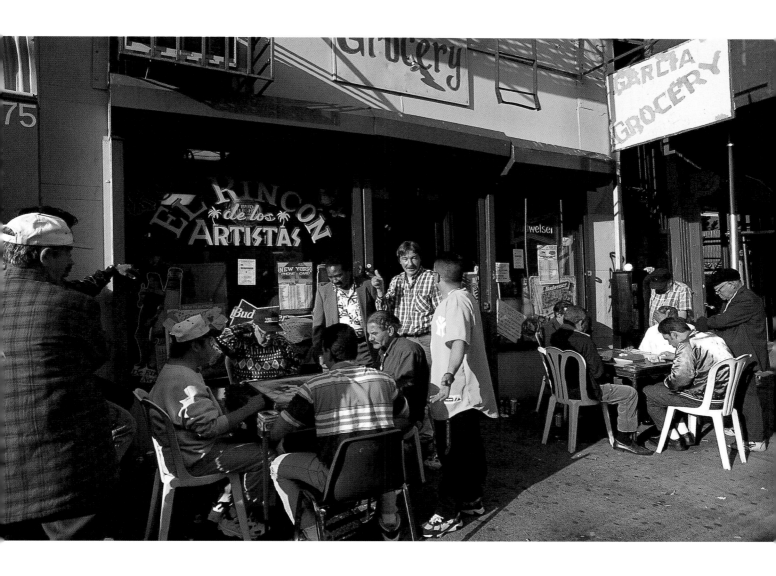

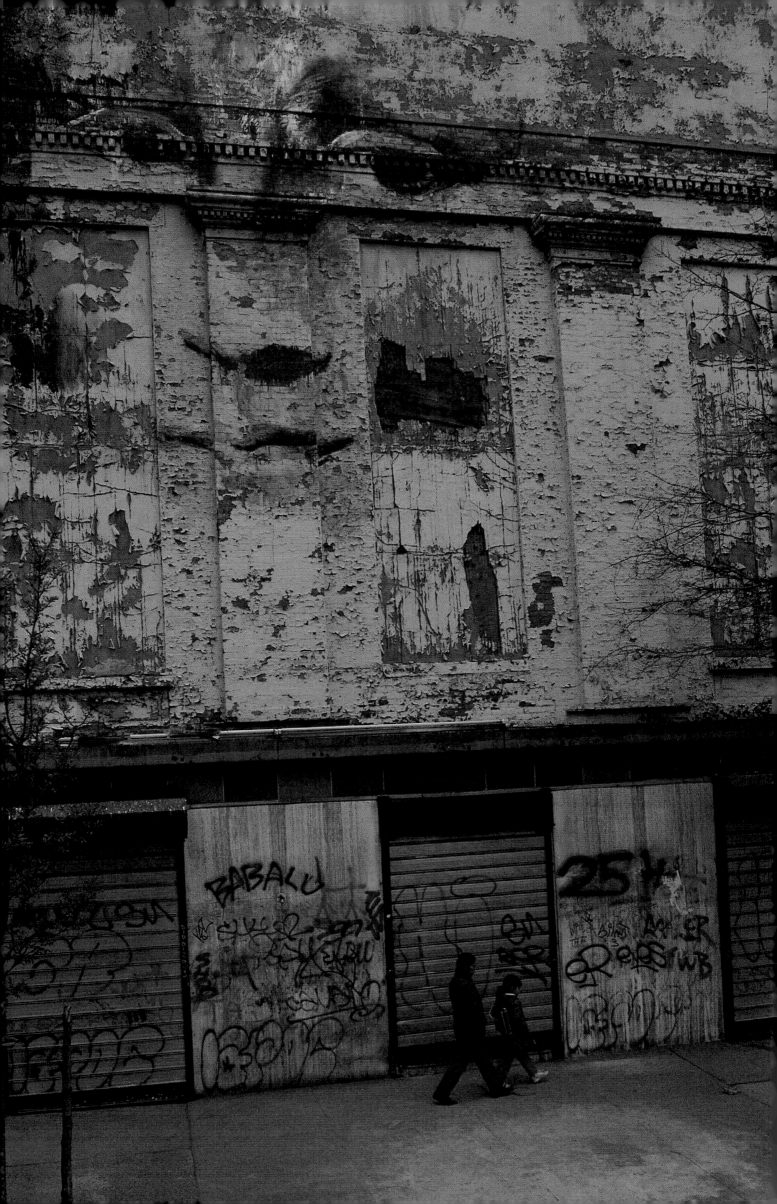

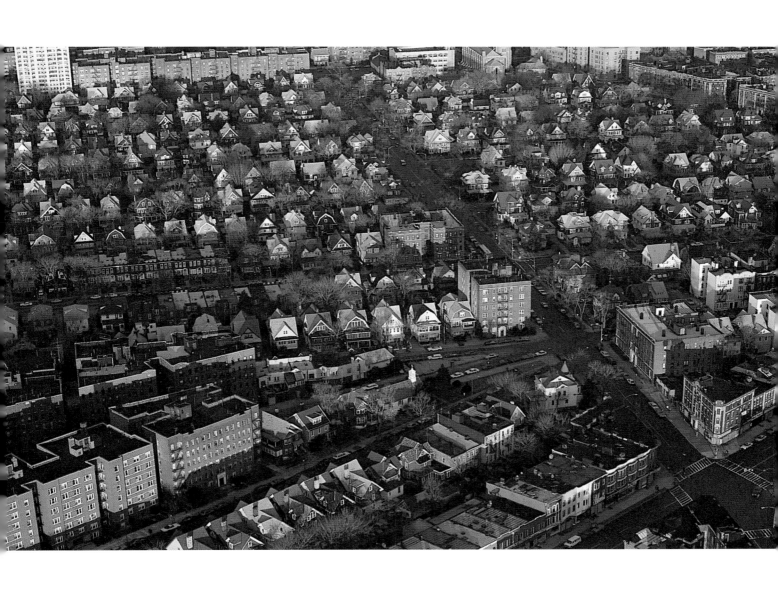

Above Brooklyn
Opposite Avenue C and Second Street, Alphabet City, Manhattan

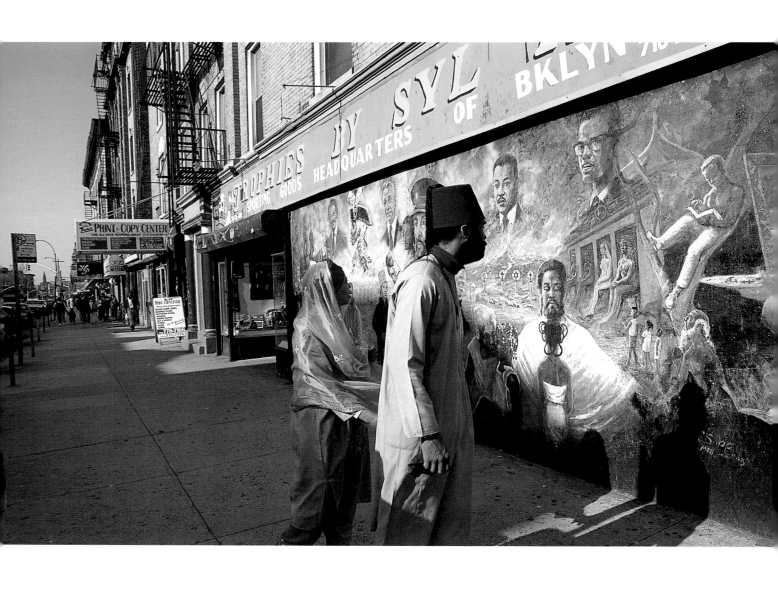

Above Nostrand Avenue, West Indian neighborhood, Crown Heights, Brooklyn
Opposite Roosevelt Avenue, Jackson Heights, Queens
Overleaf 125th Street, Manhattan

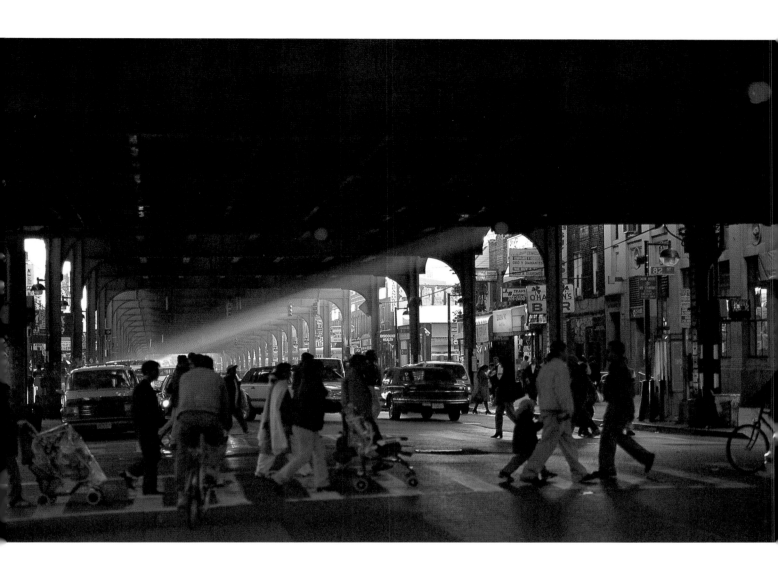

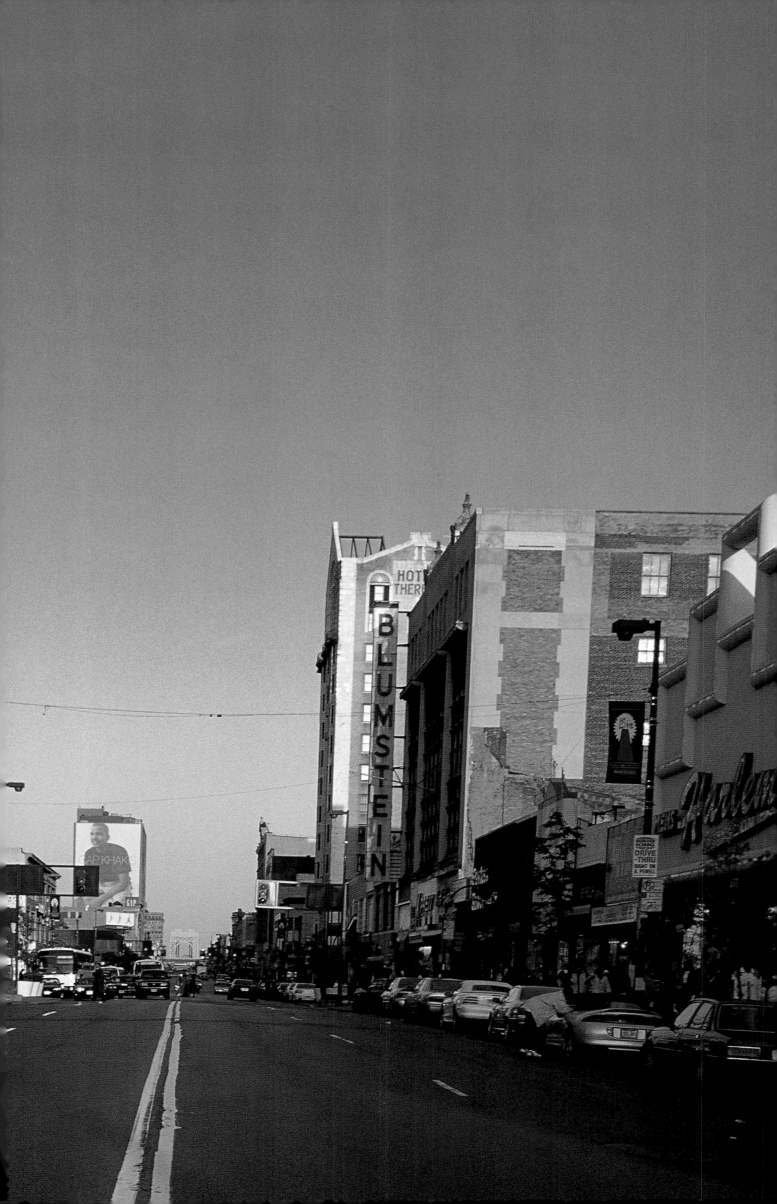

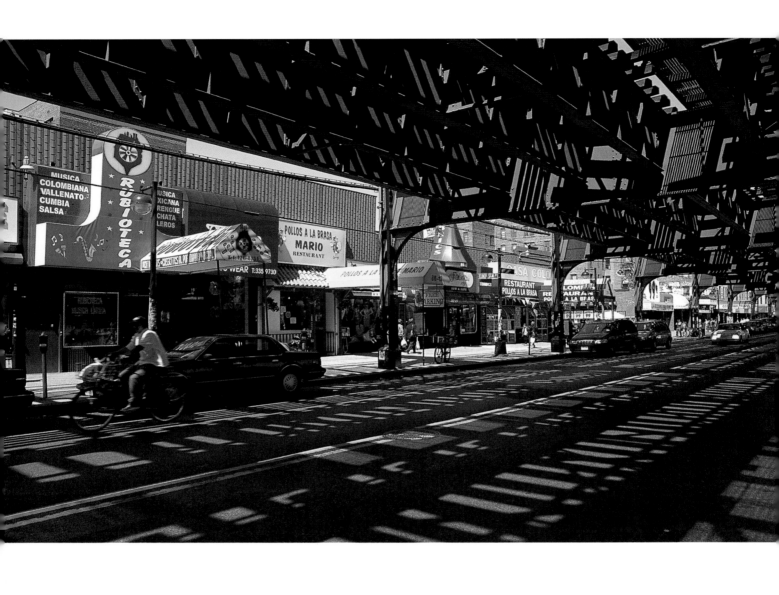

Above Roosevelt Avenue, Jackson Heights, Queens
Opposite N Train, Brooklyn
Overleaf, left West Thirtieth Street and Empire State Building, Manhattan
Overleaf, right Saint John the Divine, Morningside Heights, Manhattan

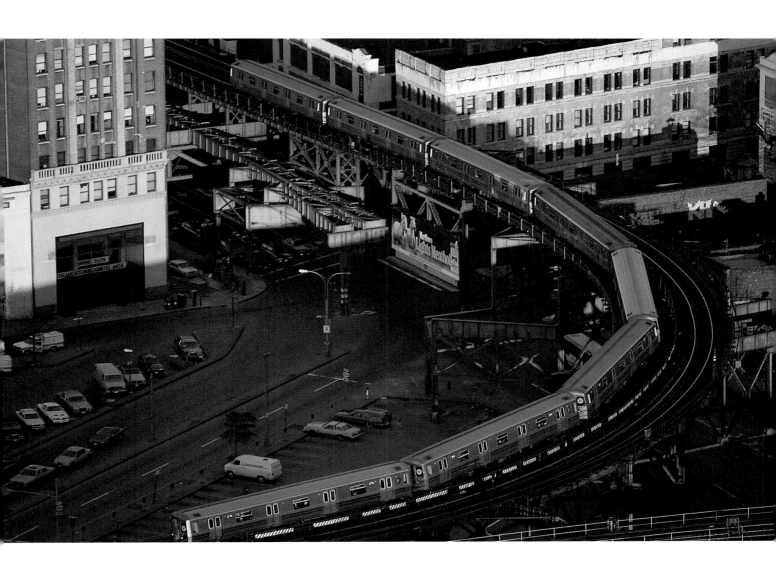

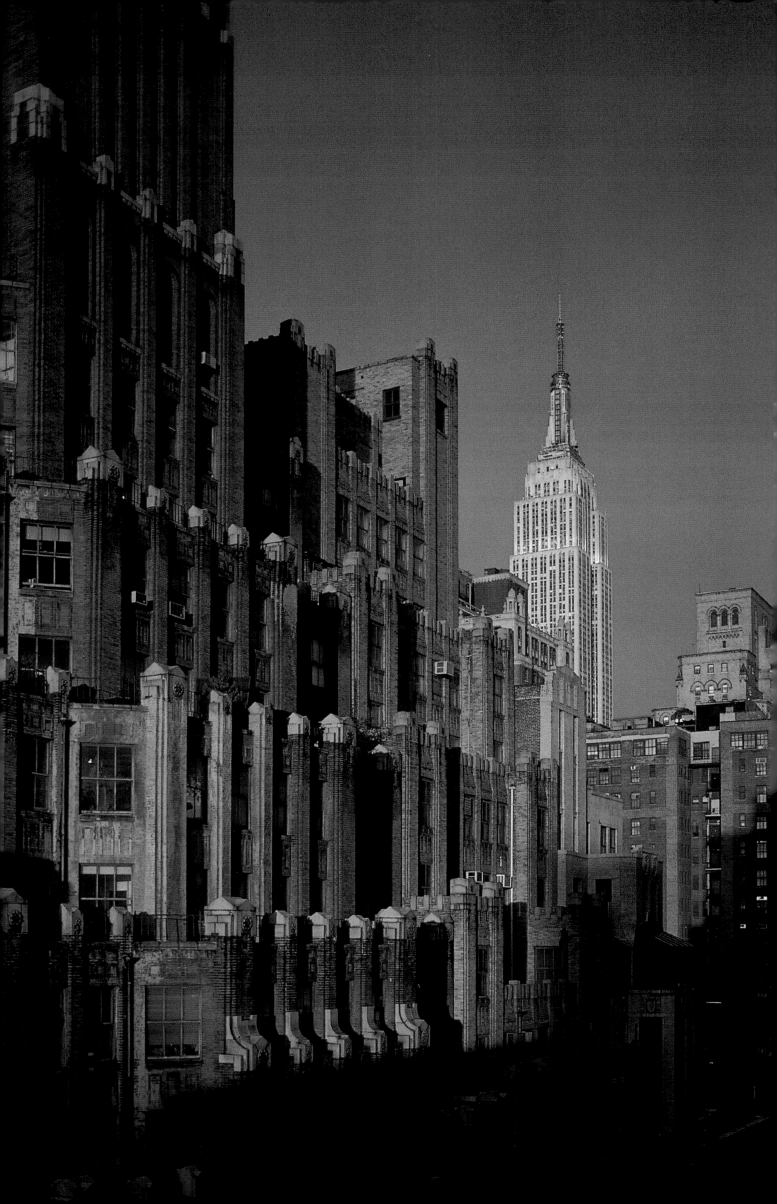

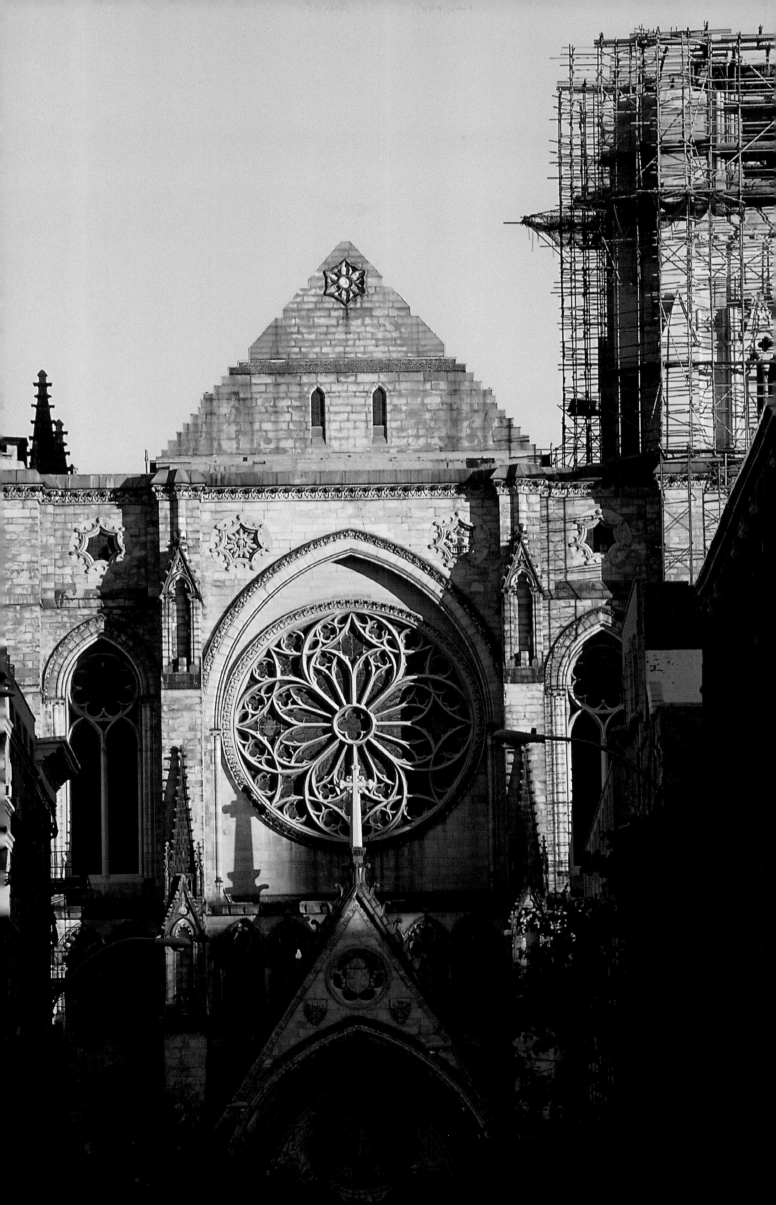

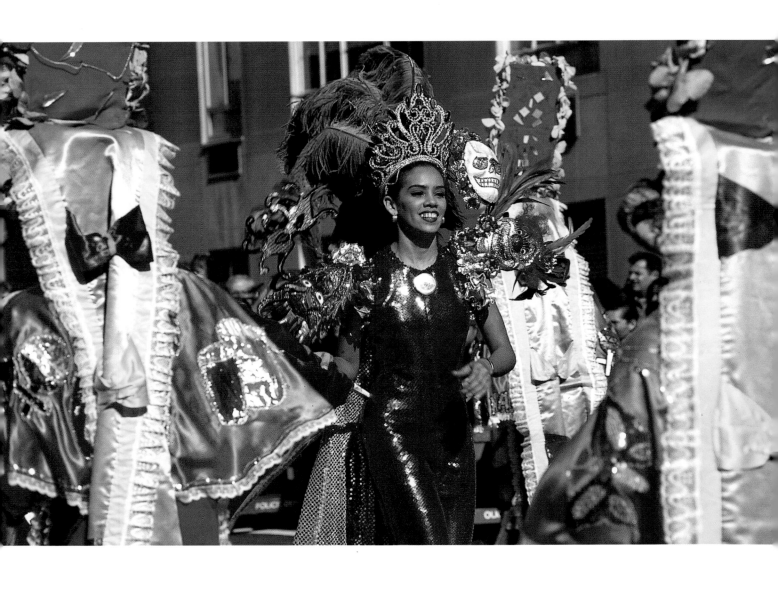

Above Spanish Columbus Day Parade, Fifth Avenue, Manhattan
Opposite Thanksgiving Day Parade, Central Park West, Manhattan

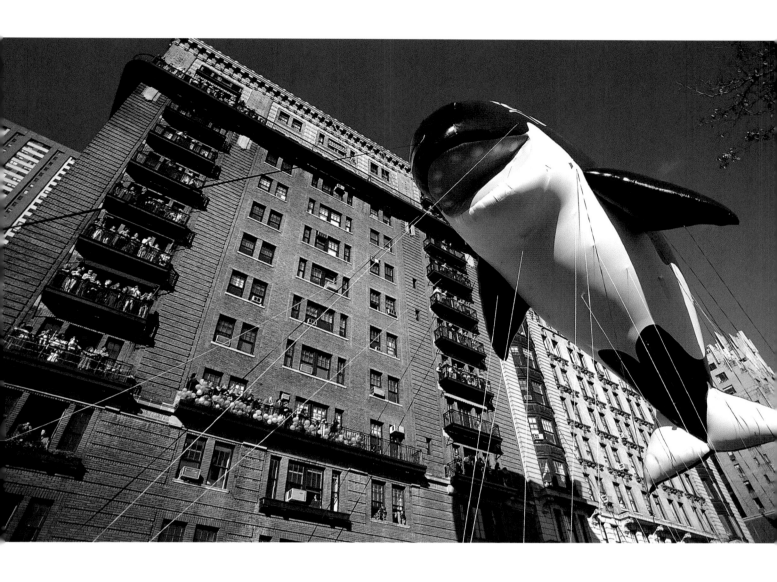

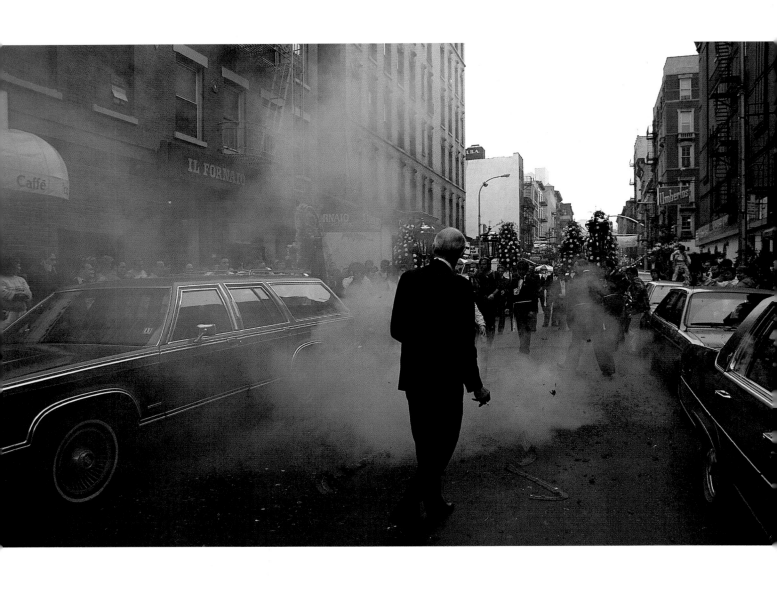

Above Feast of San Gennaro, Mulberry Street, Manhattan
Opposite Manhattan Avenue, Greenpoint, Brooklyn
Overleaf Park Avenue, Manhattan

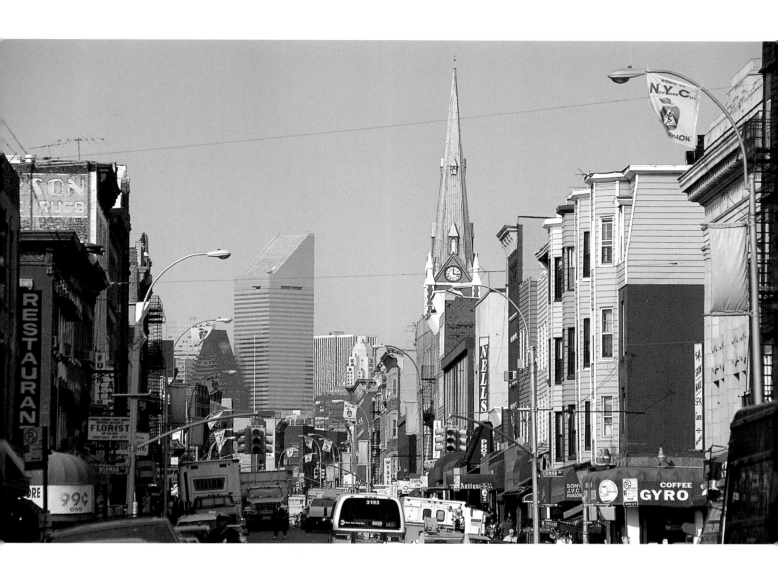

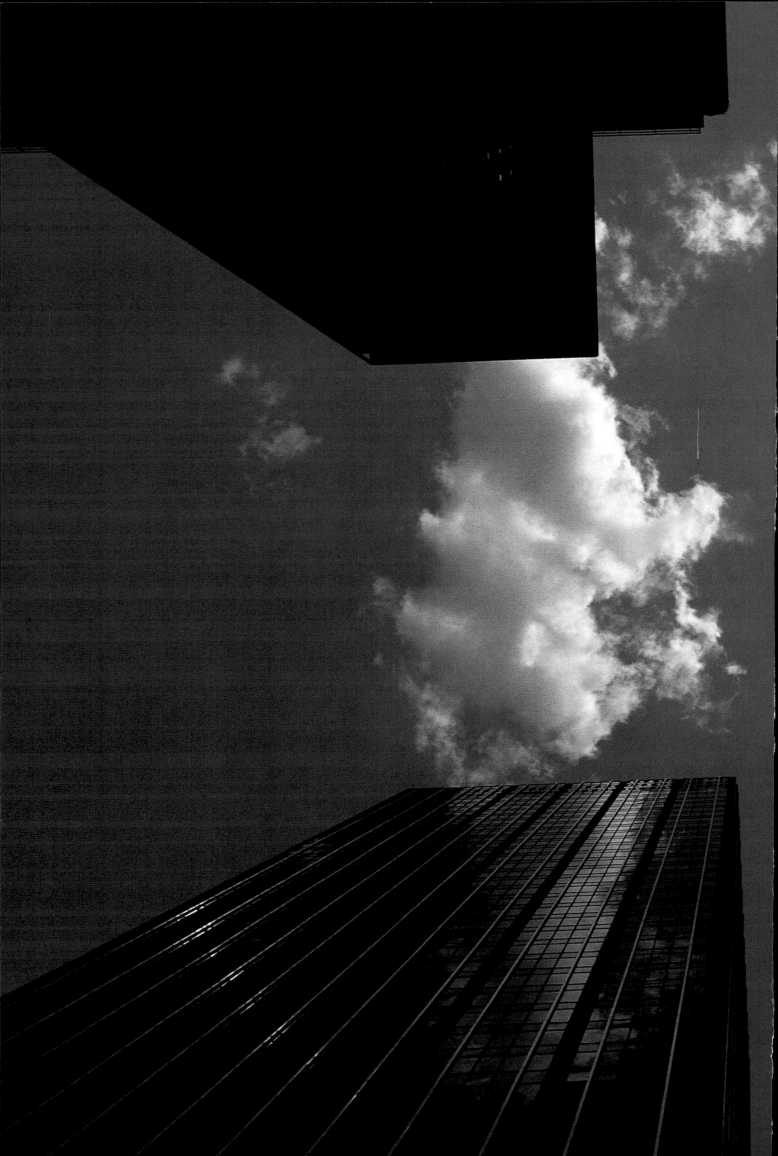

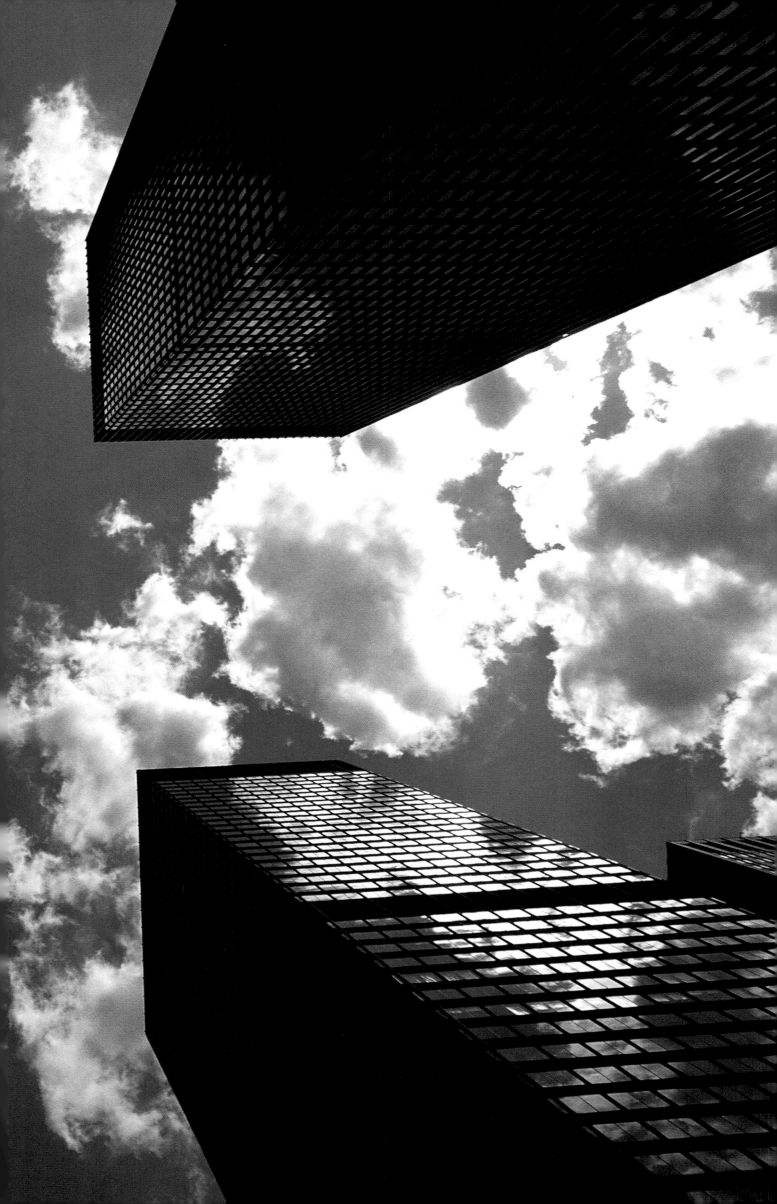

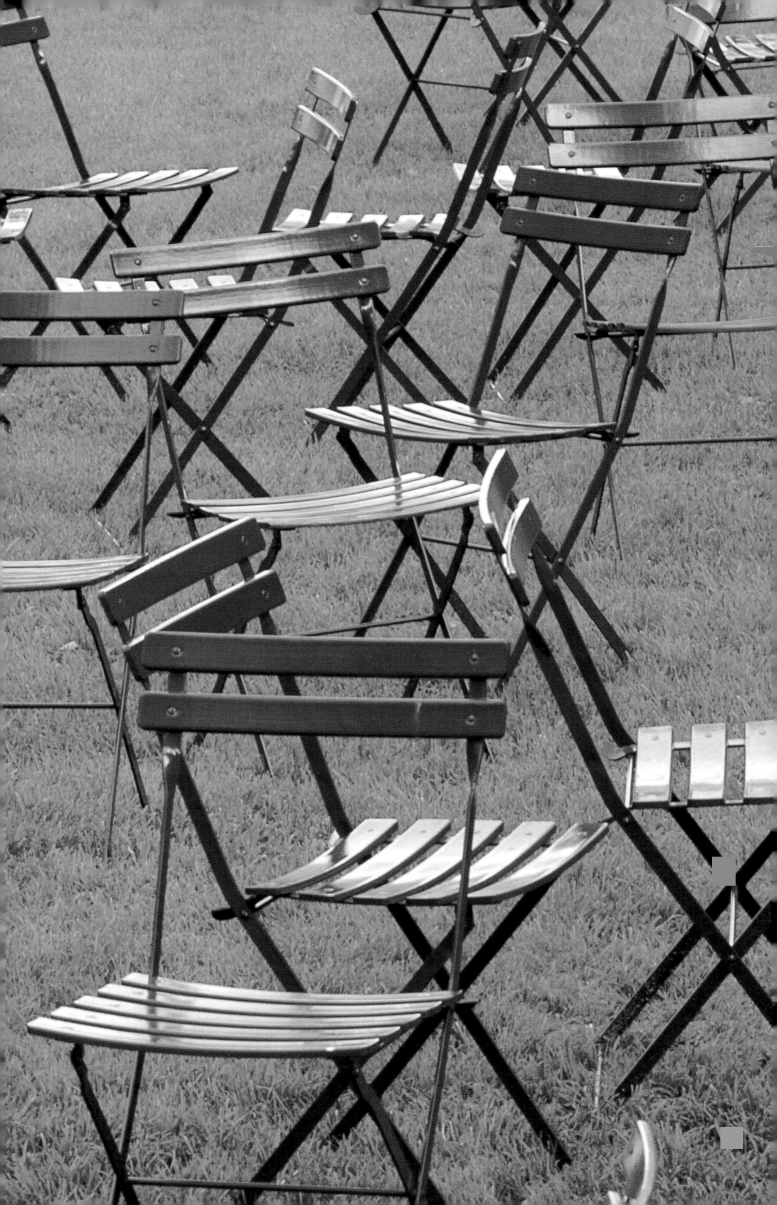

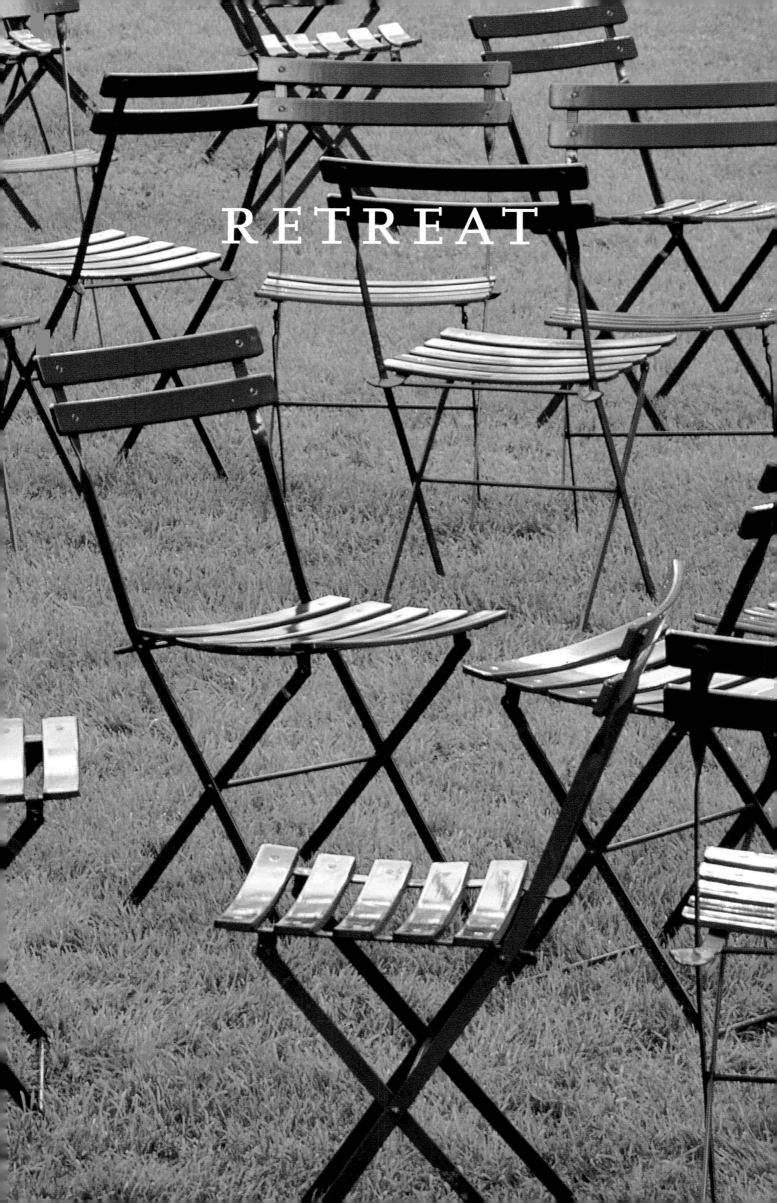

RETREAT

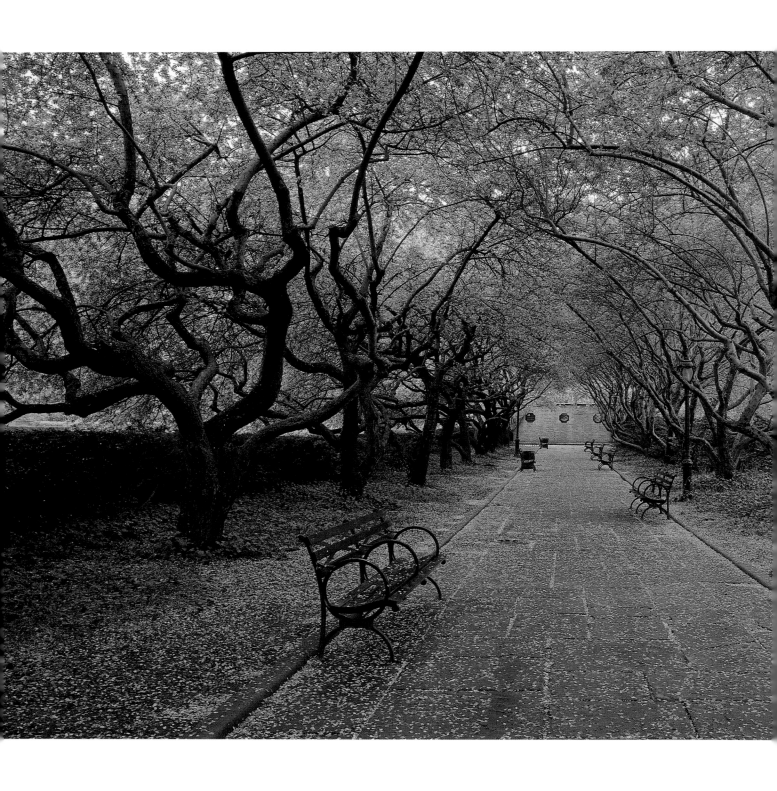

Above Conservatory Gardens, Central Park, Manhattan
Opposite Central Park, Manhattan
Preceding pages Bryant Park, Manhattan

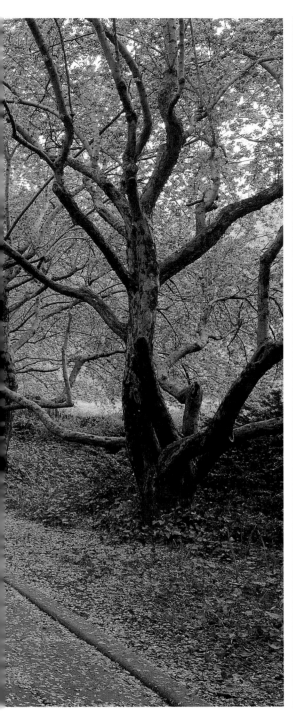
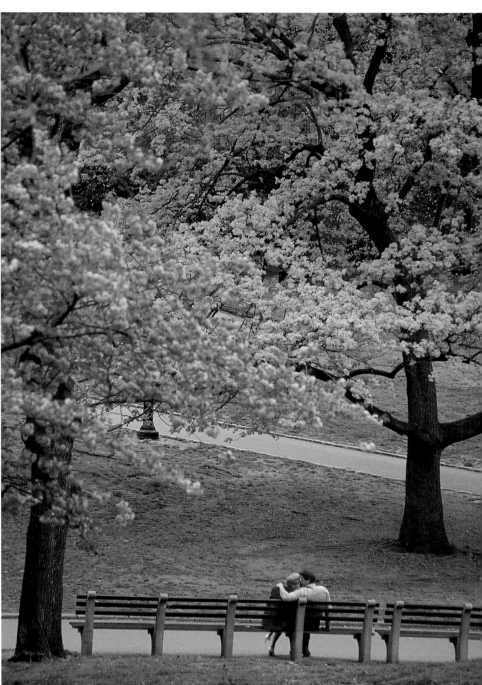

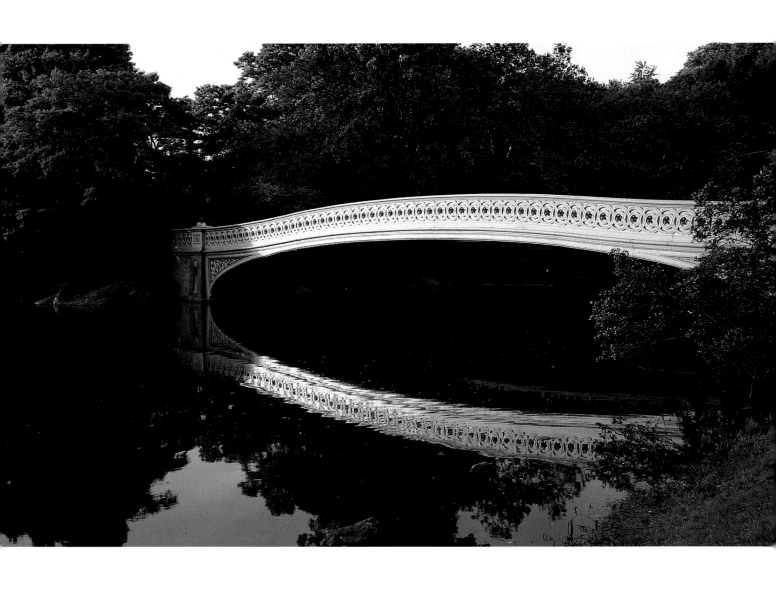

Above Bow Bridge, Central Park, Manhattan
Opposite Bow Bridge, Central Park Lake, and Central Park West, Manhattan

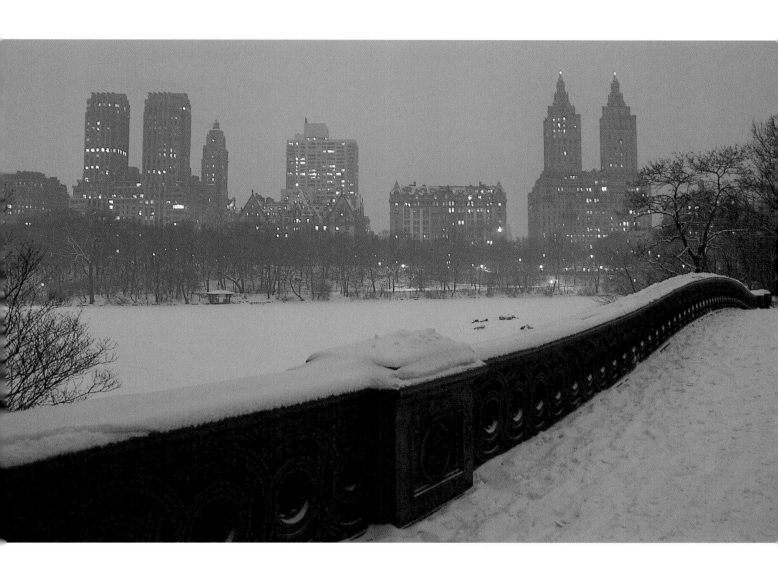

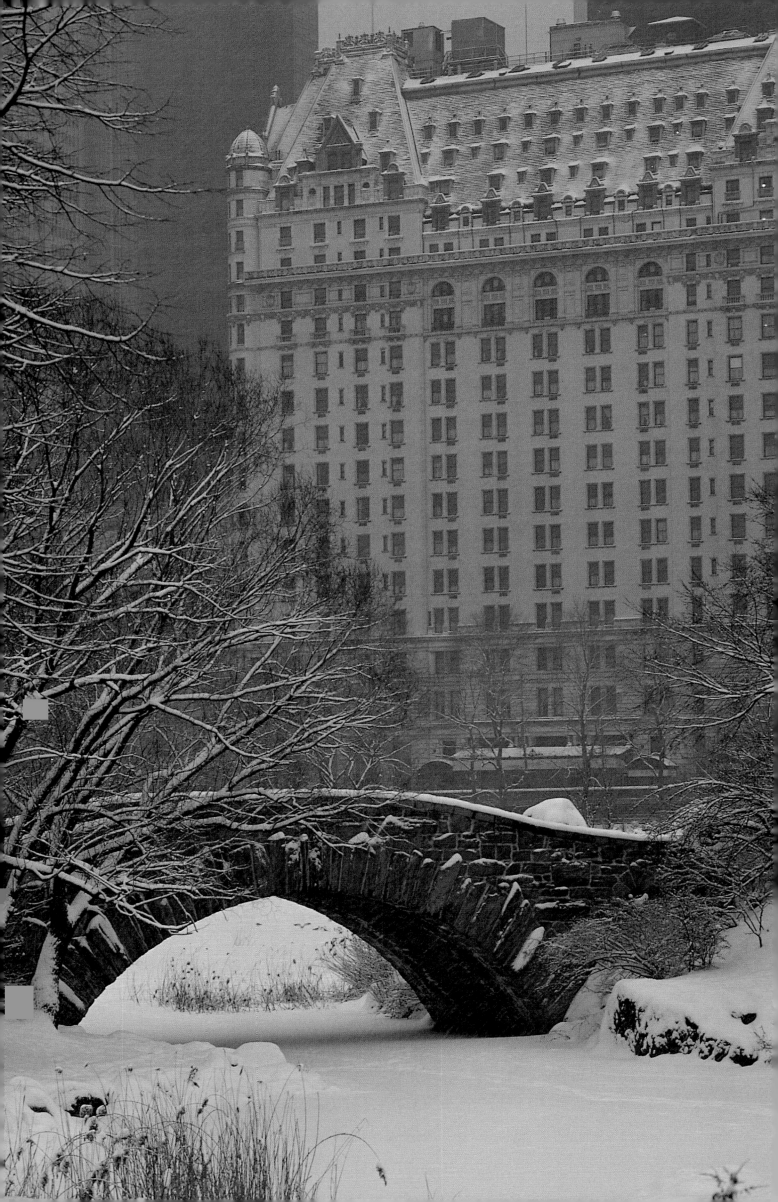

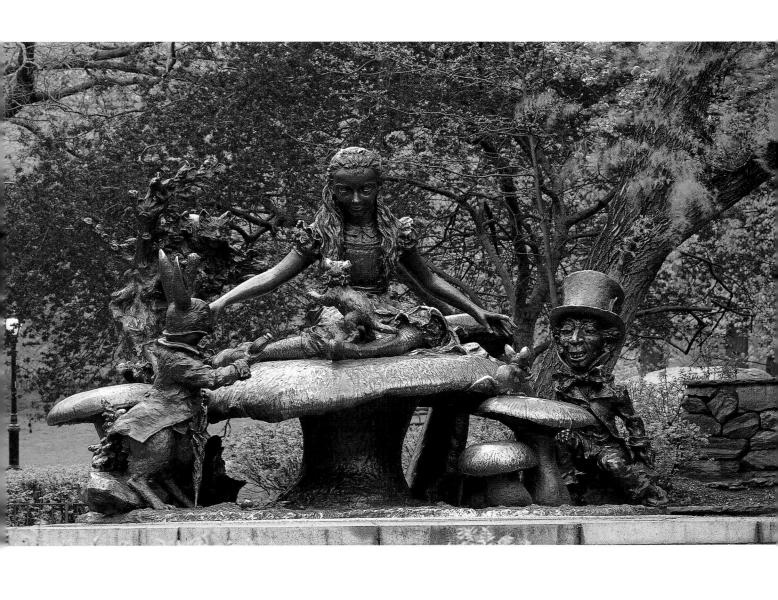

Above Alice in Wonderland statue, Central Park, Manhattan
Opposite Central Park and Plaza Hotel, Manhattan

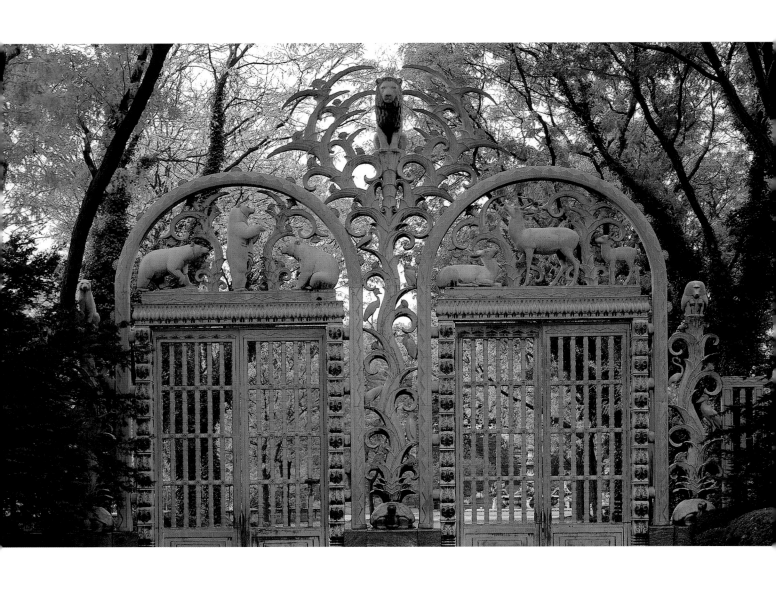

Above Rainey Memorial Gate, Bronx Zoo, the Bronx
Opposite Tavern on the Green, Central Park, Manhattan
Overleaf Central Park, Manhattan

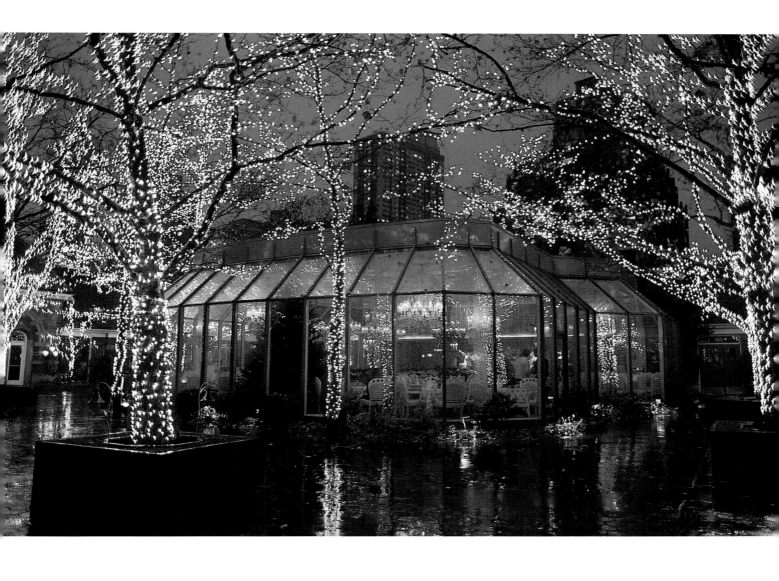

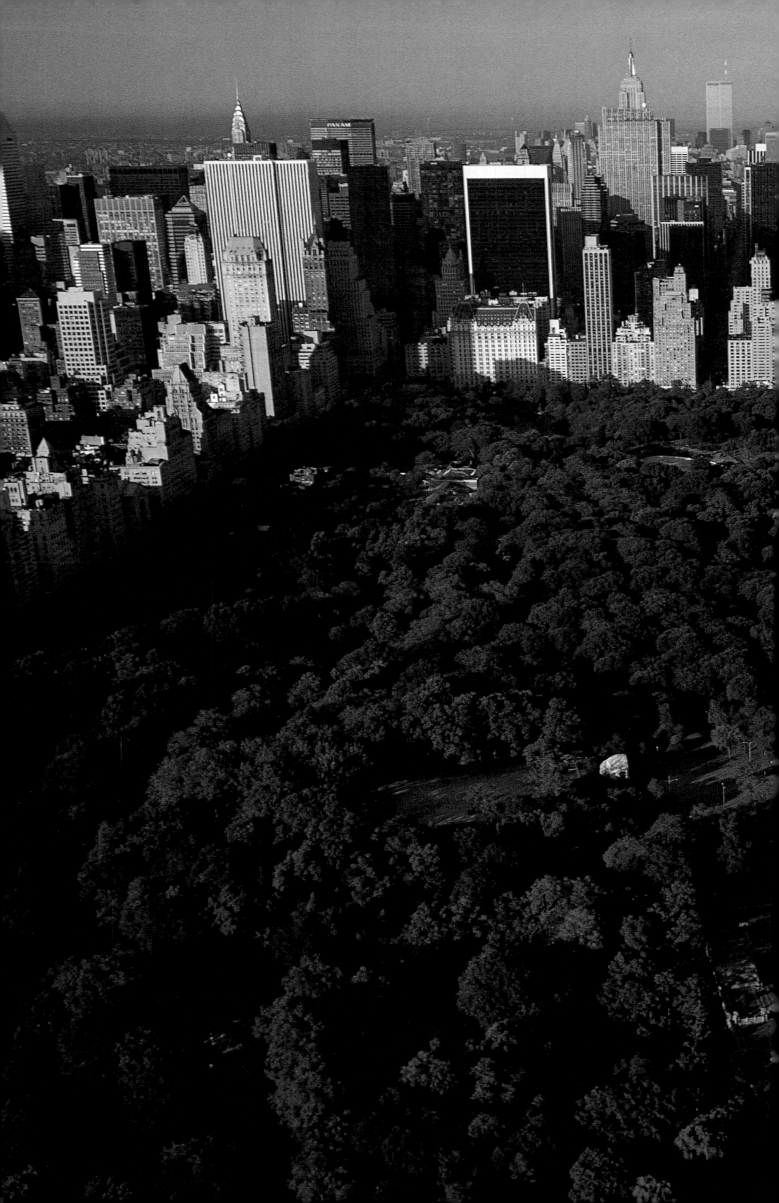

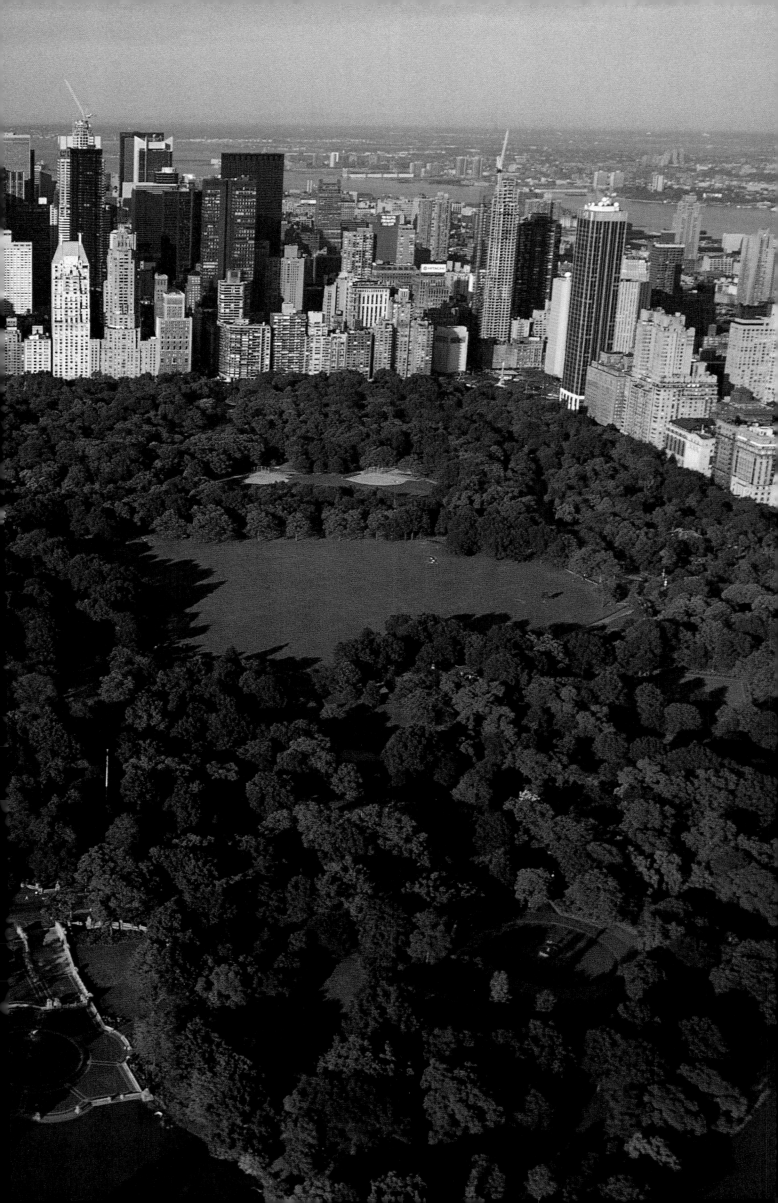

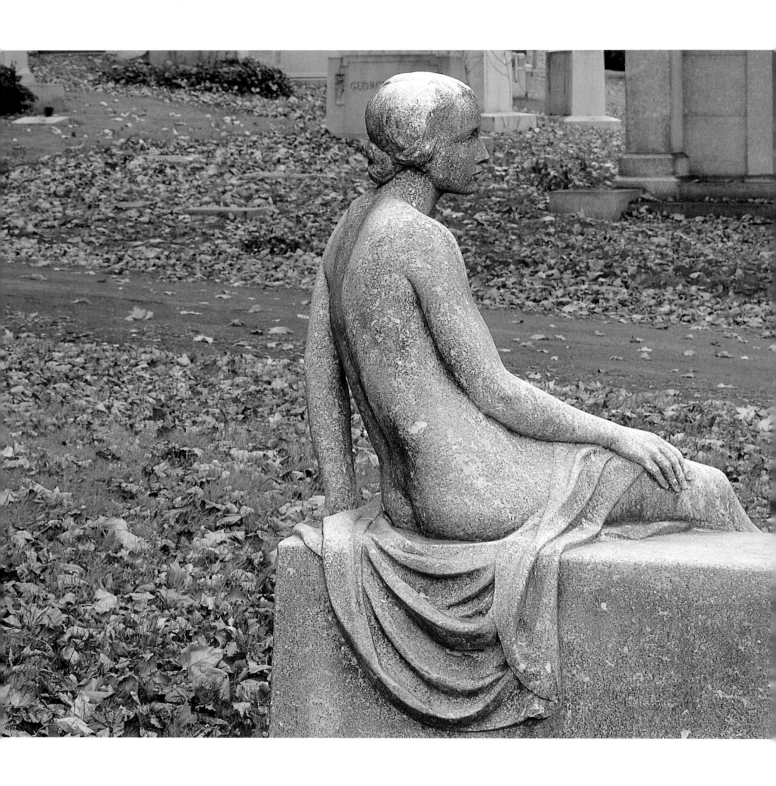

Above and opposite Woodlawn Cemetery, the Bronx

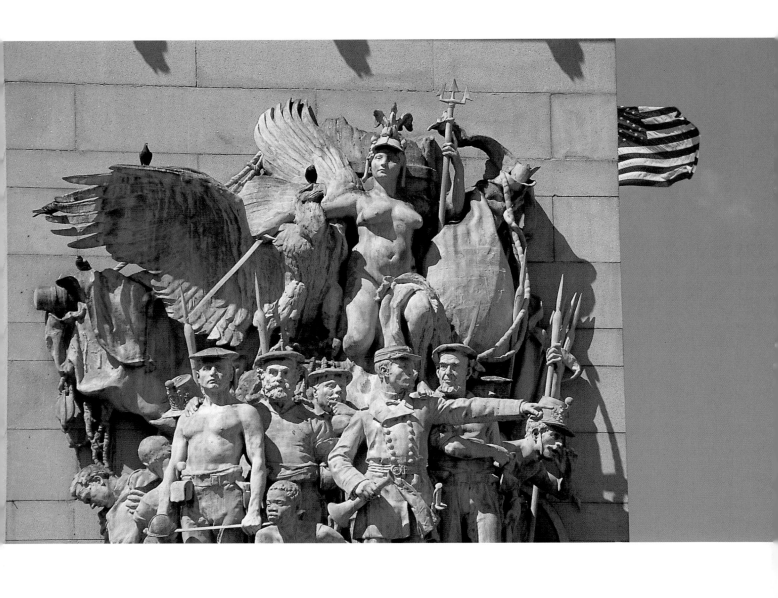

Above Soldiers' and Sailors' Memorial Arch, Grand Army Plaza, Prospect Park, Brooklyn
Opposite *Washington,* Union Square Park, with Empire State Building in the distance, Manhattan

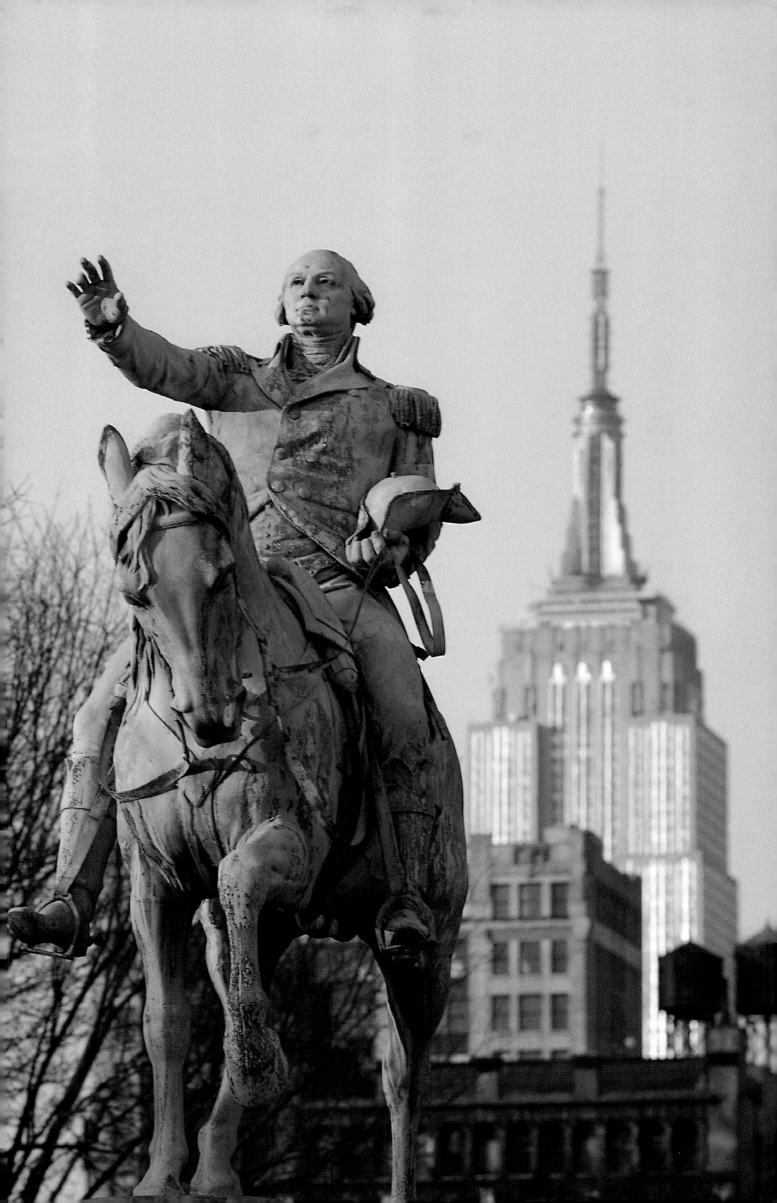

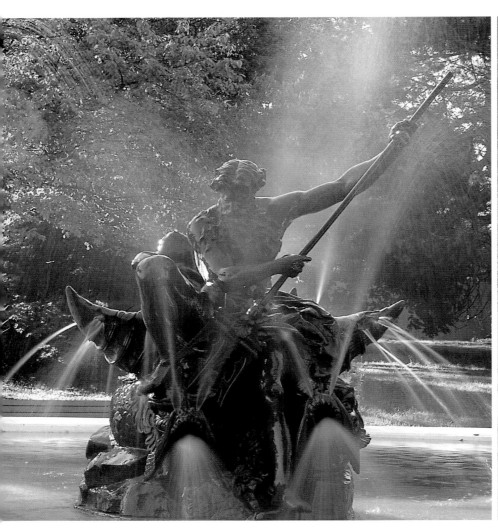
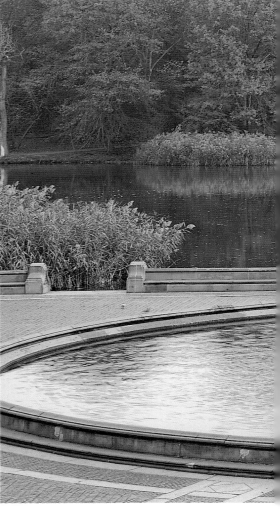

Above Poseidon statue, Snug Harbor Cultural Center, Staten Island
Opposite Bethesda Fountain, Central Park, Manhattan

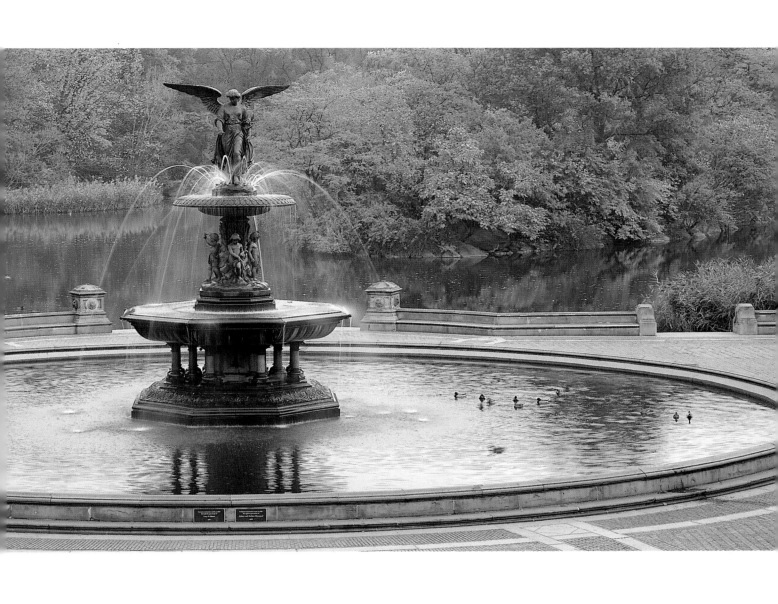

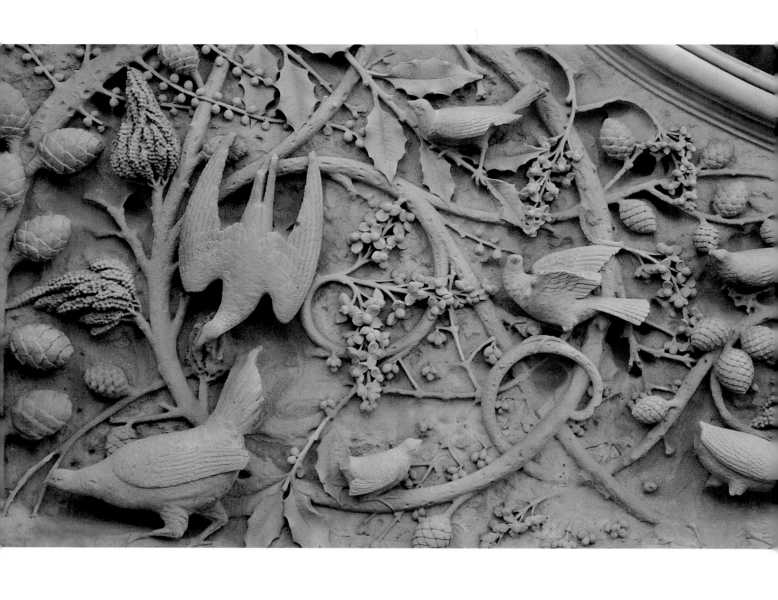

Above Bethesda Terrace detail, Central Park, Manhattan
Opposite Strawberry Fields, Central Park, Manhattan
Overleaf Enid A. Haupt Conservatory, New York Botanical Garden, the Bronx
Second overleaf Unisphere, Flushing Meadows, Queens

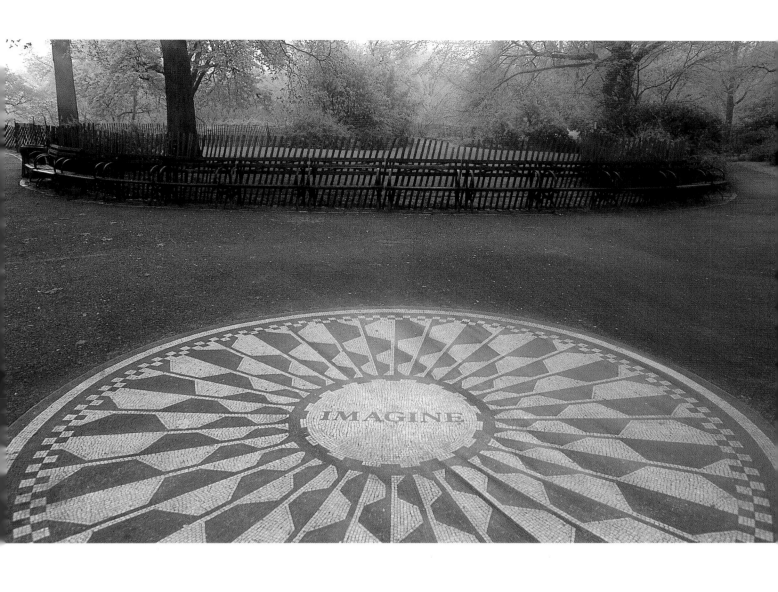

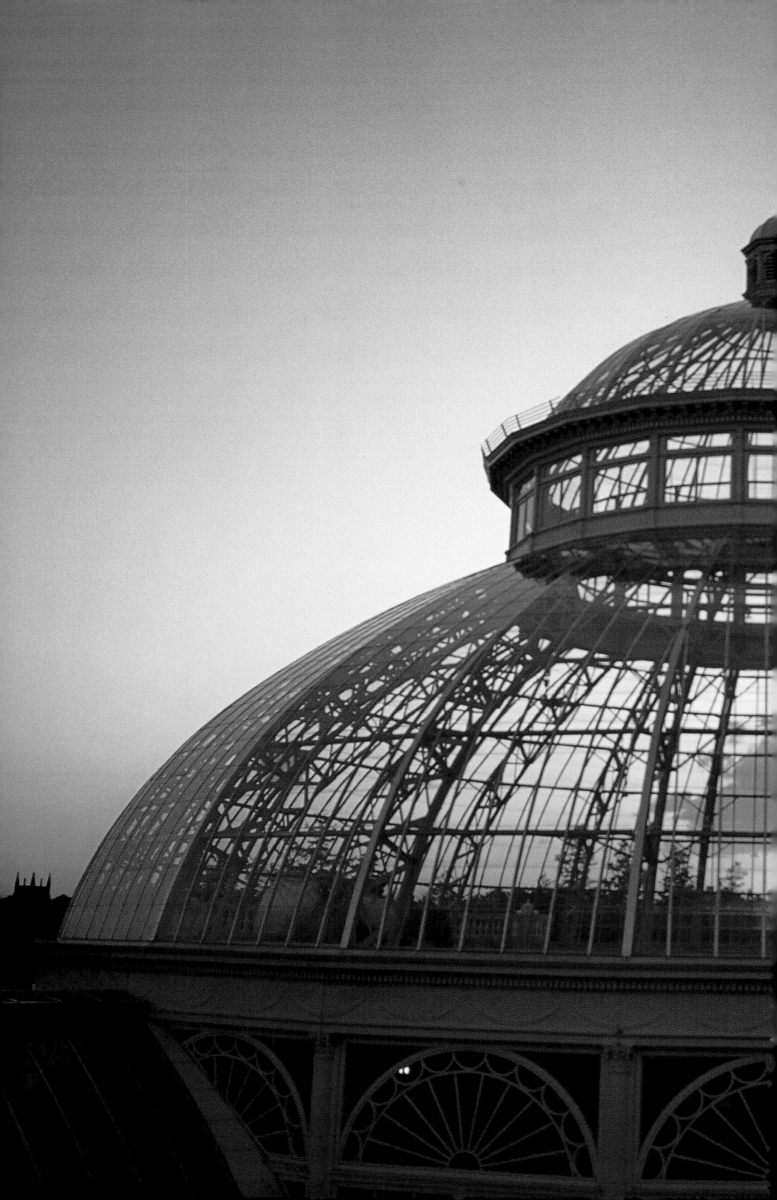

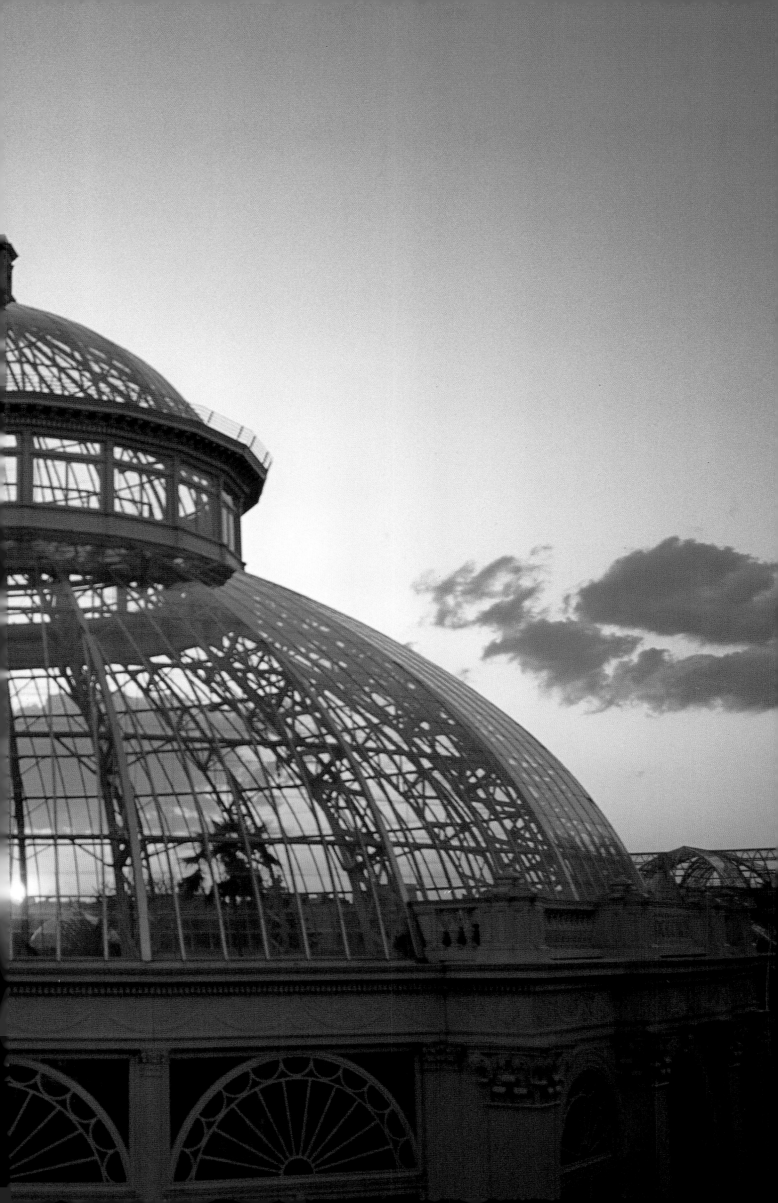

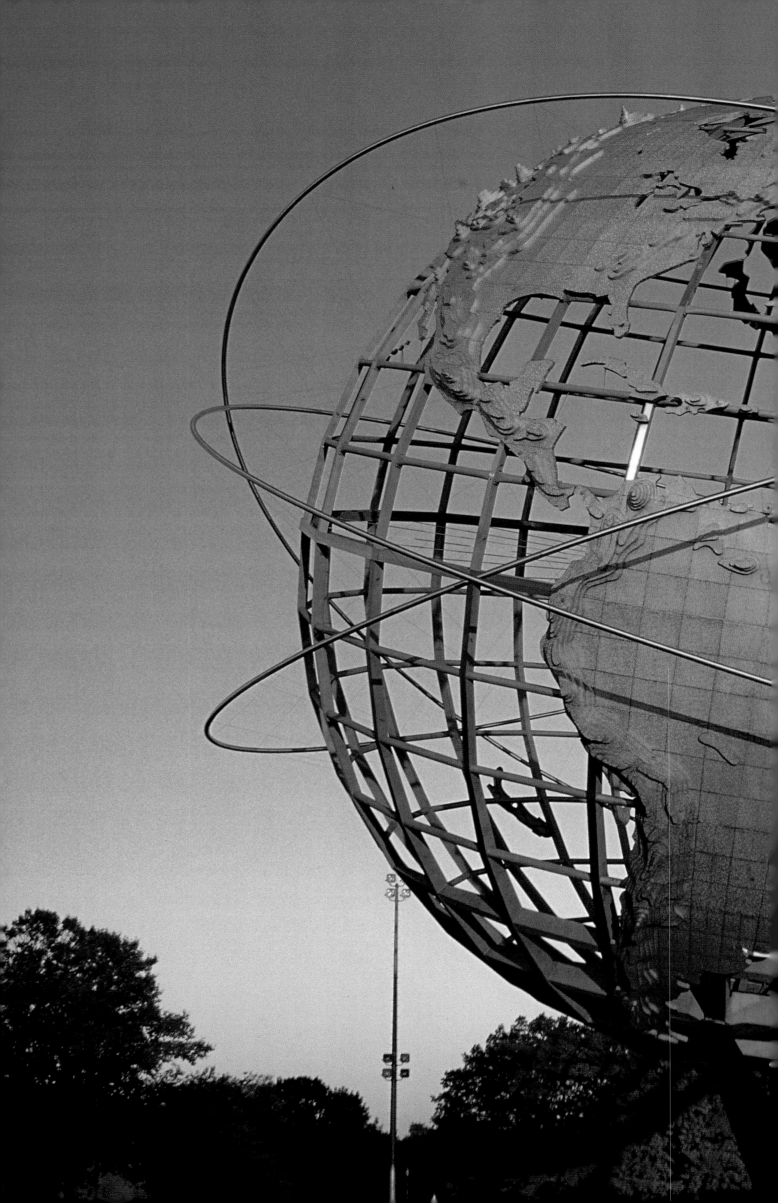

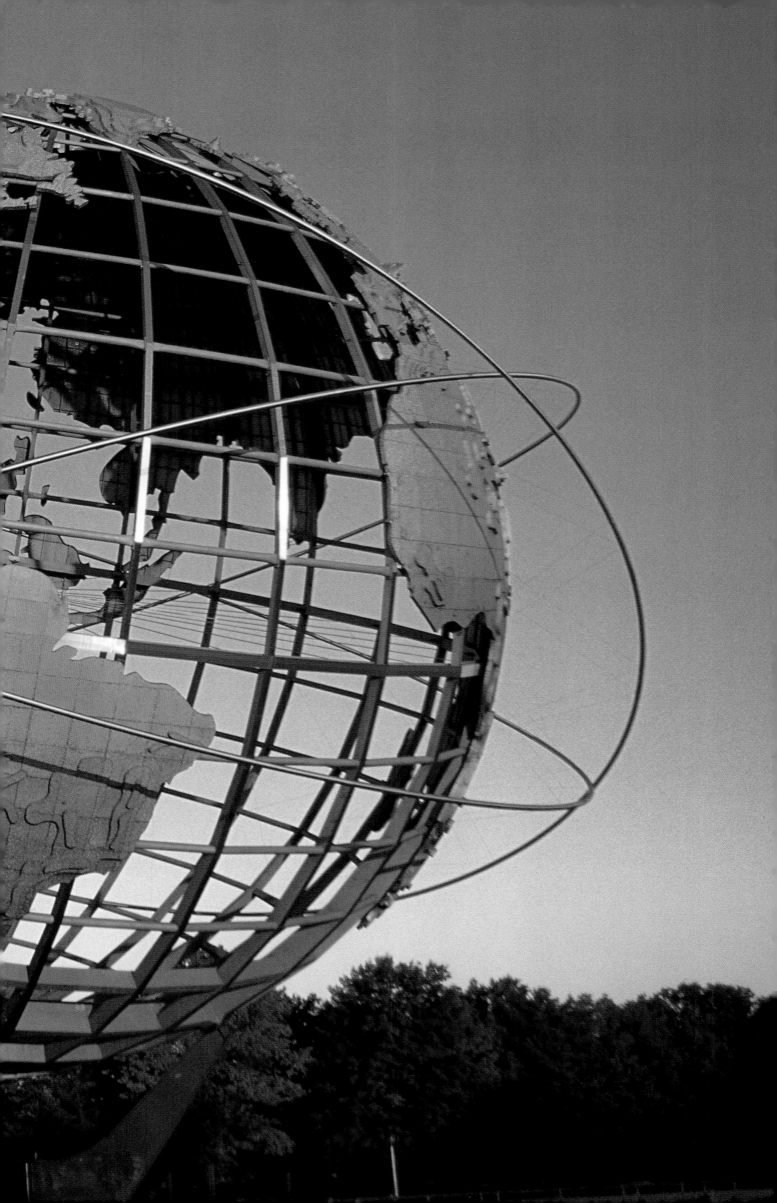

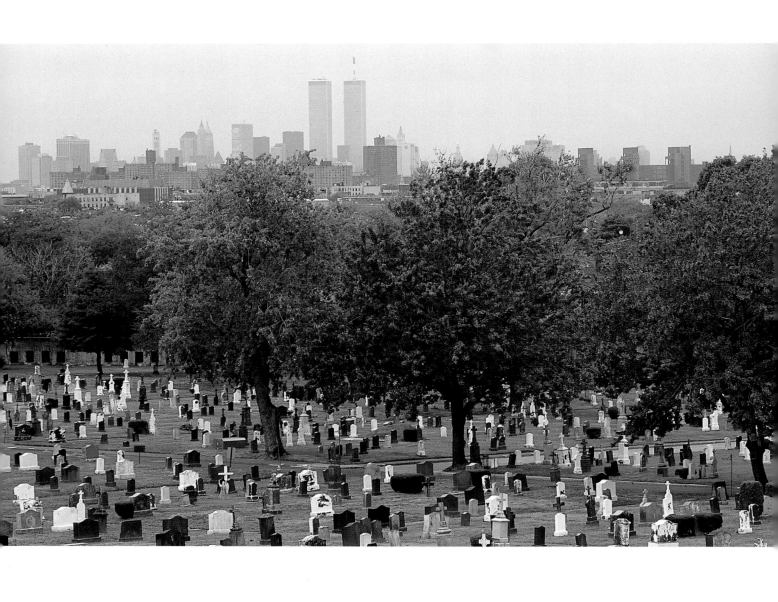

Above Trinity Cemetery, Brooklyn
Opposite Sheep Meadow, Central Park, Manhattan

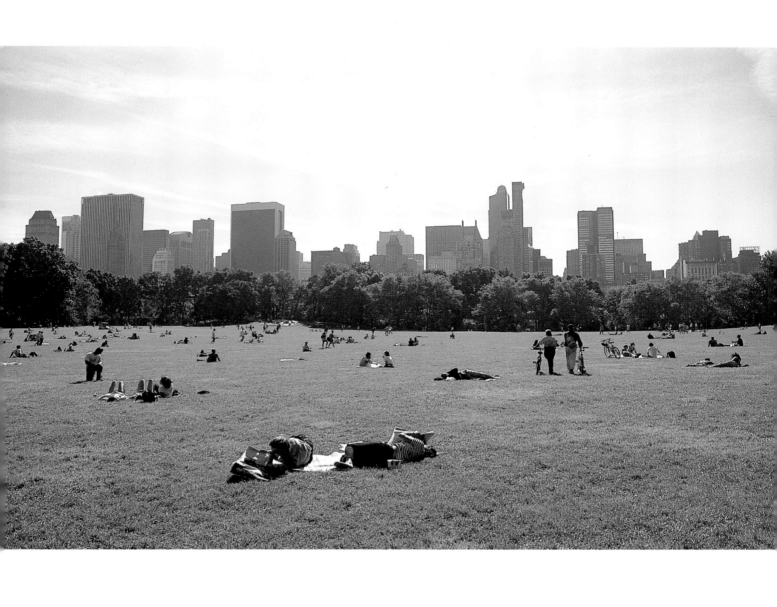

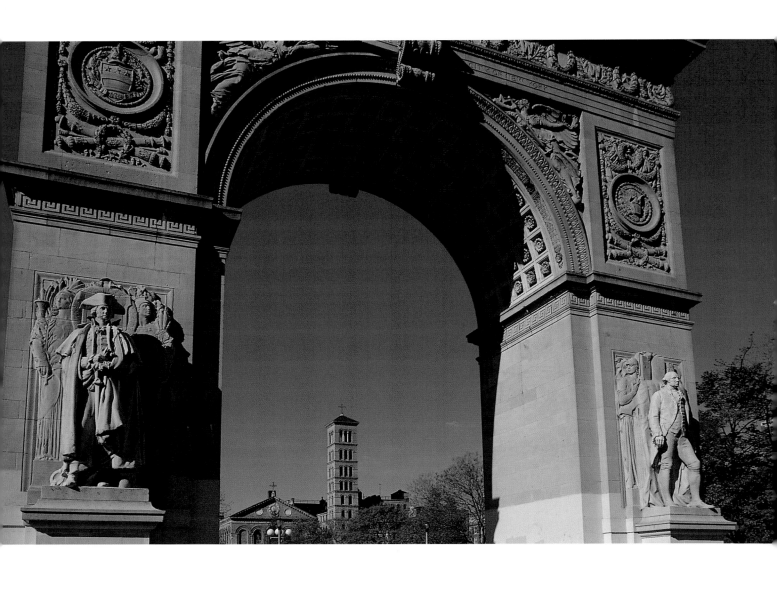

Above and overleaf Washington Arch and Washington Square Park, Manhattan
Opposite Conservatory Pond, Central Park, Manhattan

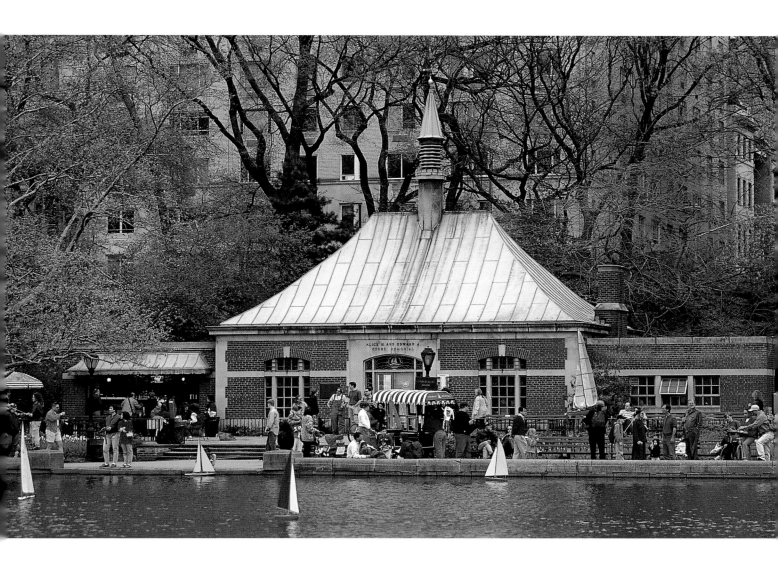

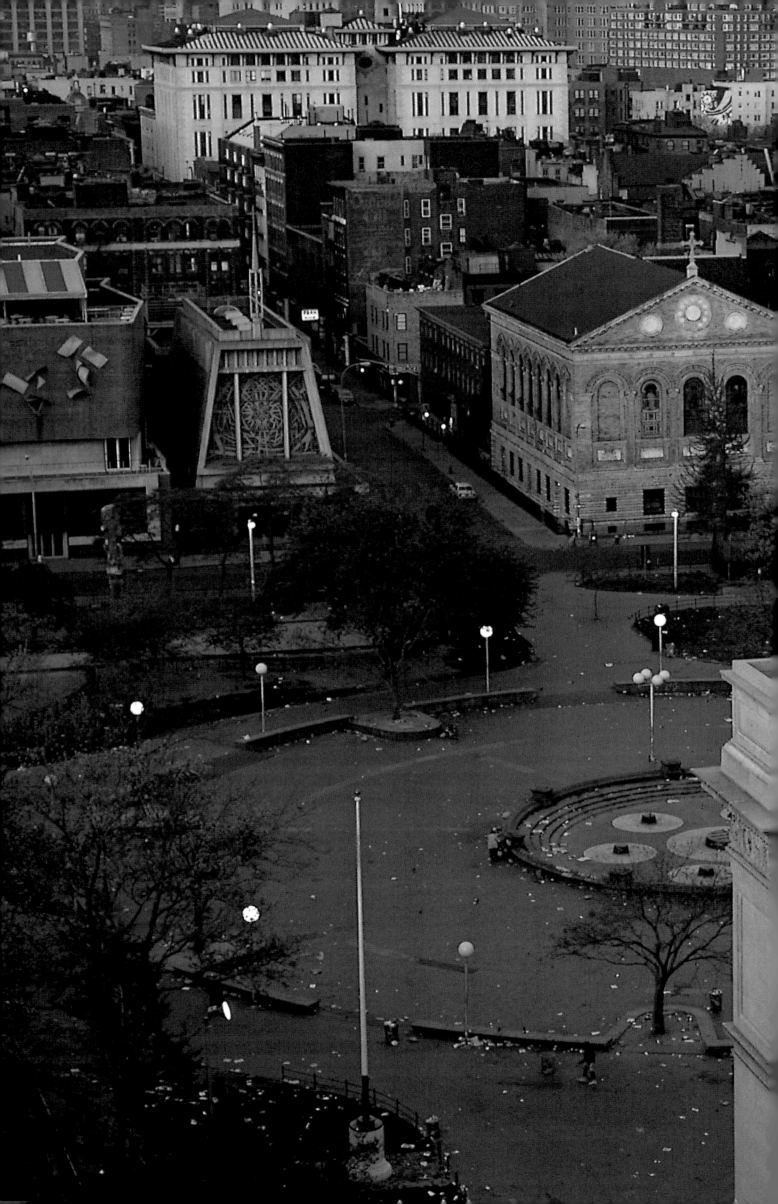

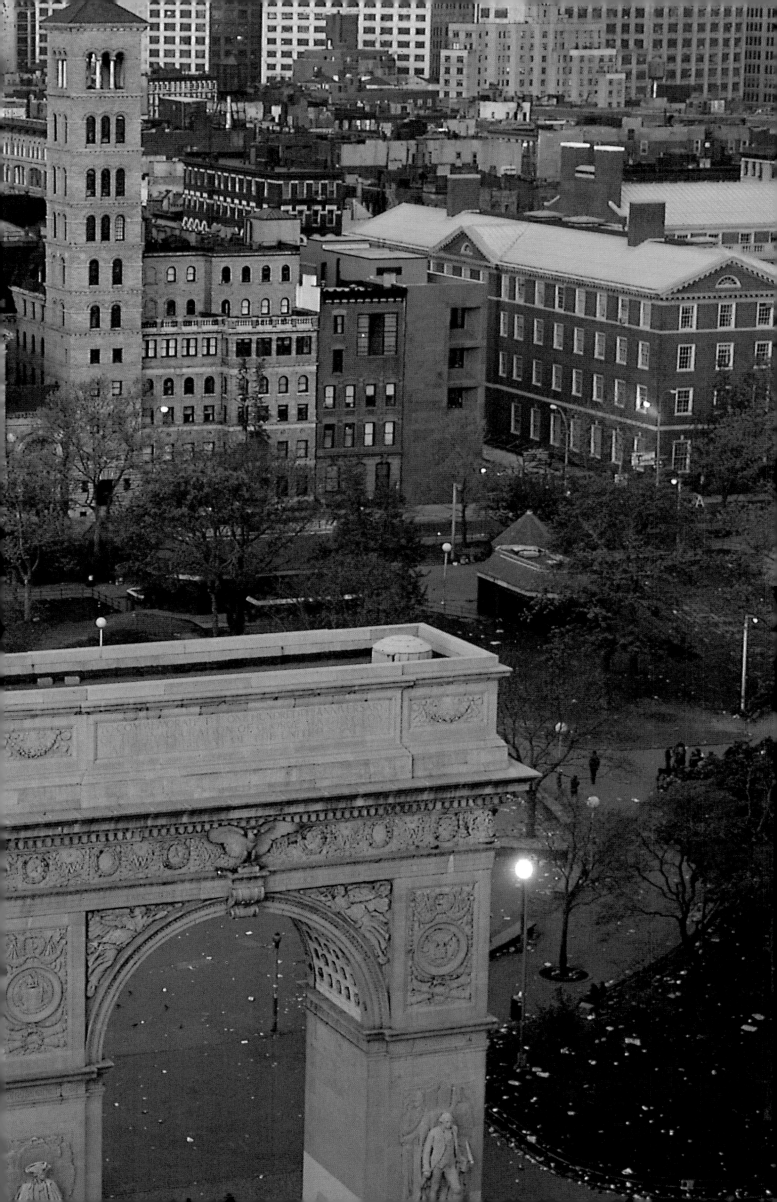

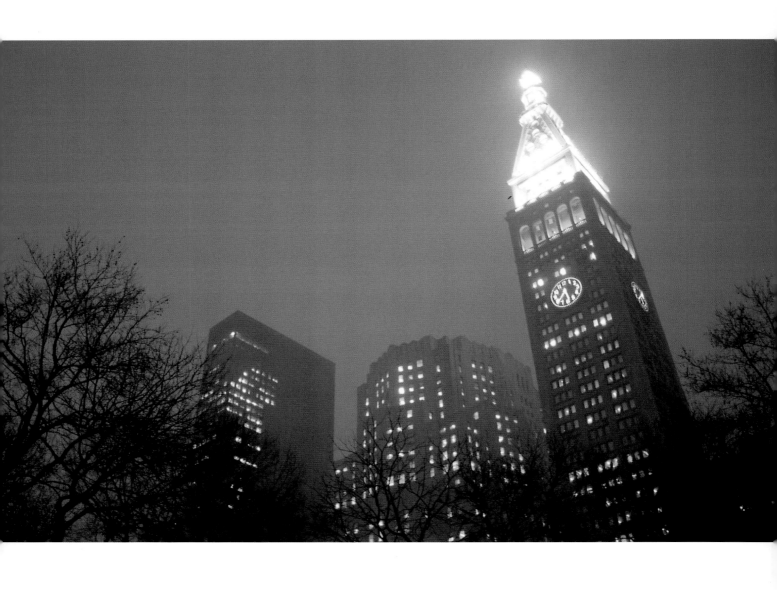

Above Metropolitan Life Building, Madison Square Park, Manhattan
Opposite The Lake and Central Park West, Central Park, Manhattan
Overleaf Rockefeller Center, Manhattan
Second overleaf Fall foliage and Bronx River, New York Botanical Garden, the Bronx

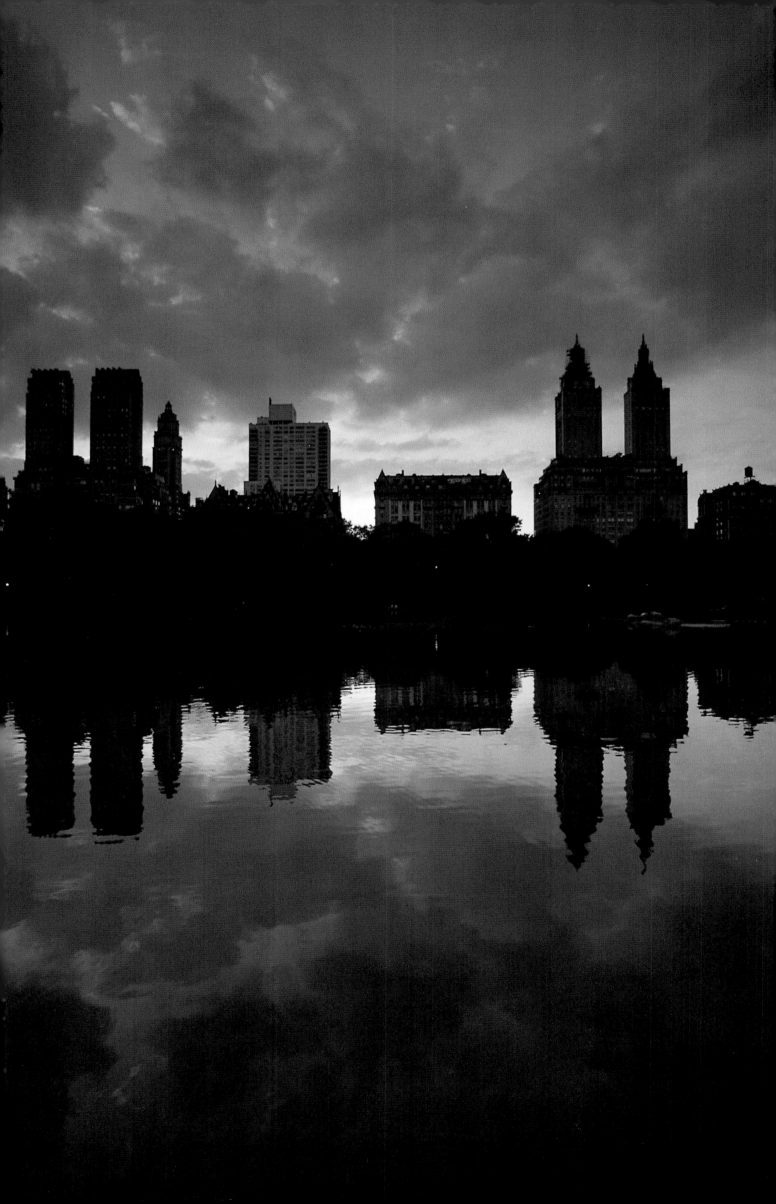

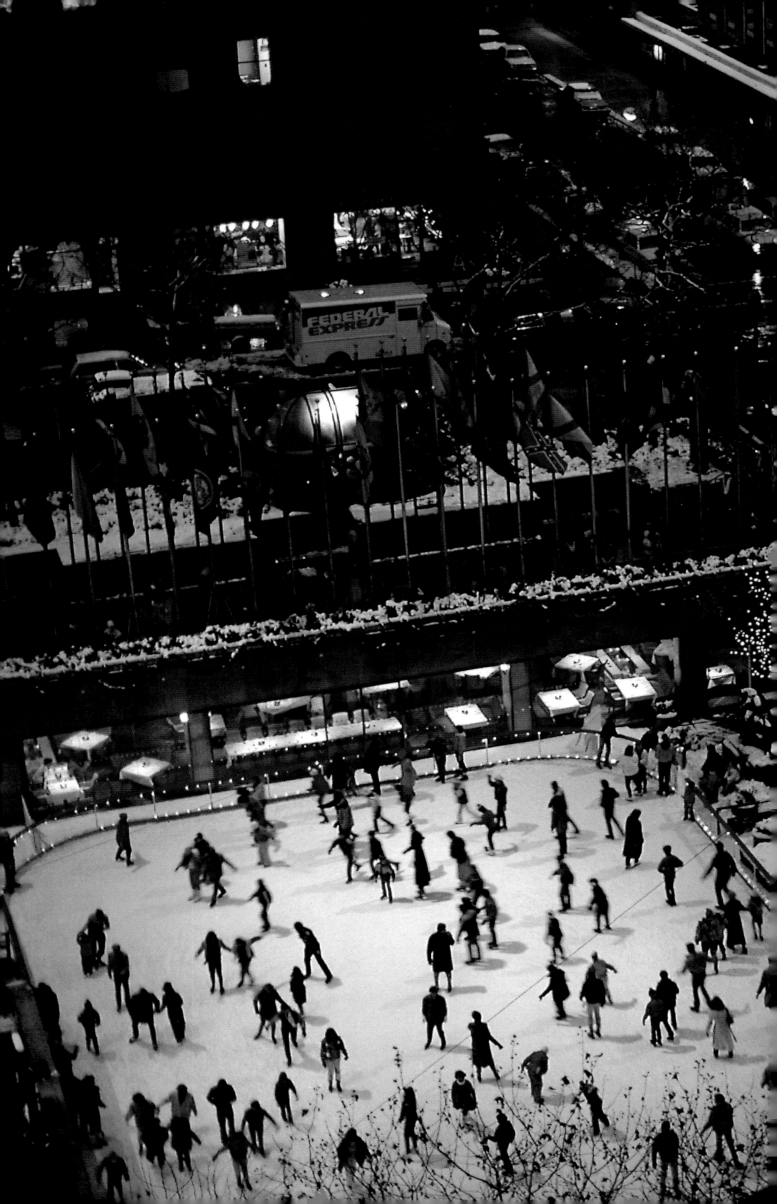

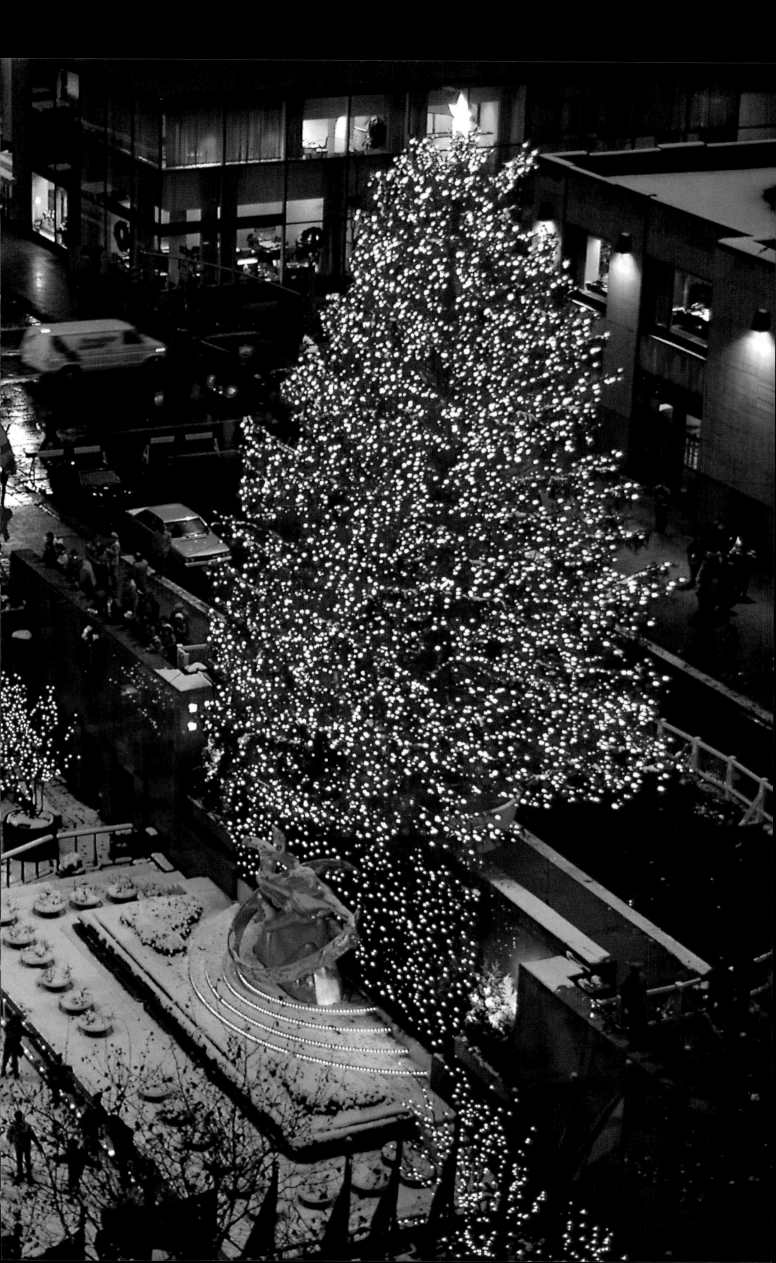

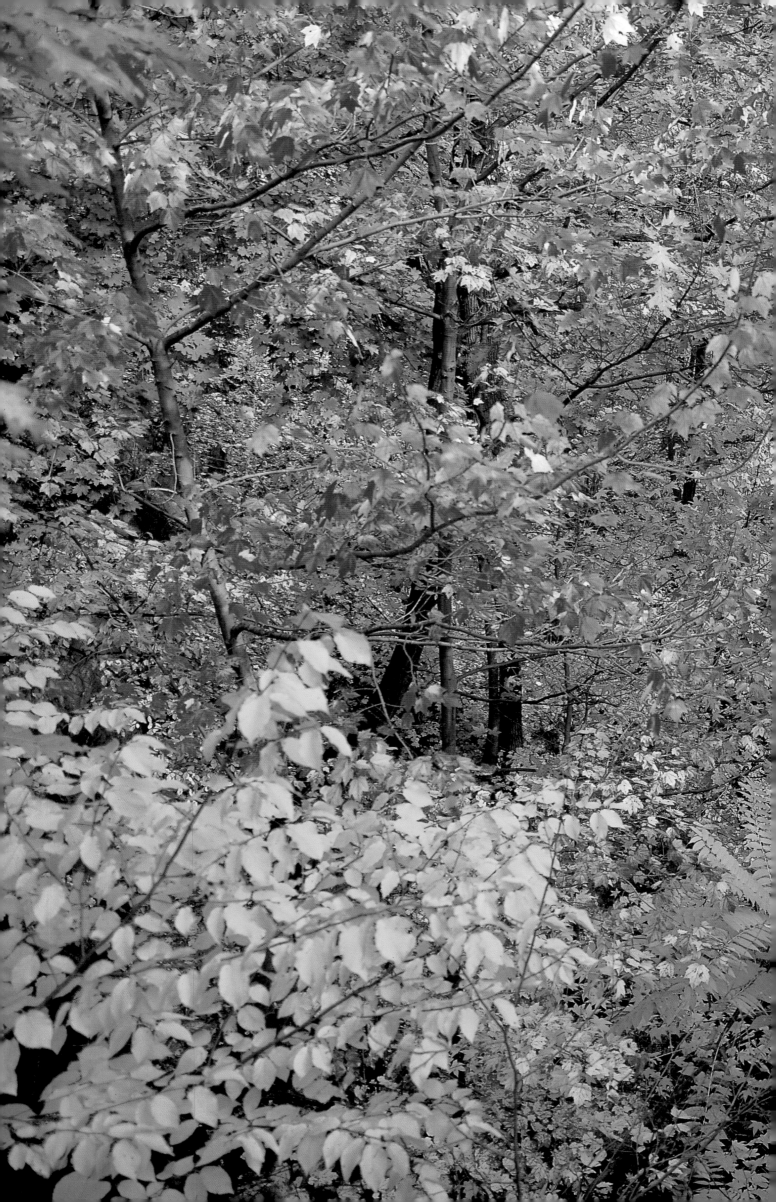

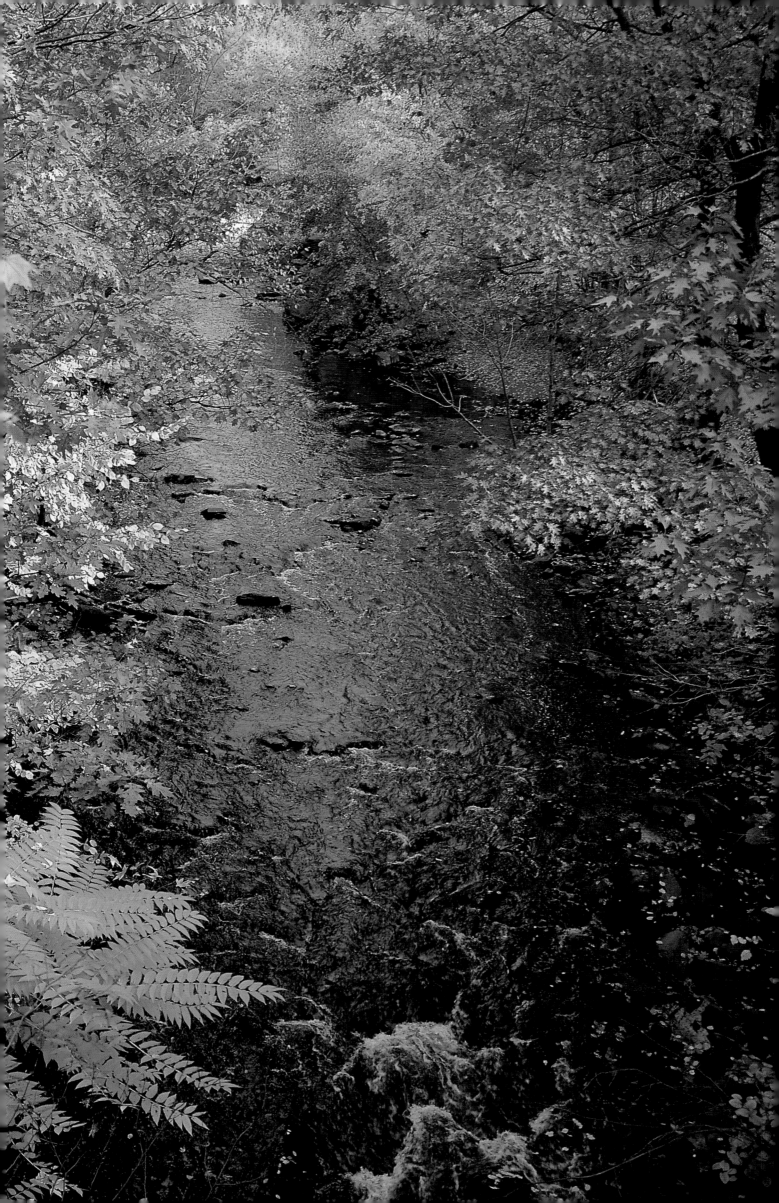

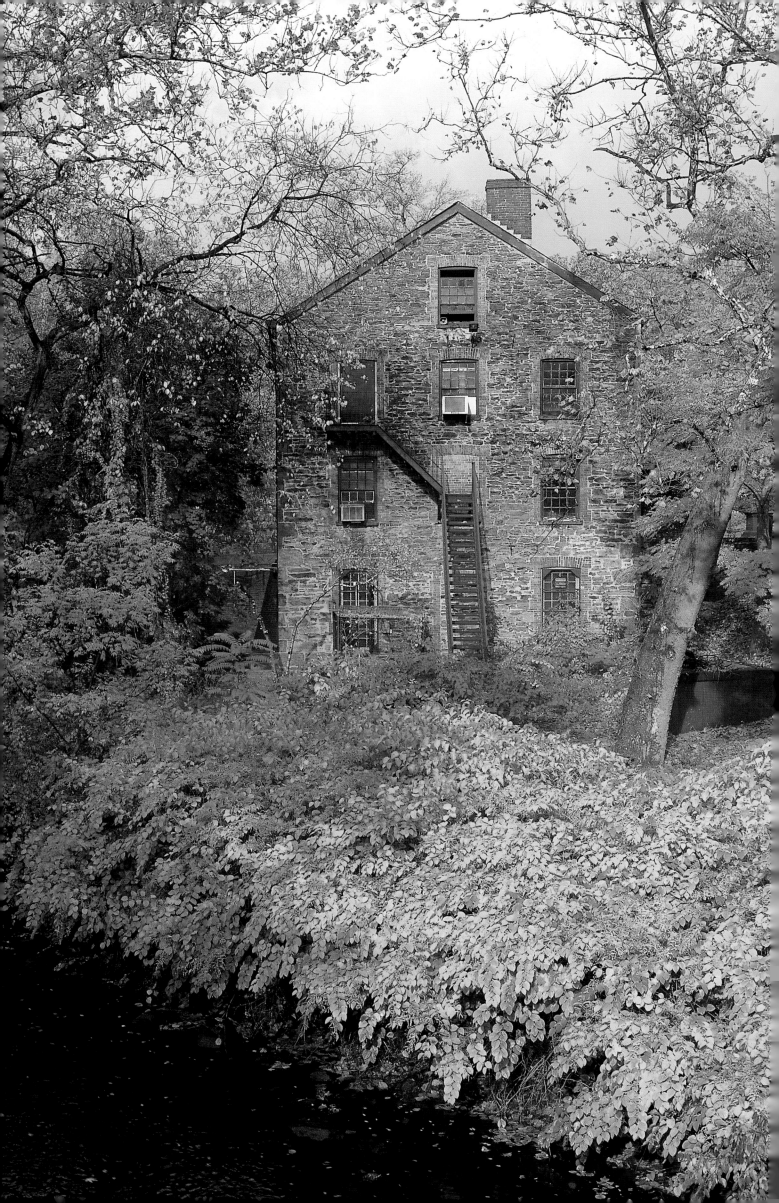

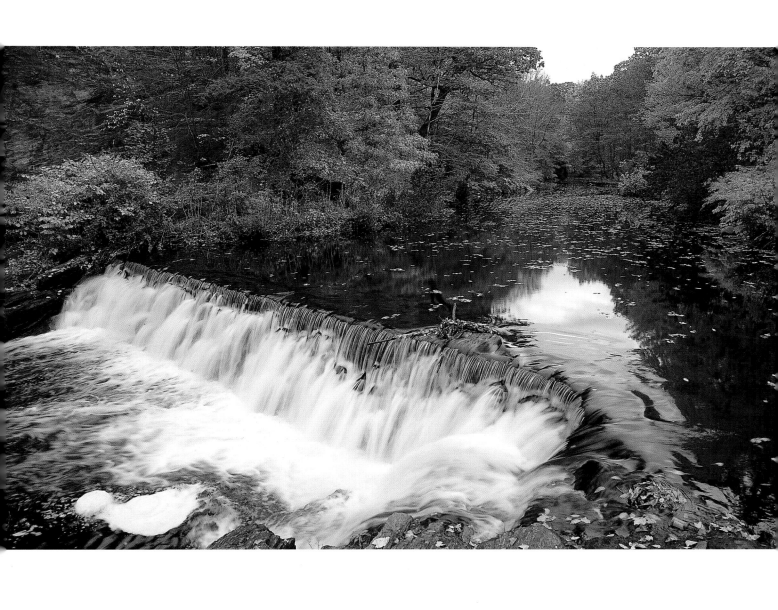

Above Bronx River, New York Botanical Garden, the Bronx
Opposite Snuff Mill, New York Botanical Garden, the Bronx

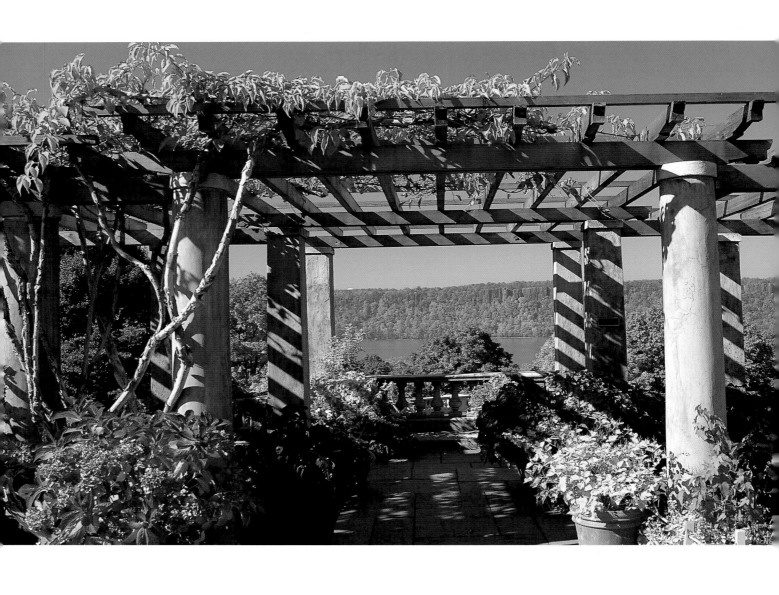

Above Hudson River Overlook, Wave Hill, the Bronx
Opposite Van Cortlandt Park, the Bronx

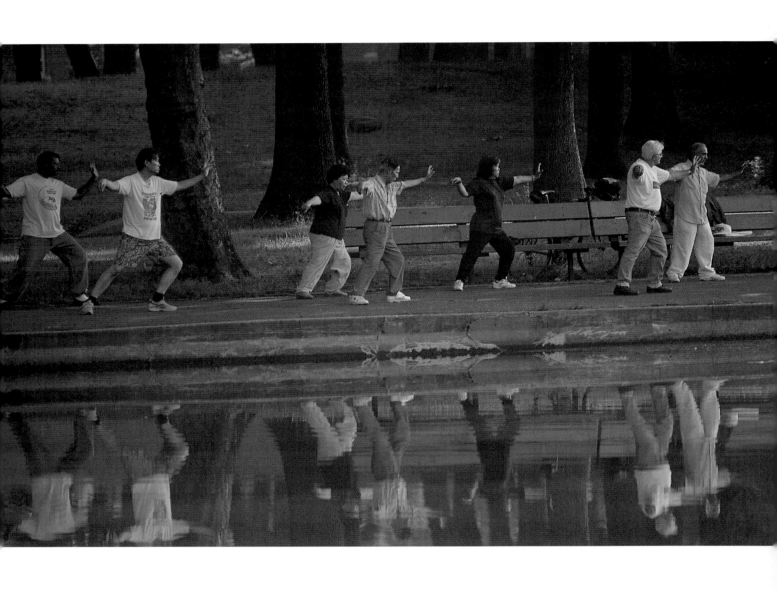

Above Tai chi practice, Kissena Park, Queens
Opposite Japanese Garden, Brooklyn Botanic Garden, Brooklyn

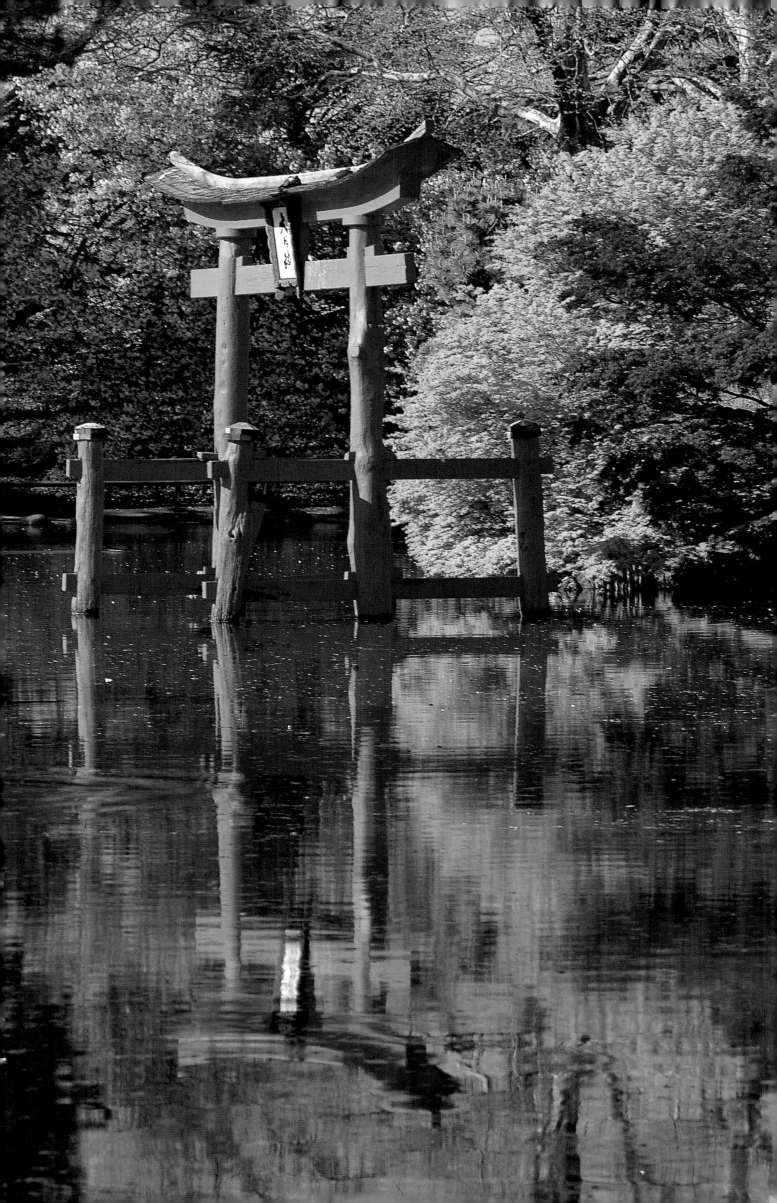

Above and opposite Brooklyn Botanic Garden, Brooklyn
Overleaf Central Park, Manhattan

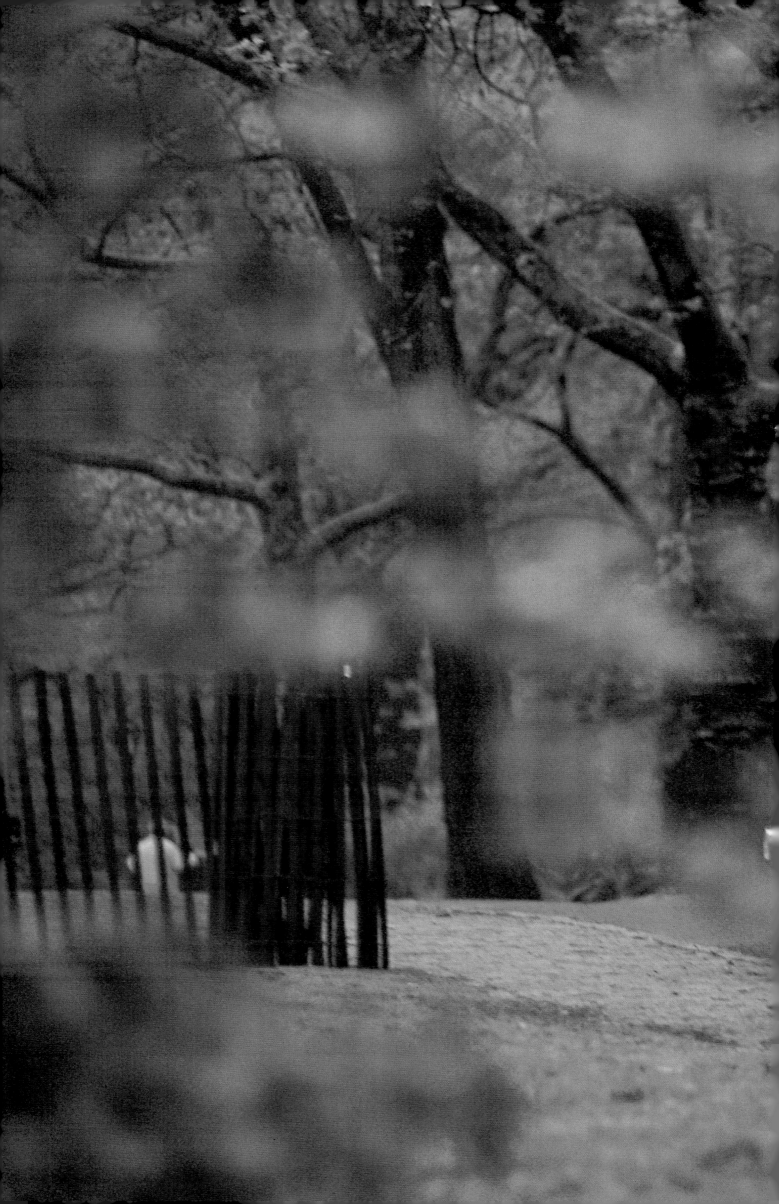

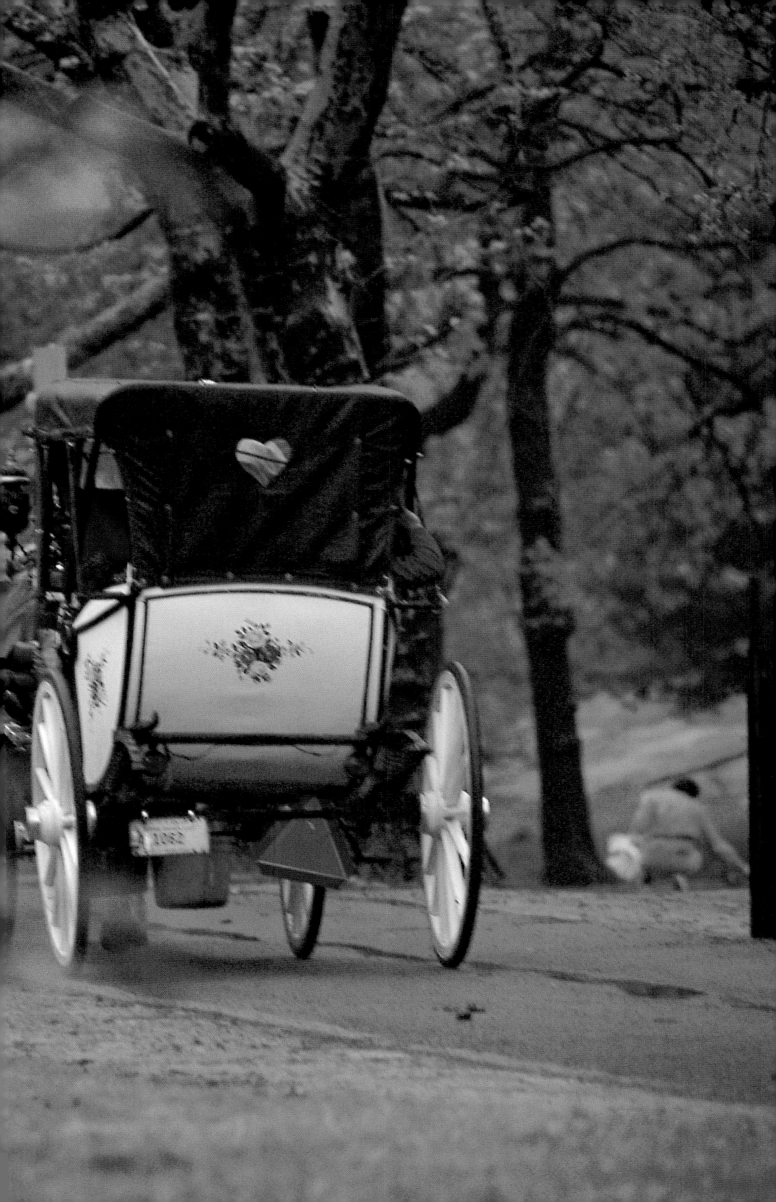

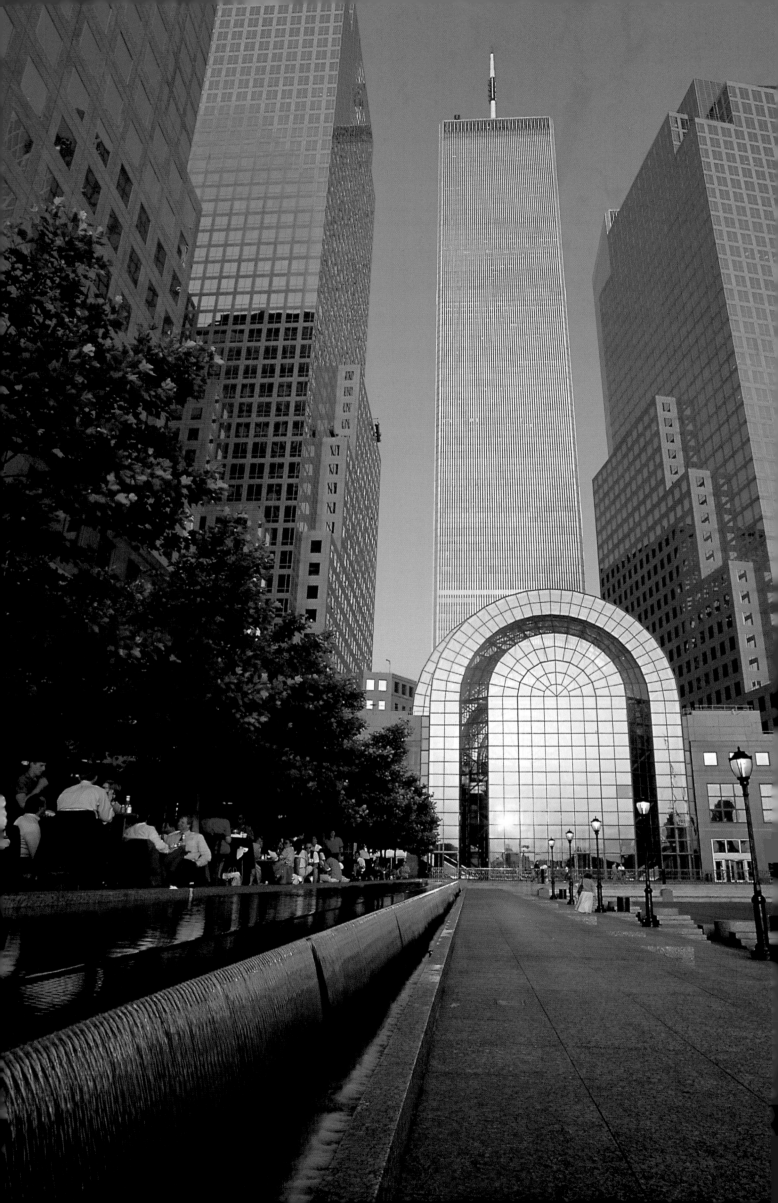

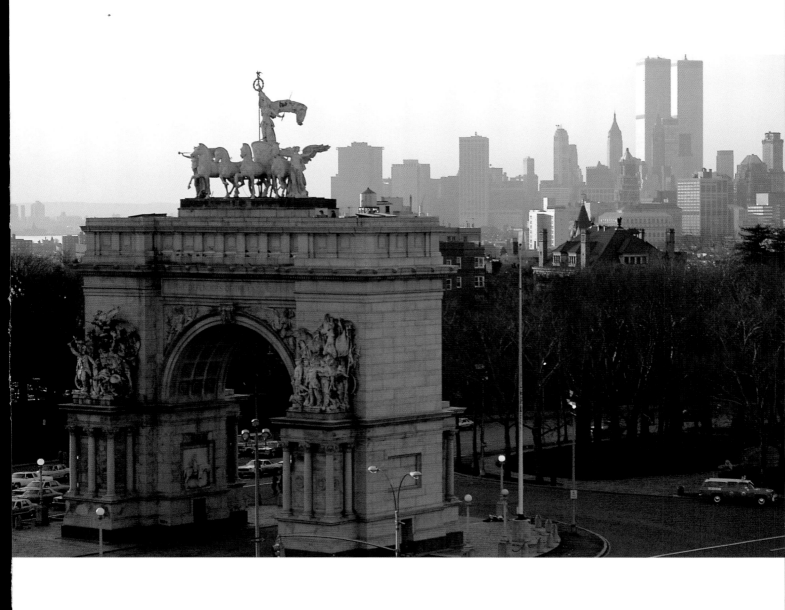

Above Soldiers' and Sailors' Memorial Arch and Grand Army Plaza, at the corner of Prospect Park, Brooklyn
Opposite Winter Garden, Battery Park City, Manhattan

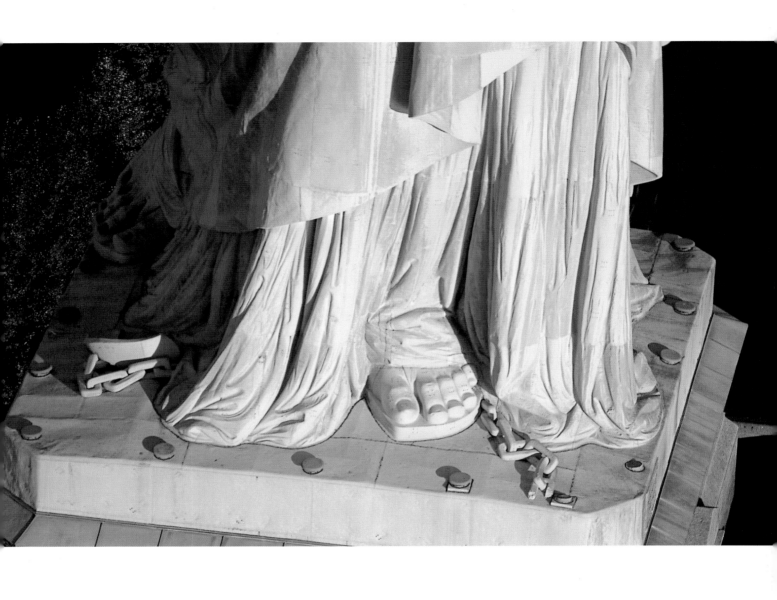

Above and opposite Statue of Liberty, Liberty Island

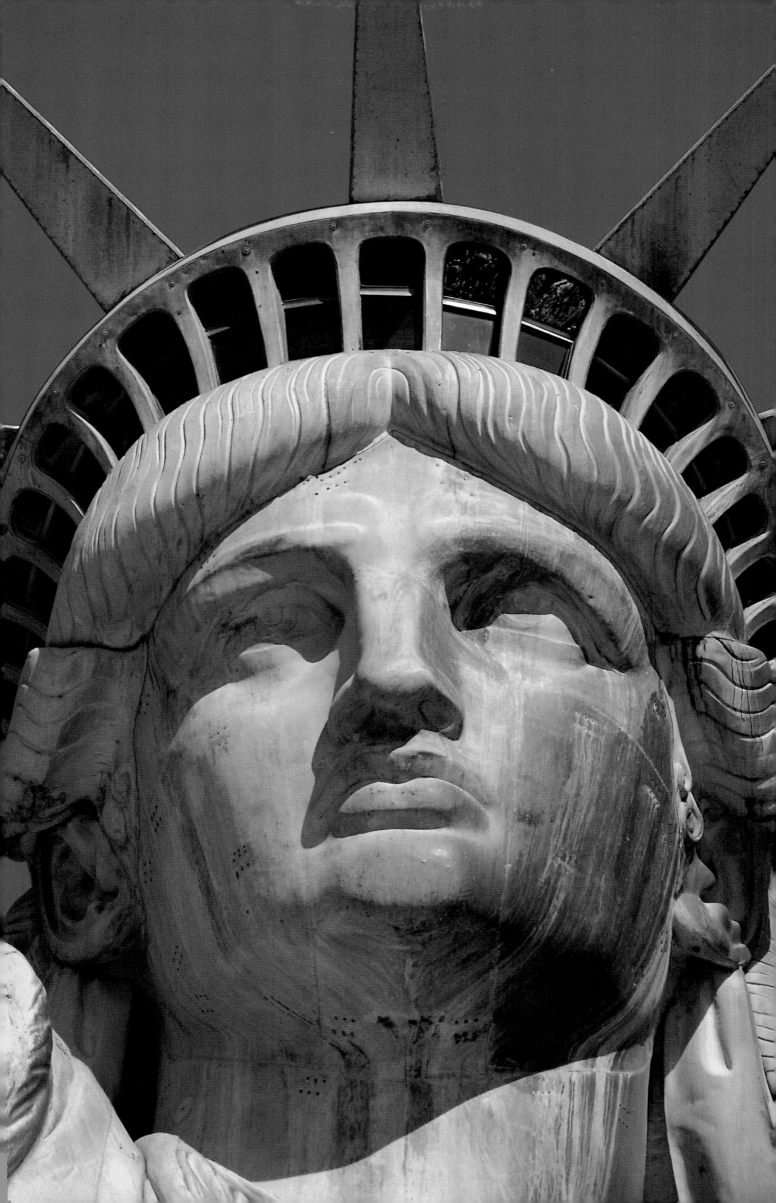

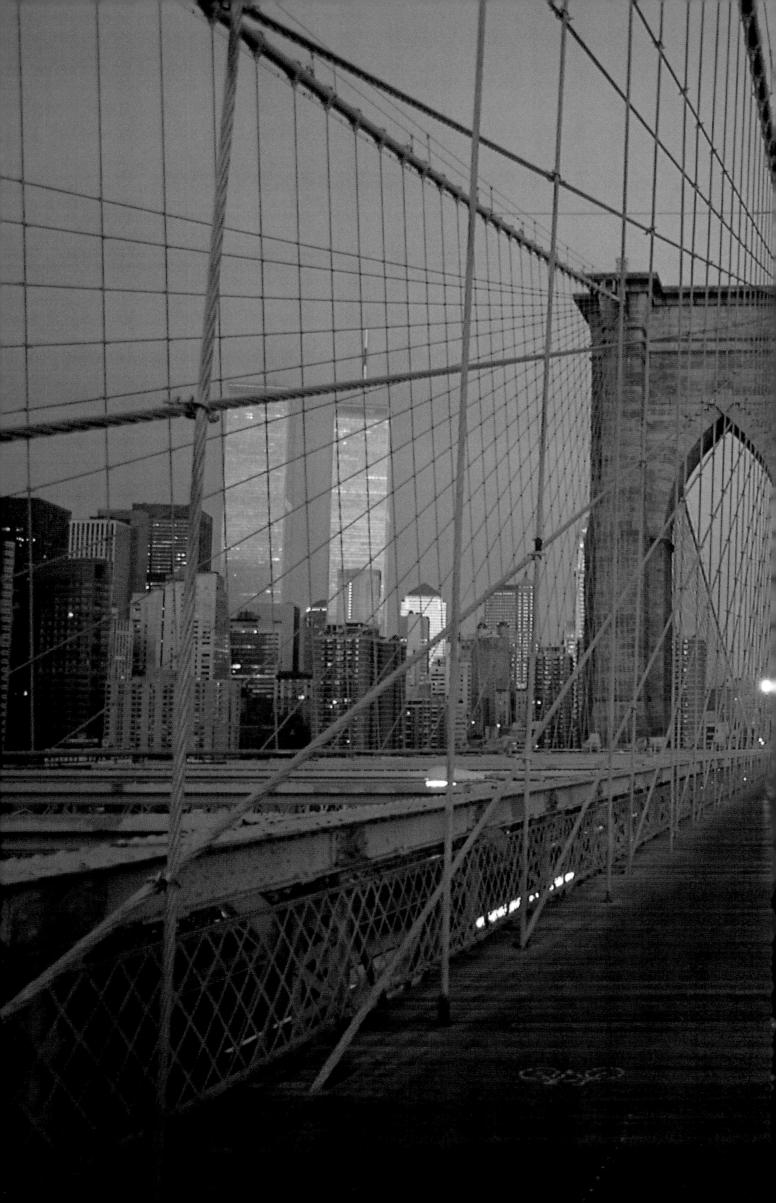

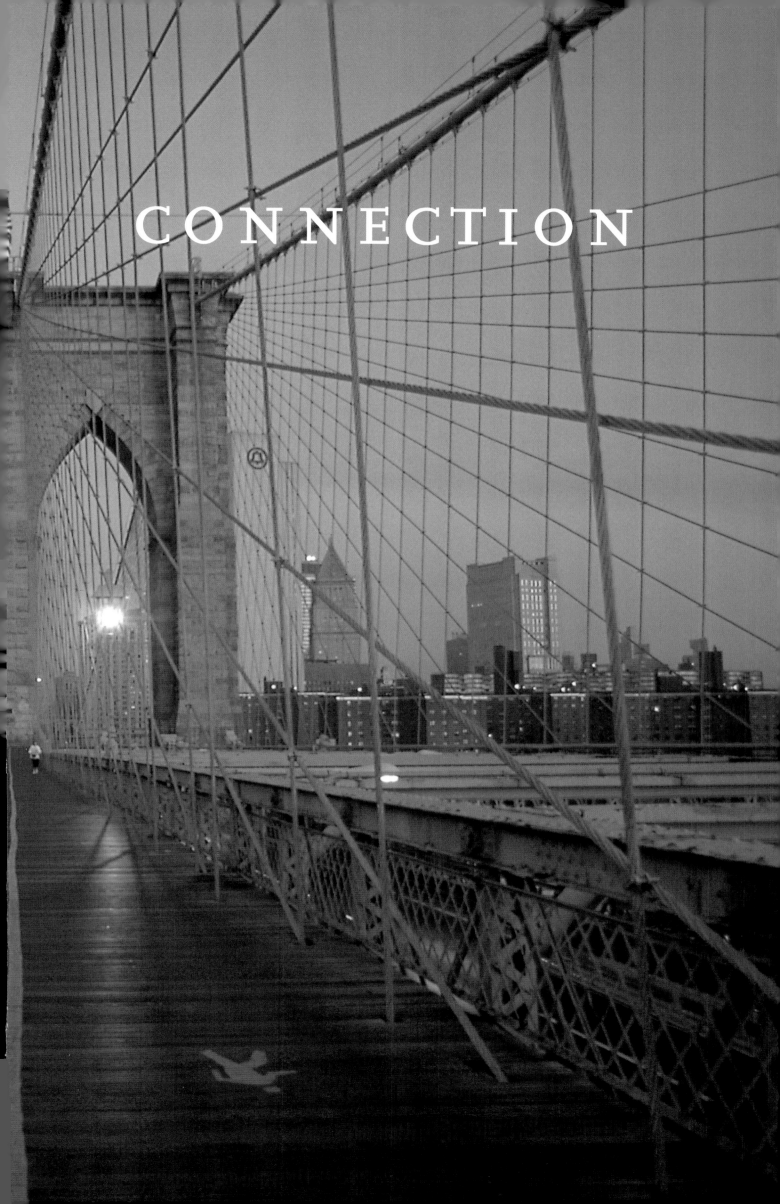

CONNECTION

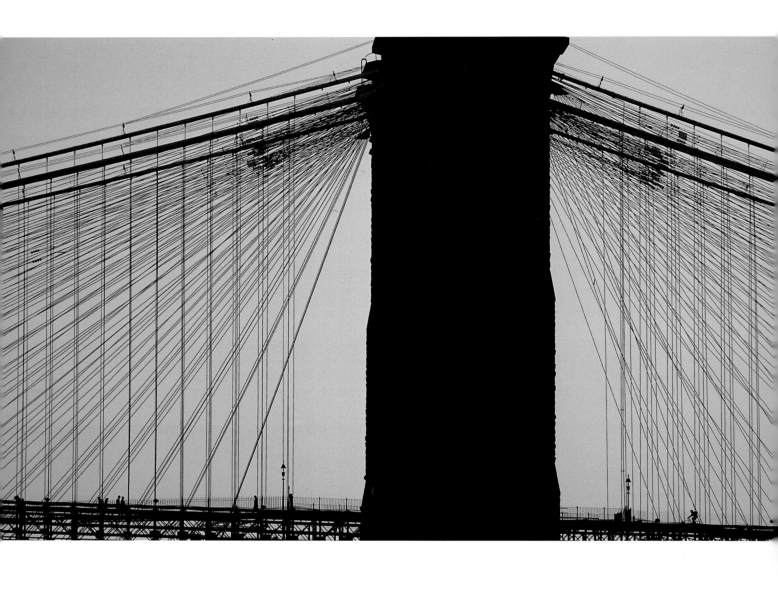

Above, opposite, and preceding pages Brooklyn Bridge (over the East River), Brooklyn/Manhattan

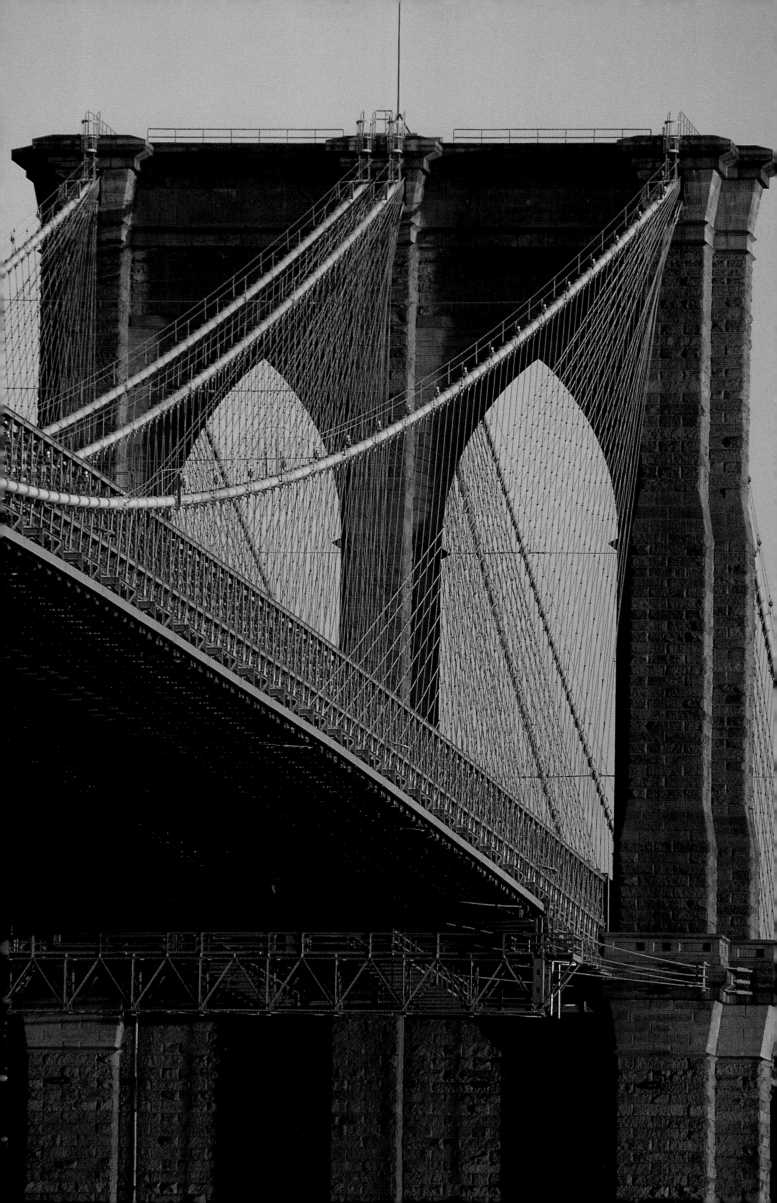

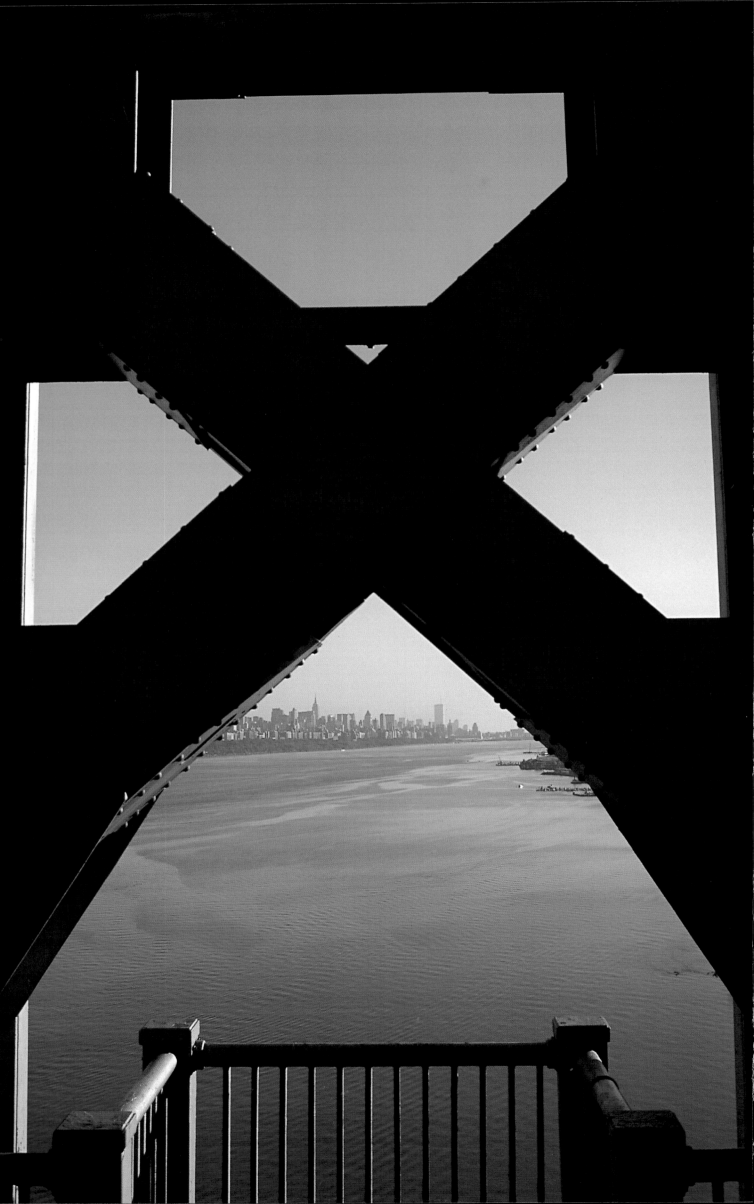

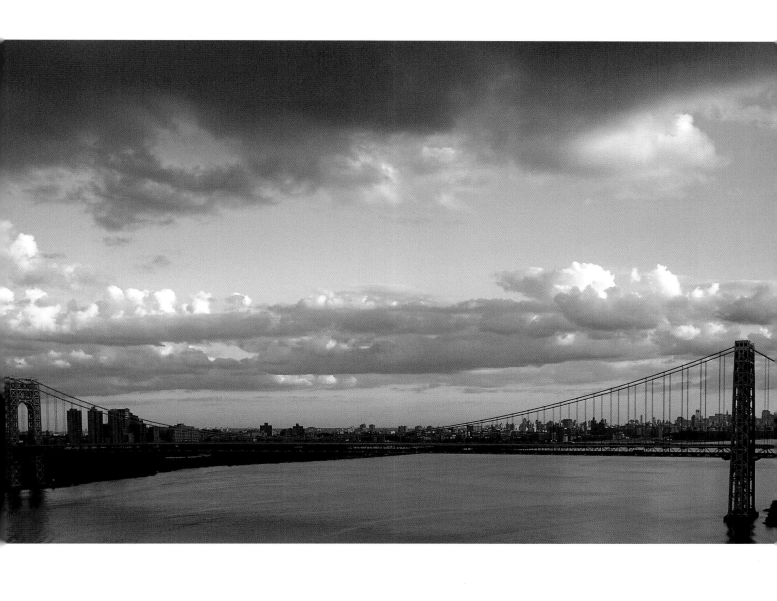

Above and opposite George Washington Bridge (over the Hudson River), New Jersey/Manhattan
Overleaf Triborough Bridge (over East River and Wards Island Park), Manhattan/Queens
Second overleaf Verrazano-Narrows Bridge (over the Narrows), Brooklyn/Staten Island

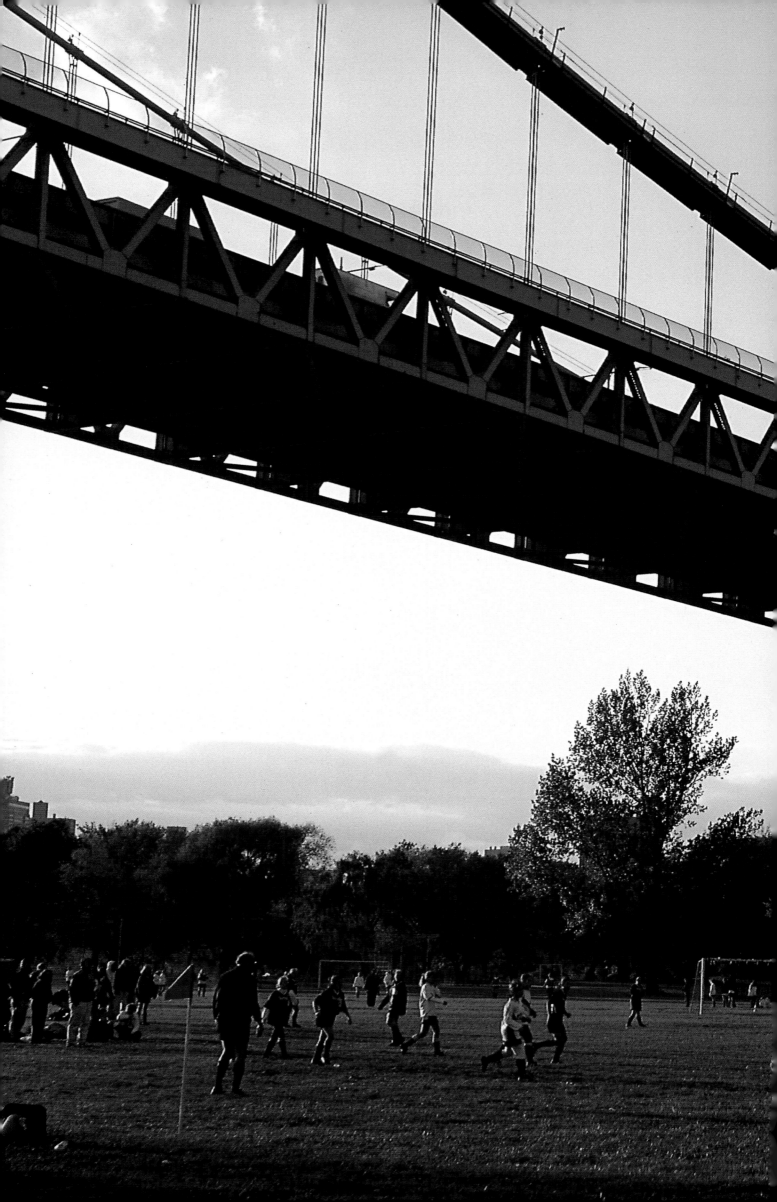

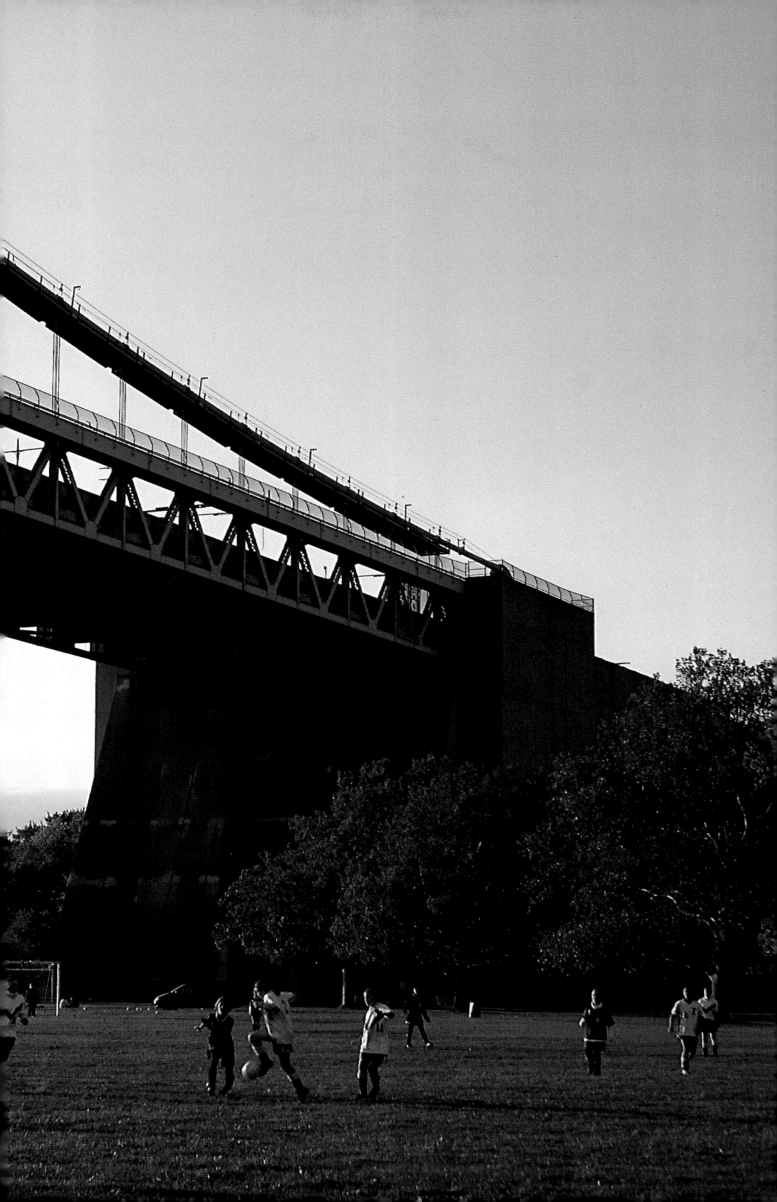

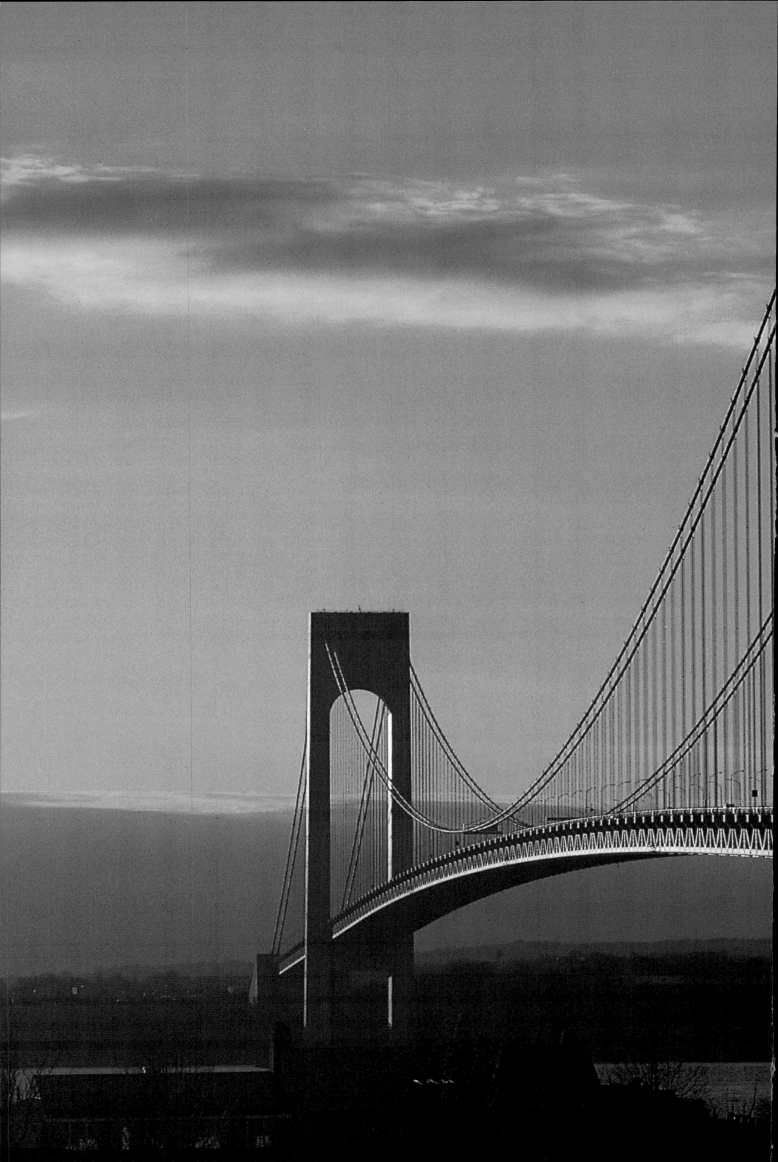

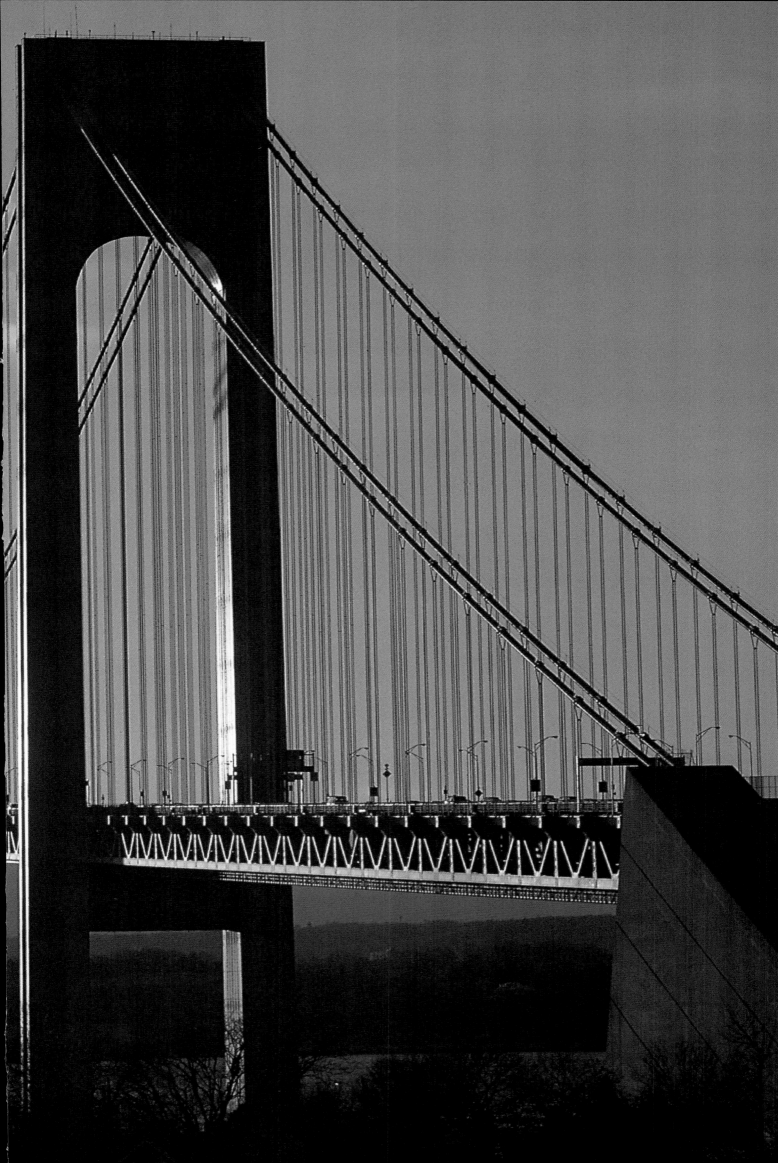

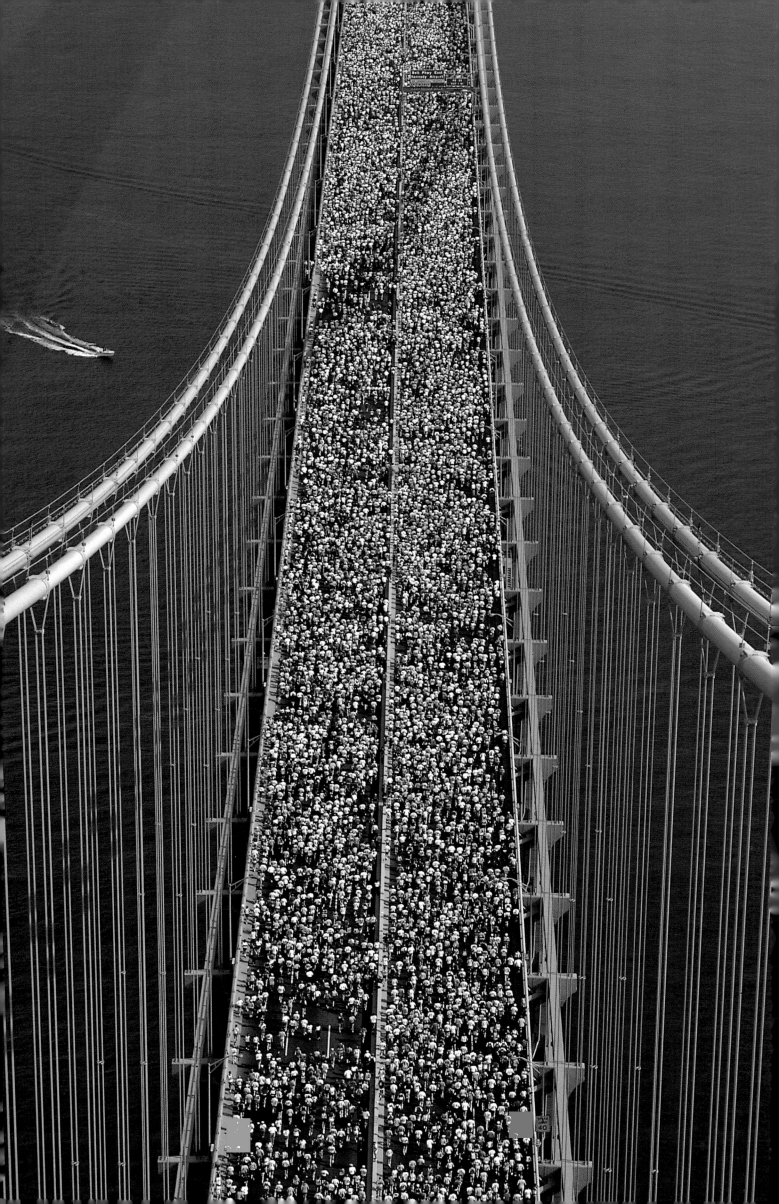

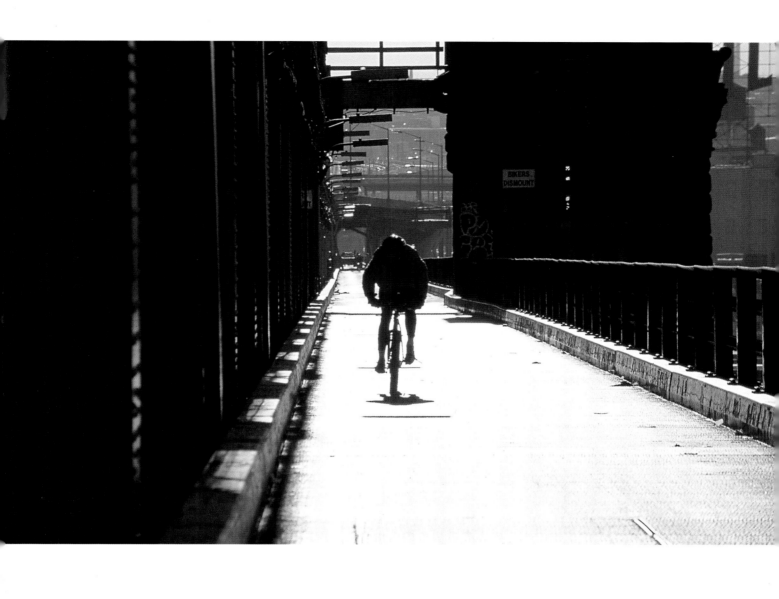

Above and overleaf Queensboro Bridge (over the East River), Manhattan/Queens
Opposite New York City Marathon, Verrazano-Narrows Bridge, Brooklyn/Staten Island

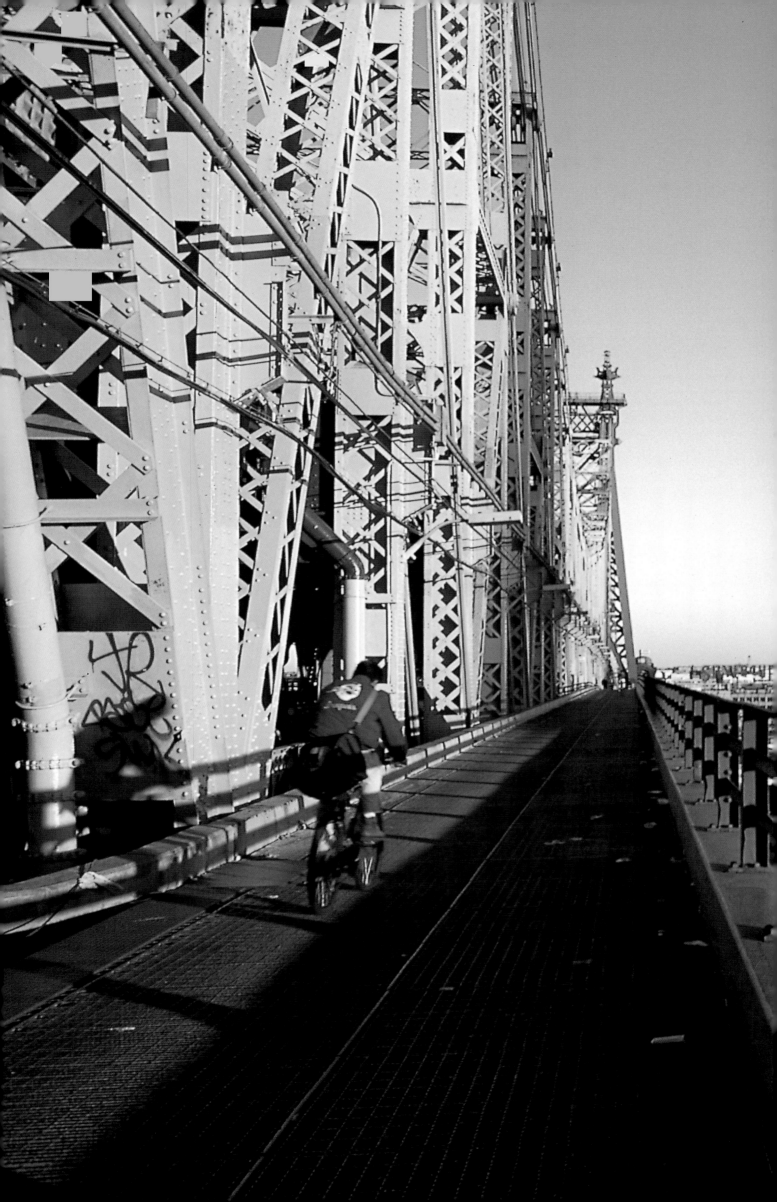

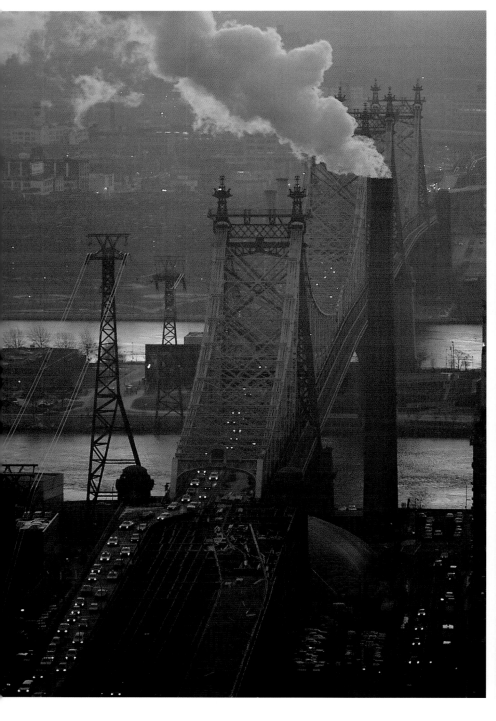

Above and opposite Queensboro Bridge, Manhattan/Queens
Overleaf Outerbridge Crossing (over Arthur Kill), Staten Island/New Jersey

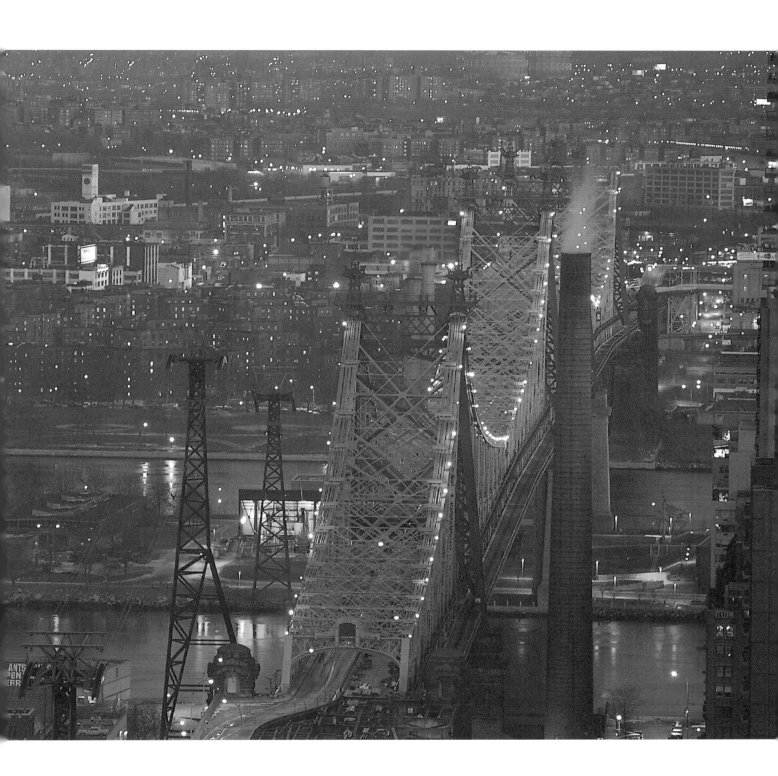

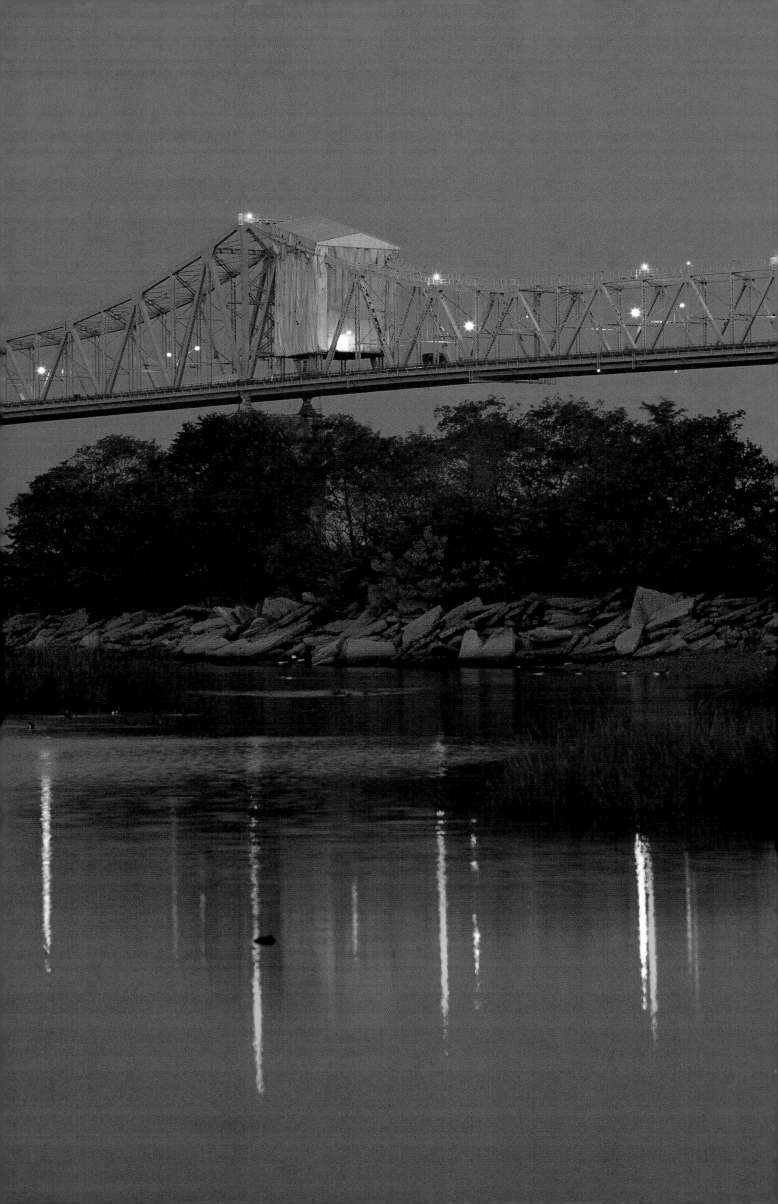

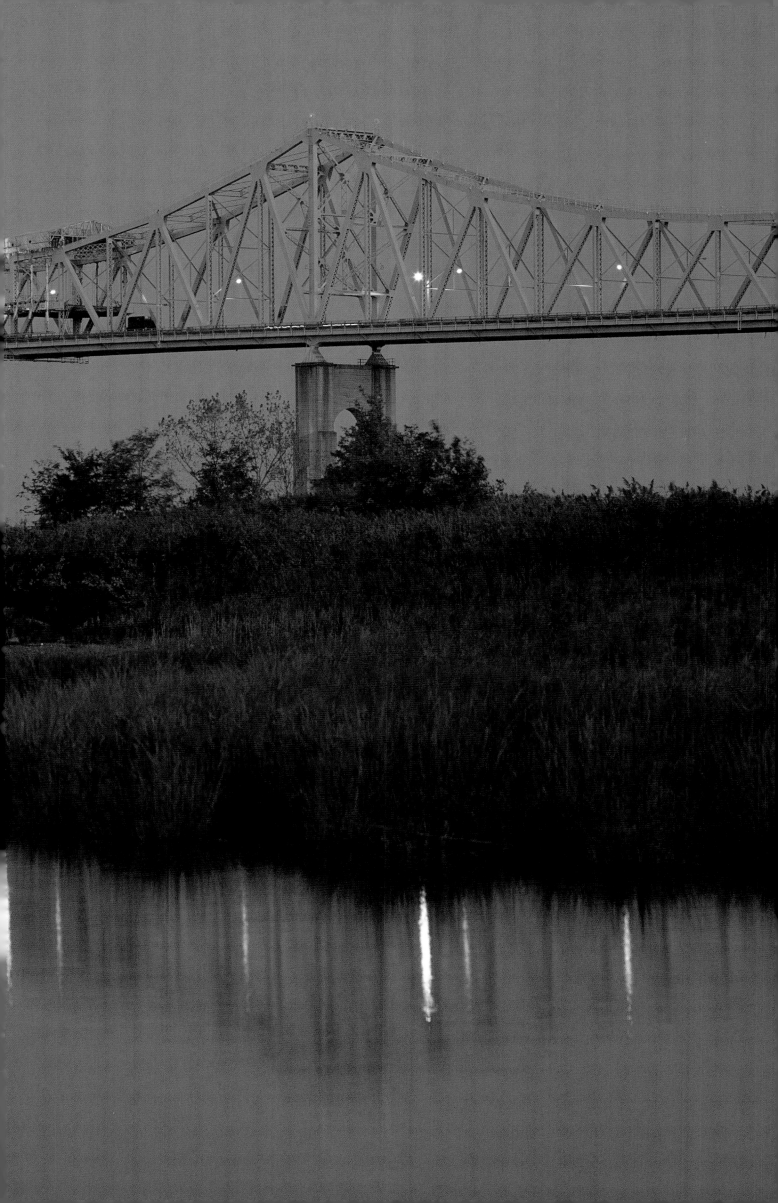

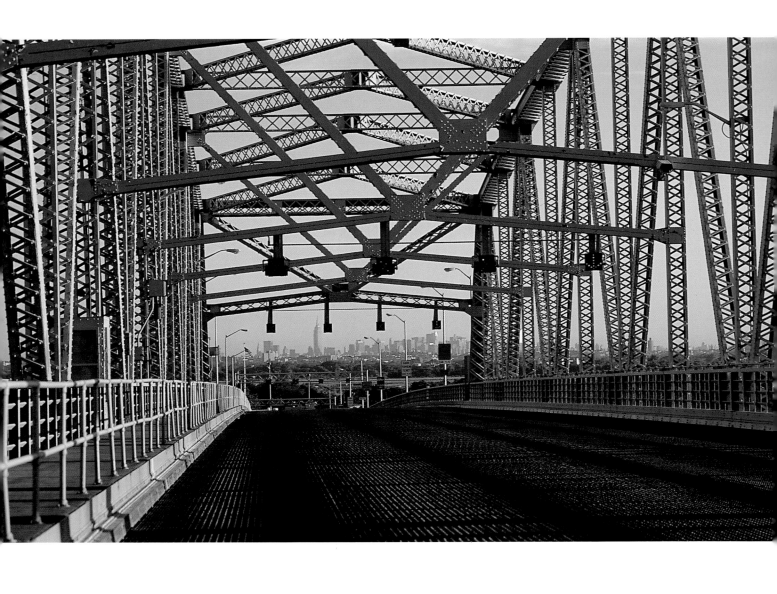

Above and opposite Marine Parkway–Gil Hodges Memorial Bridge (over Rockaway Inlet), Brooklyn/Queens

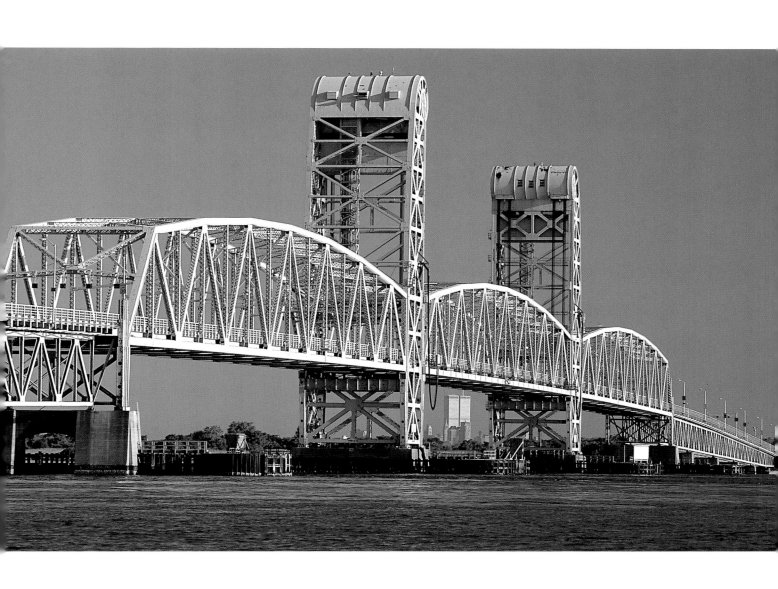

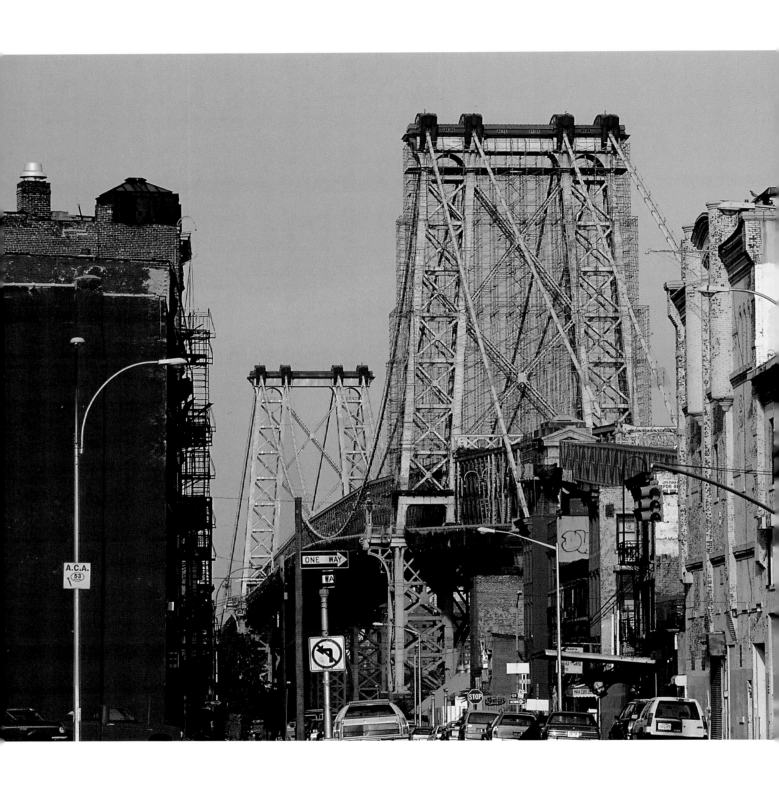

Above South Tenth Street and Williamsburg Bridge (over the East River), Williamsburg, Brooklyn
Opposite Fulton Landing, Manhattan Bridge (over the East River), Brooklyn

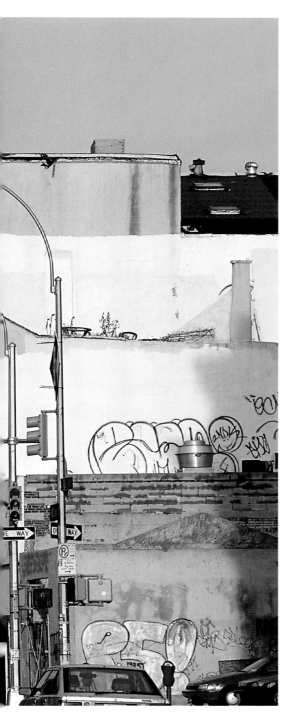
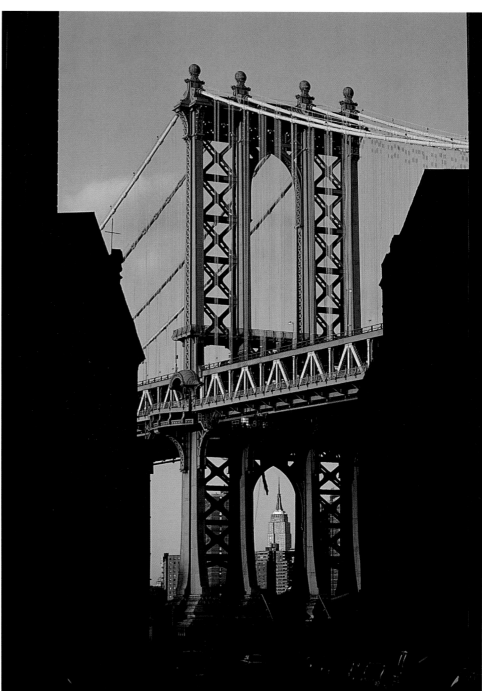

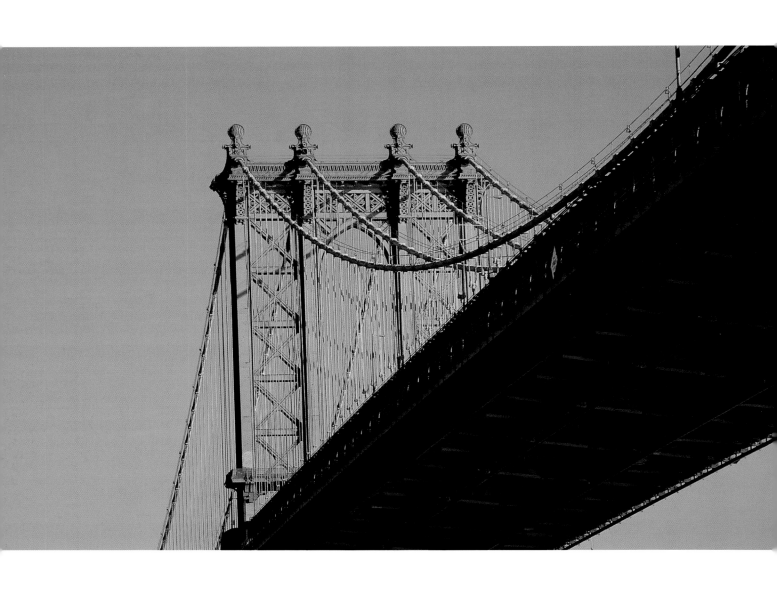

Above Manhattan Bridge, Brooklyn/Manhattan
Opposite Triborough Bridge, Manhattan/Queens
Overleaf Number 7 train, Woodside, Queens

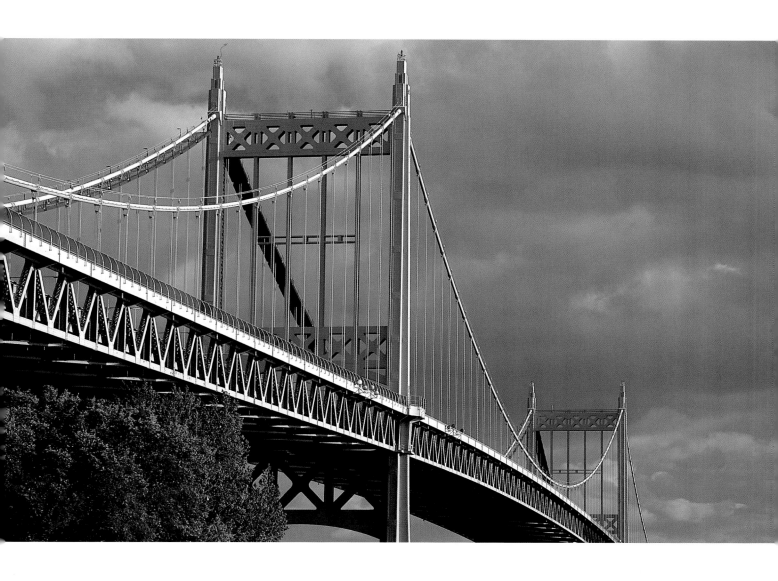

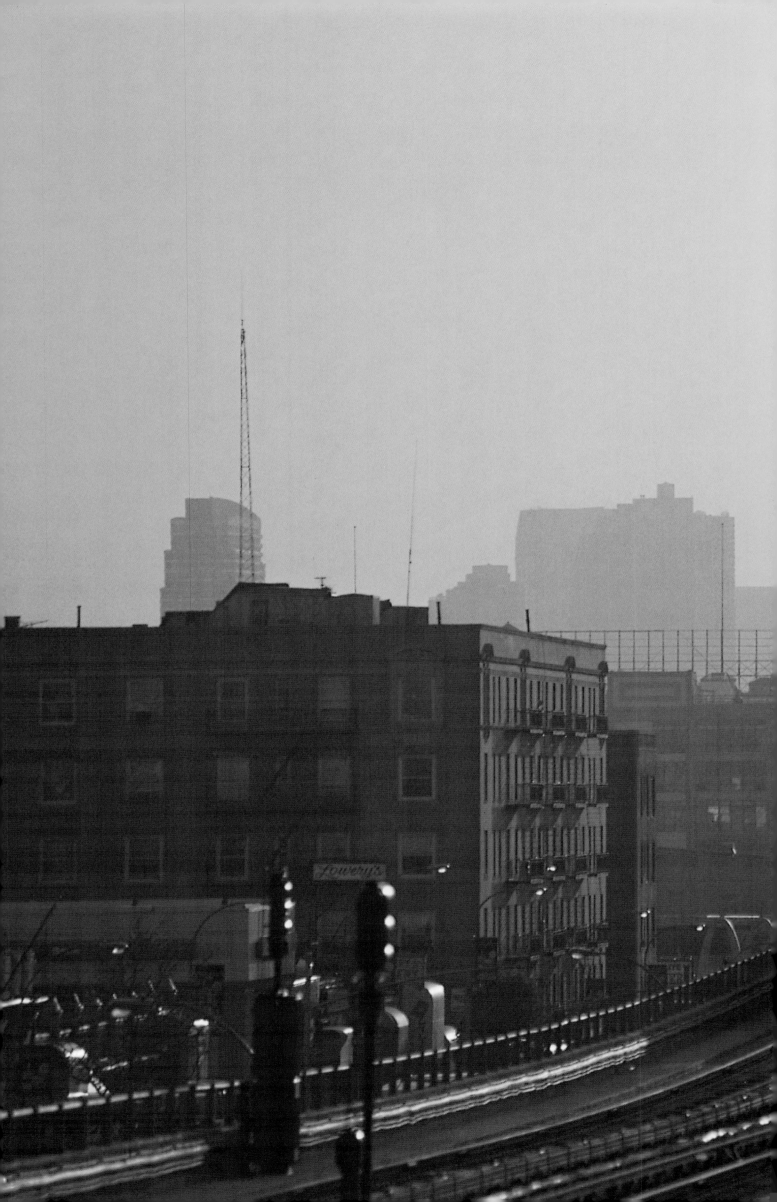

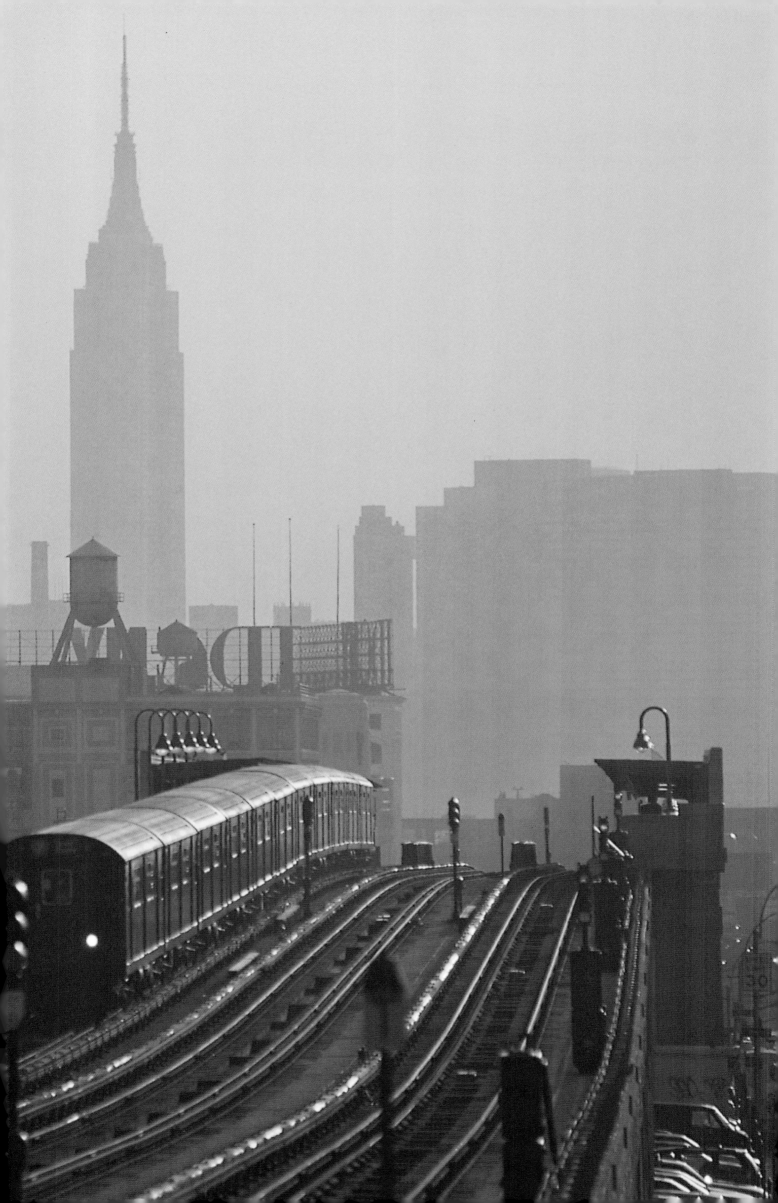

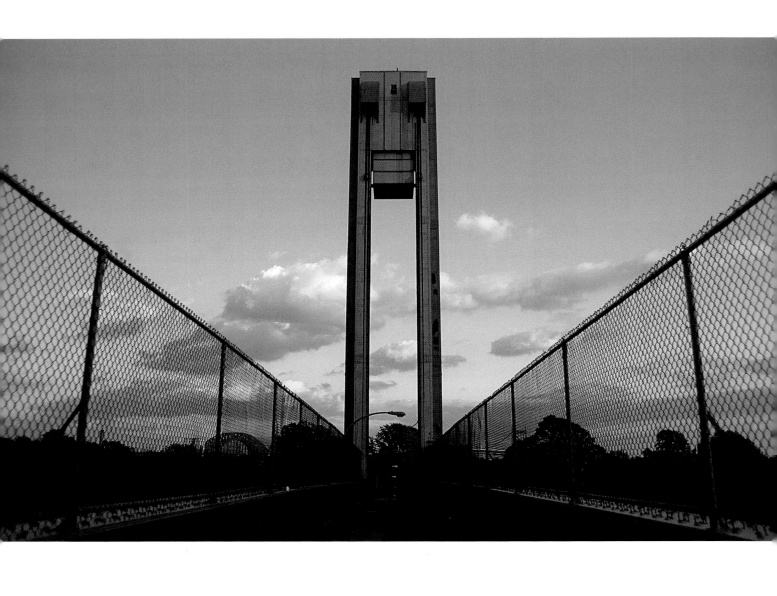

Above Wards Island pedestrian bridge (over the East River), Manhattan
Opposite Goethal's Bridge, in foreground, and B & O Railroad Bridge (over Arthur Kill), Staten Island/New Jersey
Overleaf Bayonne Bridge (over Kill Van Kull), Staten Island/New Jersey

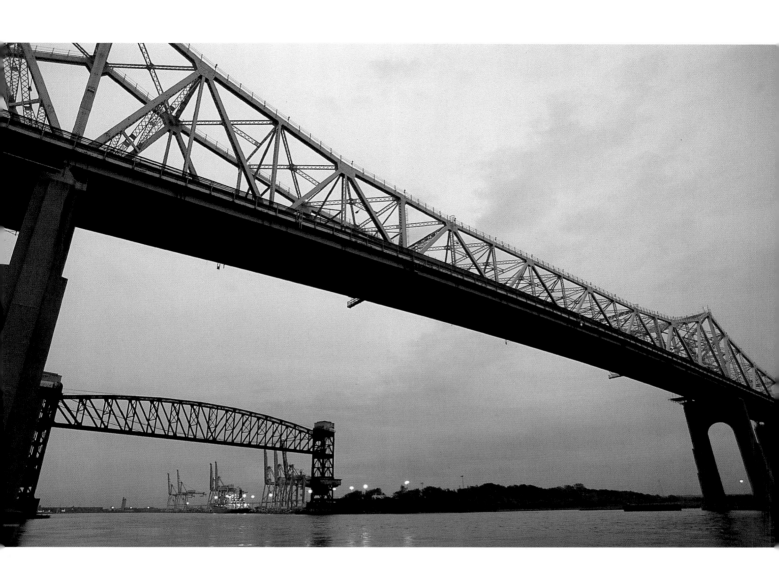

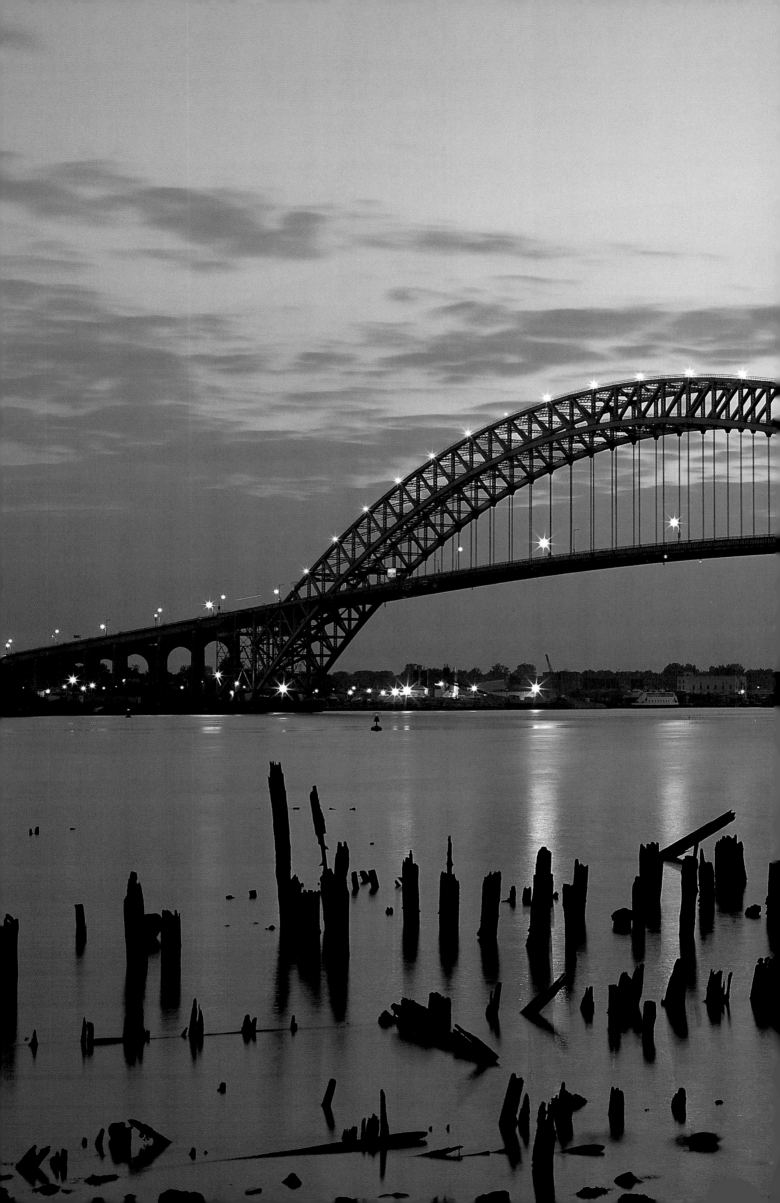

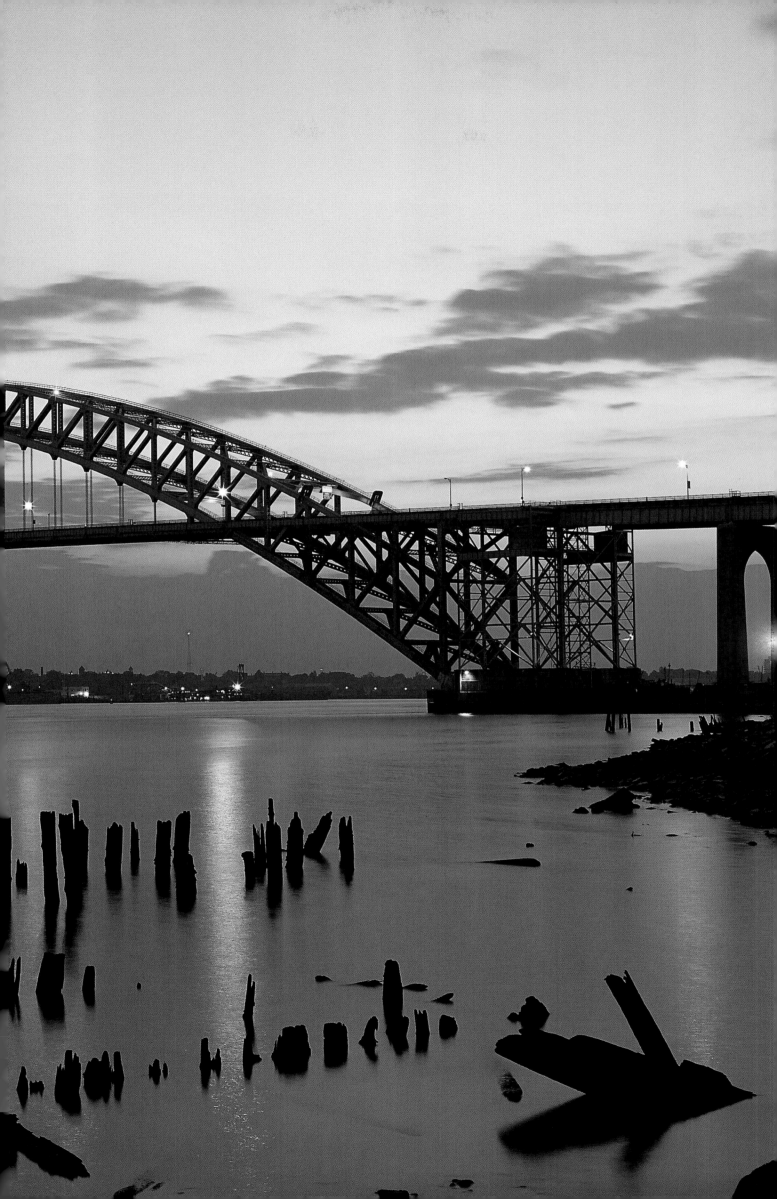

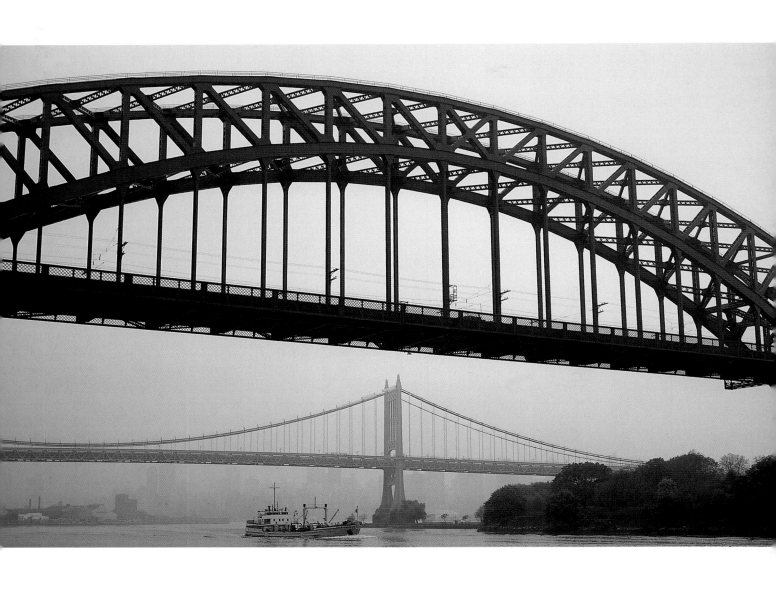

Above Hell Gate Bridge (over the East River), with Triborough Bridge in background, Wards Island/Queens
Opposite Bayonne Bridge, Staten Island/New Jersey
Overleaf Brooklyn Bridge and Lower Manhattan

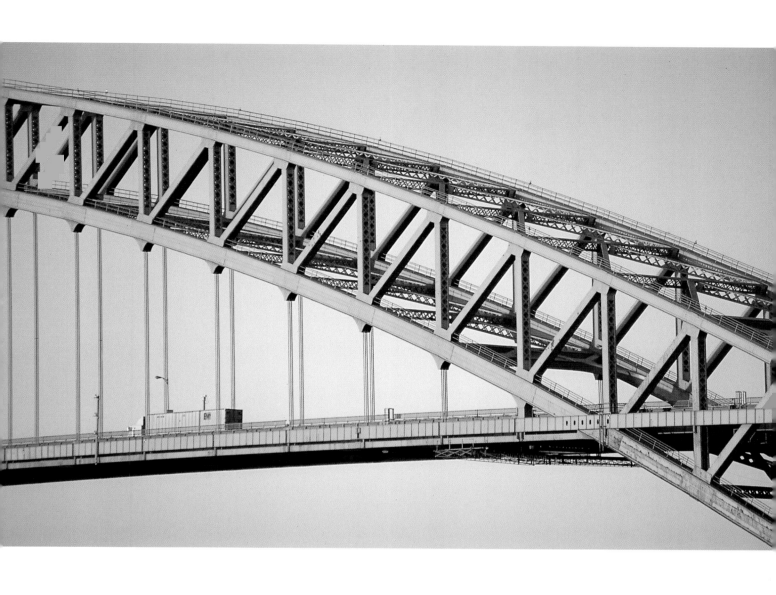

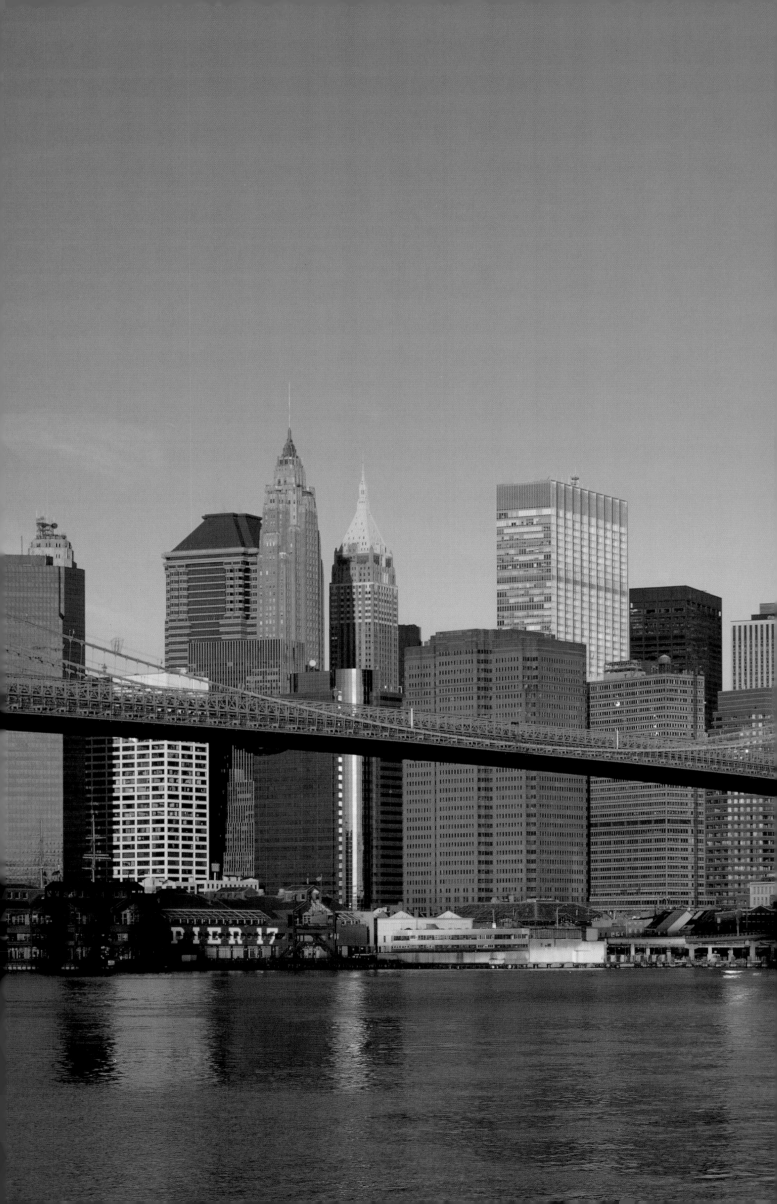

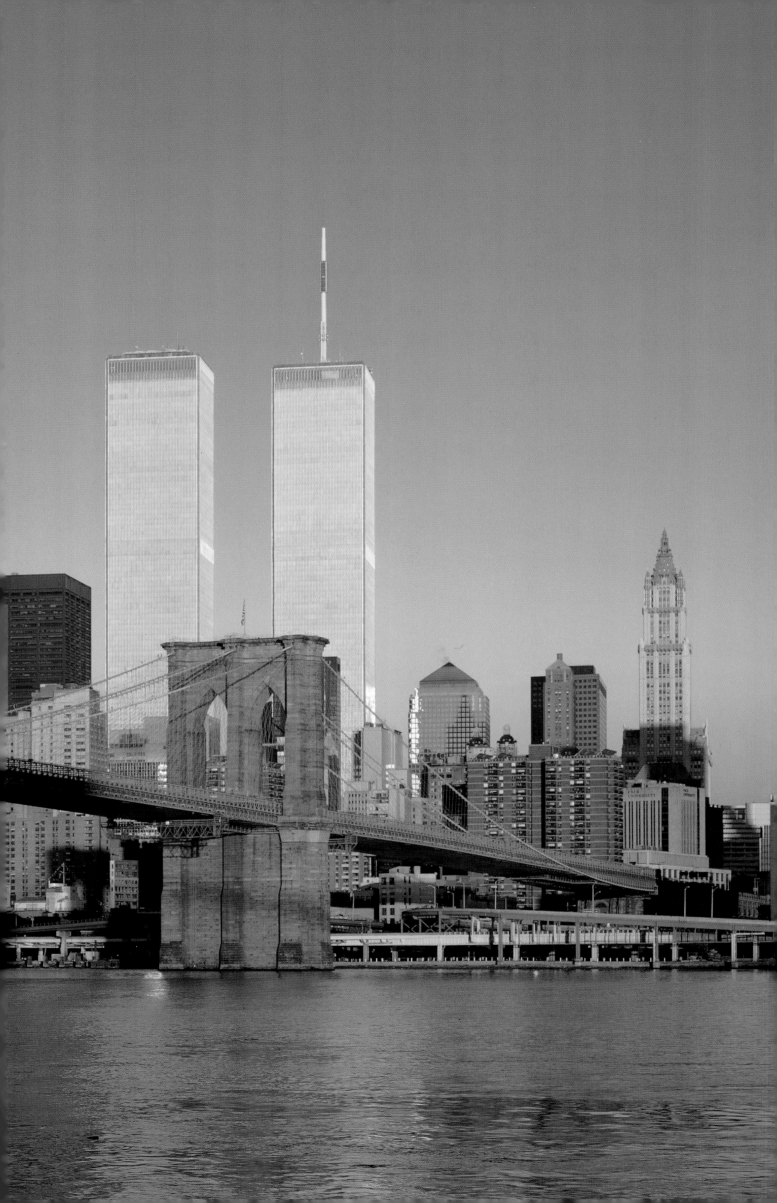

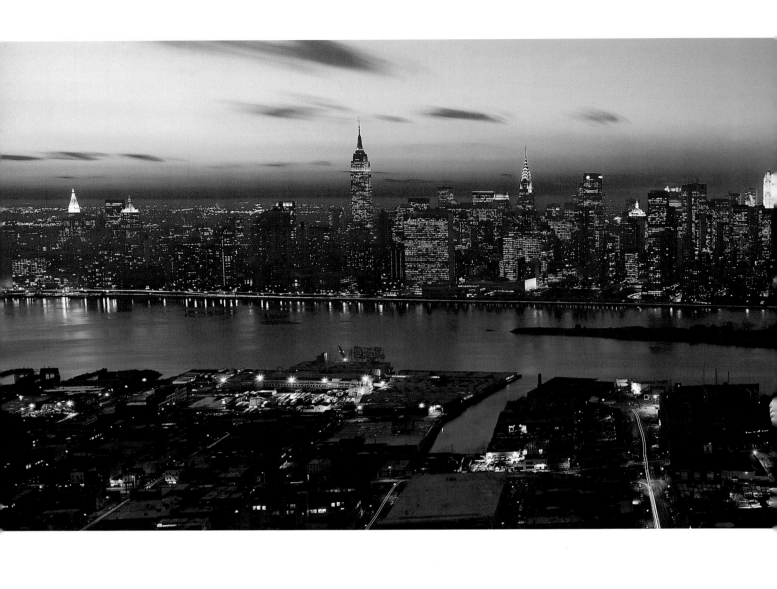

Queens, midtown Manhattan, East River, and Queensboro Bridge

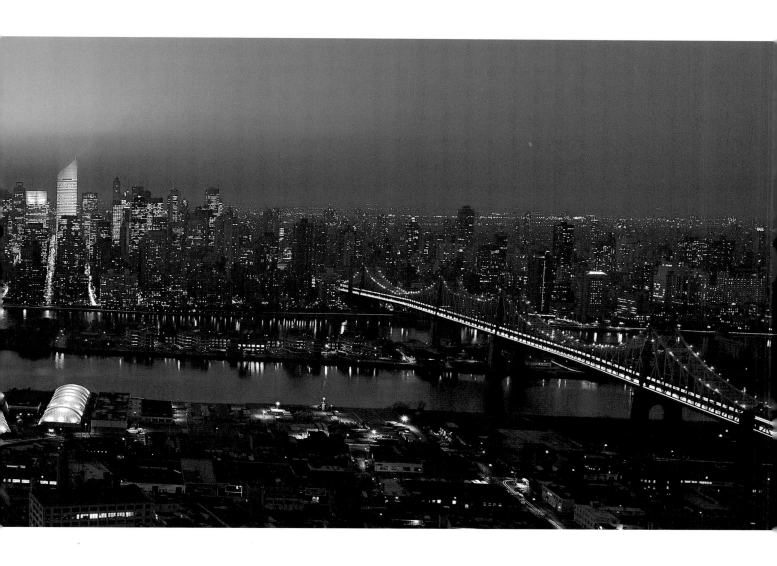

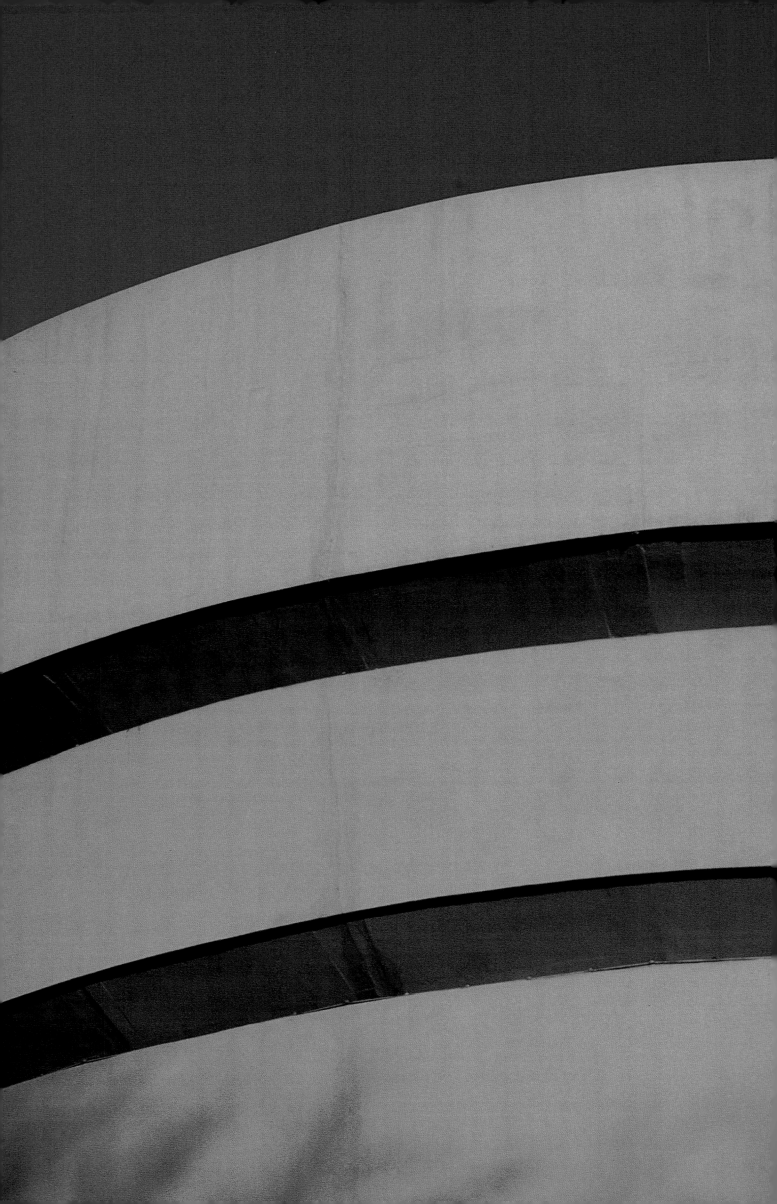

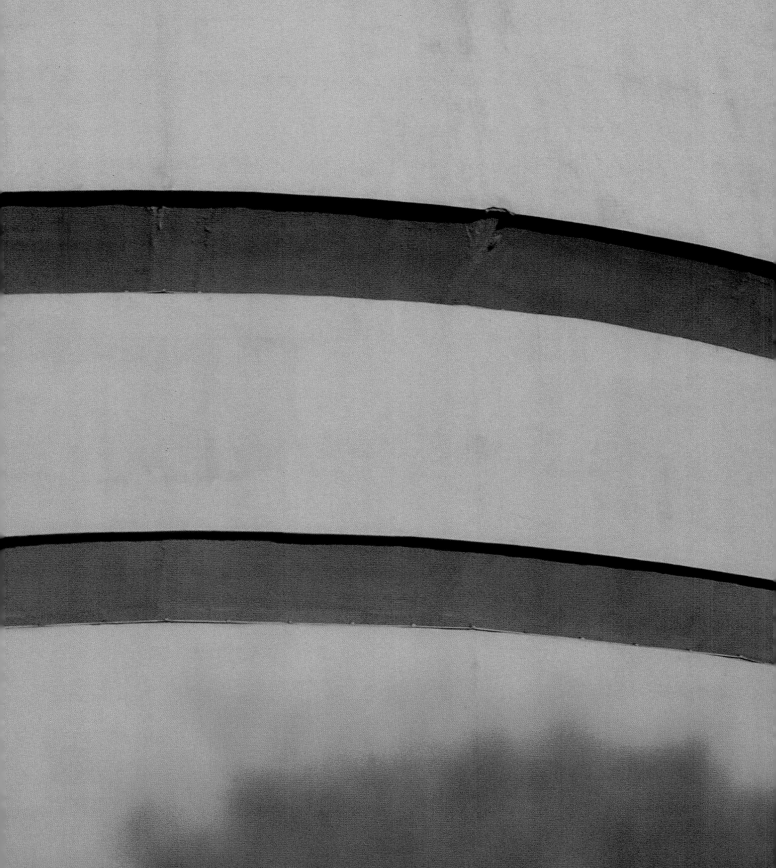

STRUCTURE

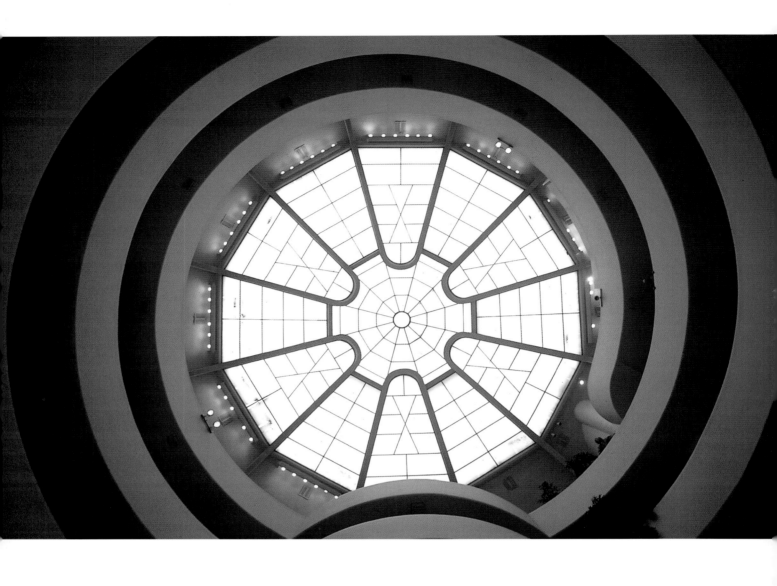

Above and preceding pages Solomon R. Guggenheim Museum, Manhattan
Opposite Winter Garden, Battery Park City, Manhattan

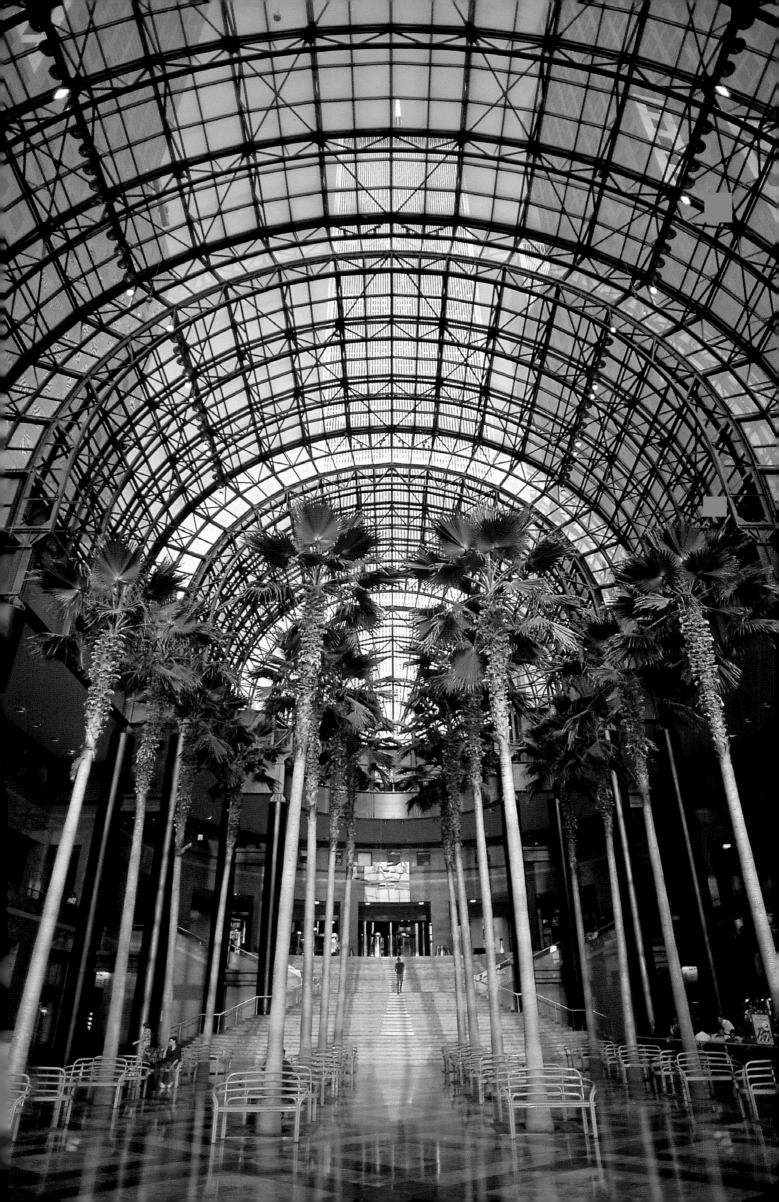

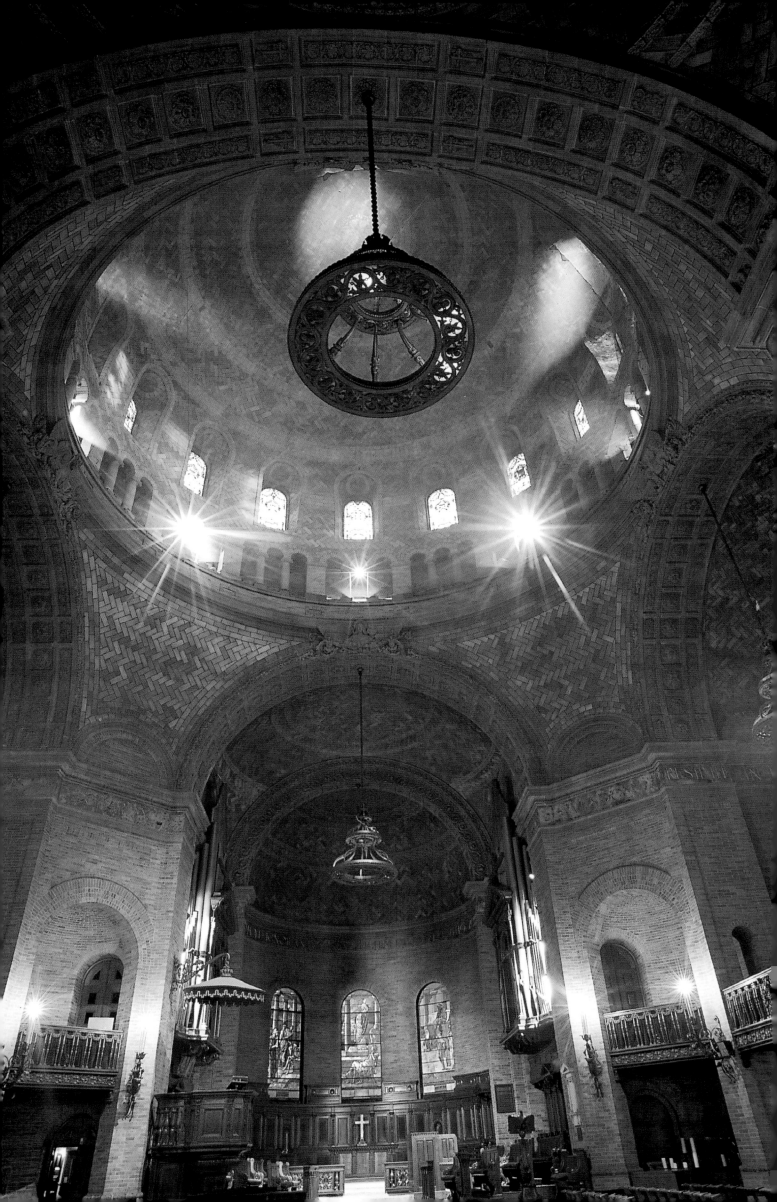

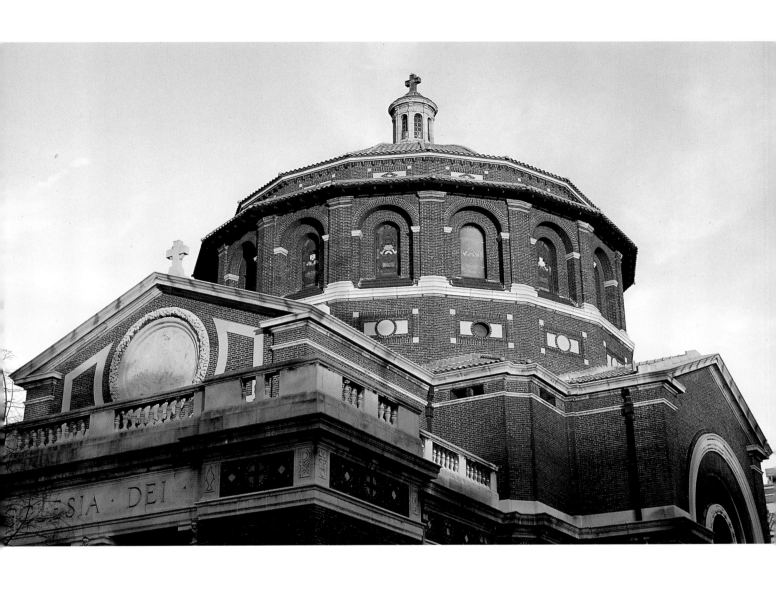

Above and opposite Saint Paul's Chapel, Columbia University, Morningside Heights, Manhattan

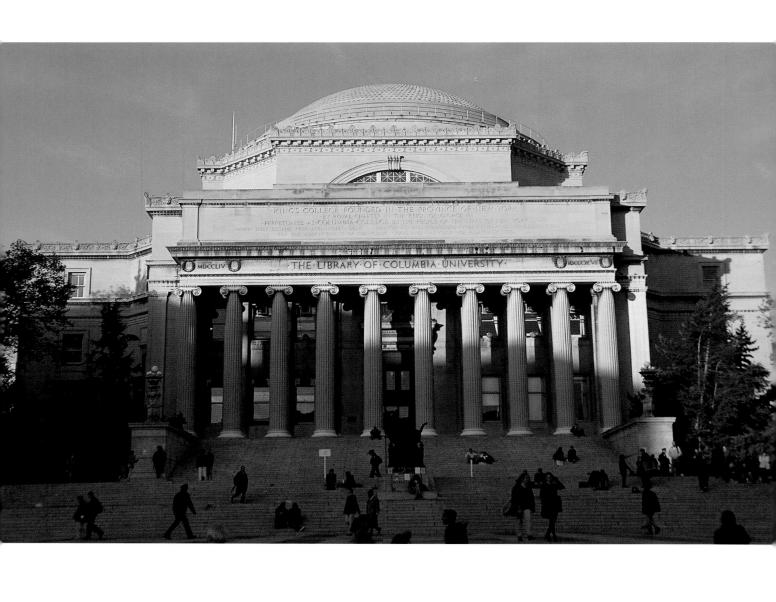

Above Low Memorial Library, Columbia University, Morningside Heights, Manhattan
Opposite Gatehouse, Greenwood Cemetery, Brooklyn

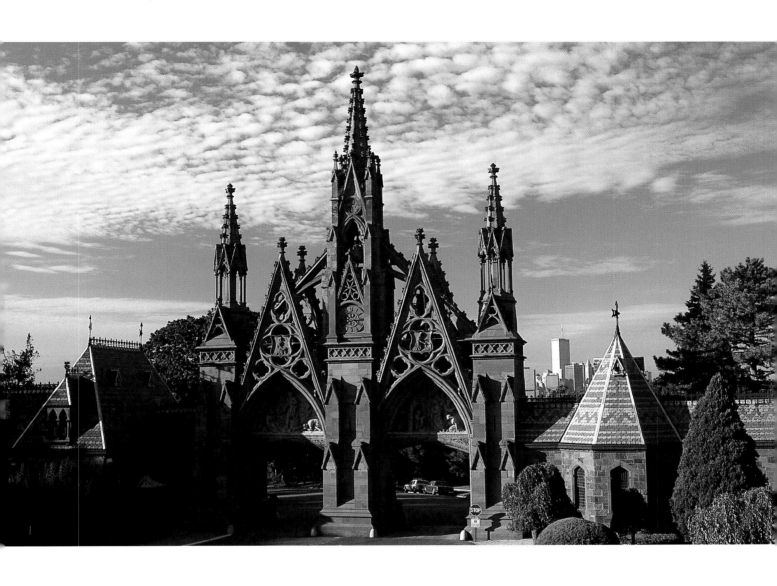

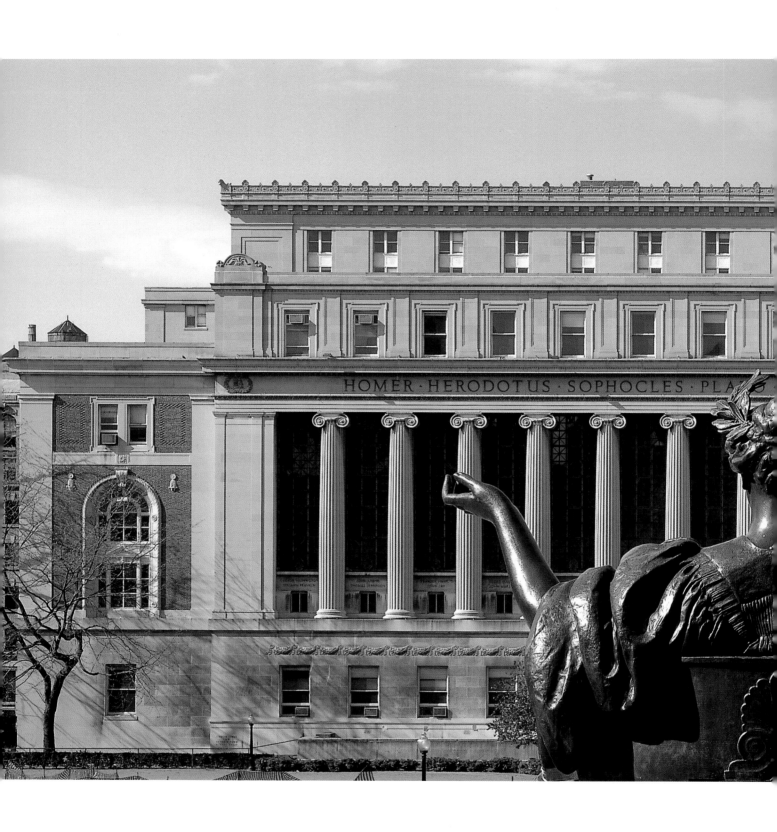

View of Butler Library from behind *Alma Mater*, Columbia University, Morningside Heights, Manhattan

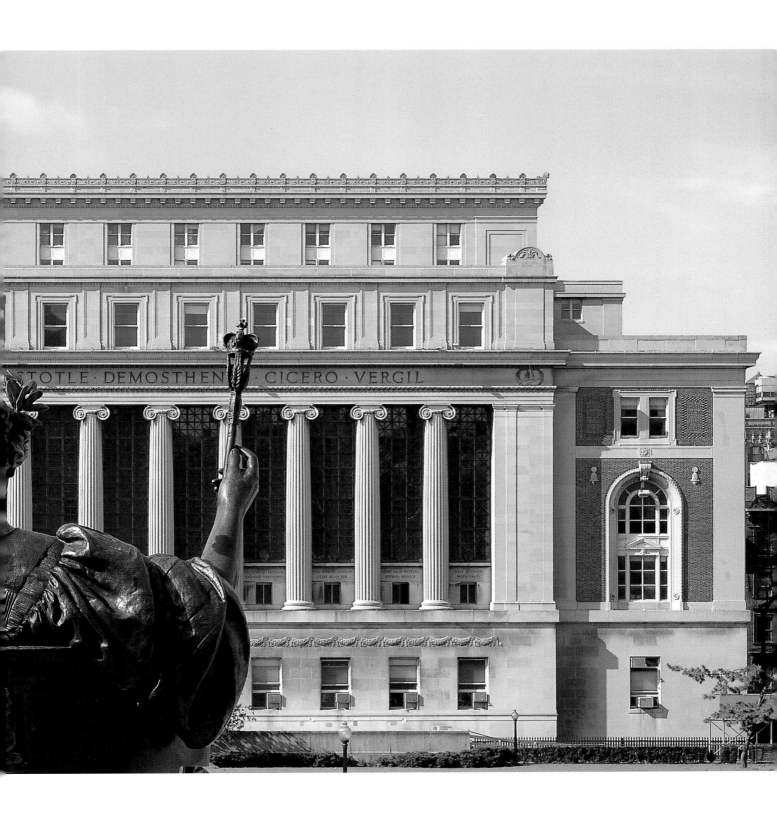

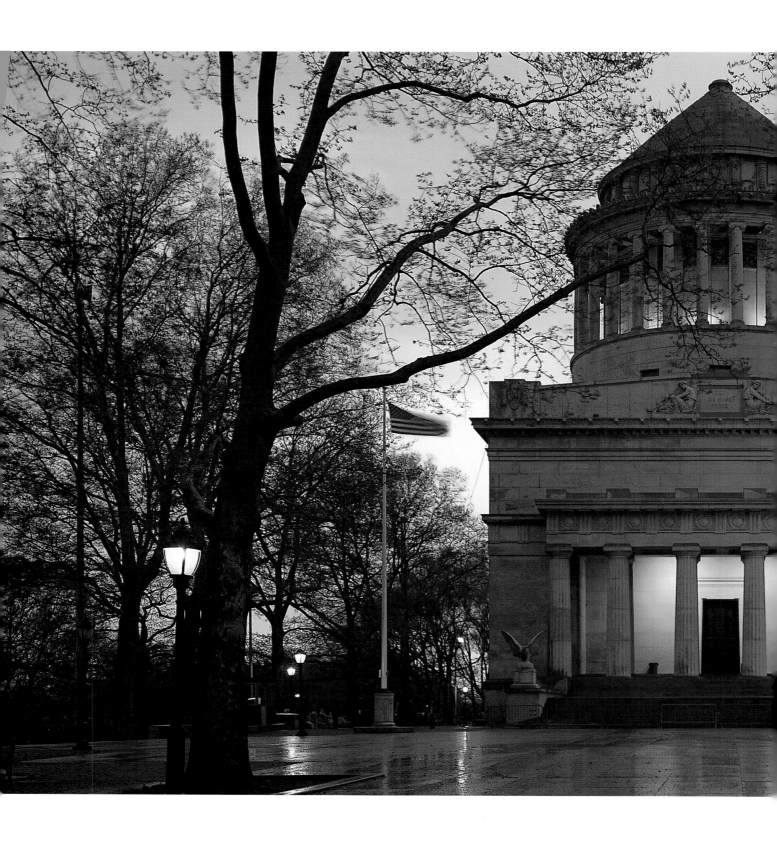

Above Grant's Tomb, Manhattan
Overleaf, left Riverside Church, Manhattan
Overleaf, right Saint Patrick's Church, Manhattan

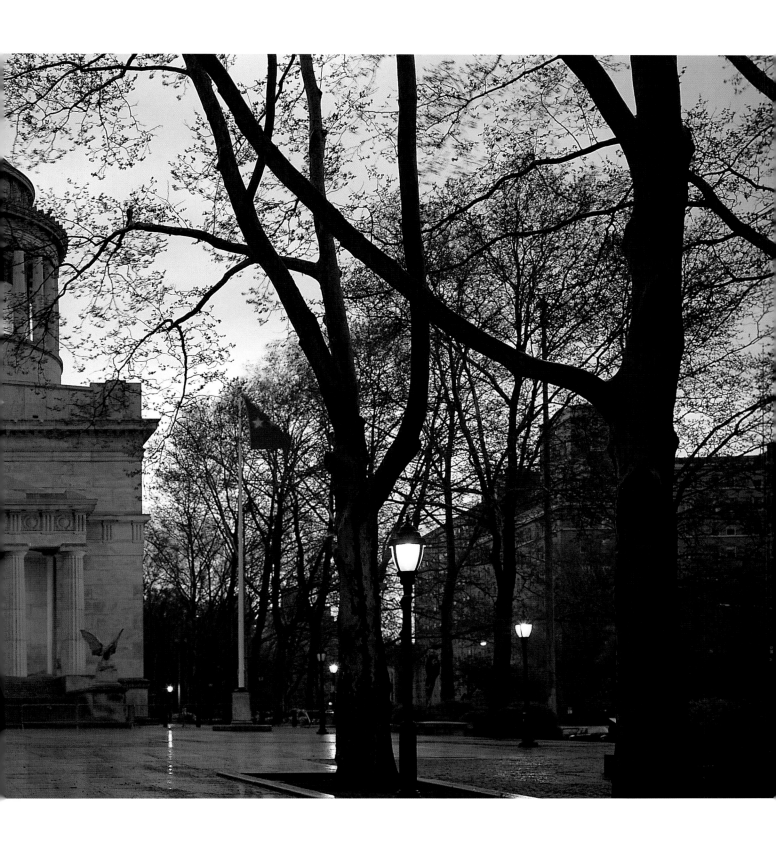

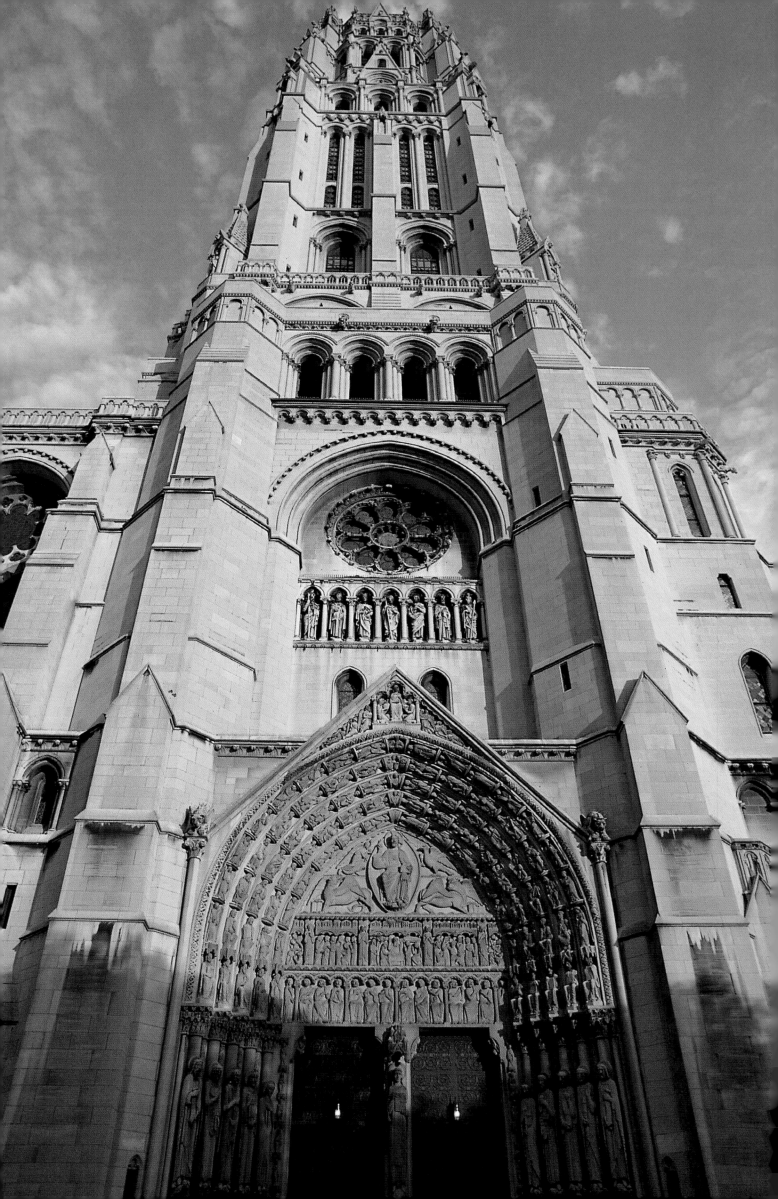

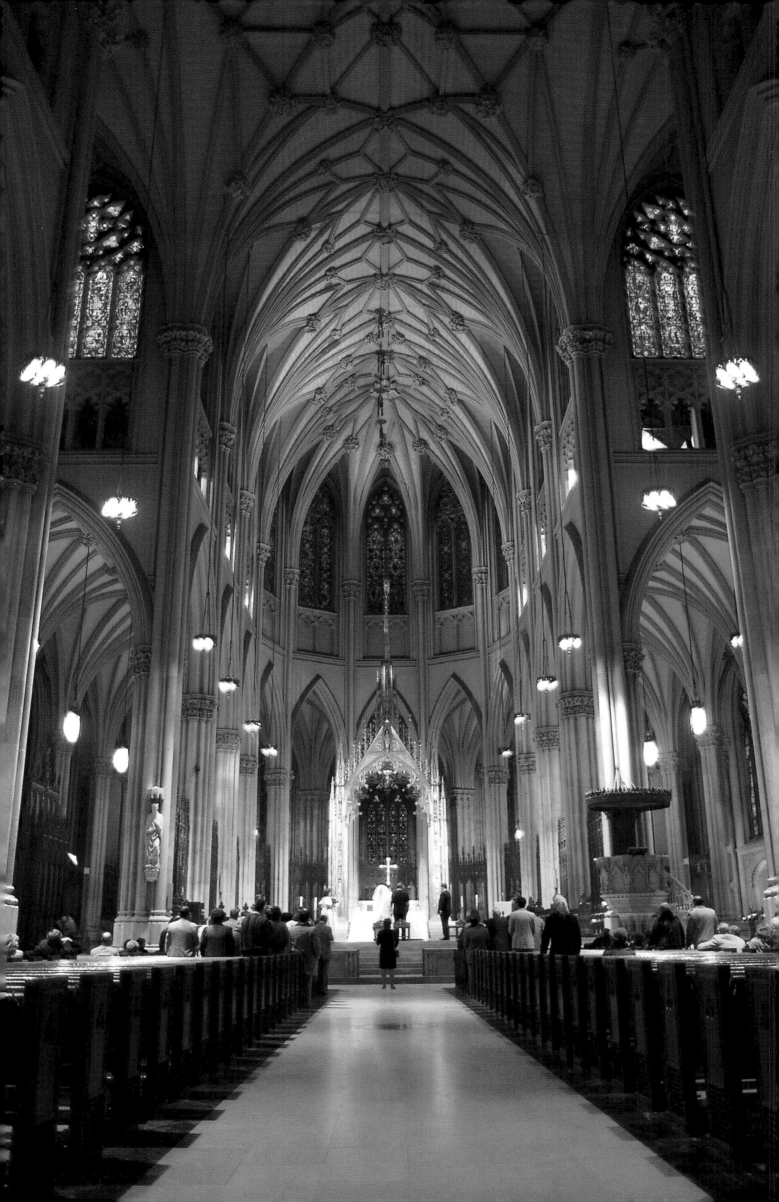

Above and opposite St. John the Divine, Morningside Heights, Manhattan

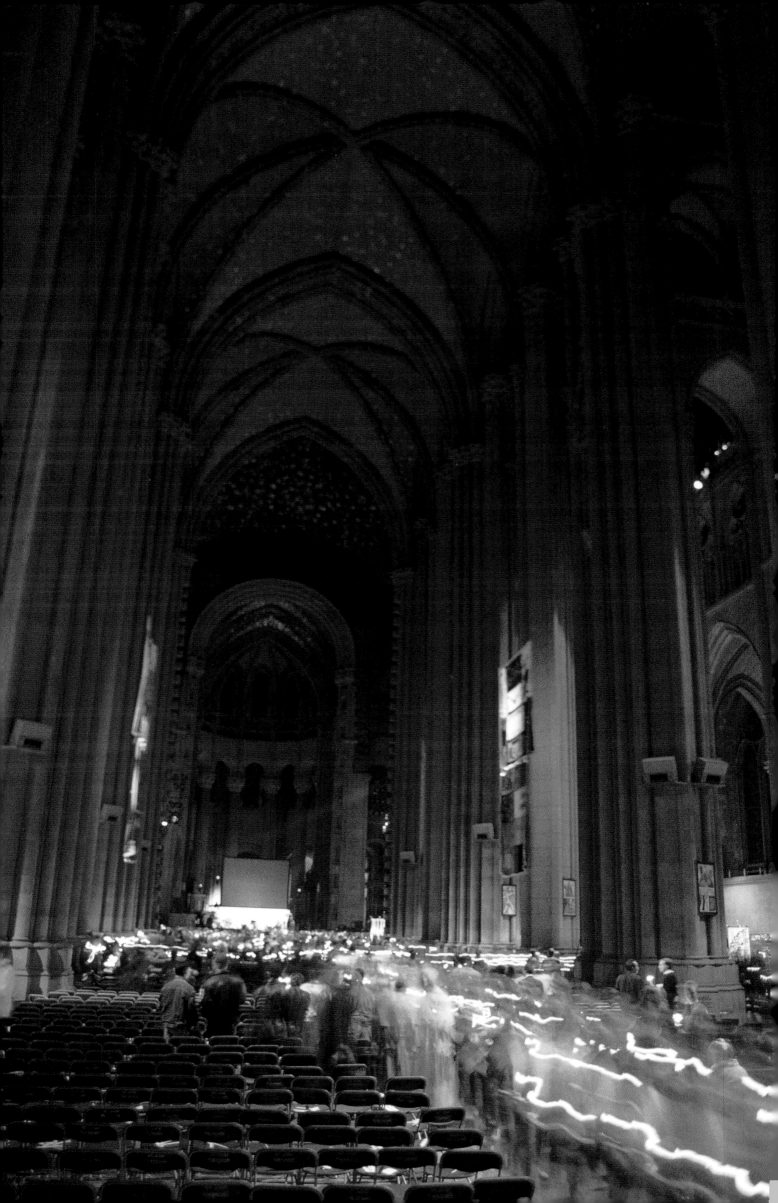

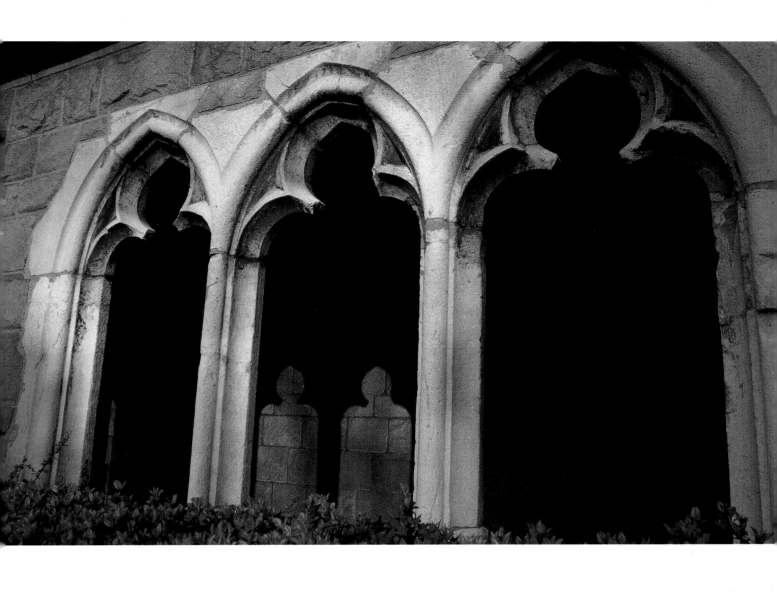

Above The Cloisters, Manhattan
Opposite St. John the Divine, Morningside Heights, Manhattan
Overleaf Metropolitan Opera House, Lincoln Center, Manhattan

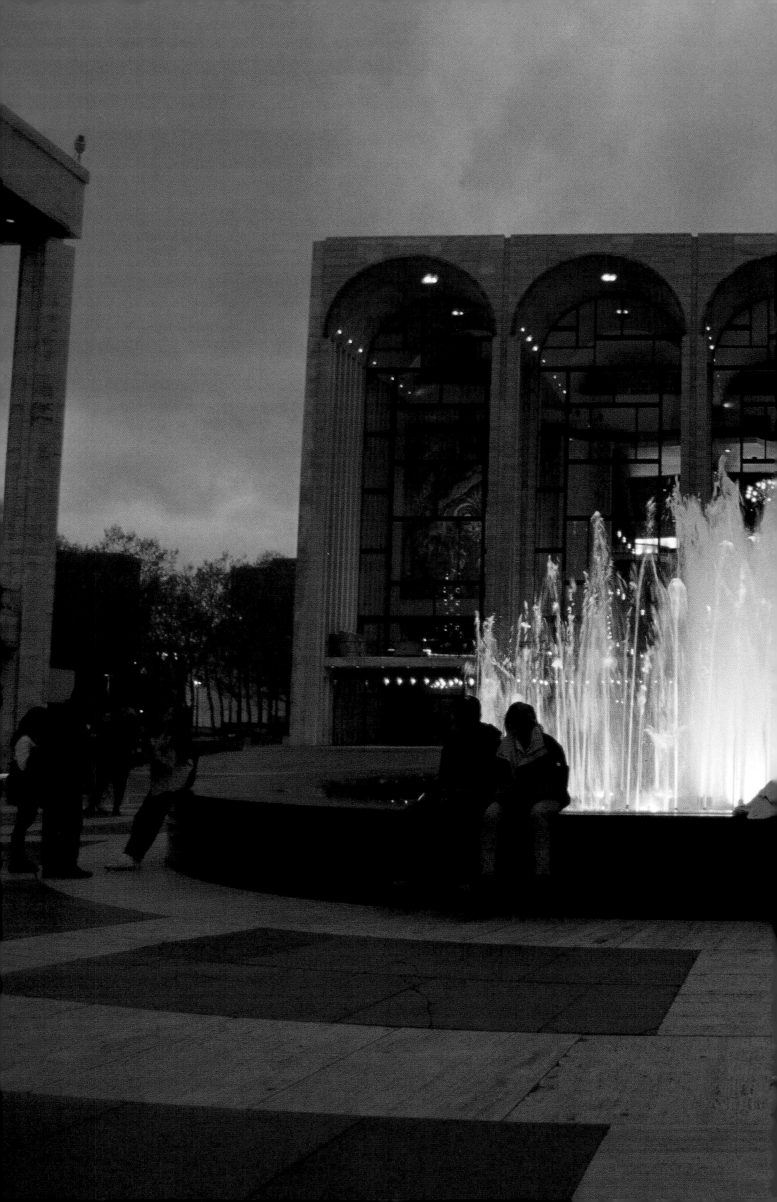

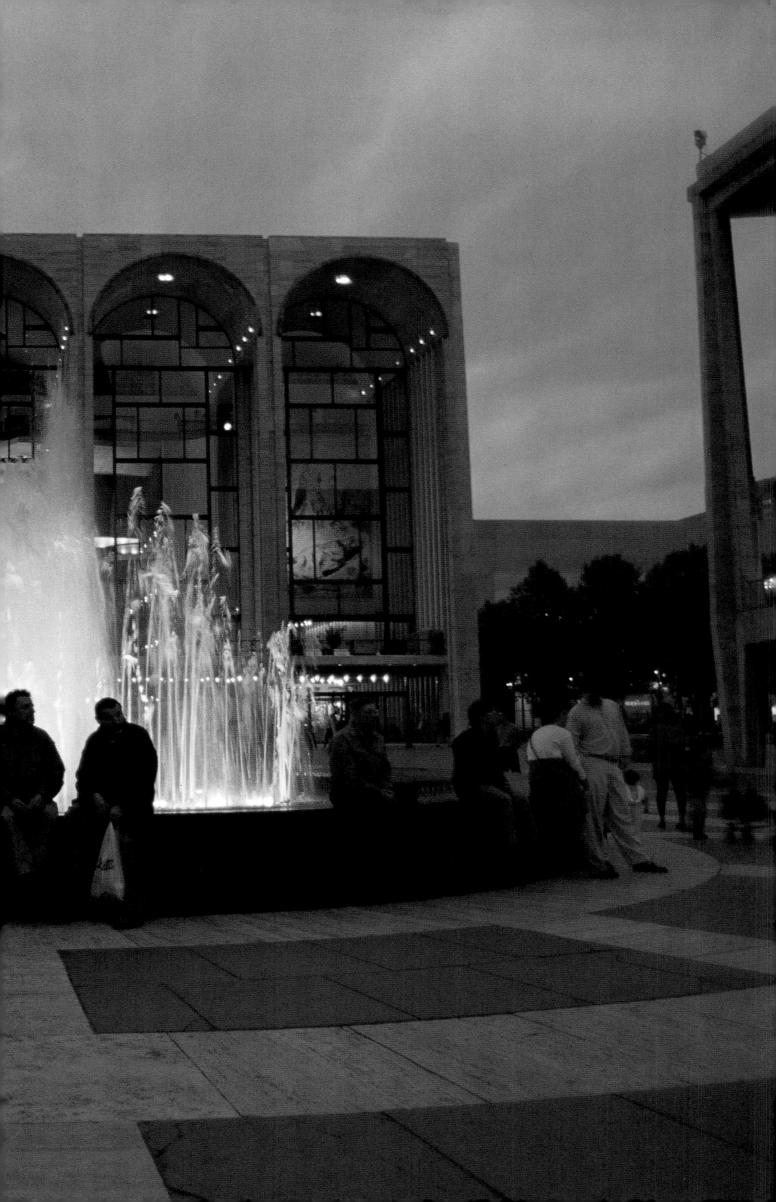

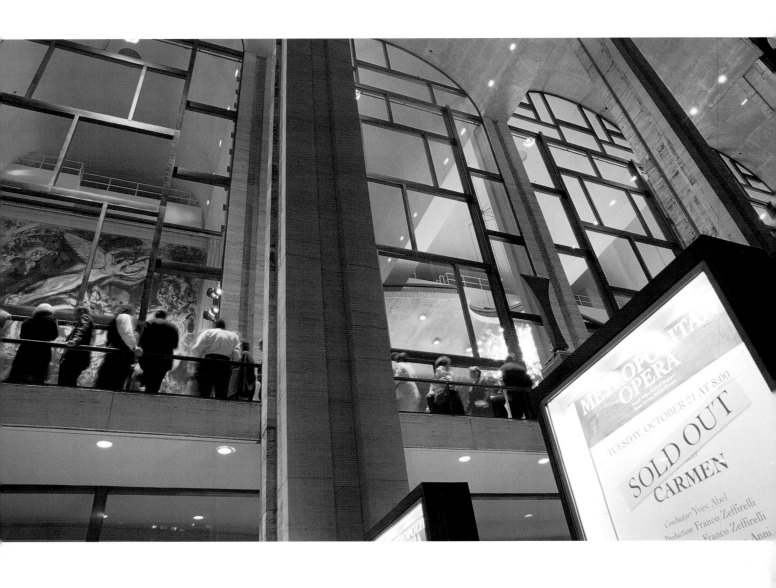

Above Metropolitan Opera House, Lincoln Center, Manhattan
Opposite *Civic Fame*, Municipal Building, Manhattan

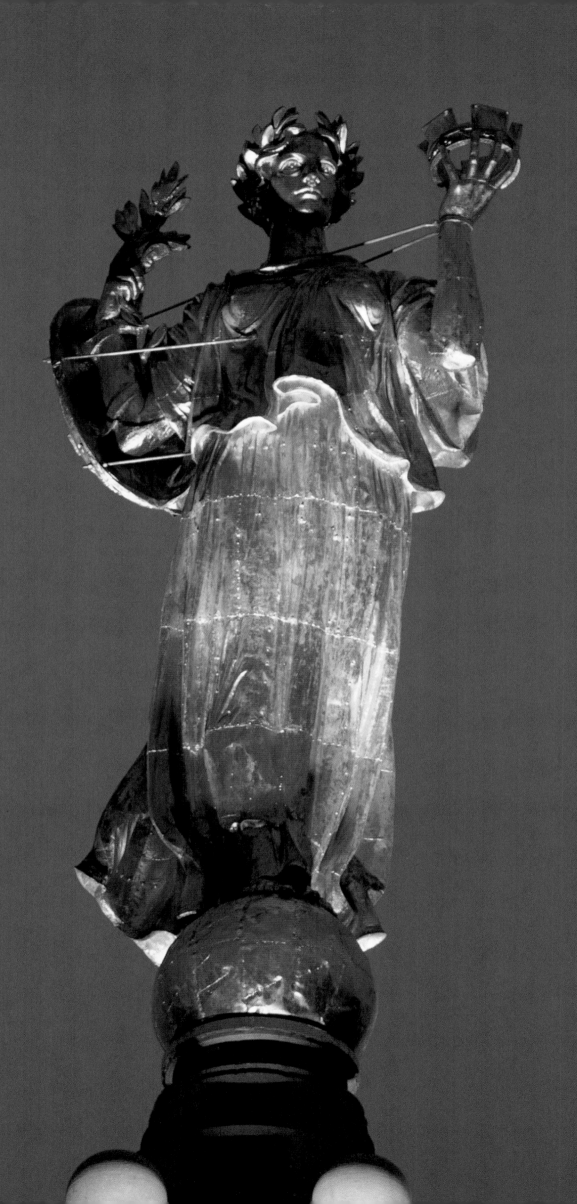

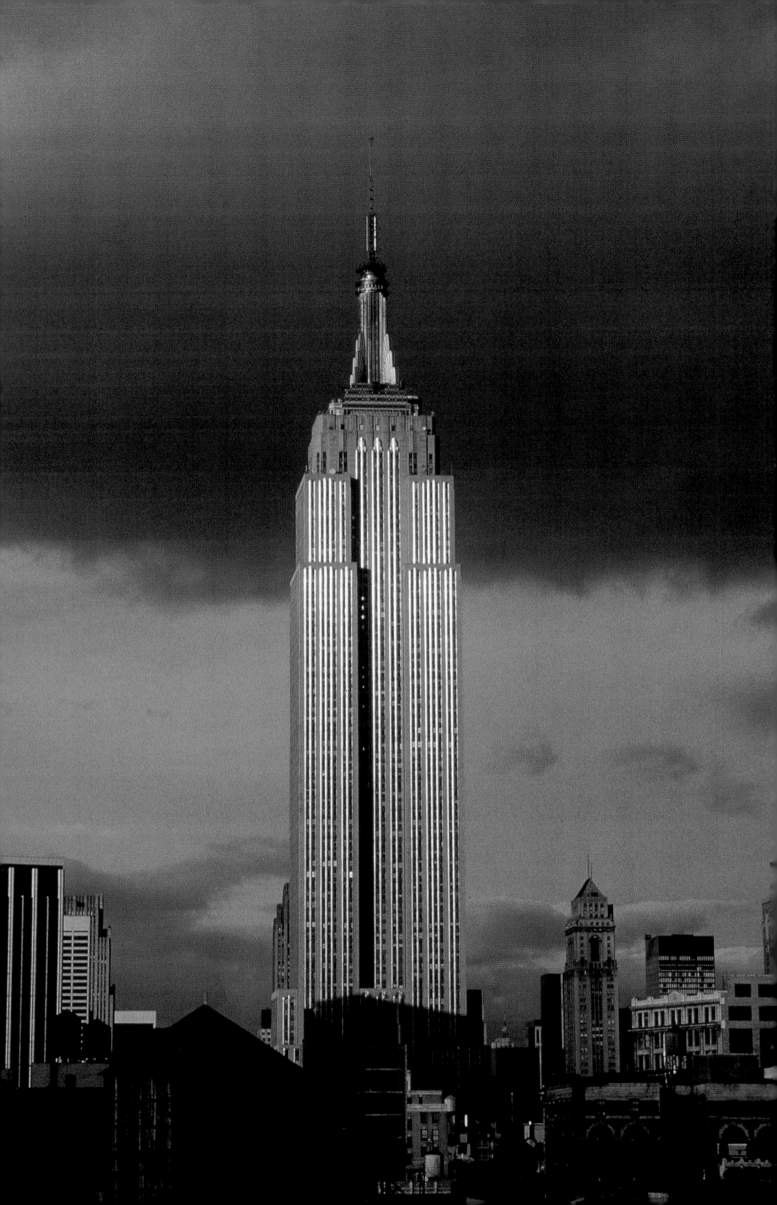

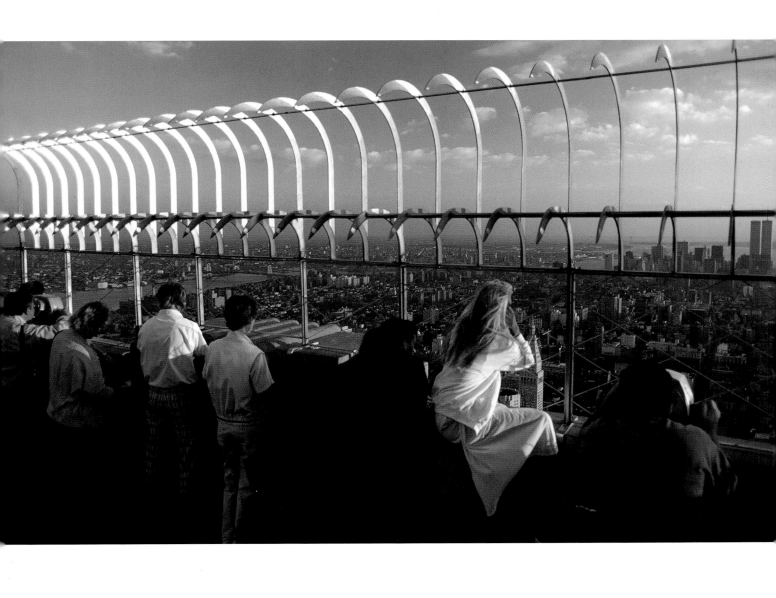

Above and opposite Empire State Building, Manhattan

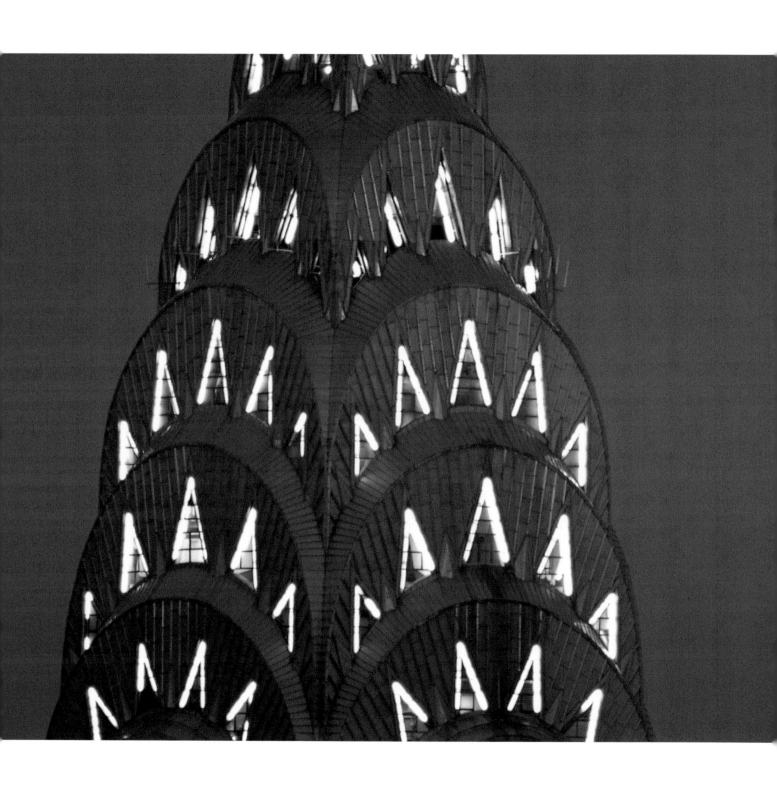

Above and opposite Chrysler Building, Manhattan
Overleaf, left View of Saint Paul Chapel from 15 Park Row, Manhattan
Overleaf, right Barosaurus, Theodore Roosevelt Rotunda, American Museum of Natural History, Manhattan

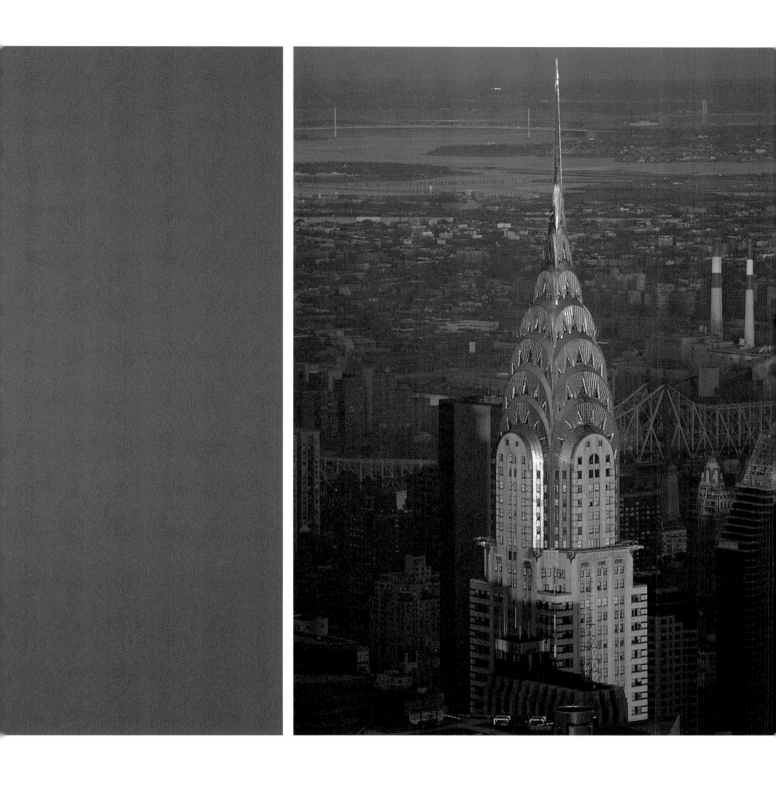

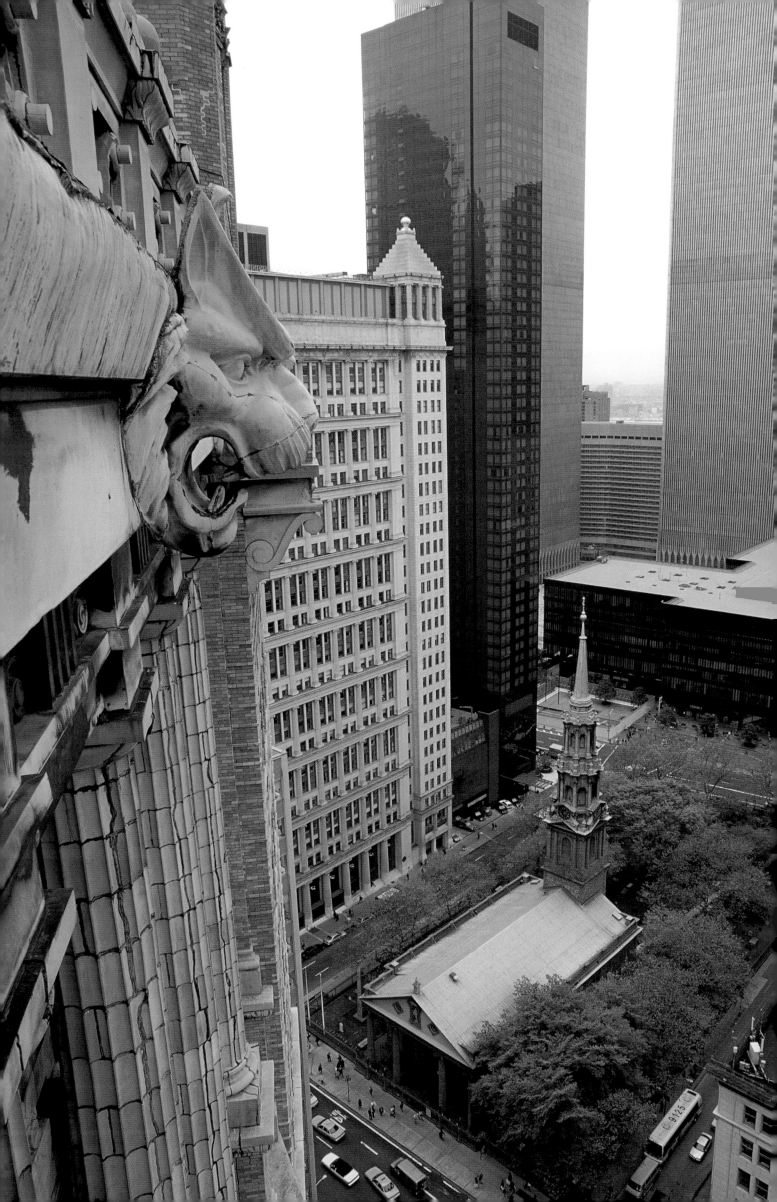

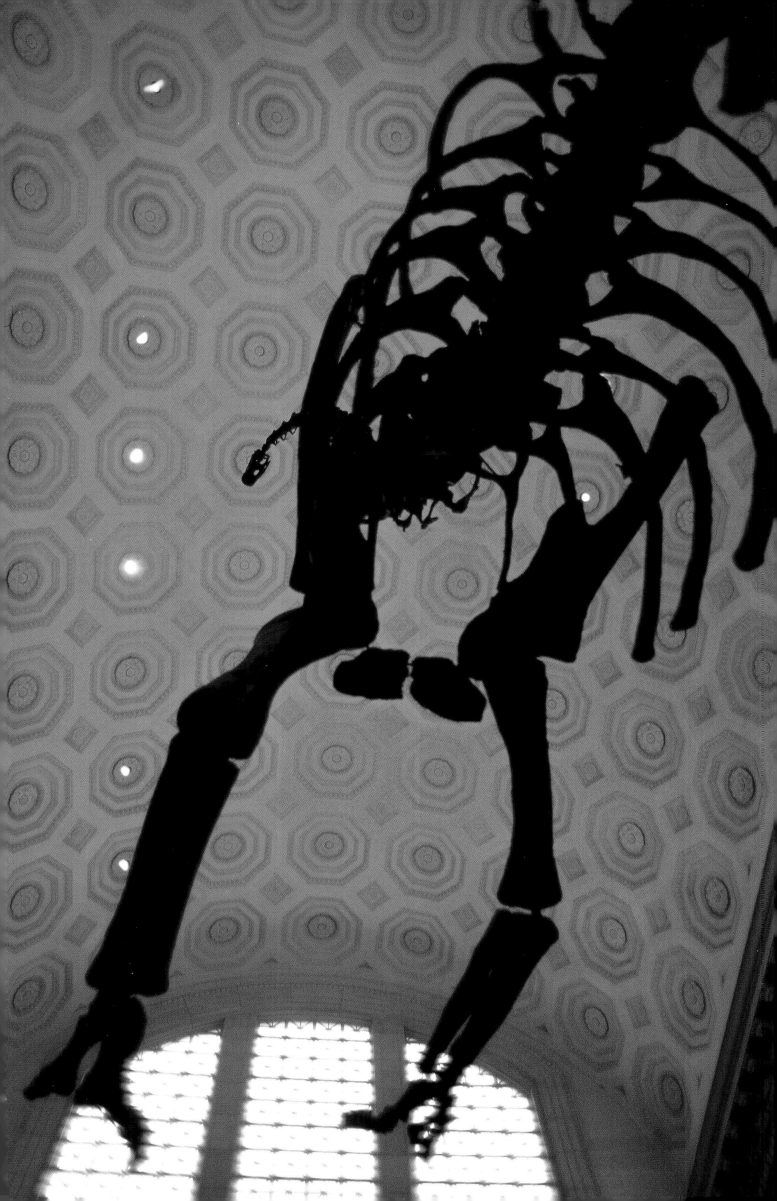

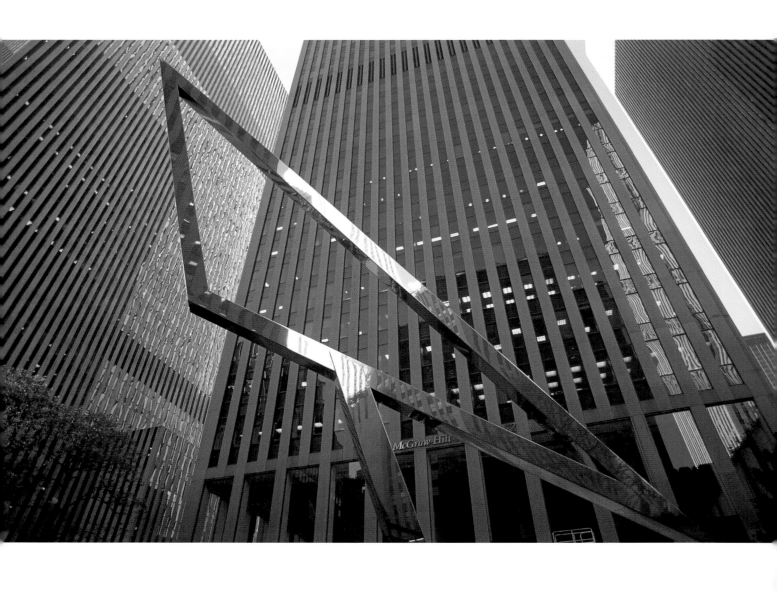

Above *Sun Triangle*, McGraw-Hill Building, Sixth Avenue, Manhattan
Opposite 9 West Fifty-seventh Street, Manhattan
Overleaf, left Holocaust Memorial and World Trade Center, Manhattan
Overleaf, right Saint Paul's Chapel and World Trade Center, Manhattan

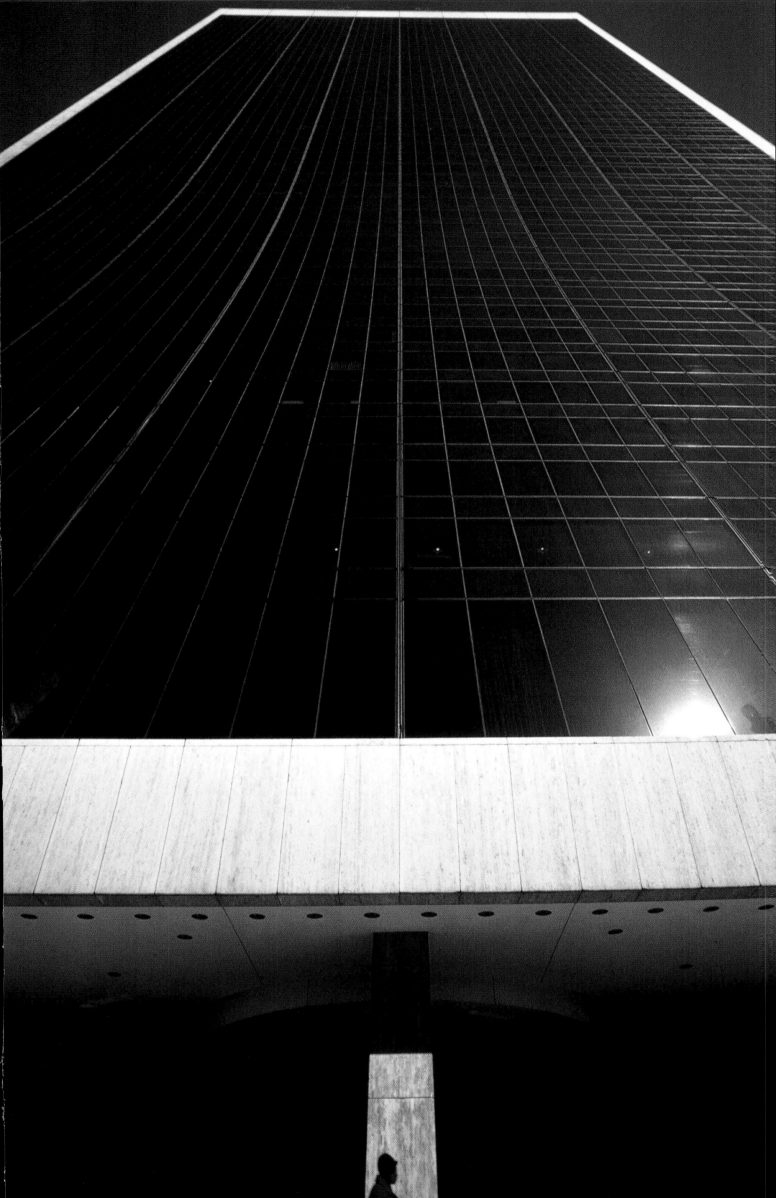

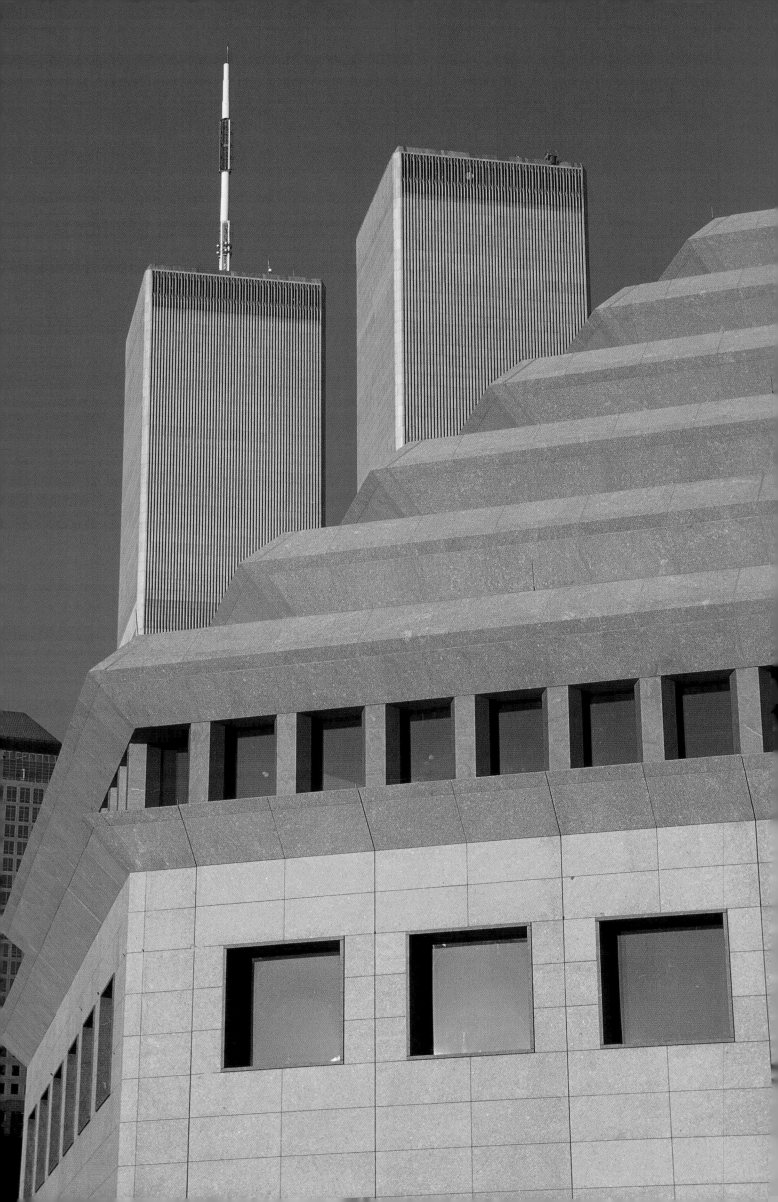

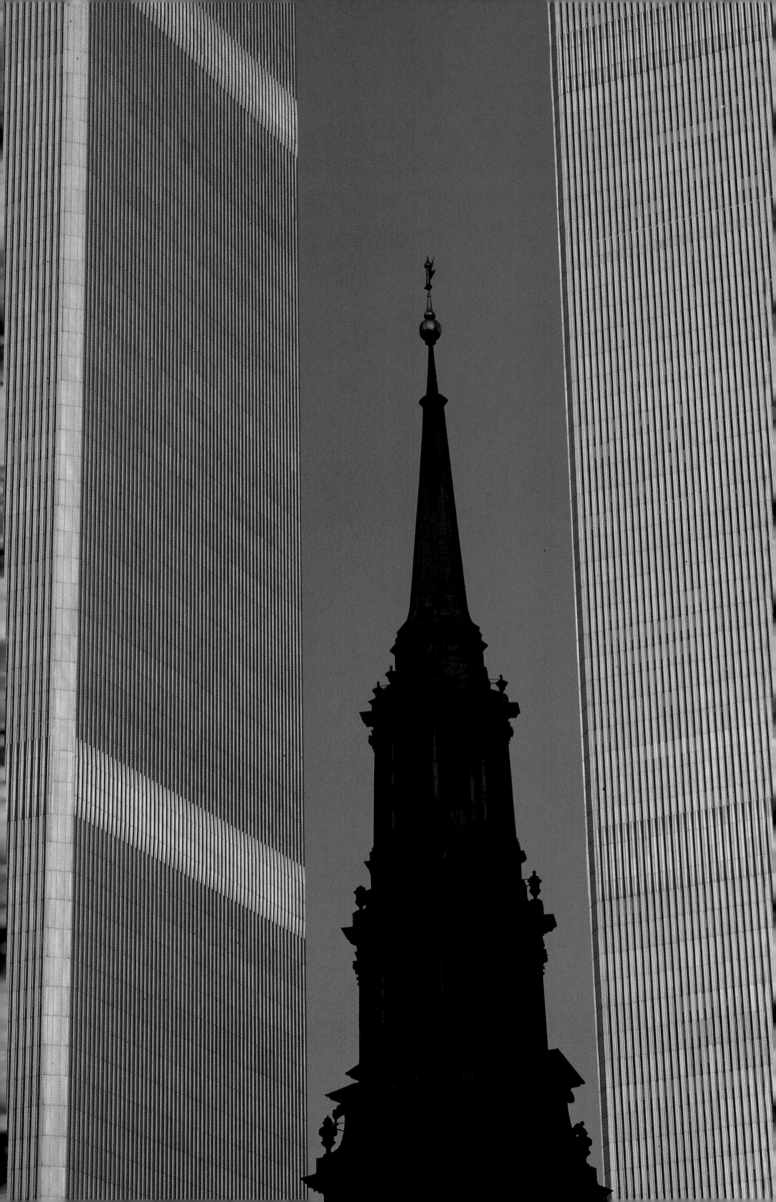

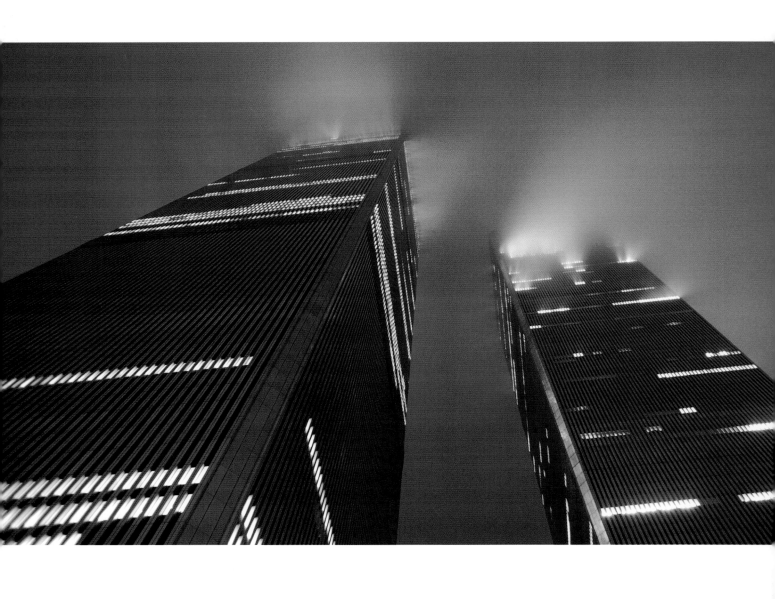

Above World Trade Center, Manhattan
Opposite and overleaf Flatiron Building, Manhattan
Second overleaf Grand Central Station, Manhattan
Third overleaf Yankee Stadium, the Bronx

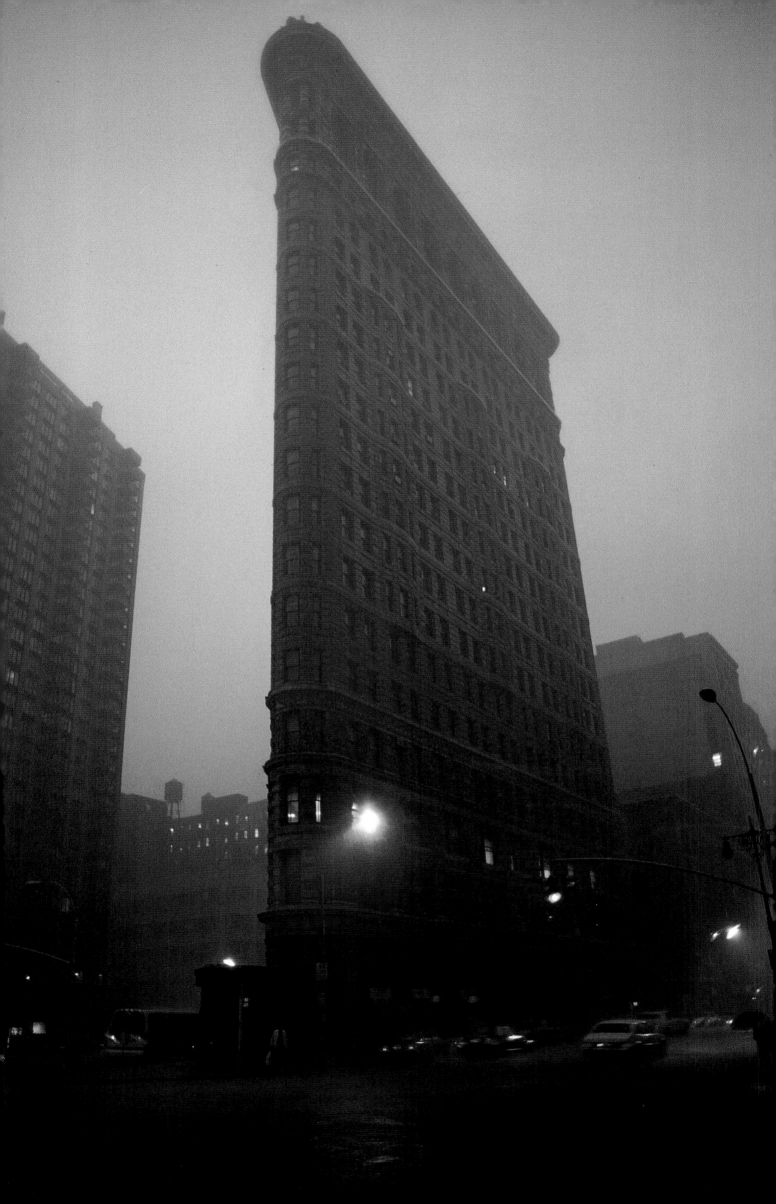

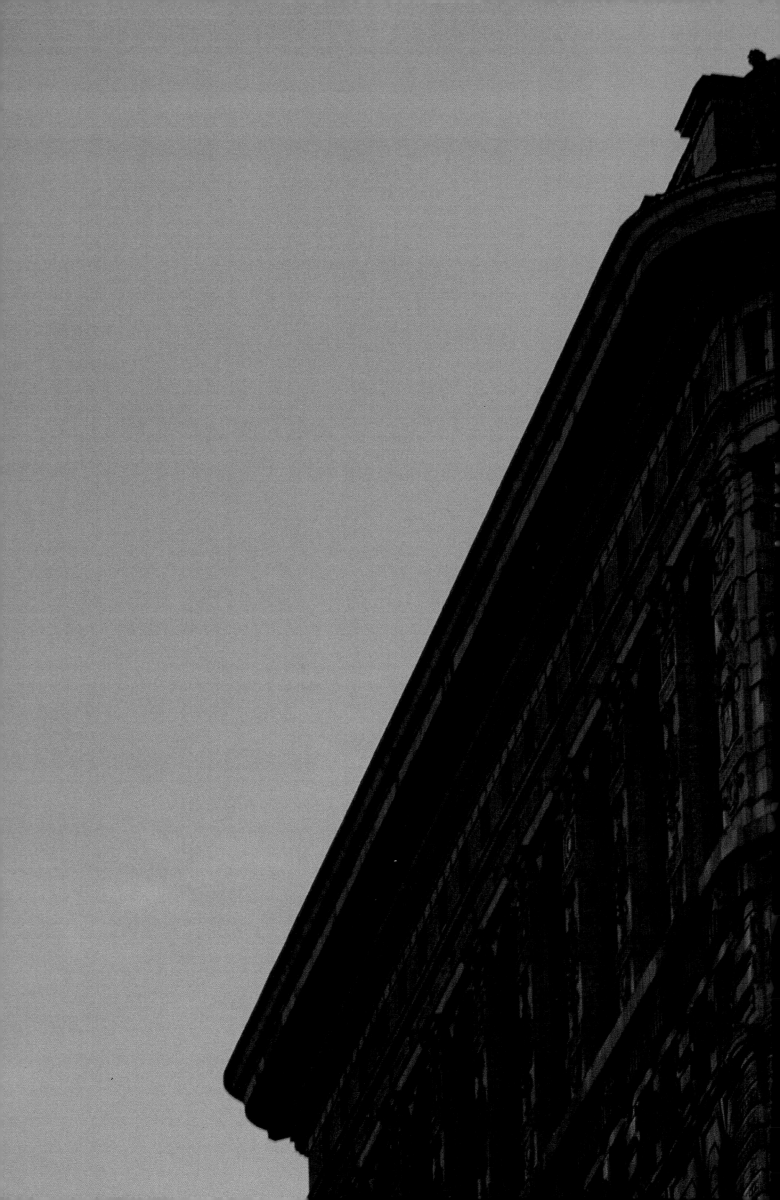

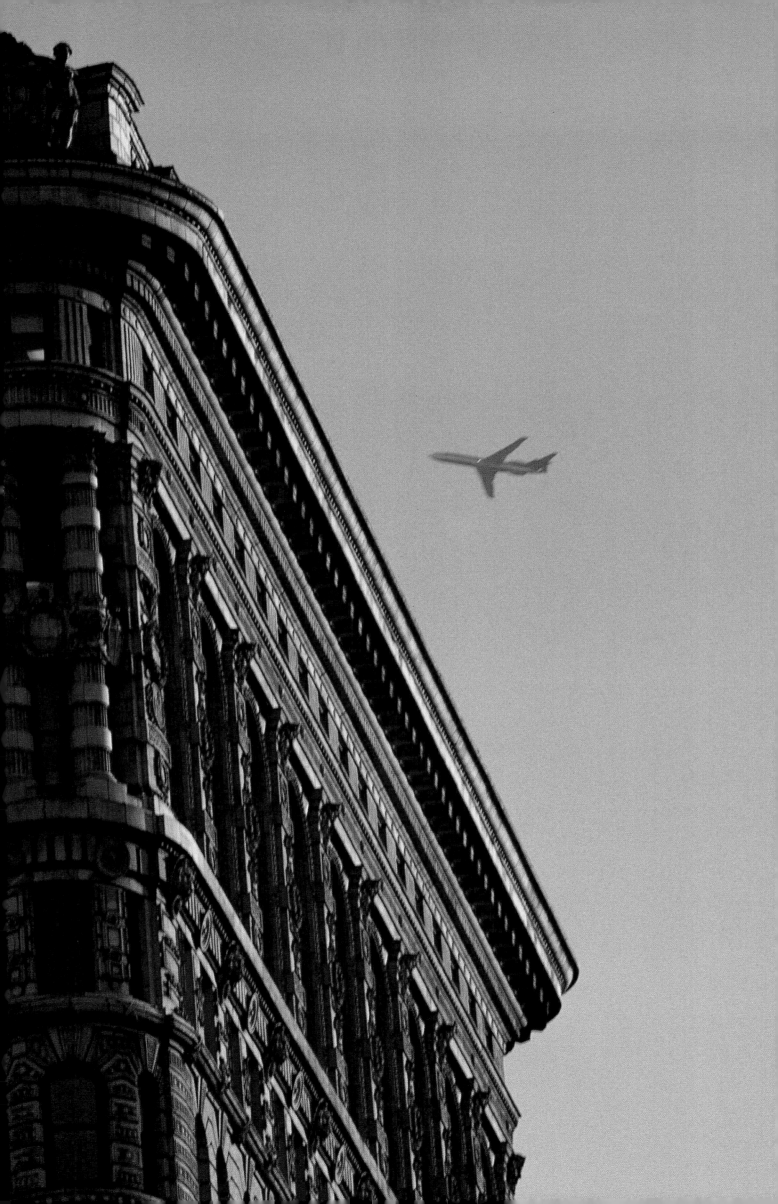

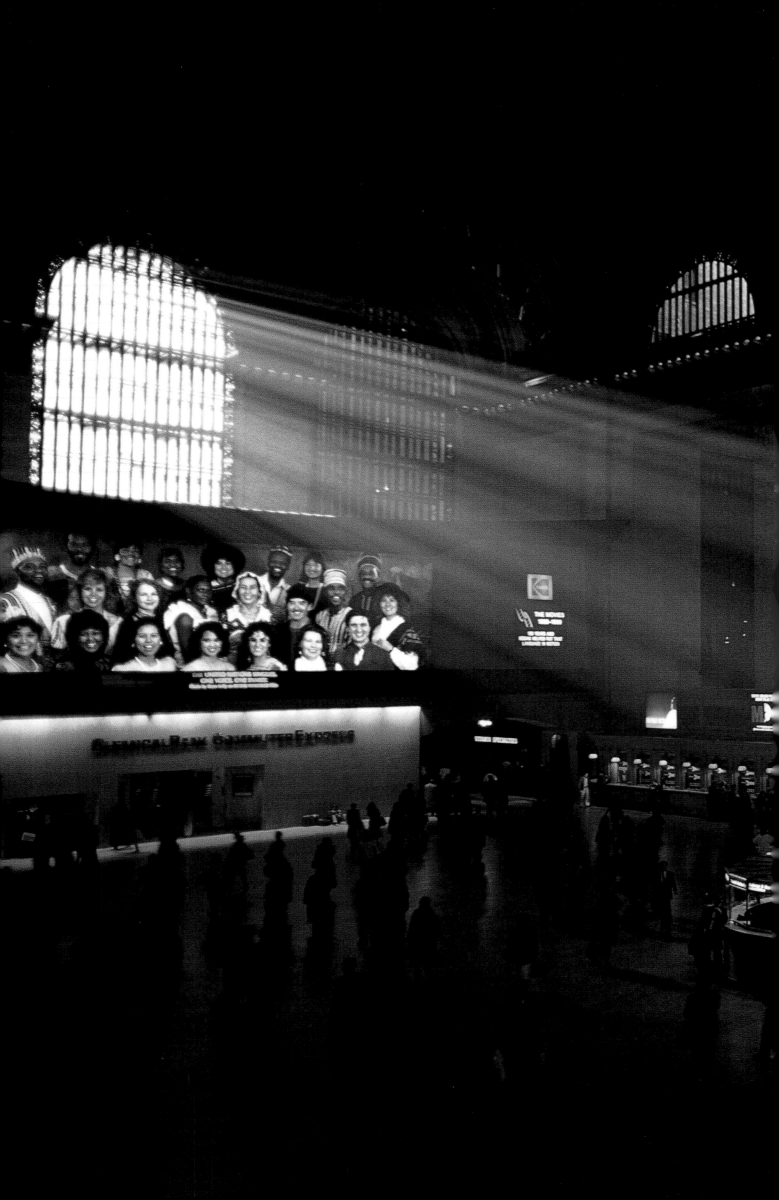

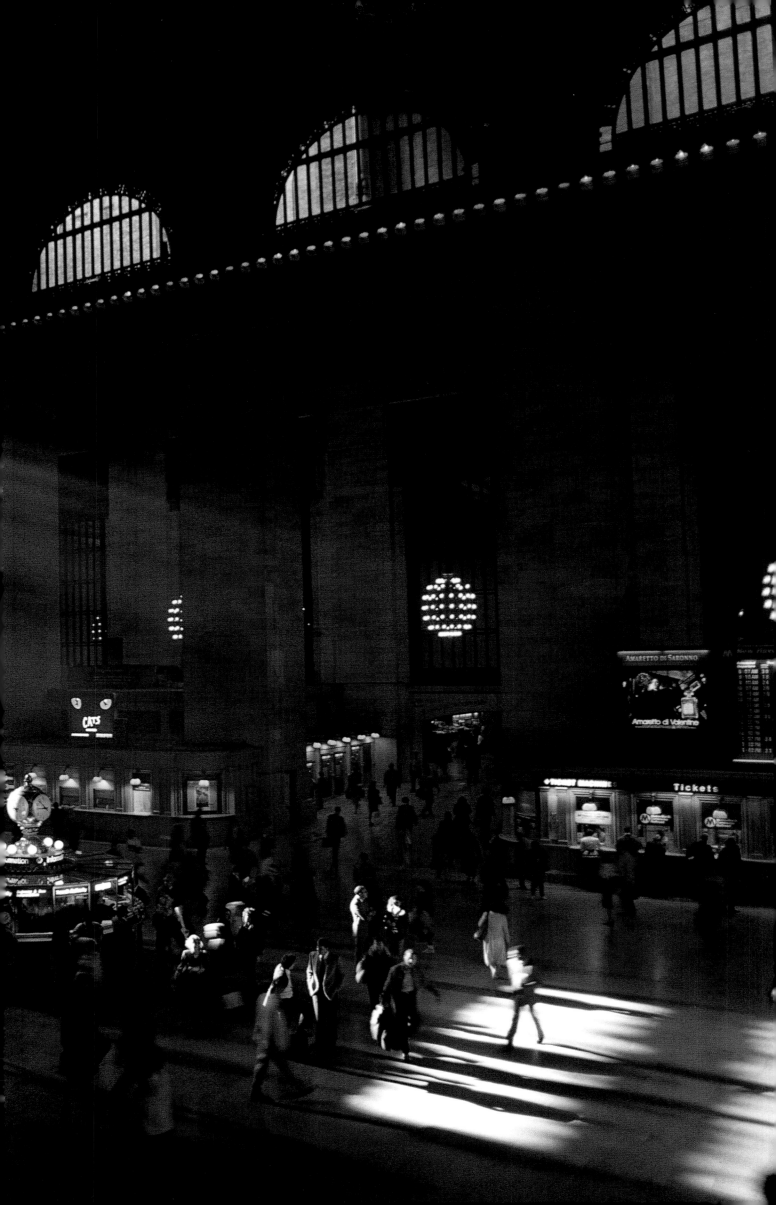

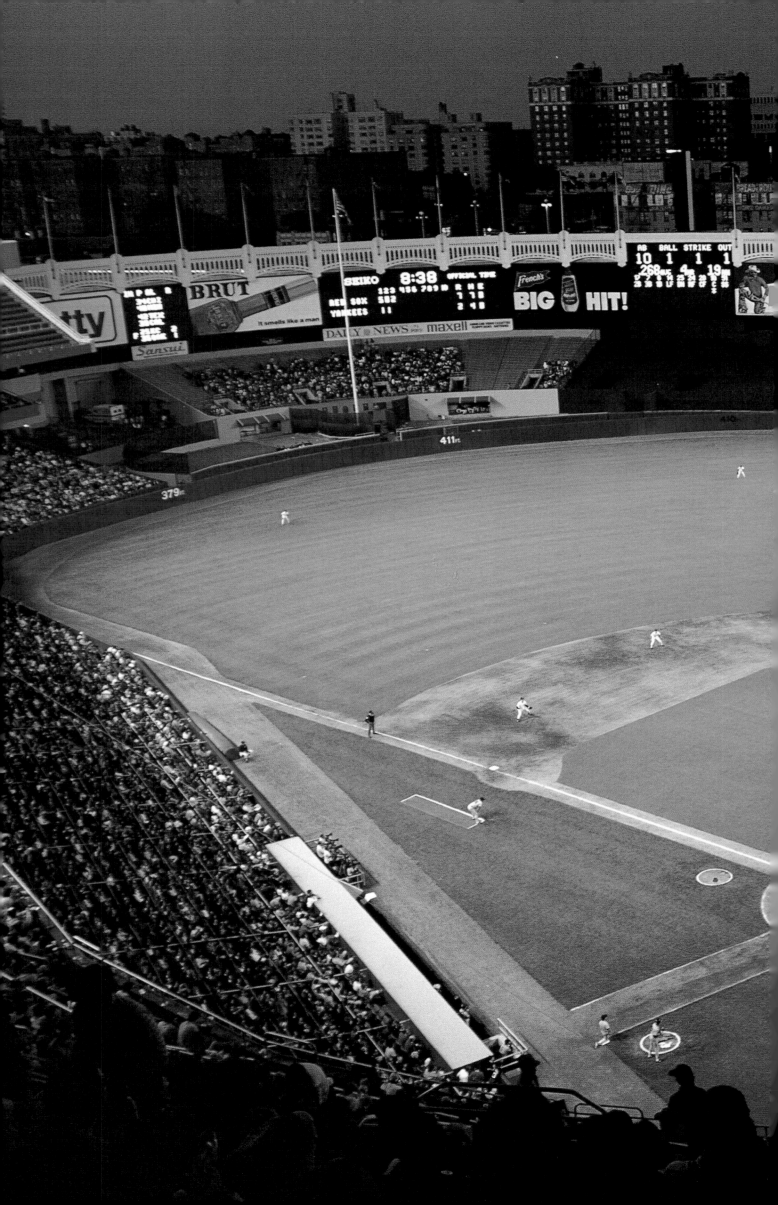

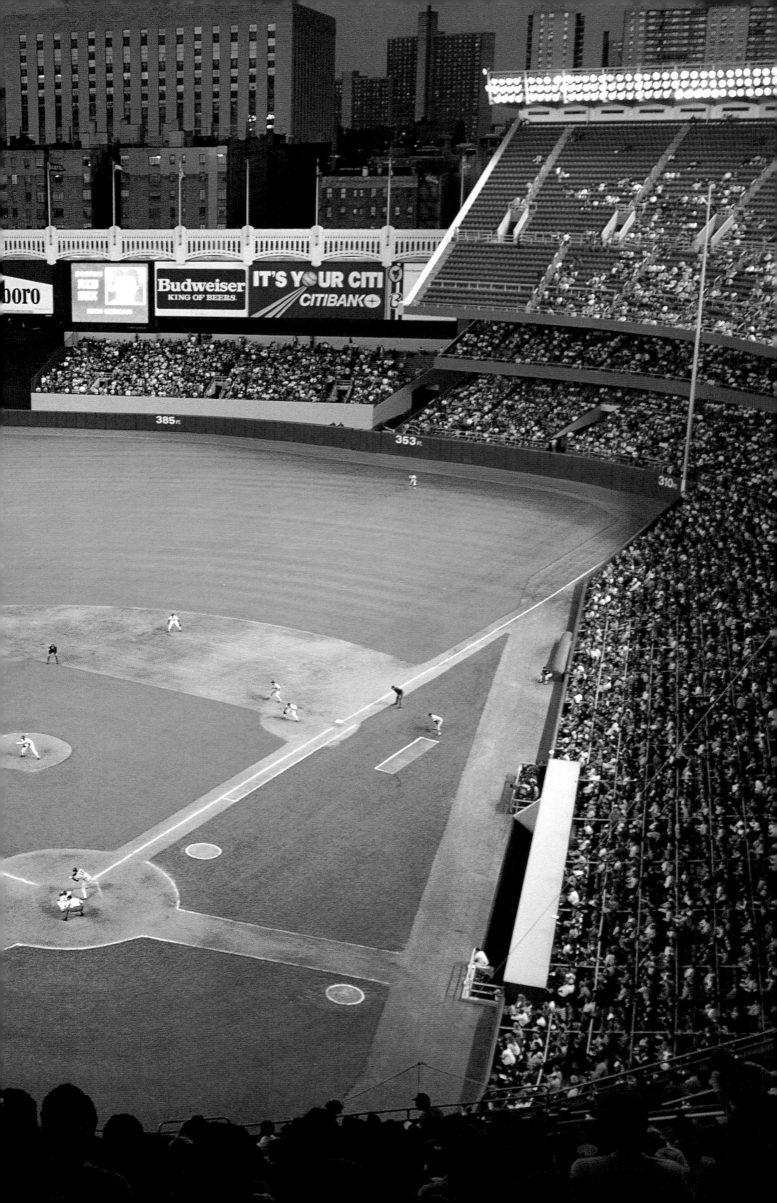

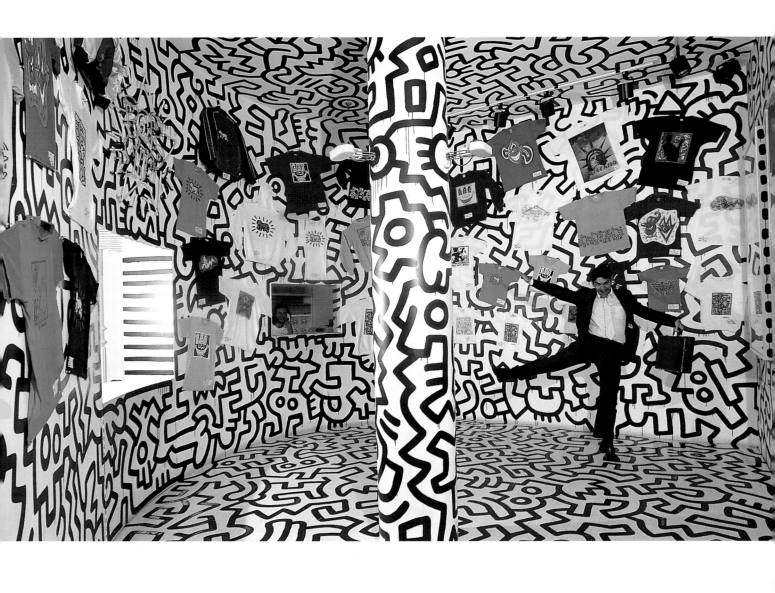

Above Pop Shop, Soho, Manhattan
Opposite East 104th Street, Harlem, Manhattan
Overleaf East 102nd Street, Harlem, Manhattan

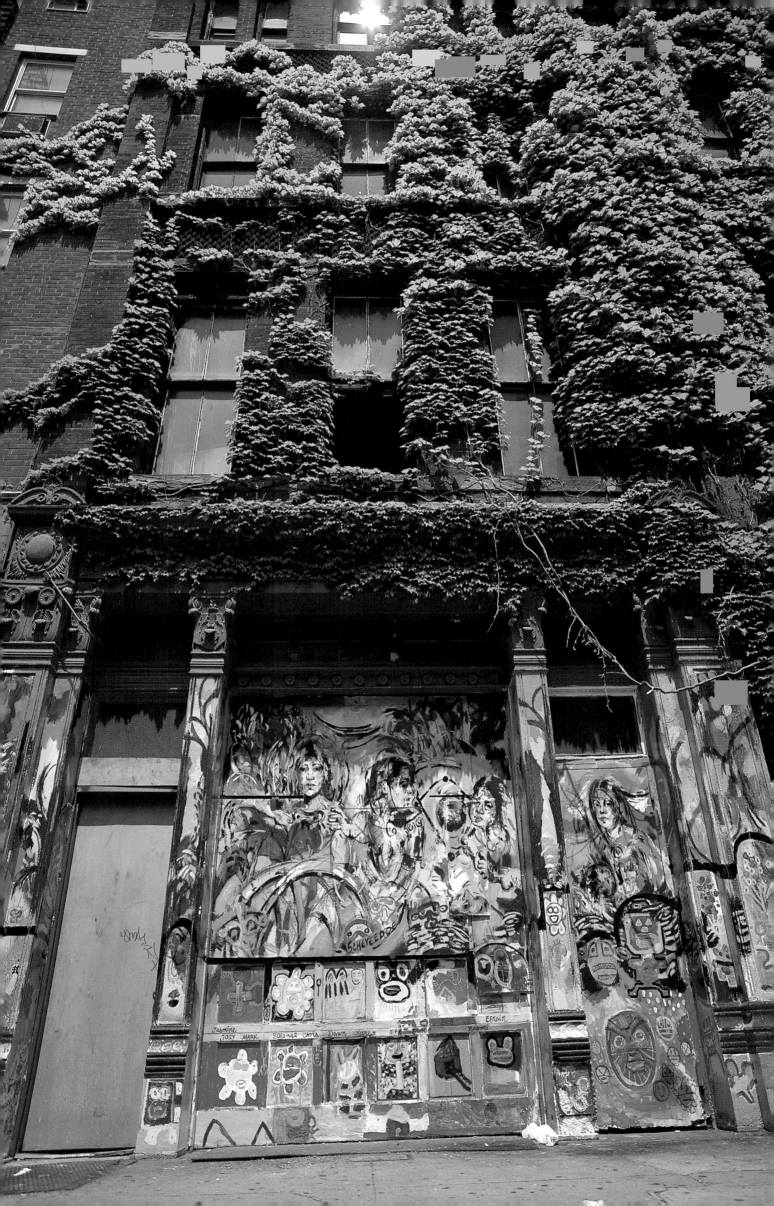

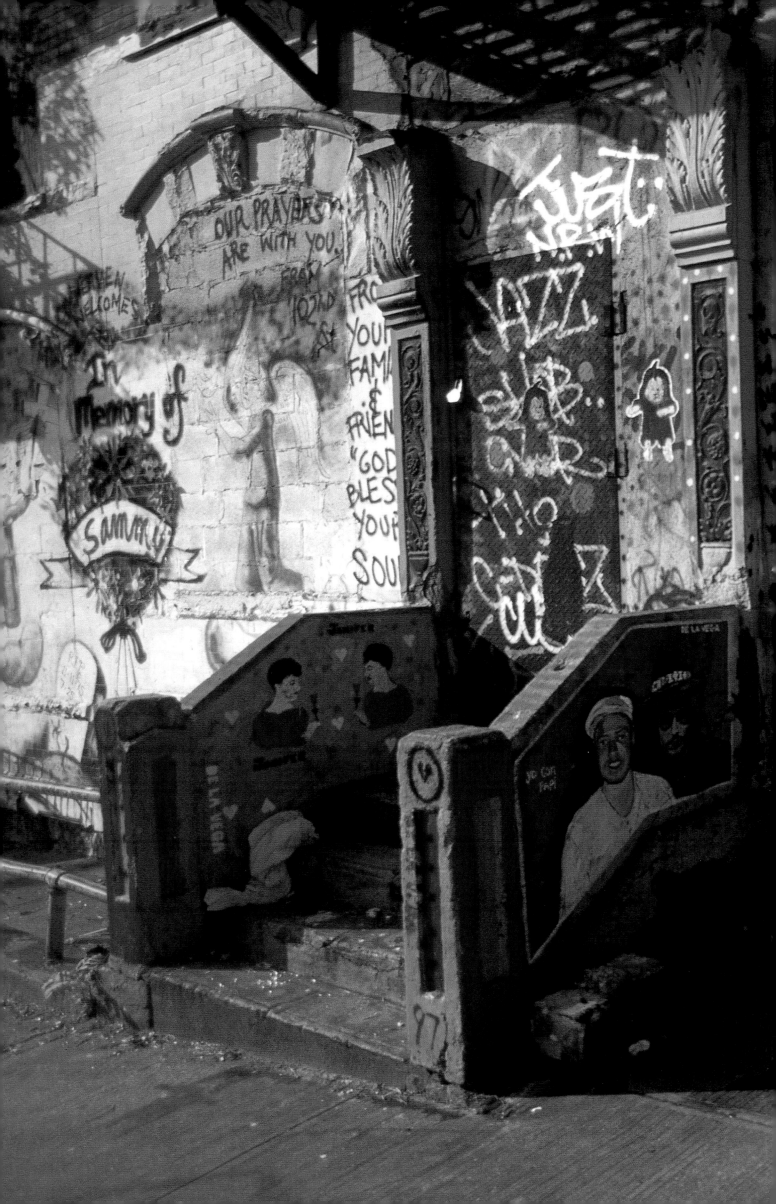

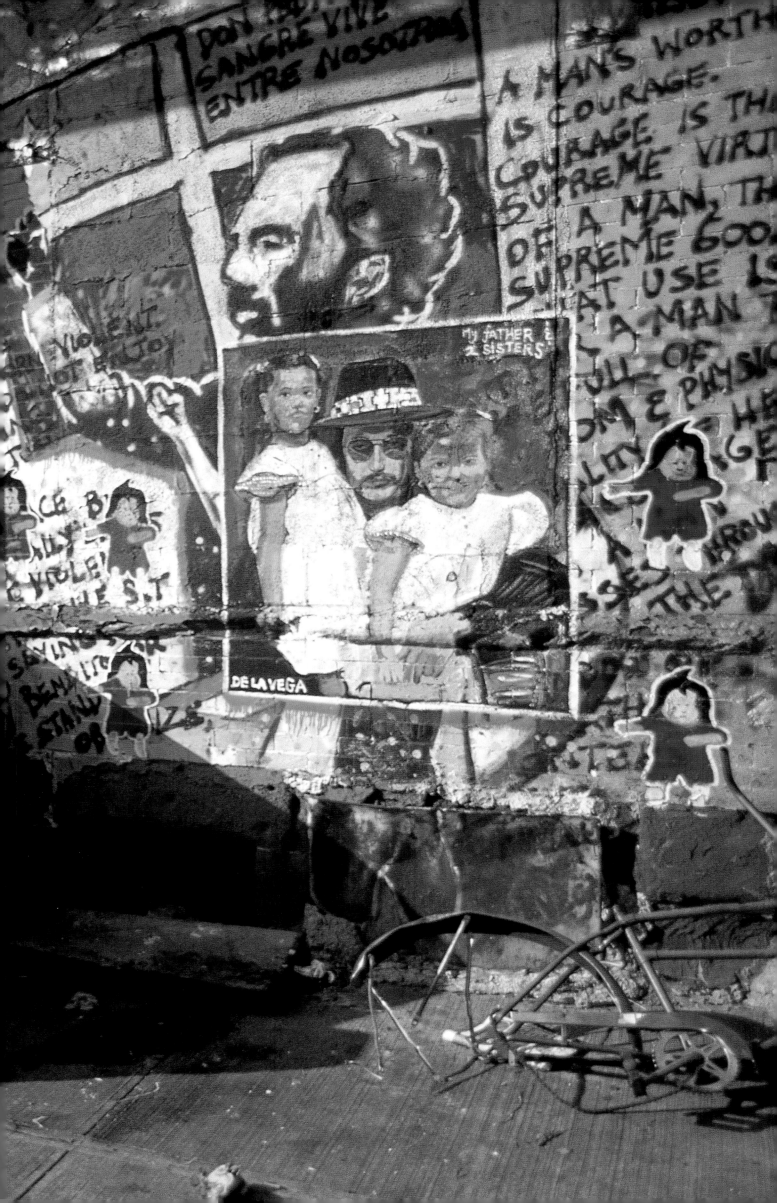

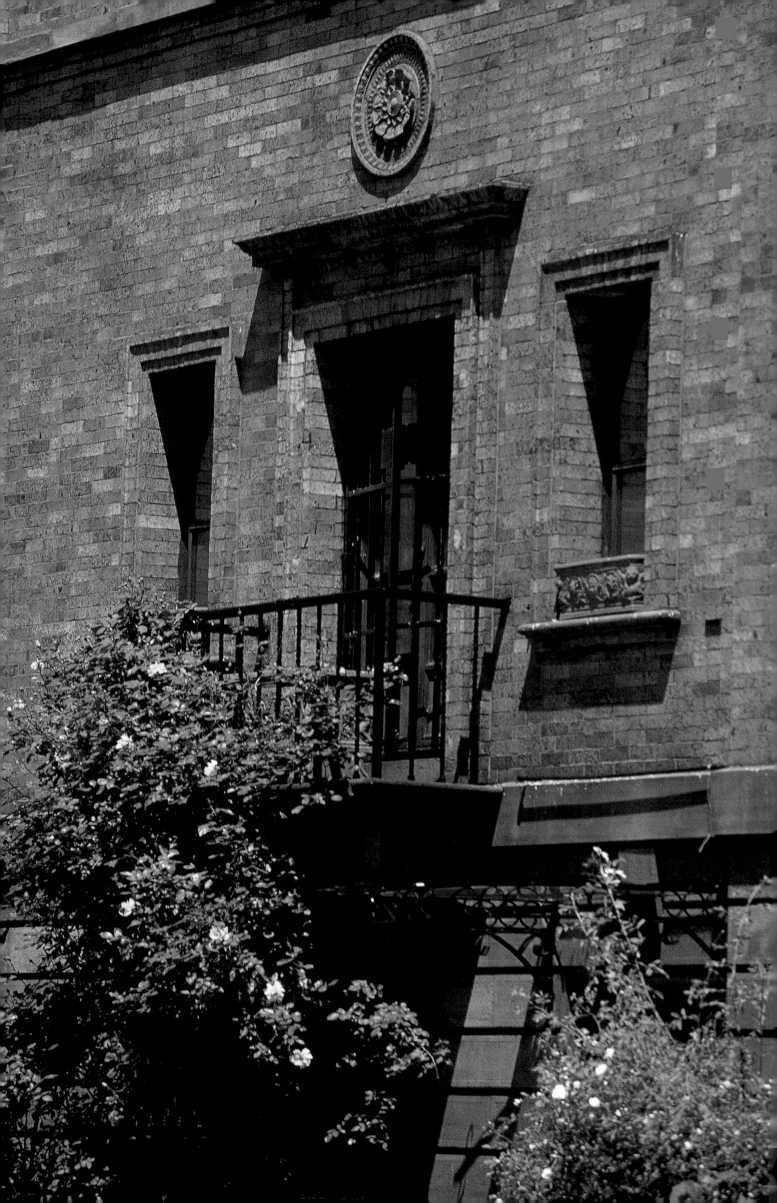

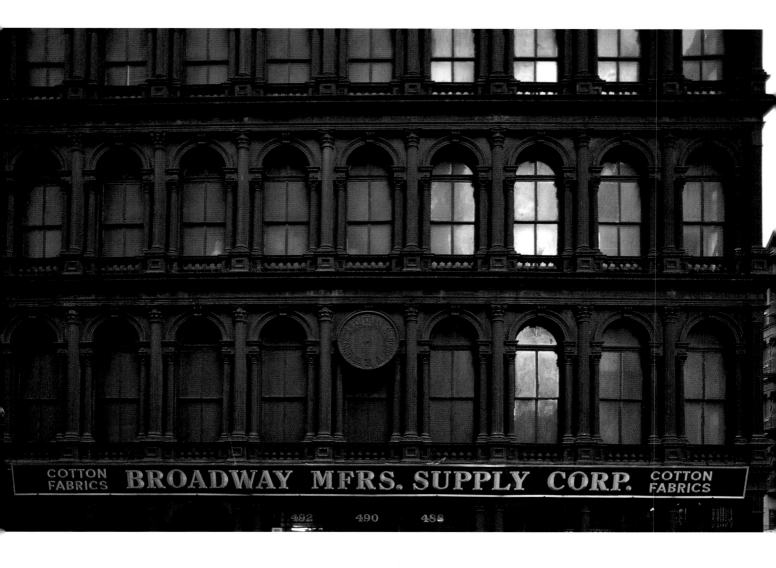

Above Cast-iron building, Broadway between Spring and Broome Streets, Soho, Manhattan
Opposite King Model Houses (Strivers' Row), West 139th Street, Harlem, Manhattan

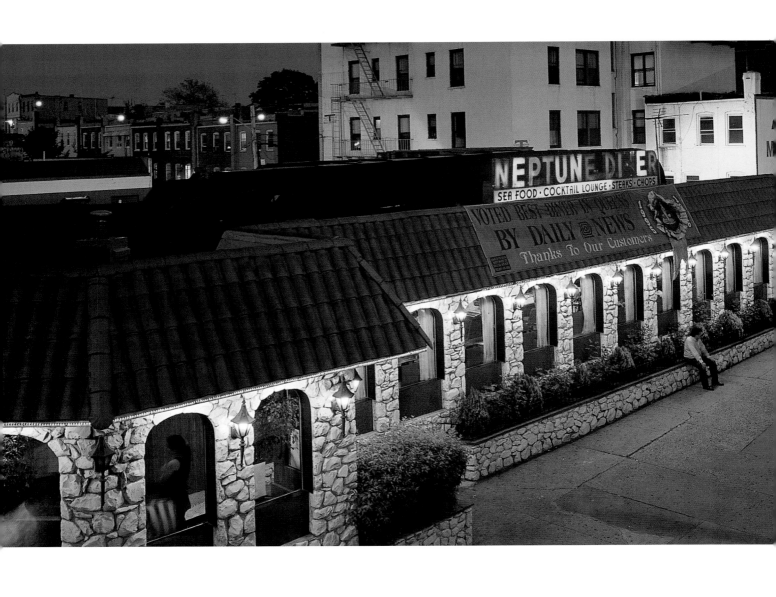

Above Neptune Diner, Astoria, Queens
Opposite Bayonne Bridge and Grove Avenue, Port Richmond, Staten Island

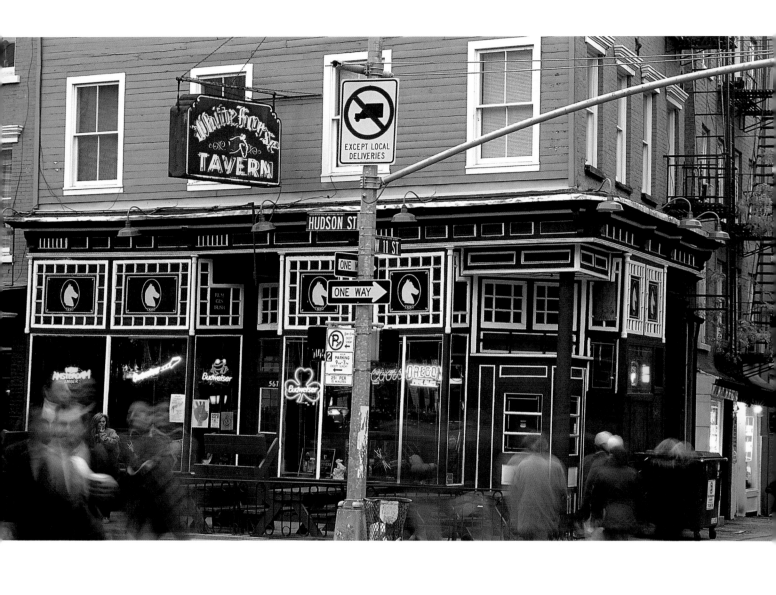

Above White Horse Tavern, Greenwich Village, Manhattan
Opposite Lobster House, City Island, the Bronx
Overleaf "21" Club, Manhattan

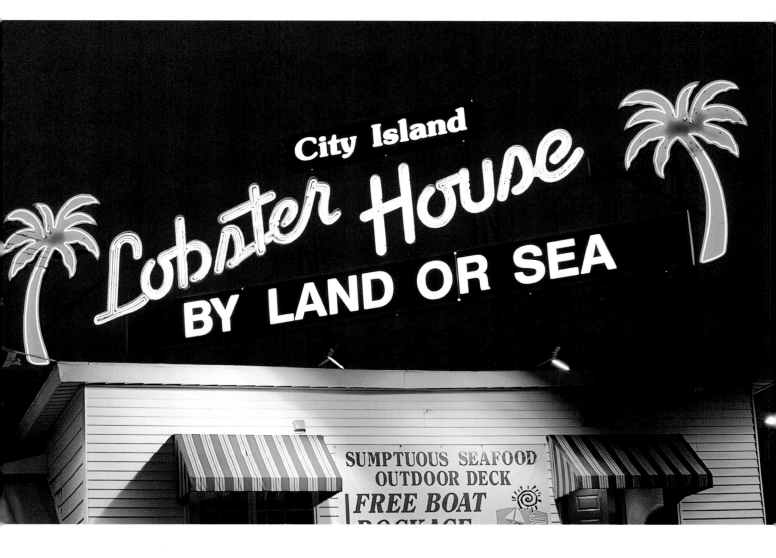

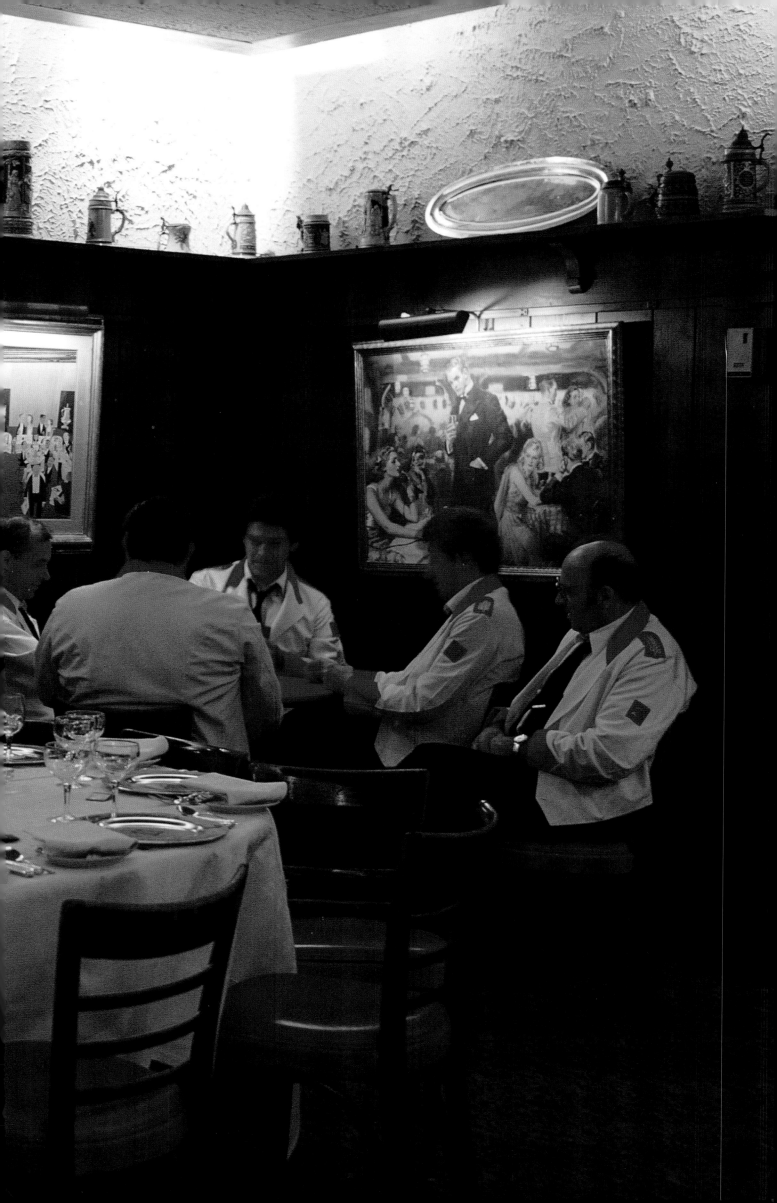

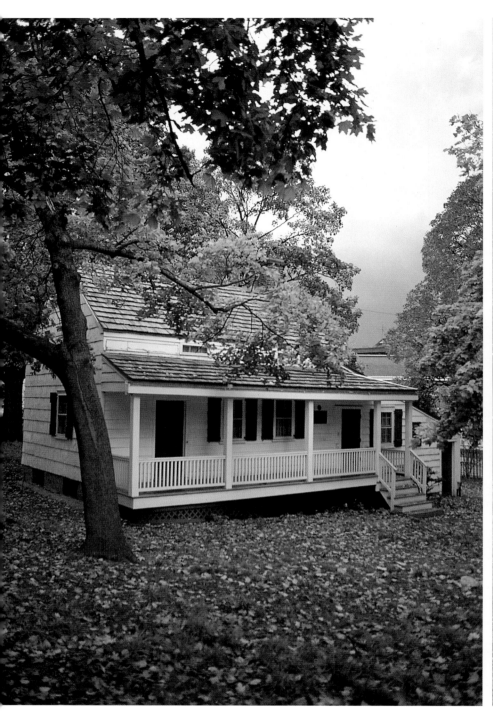

Above Edgar Allan Poe Cottage, the Bronx
Opposite Seguine House, Staten Island

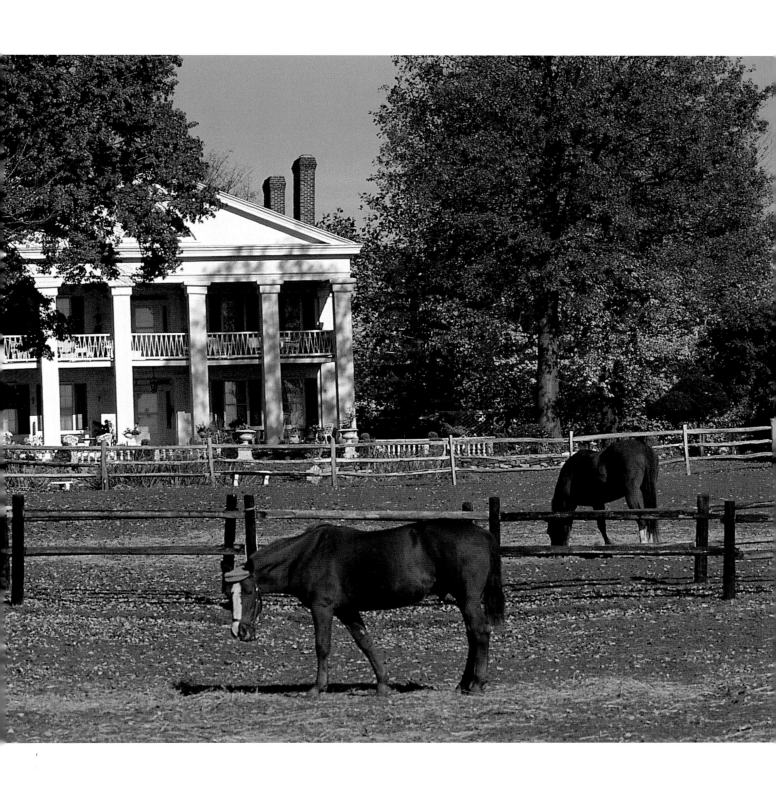

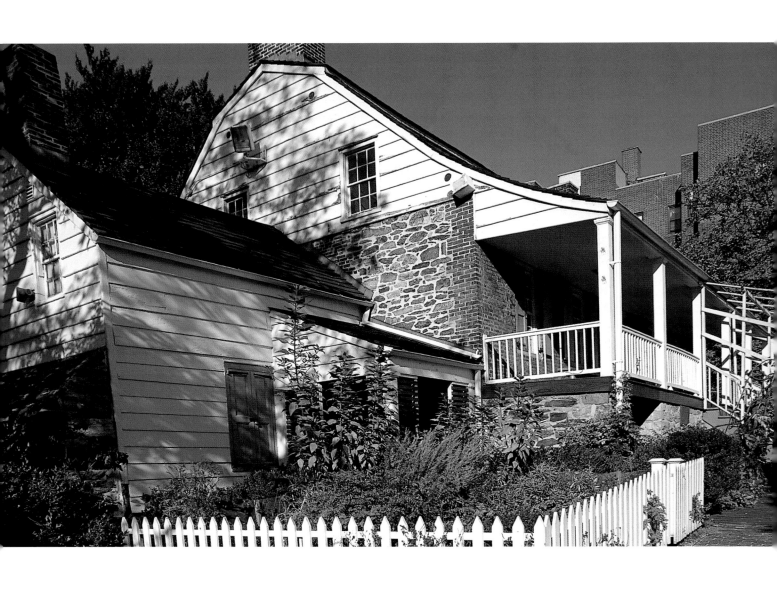

Above Dyckman House, Broadway and 204th Street, Manhattan
Opposite Conference House, Staten Island

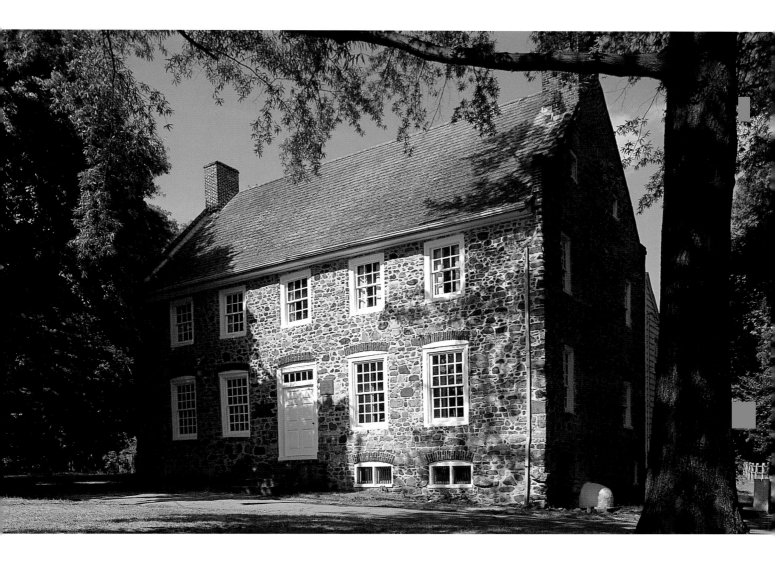

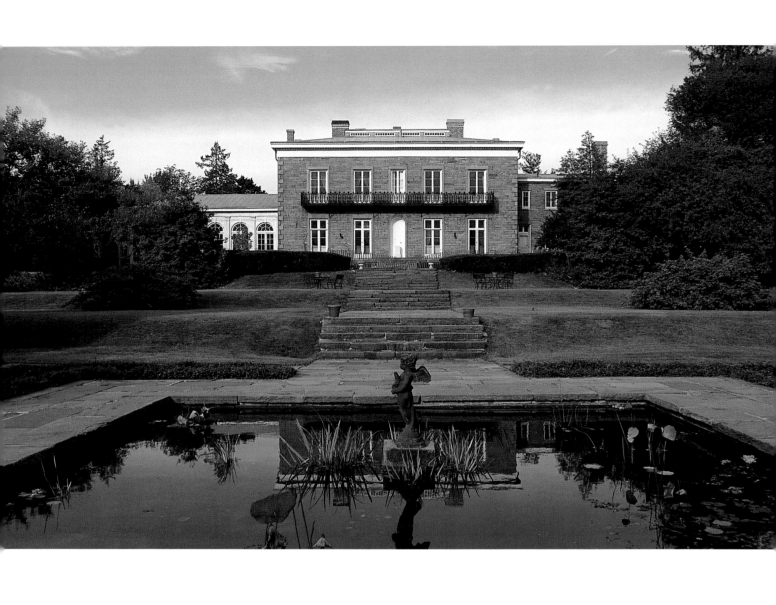

Above Bartow-Pell Mansion Museum, Pelham Bay Park, the Bronx
Opposite The Cloisters, Fort Tryon Park, Manhattan

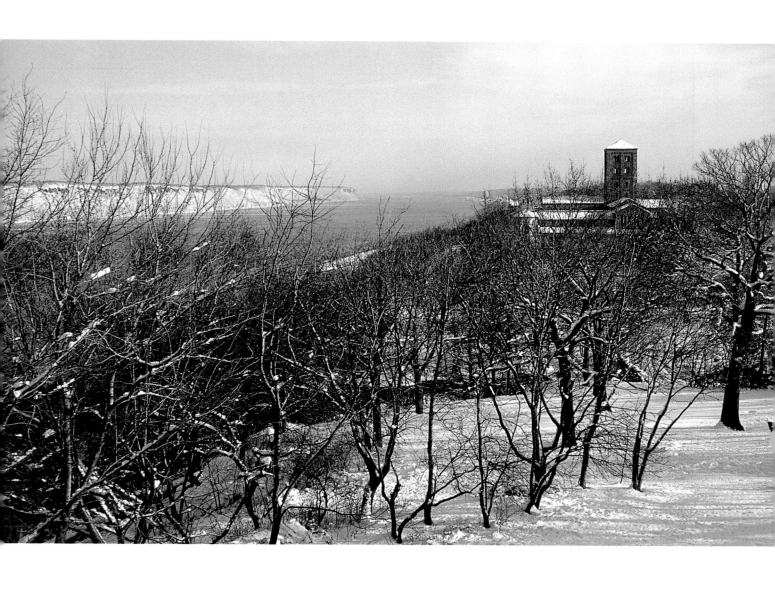

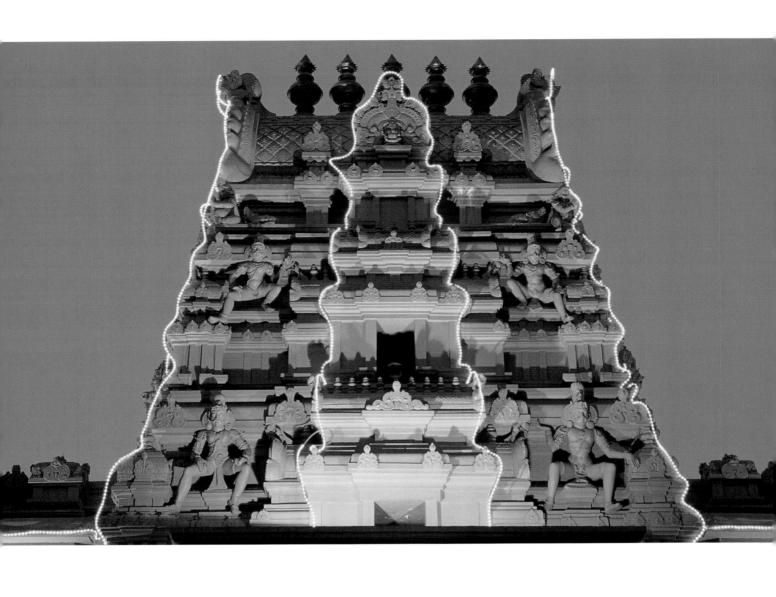

Above Hindu Temple Society of North America, Flushing, Queens
Opposite Sony (formerly AT&T) Building, Manhattan
Overleaf Water towers and Lower Manhattan

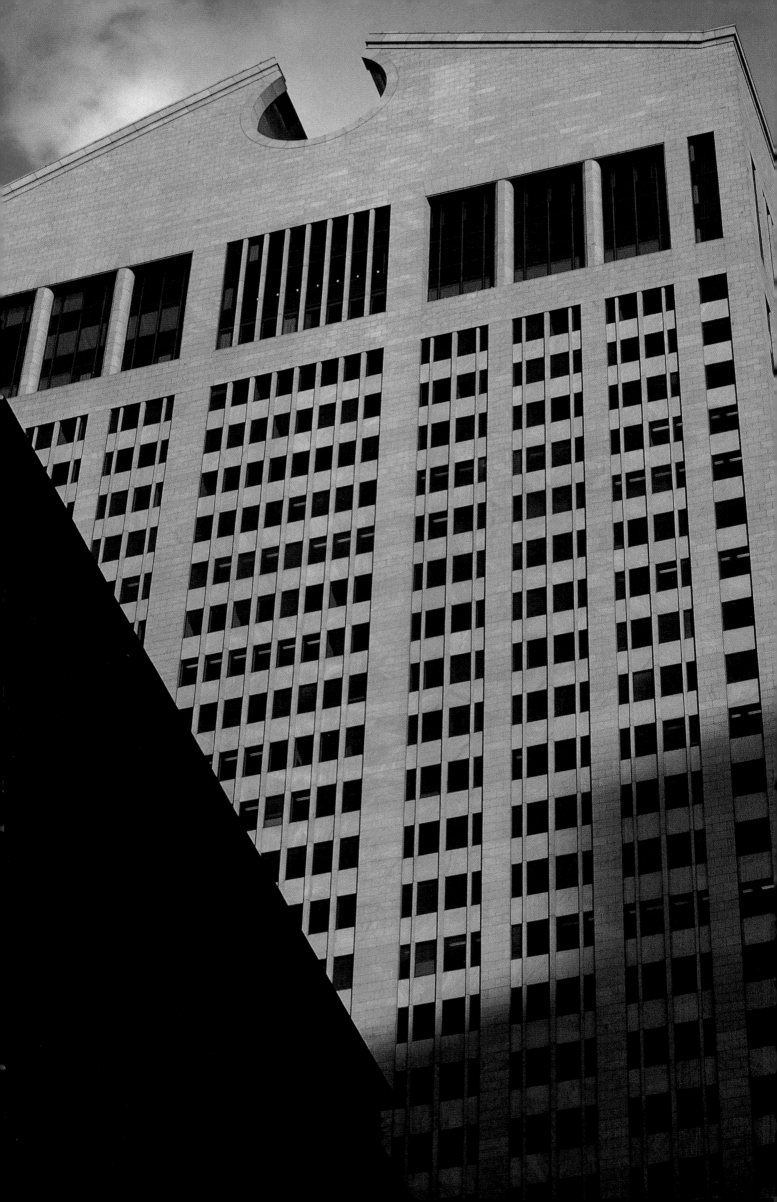

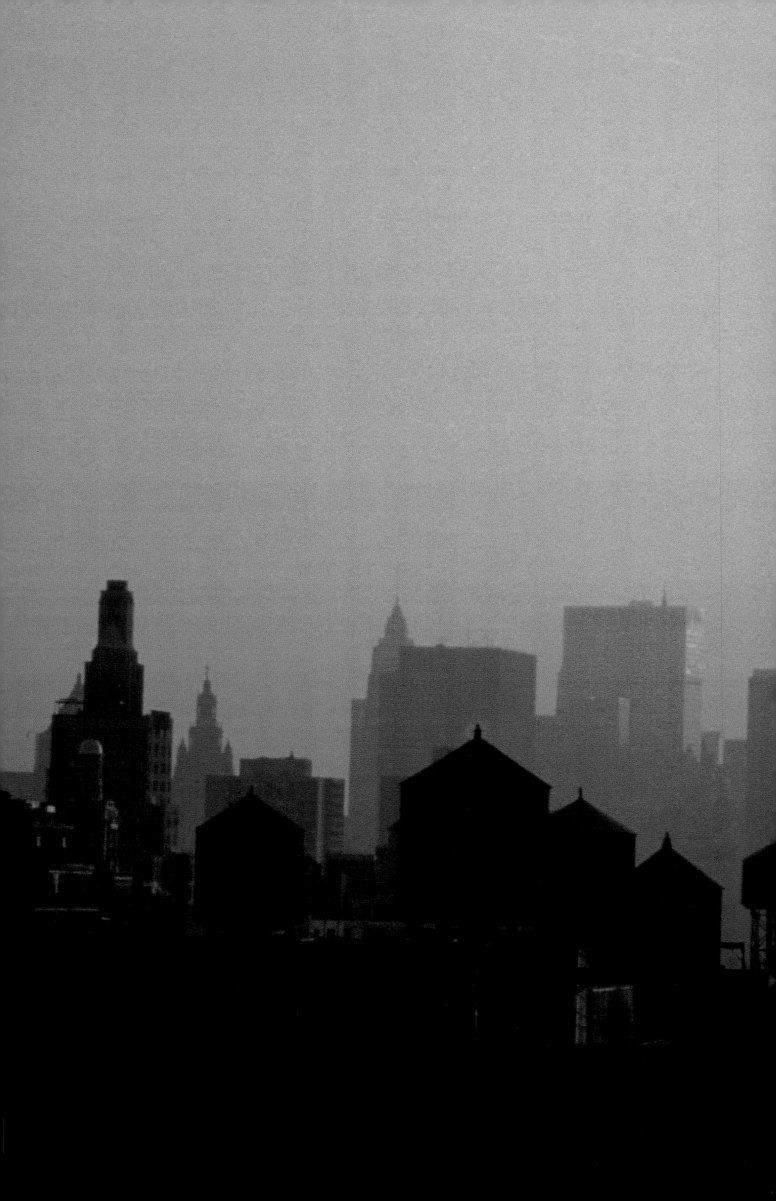

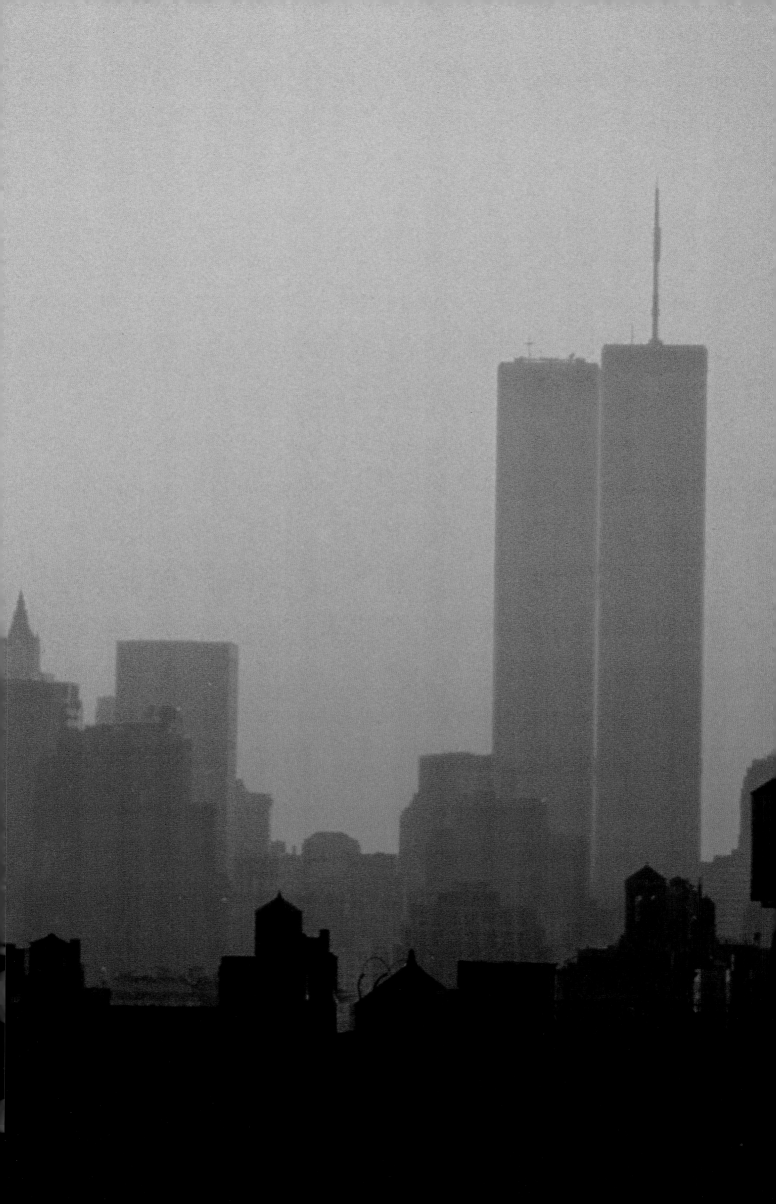

EDGE

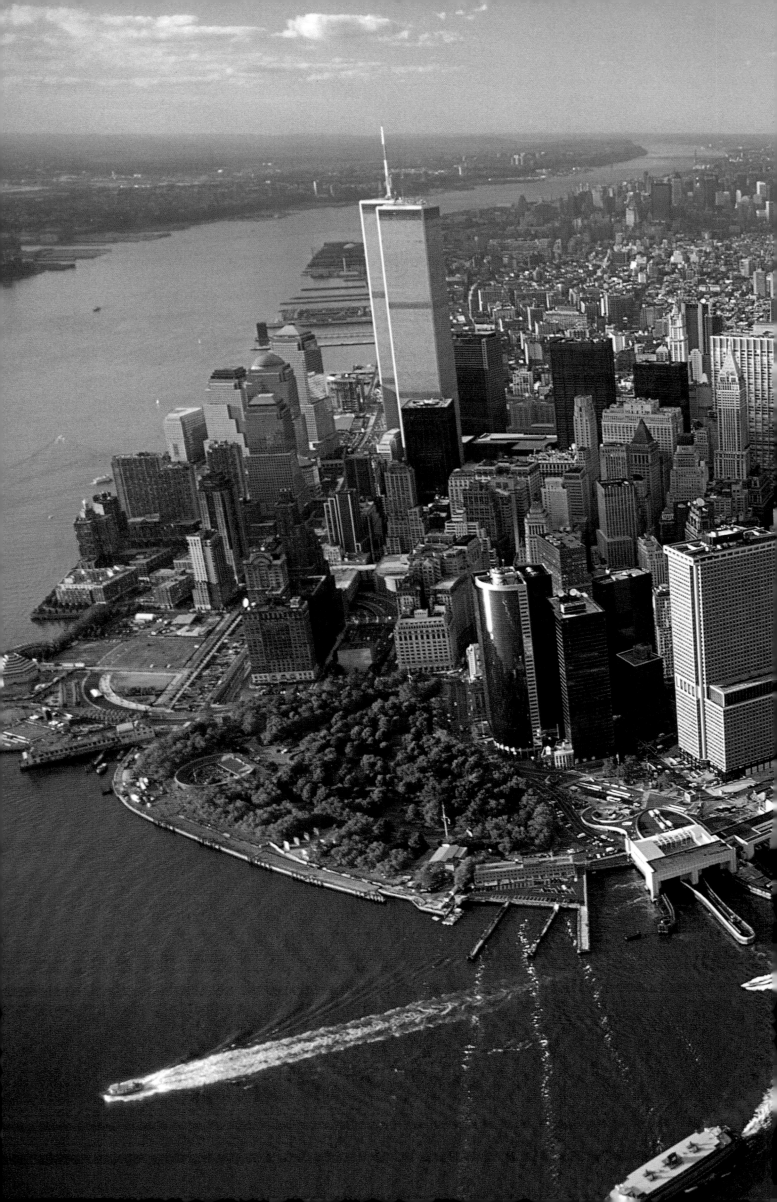

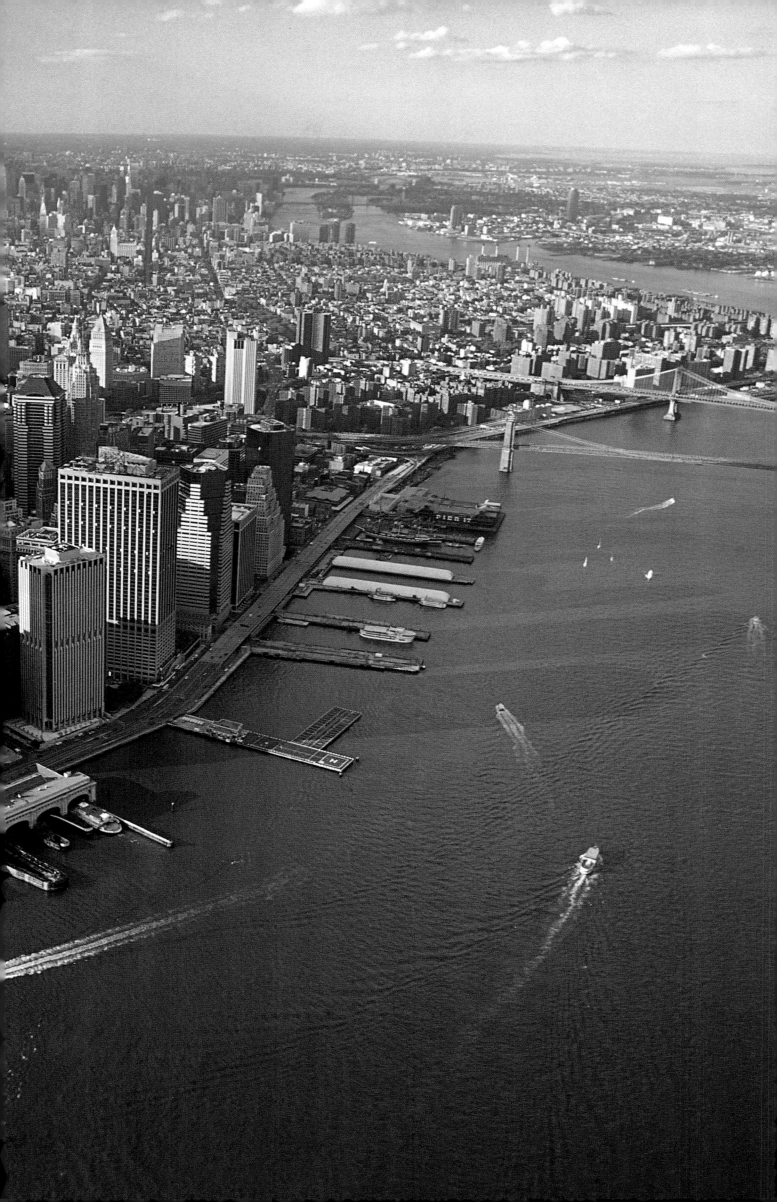

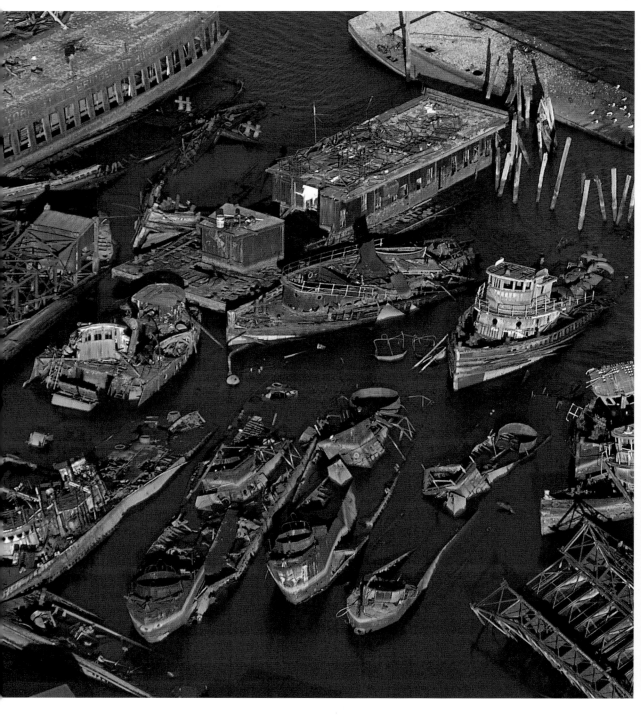

Above Ship graveyard, Arthur Kill, Staten Island
Opposite Arthur Kill, Staten Island
Preceding pages Jacob Riis Park, Gateway National Recreation Area, Queens; Battery Park and Manhattan
Overleaf Sheepshead Bay, Brooklyn

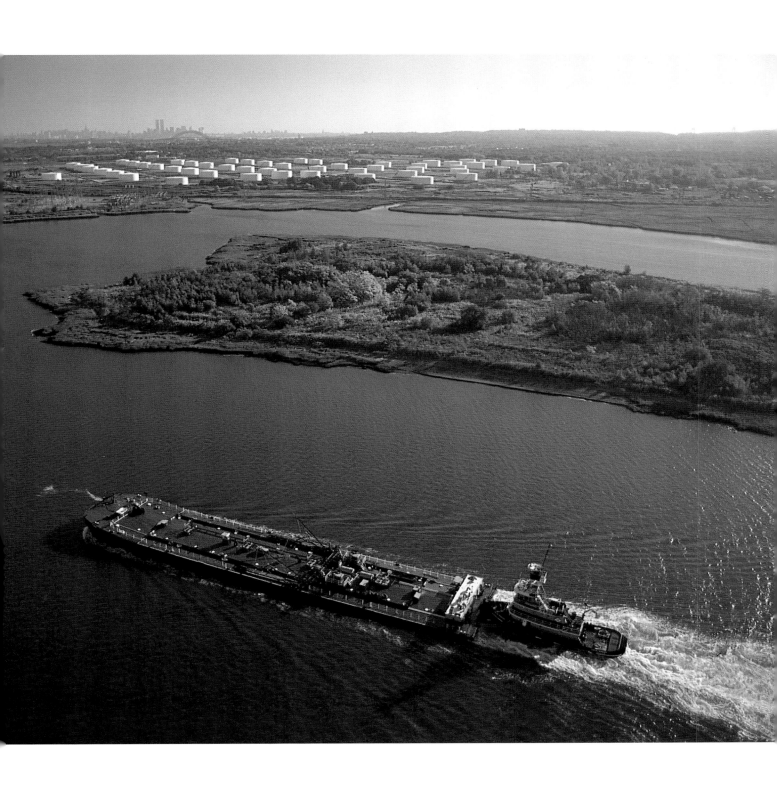

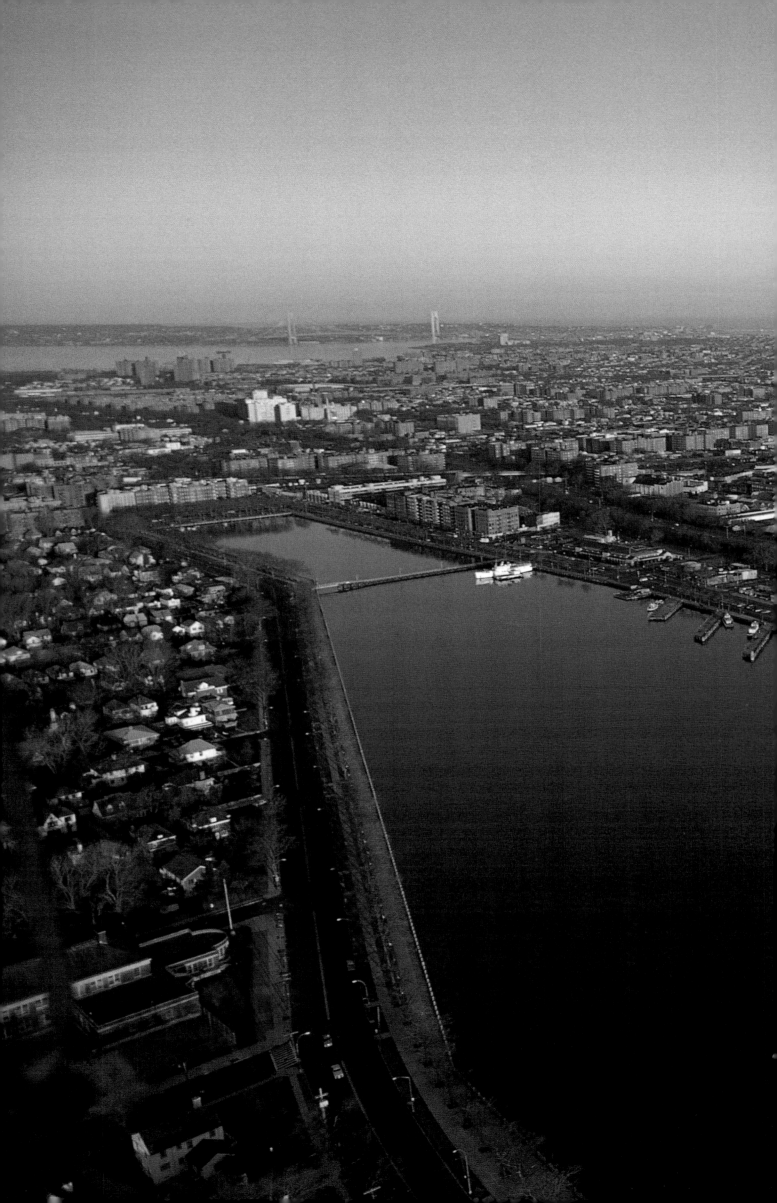

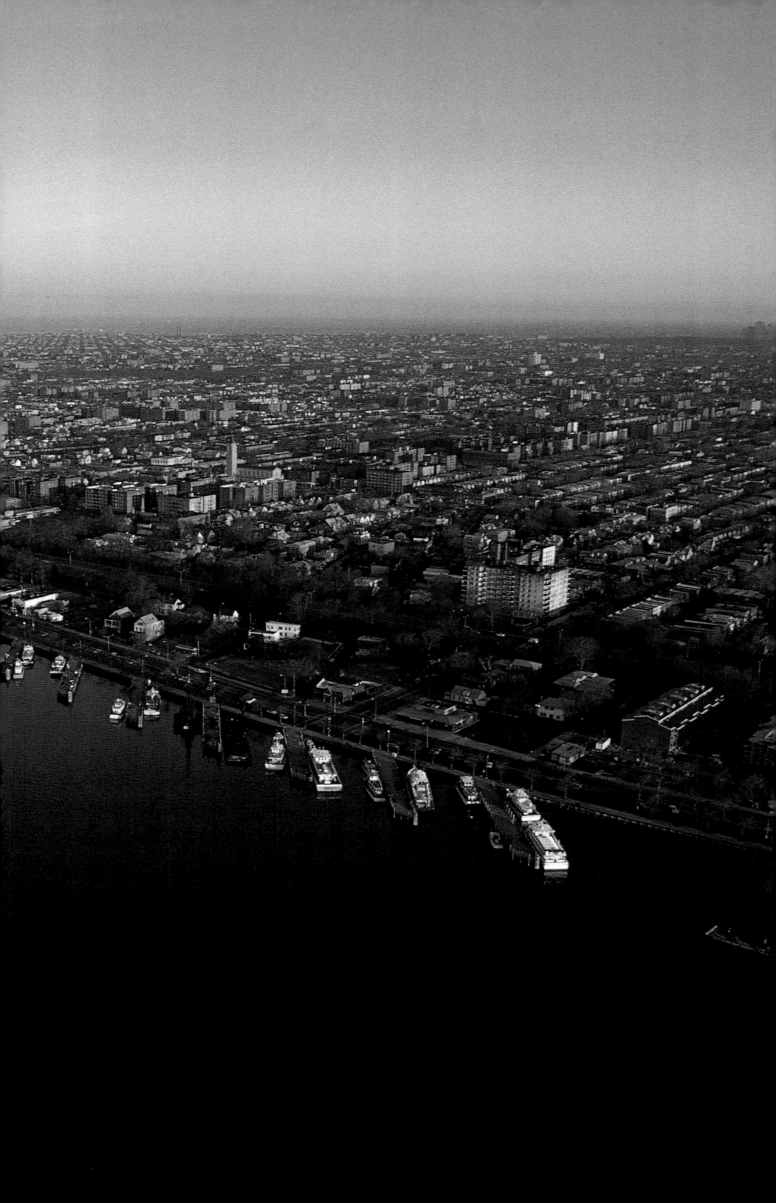

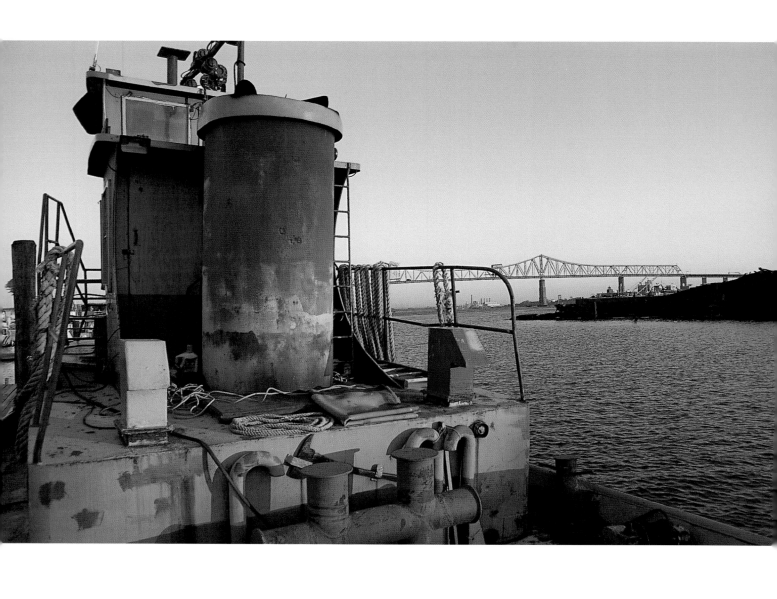

Above Tugboat, with Outerbridge Crossing in the distance, Arthur Kill, Staten Island
Opposite Staten Island Ferry, Upper New York Bay

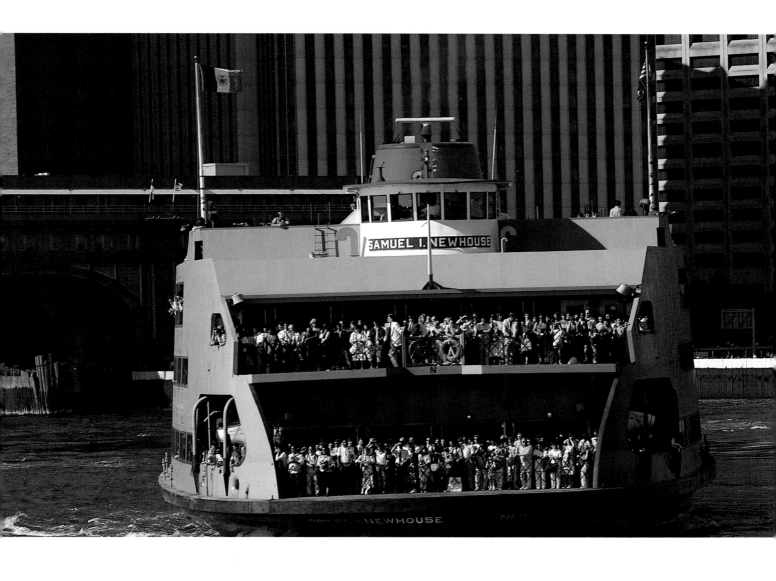

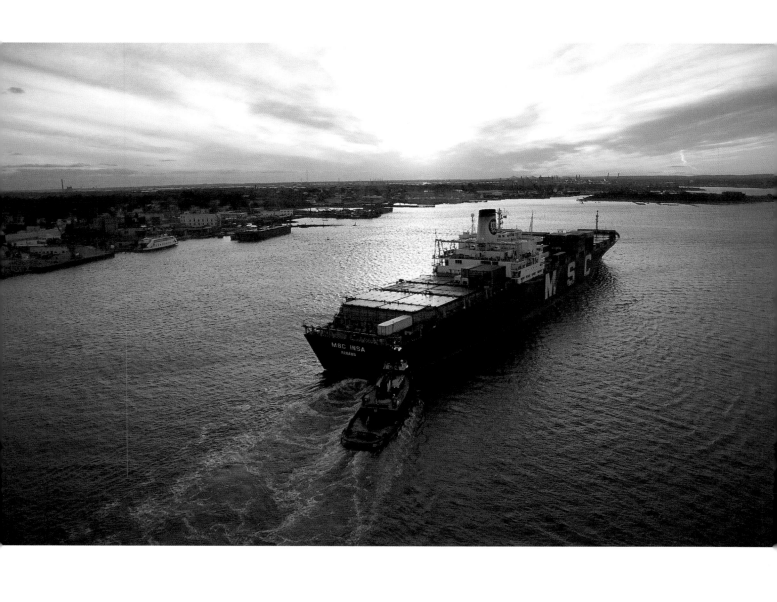

Above and opposite Kill Van Kull, Staten Island
Overleaf Great Kills Harbor, Staten Island

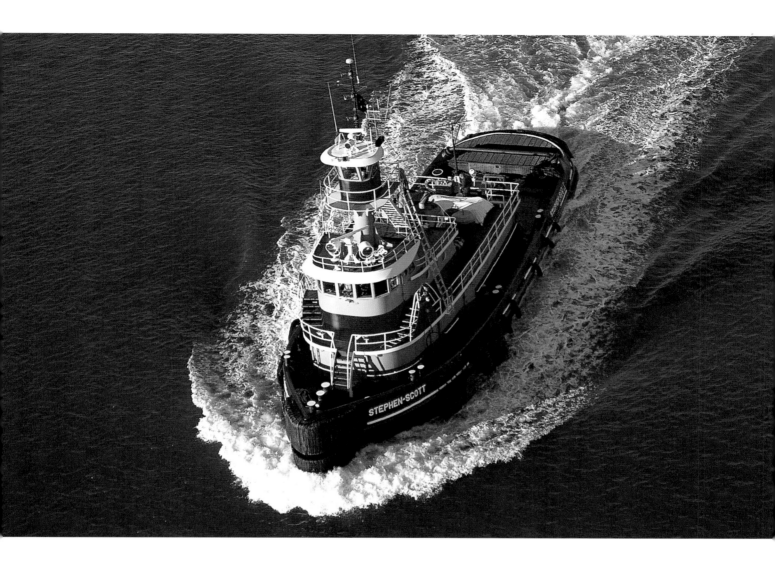

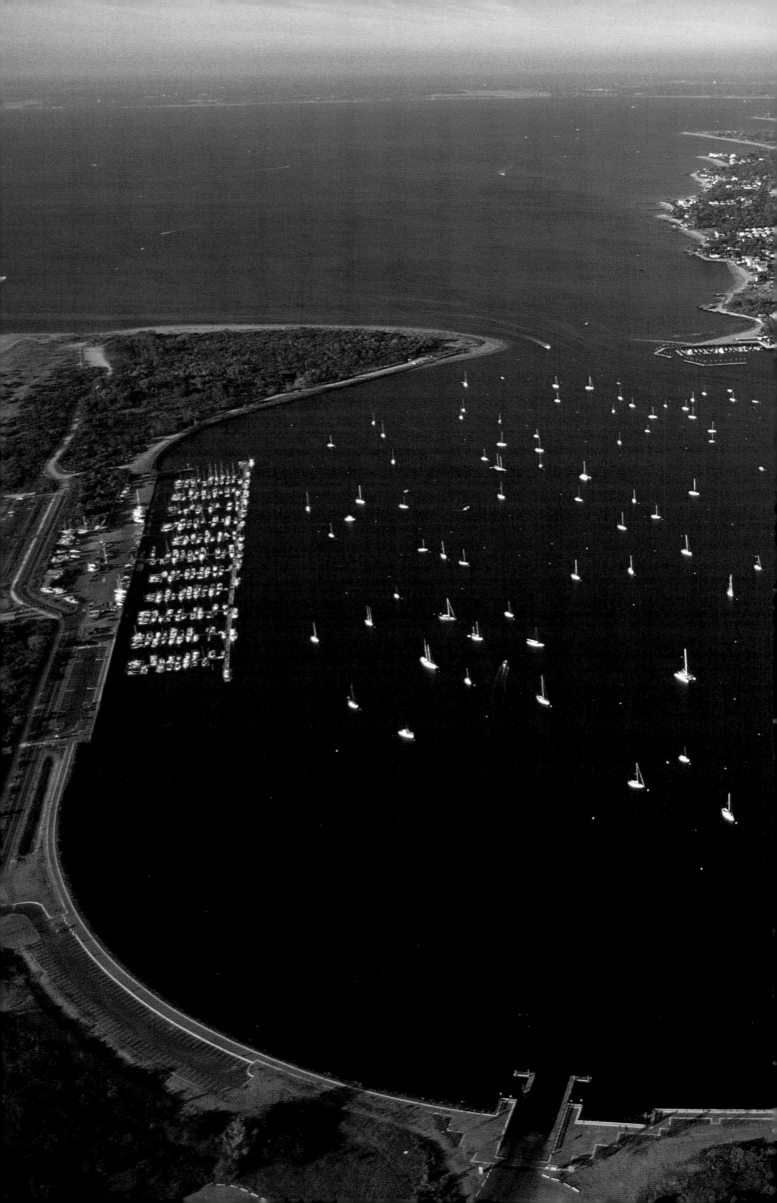

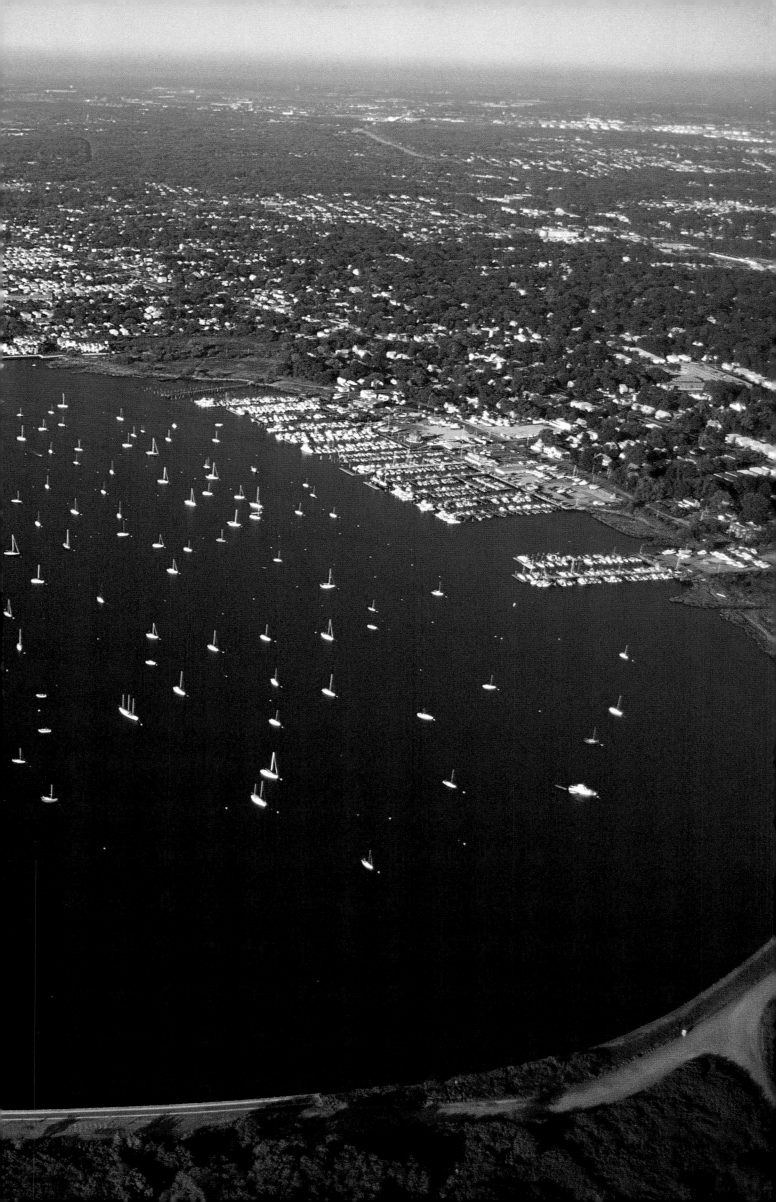

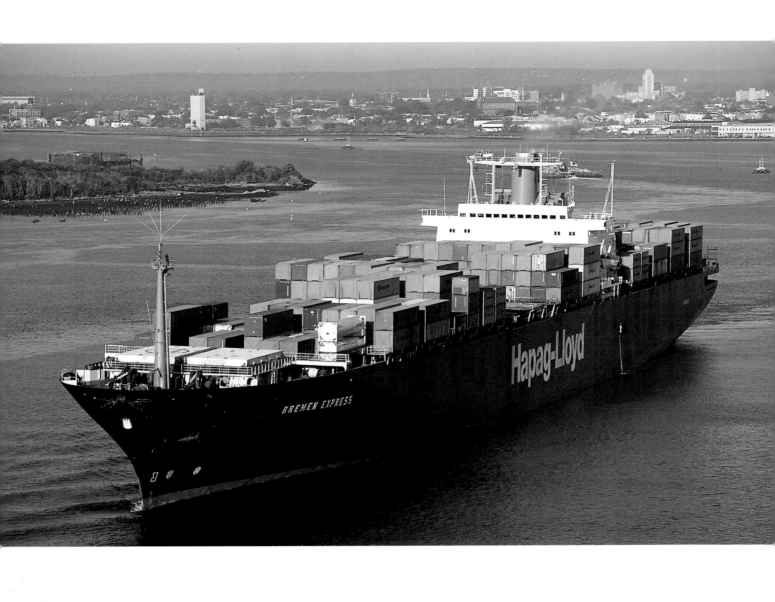

Above Kill Van Kull, Staten Island
Opposite Verrazano-Narrows Bridge and Staten Island

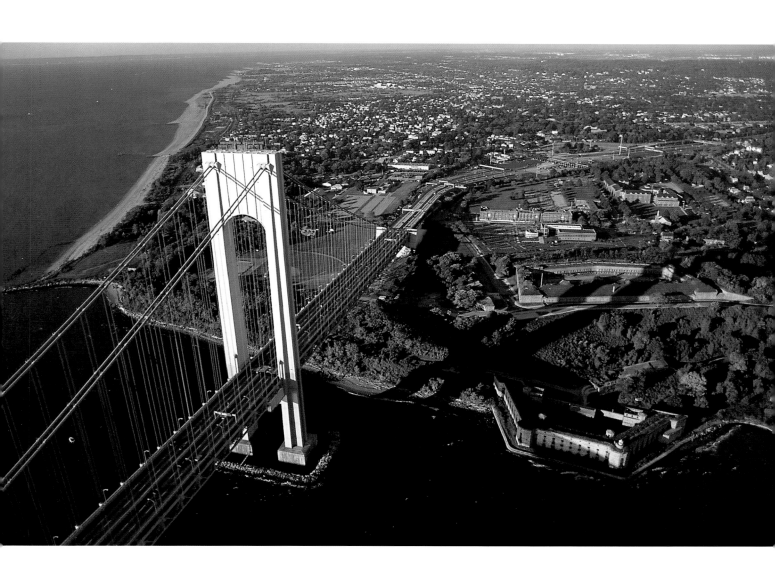

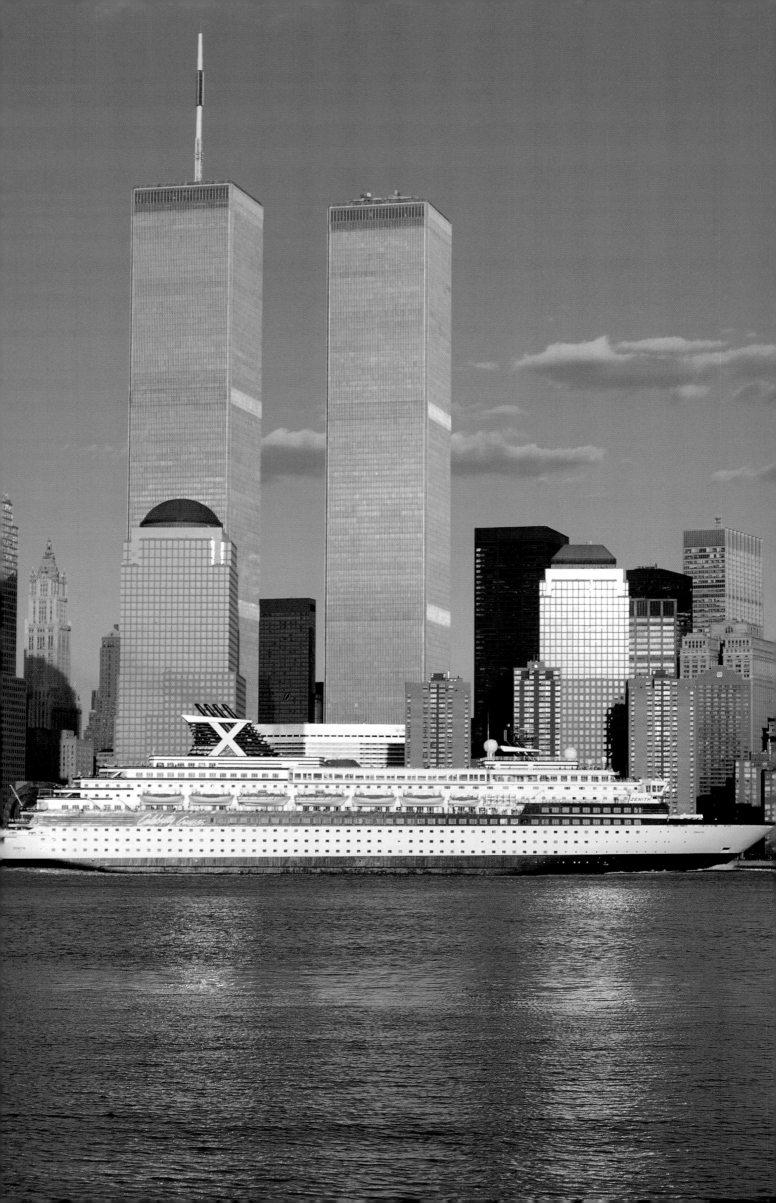

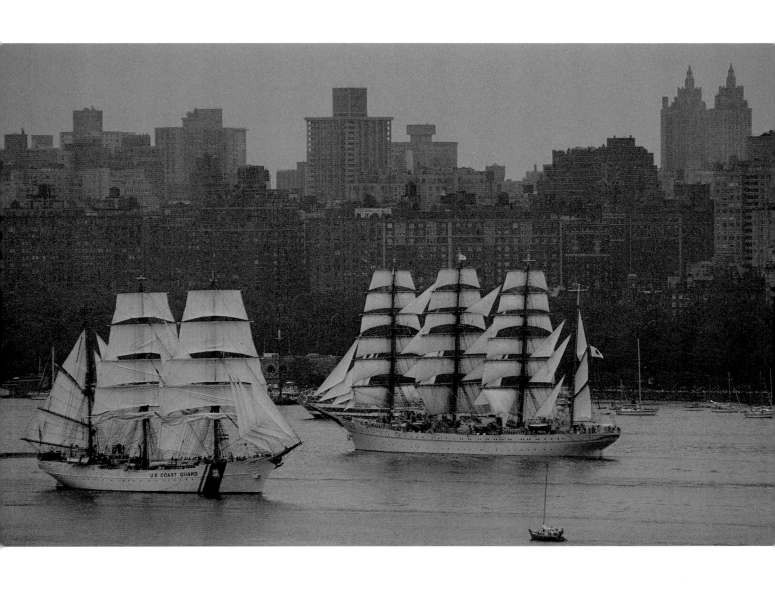

Above Tall ships, Hudson River, and West Side, Manhattan
Opposite Hudson River and Lower Manhattan

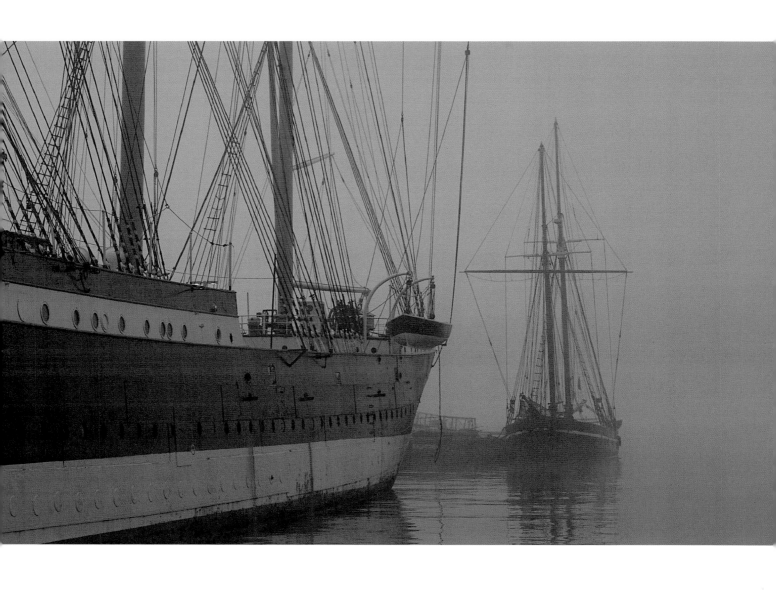

Above South Street Seaport, Manhattan
Opposite Ellis Island National Monument

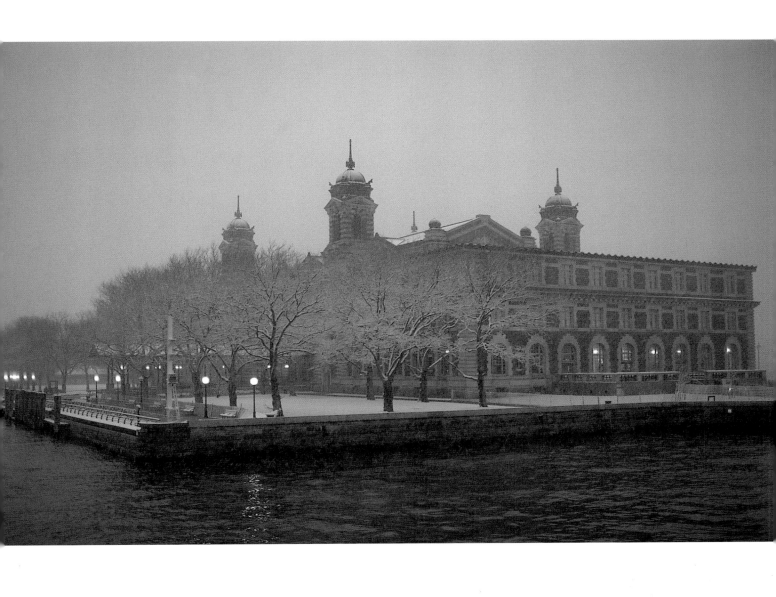

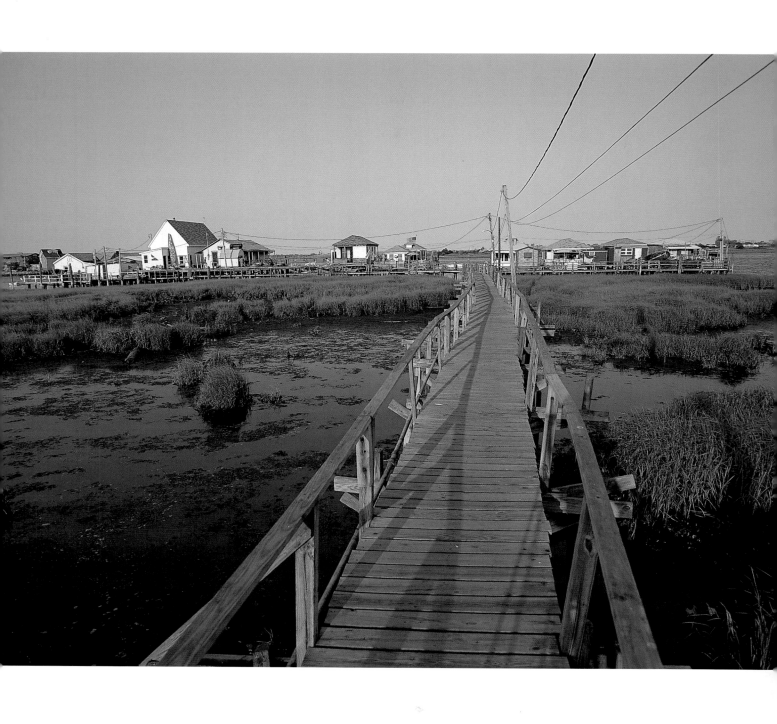

Above Broad Channel, Queens
Opposite South Cove, Battery Park City, Manhattan
Overleaf Riverside Park, Manhattan

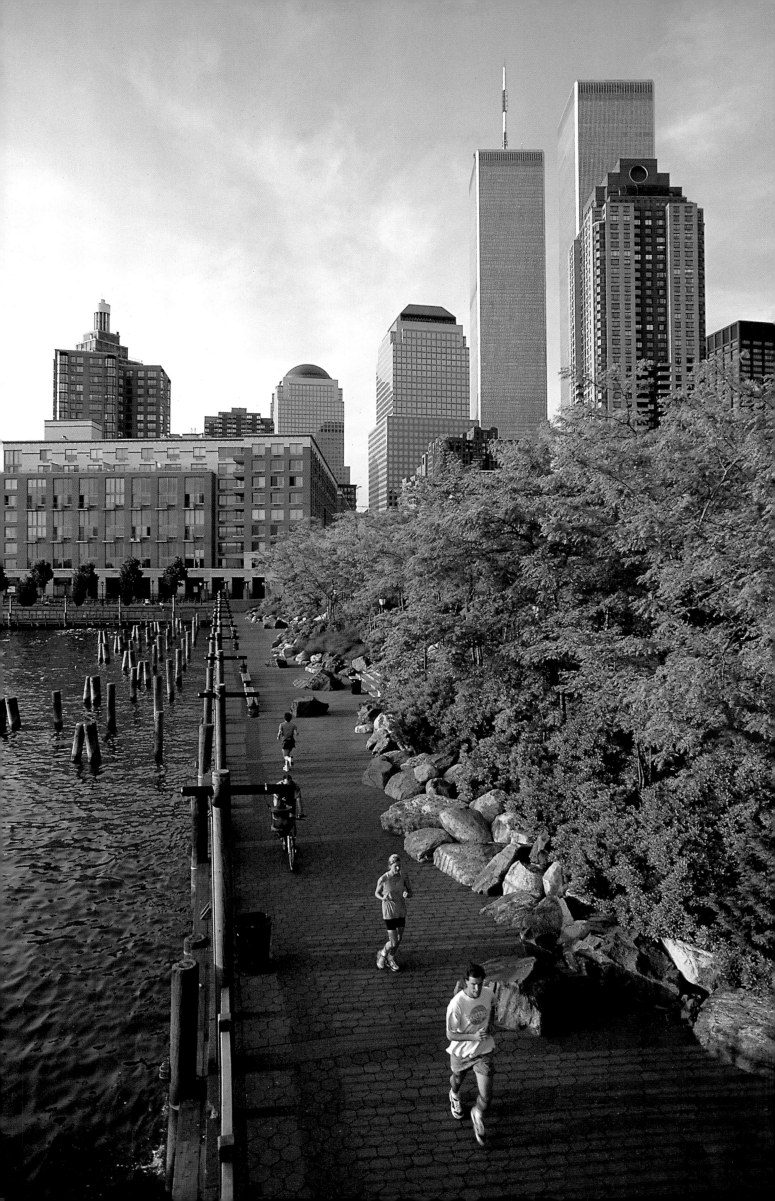

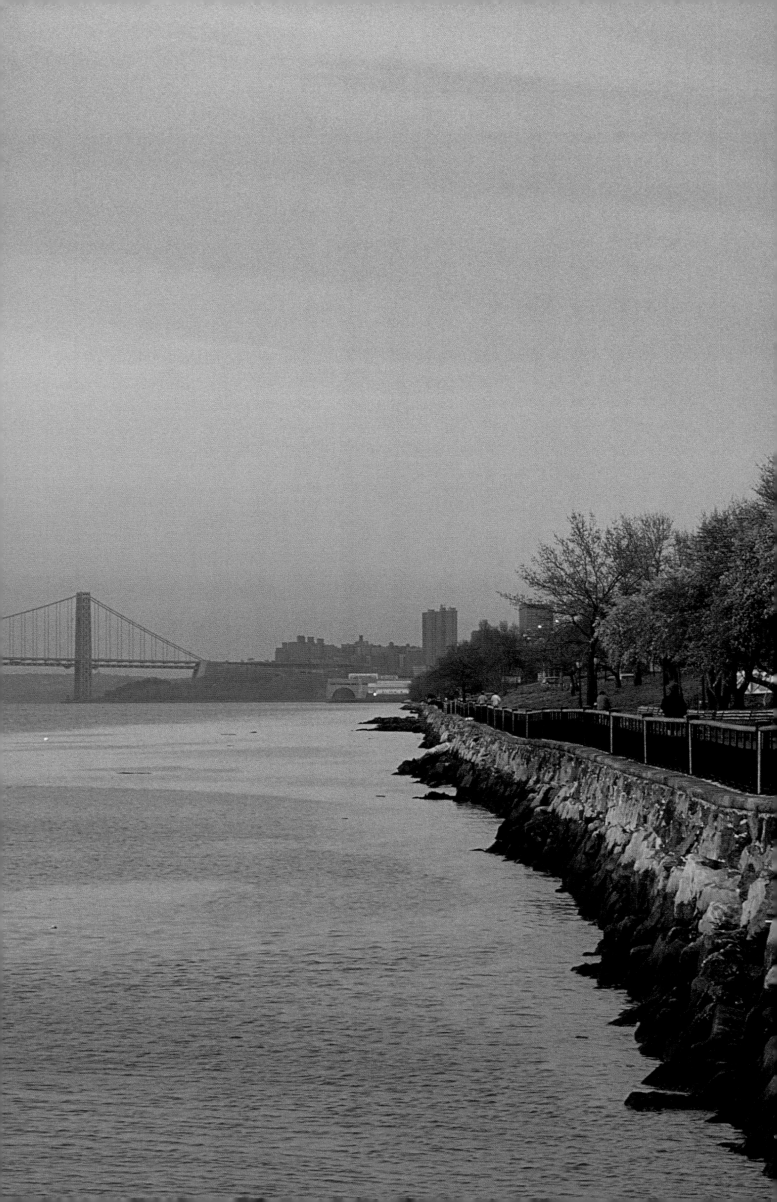

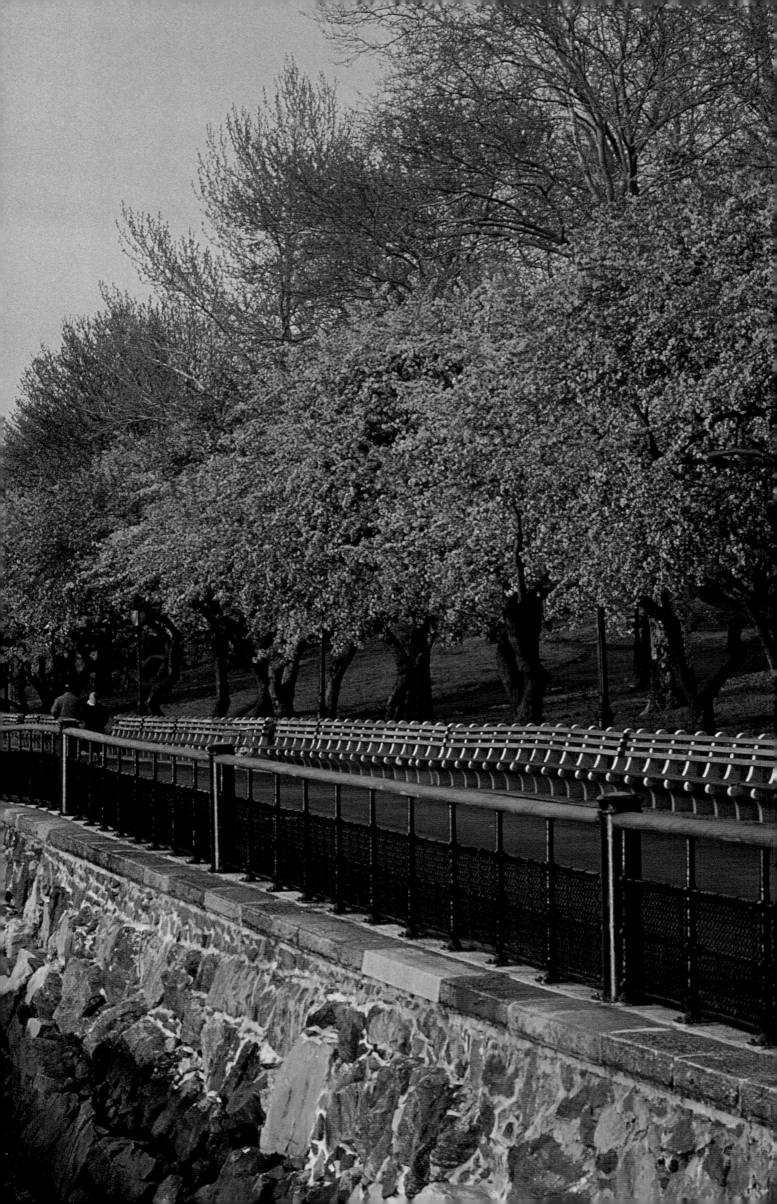

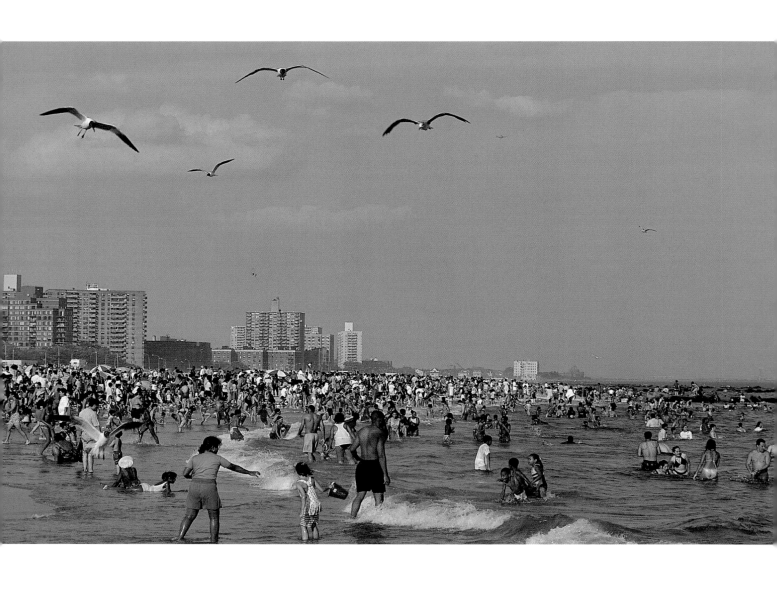

Above Coney Island, Brooklyn
Opposite Brighton Beach, Brooklyn
Overleaf Cyclone roller-coaster, Coney Island, Brooklyn

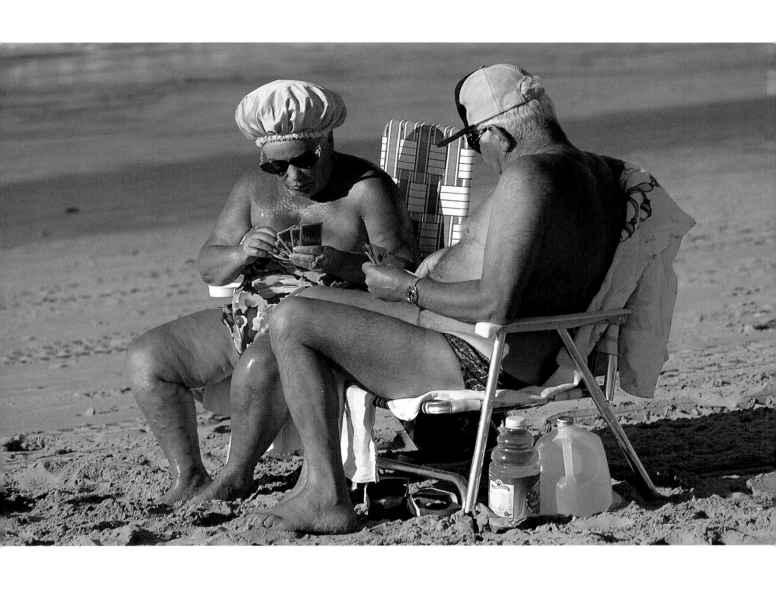

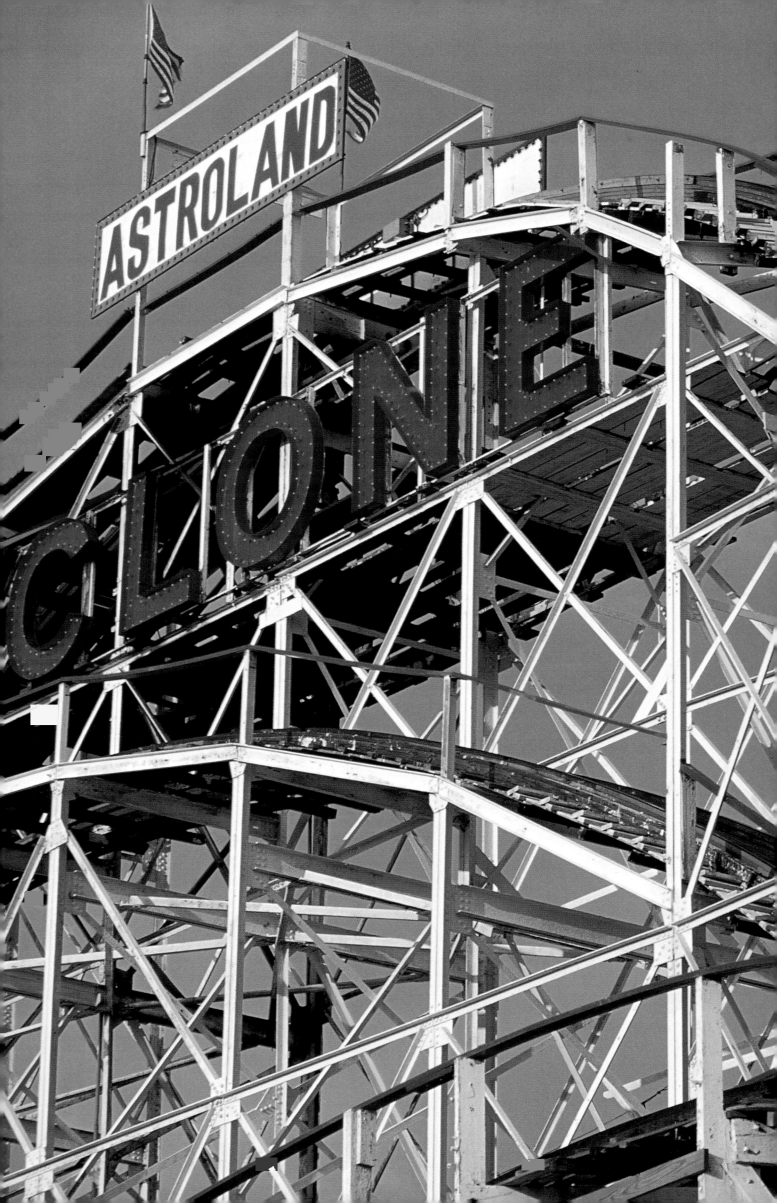

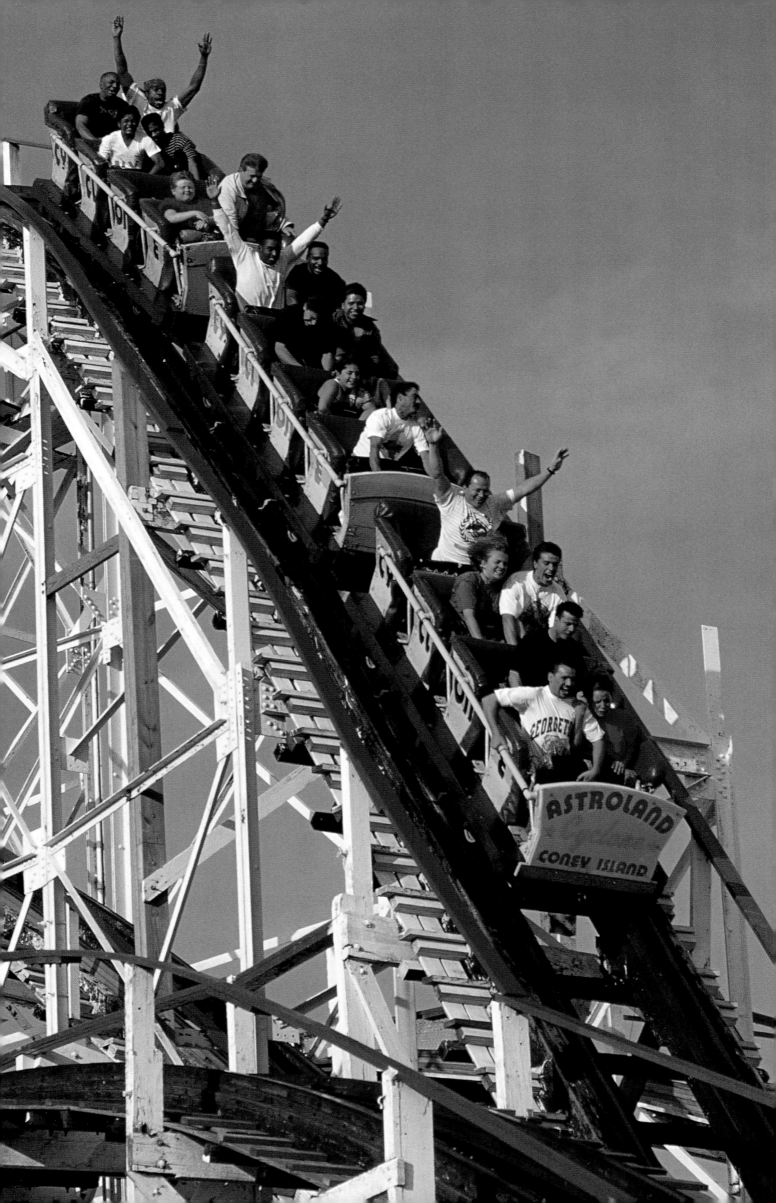

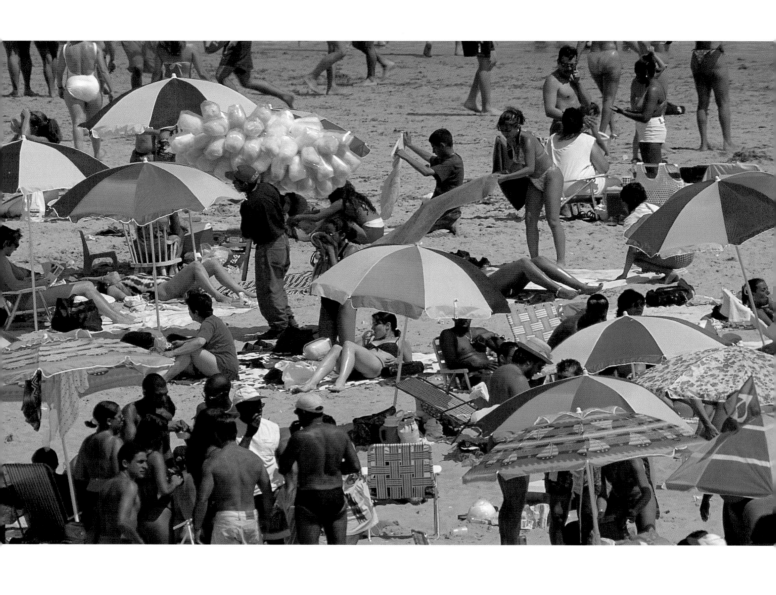

Above Rockaway Beach, Queens
Opposite Coney Island, Brooklyn

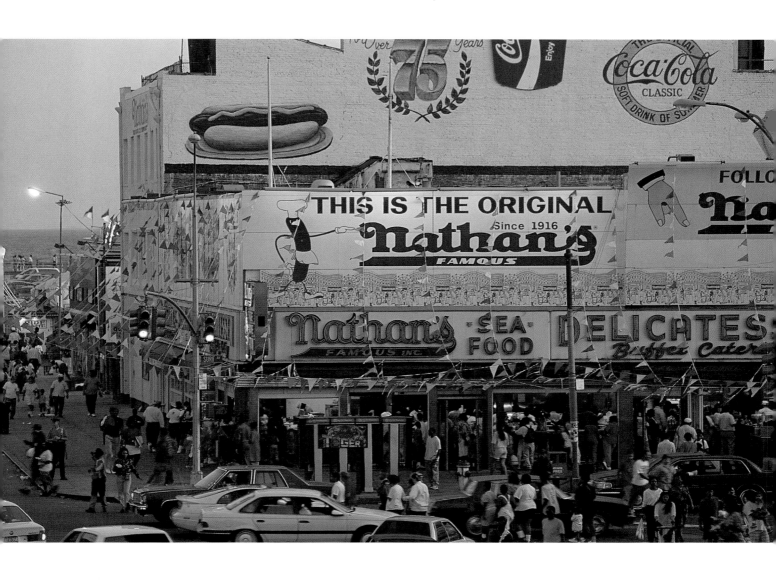

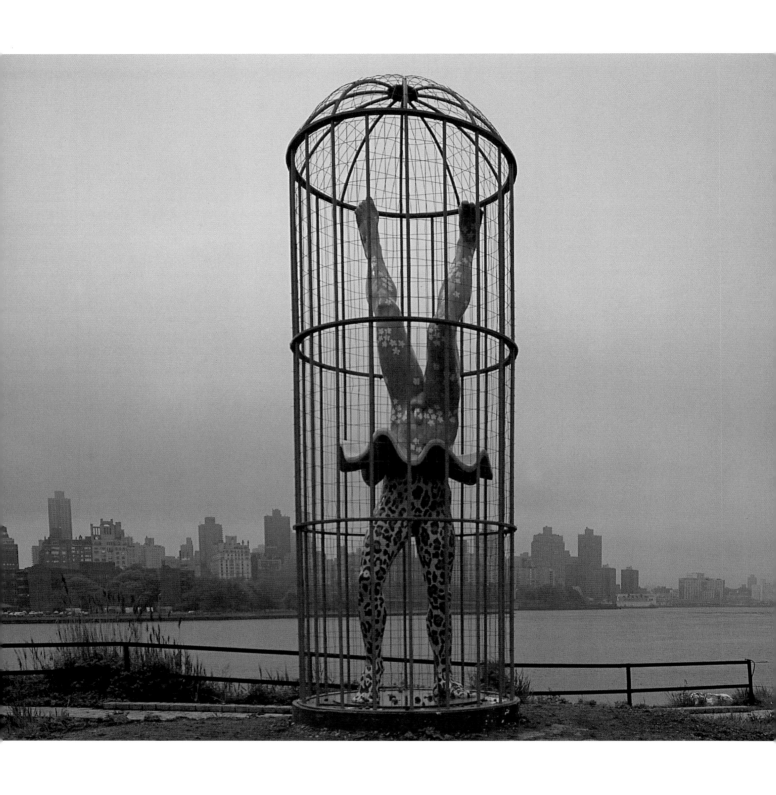

Above Socrates Sculpture Park, Long Island City, Queens
Opposite Brighton Beach, Brooklyn

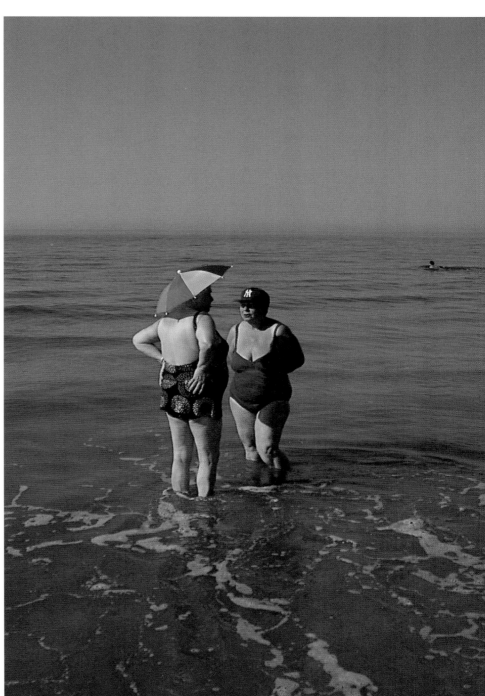

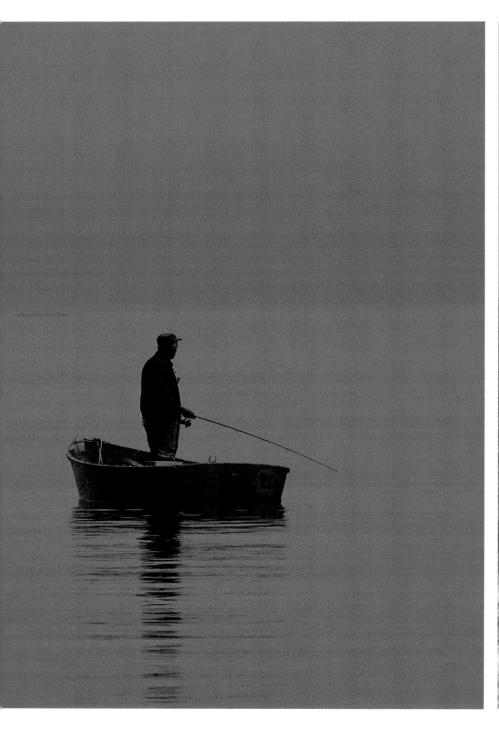

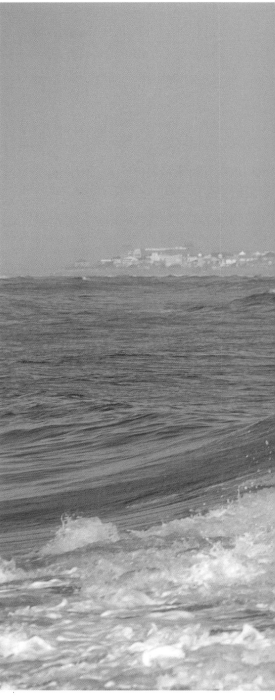

Above City Island, the Bronx
Opposite and overleaf Rockaway Beach, Queens

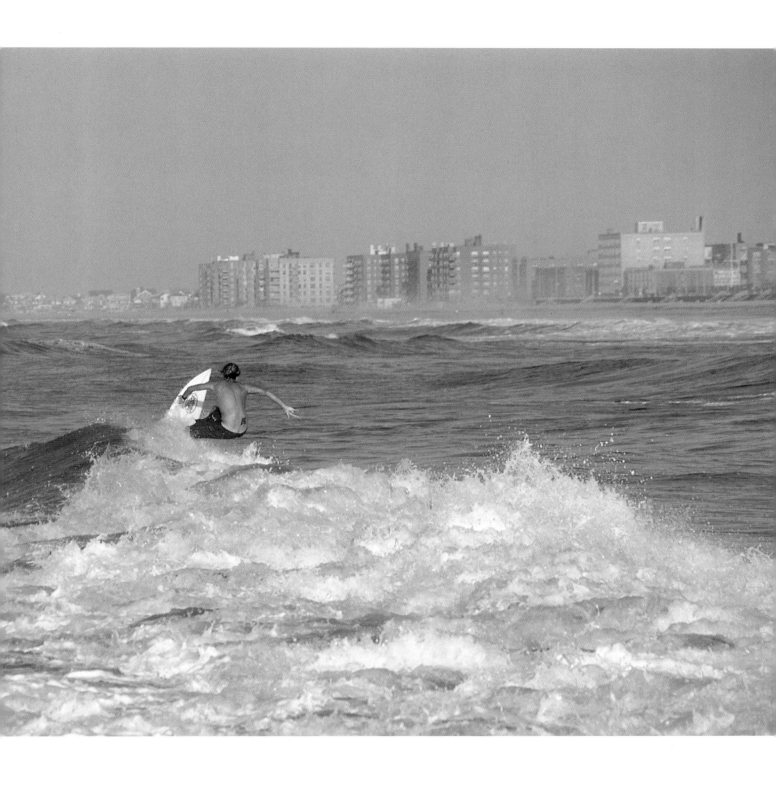

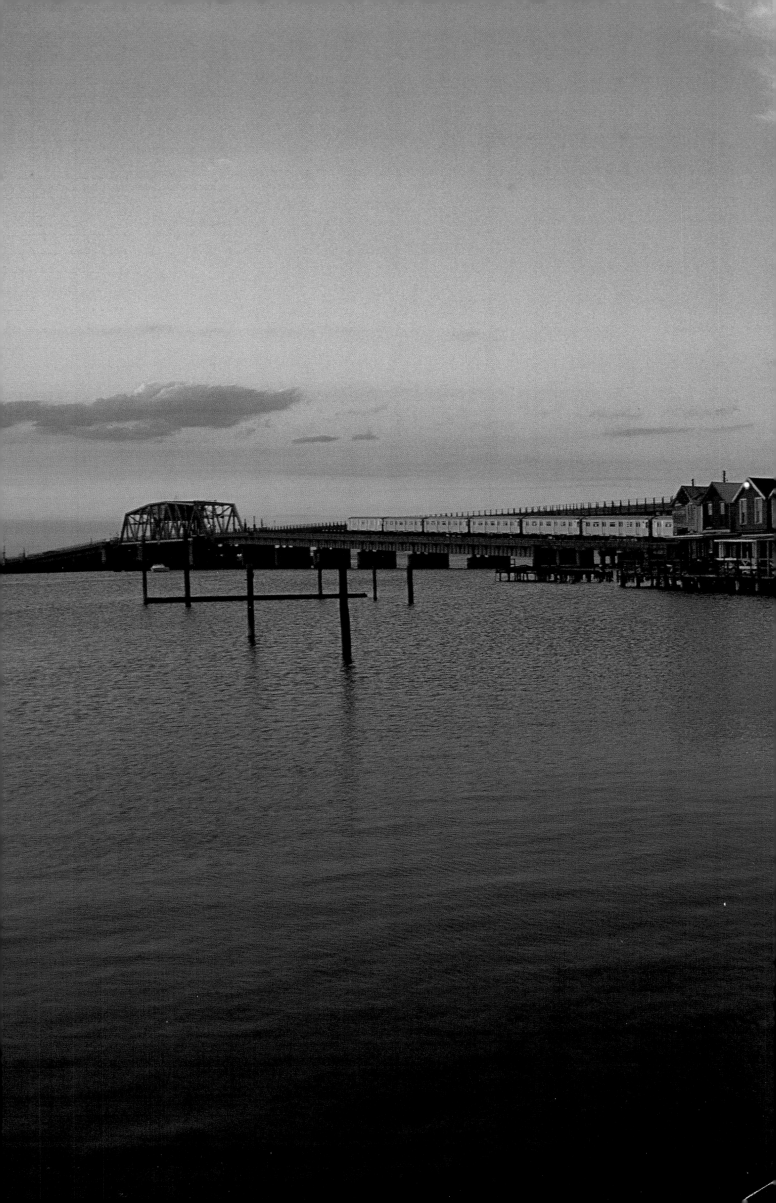

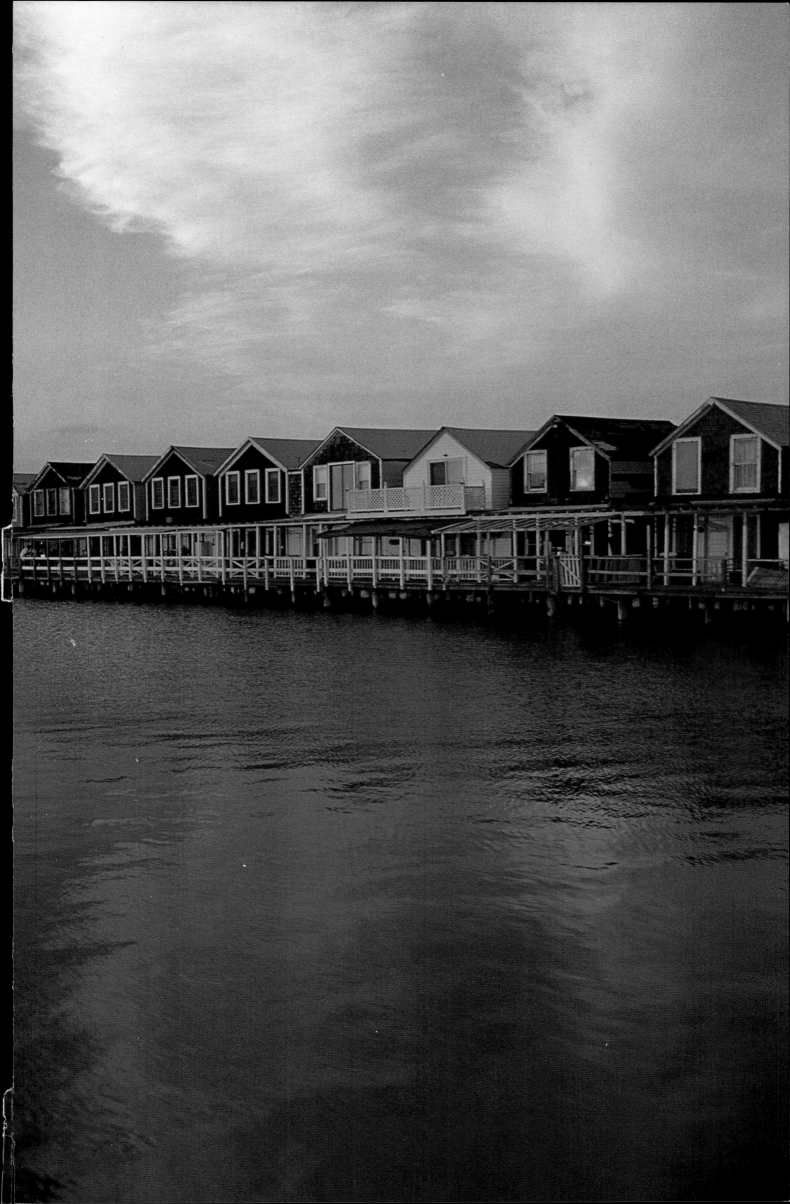

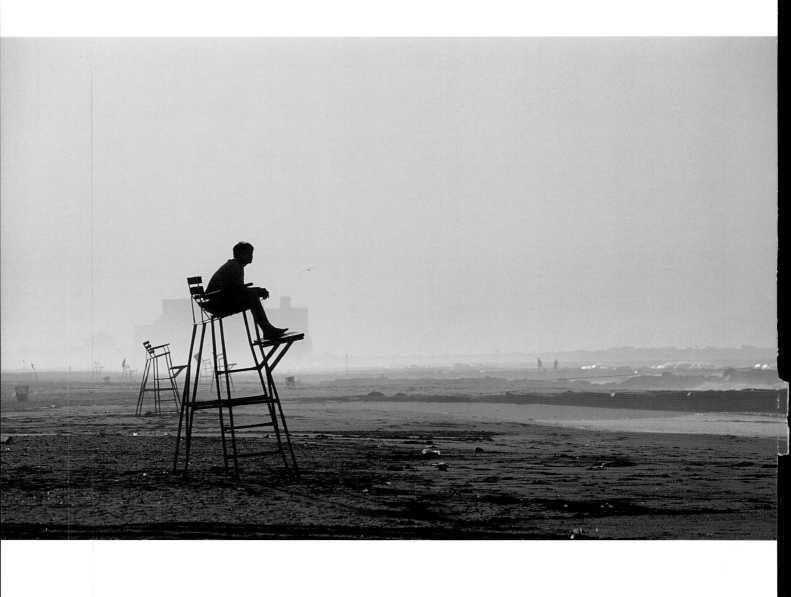

Above Rockaway Beach, Queens
Opposite Jacob Riis Park, Gateway National Recreation Area, Queens
Overleaf Orchard Beach, Pelham Bay, the Bronx

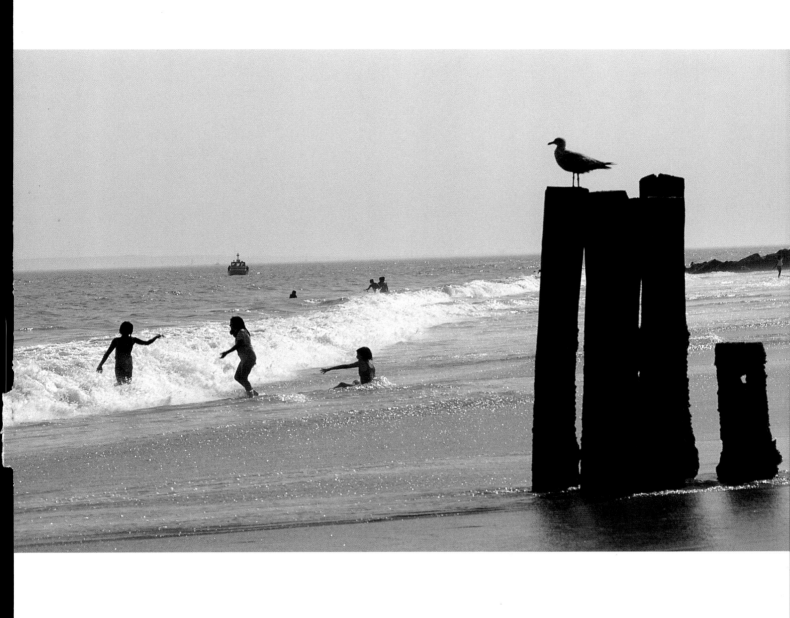

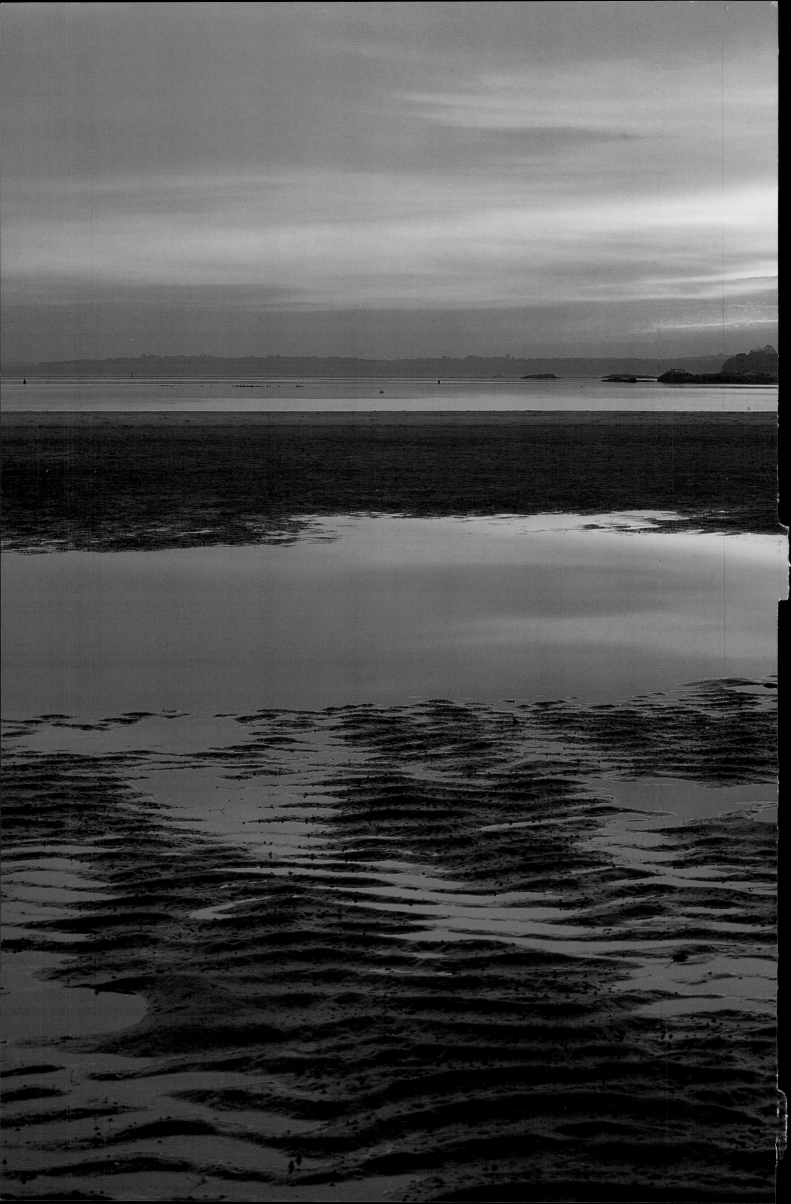

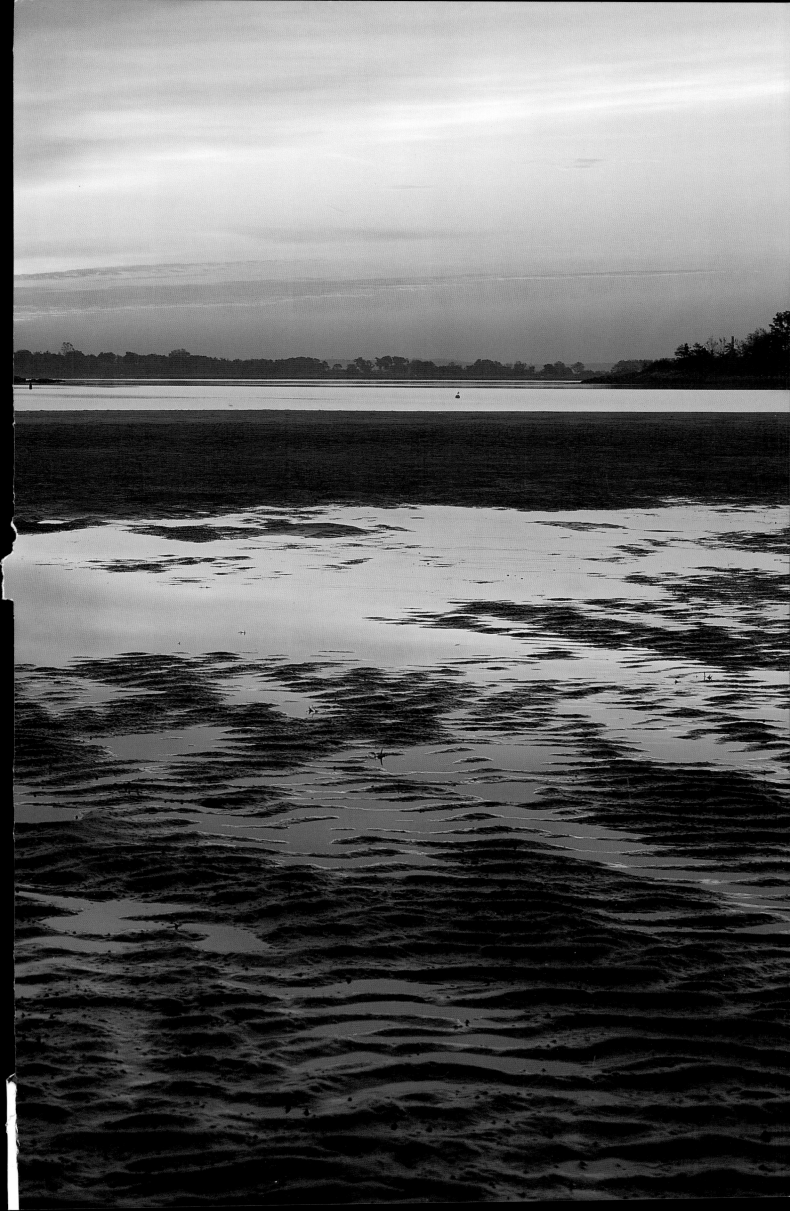

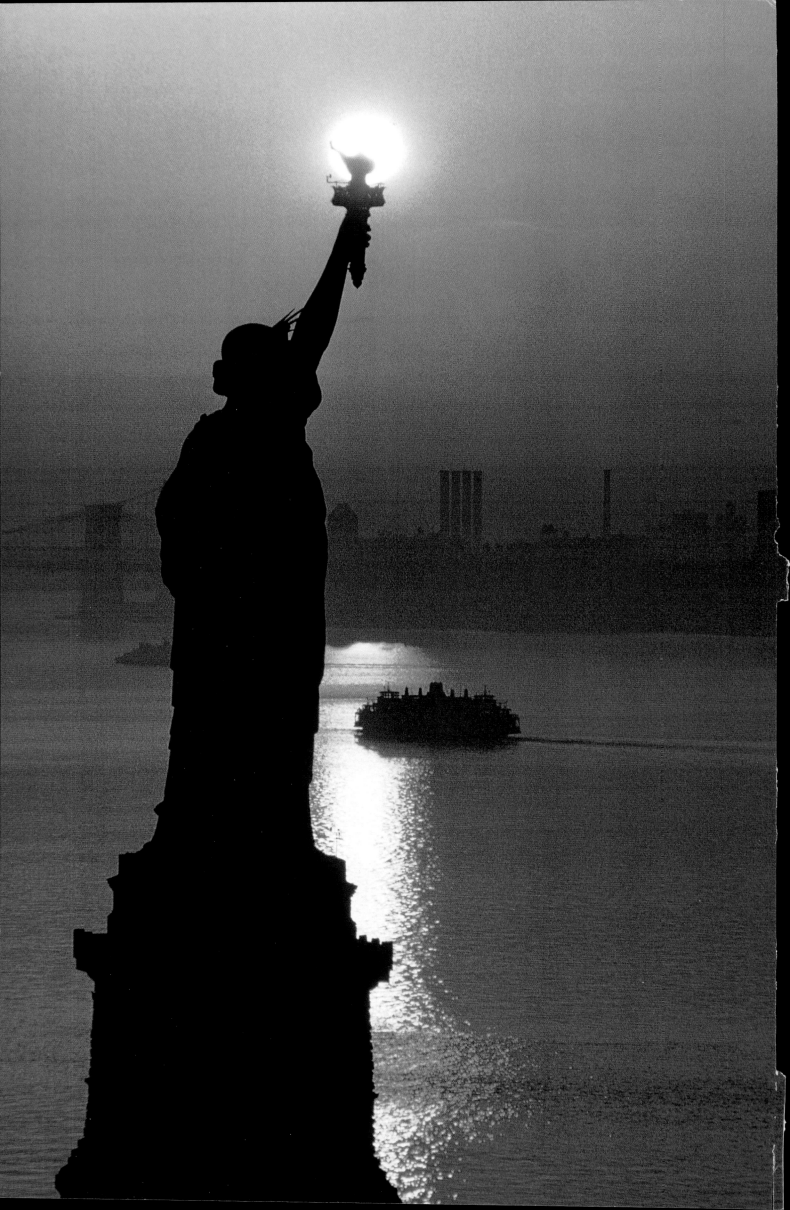

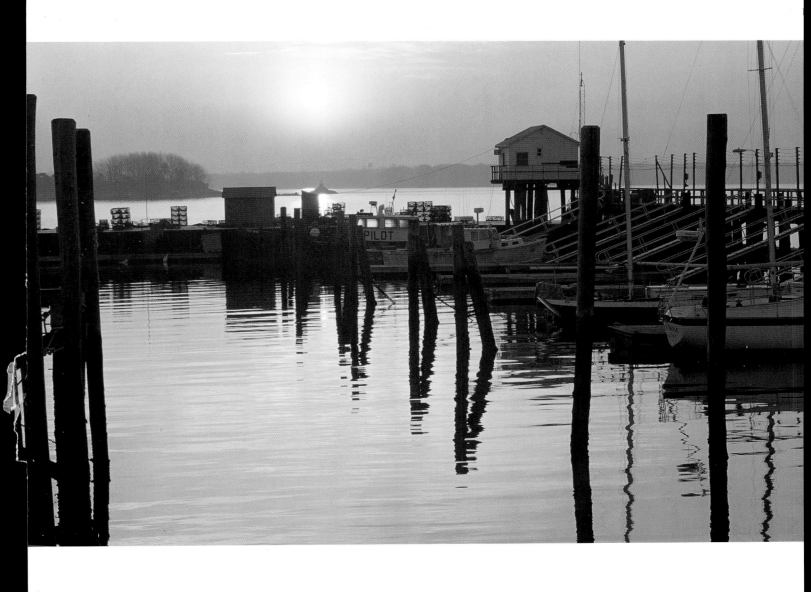

Above City Island, the Bronx
Opposite Statue of Liberty, Liberty Island
Overleaf Brooklyn Bridge, Brooklyn/Manhattan

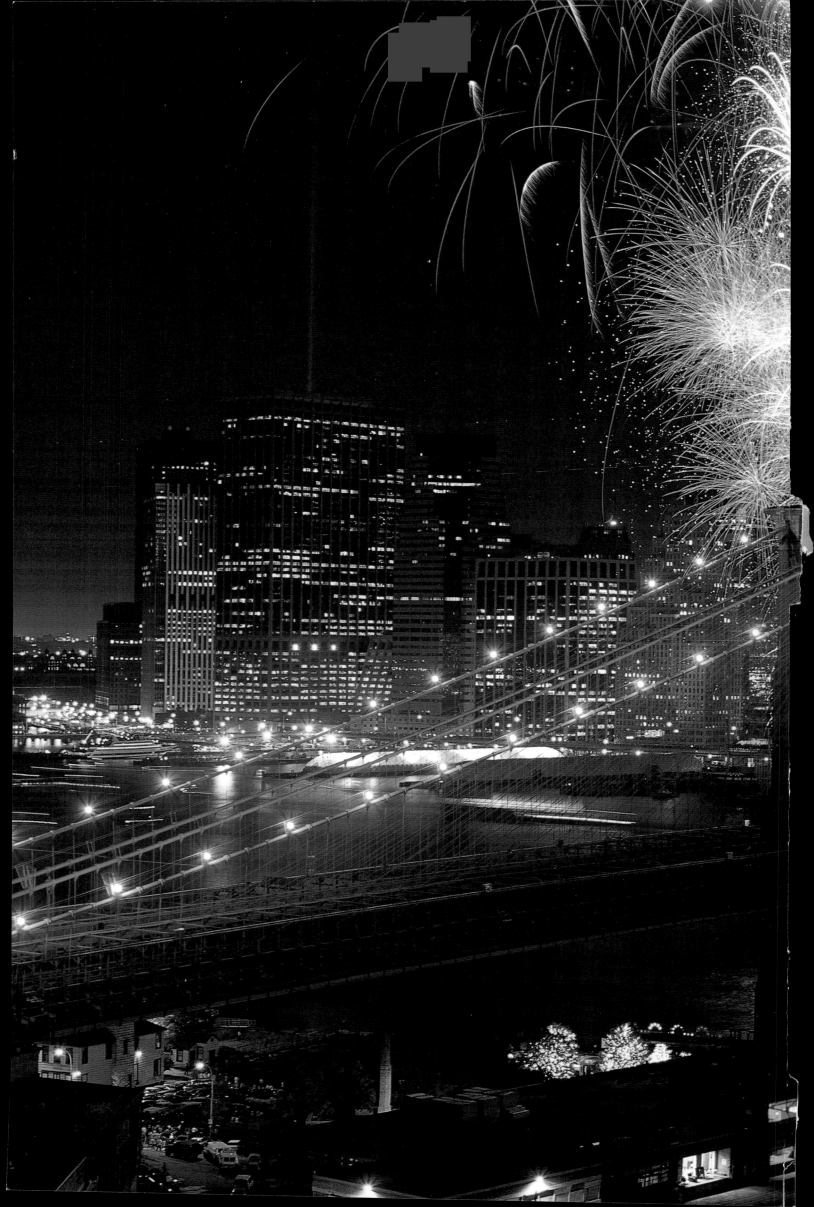

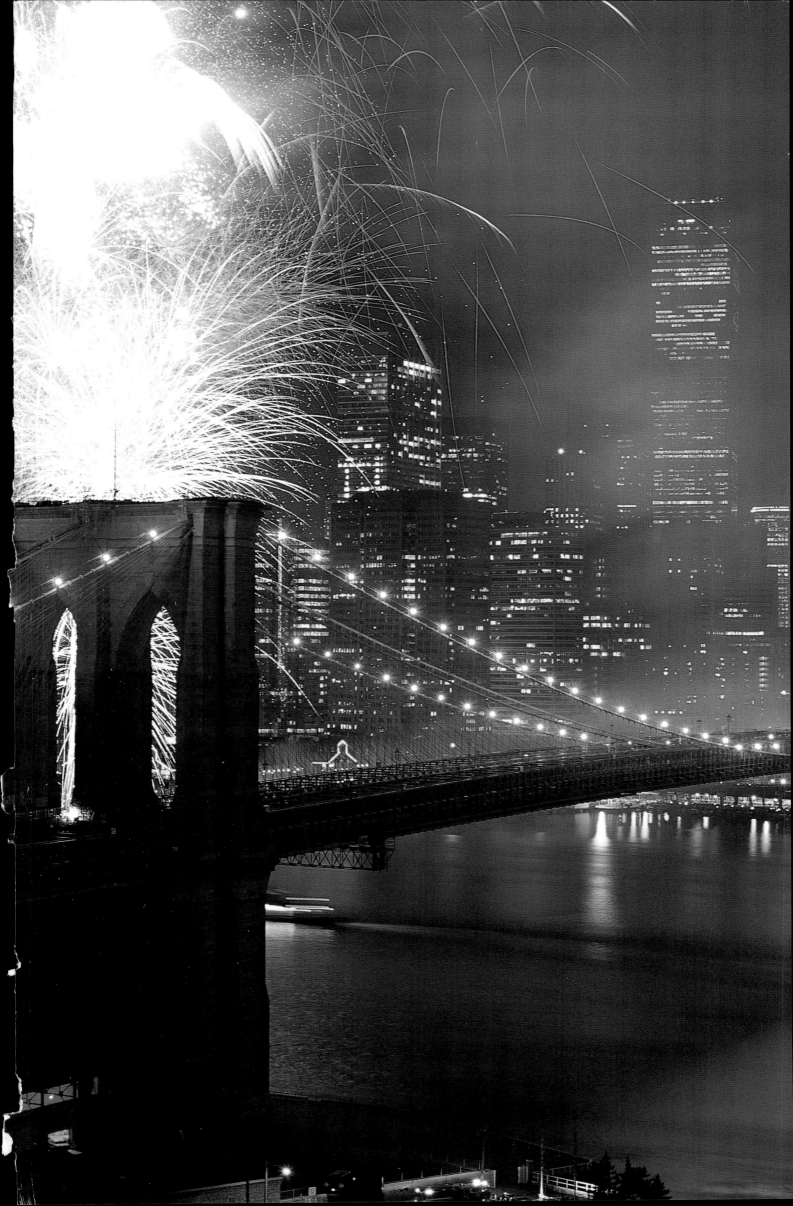

TO ANNE, CHLOE, AND OLIVIA

SPECIAL THANKS TO
John Botkin, Steve Dailey, Will Dailey, Angel Gamez, Michael Goldstein, John and Carol Grady,
Ruth Graves, Pete Hamill, Karl F. Lauby, New York Botanical Gardens, Gianfranco Monacelli,
Andrea Monfried, Grant Parrish, Anne, Chloe, and Olivia Rajs, Janina Rajs, Julius Rajs,
Geoff Rawlings, Frank Raziano, Michael Rock, Charles Rosario, Jordan Schaps, Steve Sears,
Jules Solo, Mark Speed, Frances, Tim, and Benjamin Wagner, Adele Waterman, Jimmy Winstead